D0162827

**National Gallery of Art
Washington**

**Princeton University Press
Princeton and Oxford**

David Alan Brown

Mary Westerman Bulgarella

Elizabeth Cropper

Dale Kent

Victoria Kirkham

Roberta Orsi Landini

Eleonora Luciano

Joanna Woods-Marsden

Virtue and Beauty | **Leonardo's *Ginevra de' Benci* and Renaissance Portraits of Women**

HOUSTON PUBLIC LIBRARY

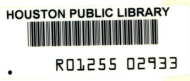

R01255 02933

The exhibition is made possible by generous support from Airbus

The exhibition was organized by the National Gallery of Art, Washington

Exhibition Dates
30 September 2001–6 January 2002

Copyright © 2001. Board of Trustees, National Gallery of Art, Washington. All rights reserved.

Produced by the Editors Office, National Gallery of Art, Washington
Judy Metro, *Editor-in-chief*

Edited by Susan Higman
Designed by Margaret Bauer

Typeset in Adobe Garamond and FF Meta by Duke & Company, Devon, PA, and printed on Phoenix Motion Xantur, 150 gsm by Arnoldo Mondadori Editore, Verona, Italy

Index prepared by Marshall Indexing Services, College Park, MD

Hardcover edition published by the National Gallery of Art in association with Princeton University Press.

Princeton University Press
41 William Street
Princeton, New Jersey 08540

www.pup.princeton.edu

In the United Kingdom:
Princeton University Press
3 Market Place
Woodstock, Oxfordshire OX20 1SY

Library of Congress Cataloging-in-Publication Data

Virtue & beauty: Leonardo's Ginevra de' Benci and Renaissance portraits of women / David Alan Brown … [et al.]; with contributions by Elizabeth Cropper and Eleonora Luciano.
p. cm.
Catalog of an exhibition held Sept. 30, 2001–Jan. 6, 2002 at the National Gallery of Art.

Includes bibliographical references.
ISBN 0-89468-285-7 (paper)
ISBN 0-691-09057-2 (cloth)

1. Portraits, Italian—Italy—Florence—Exhibitions.
2. Portraits, Renaissance—Italy—Florence—Exhibitions.
3. Women—Portraits—Exhibitions.
4. Women in art—Exhibitions.
5. Leonardo, da Vinci, 1452–1519. Ginevra de' Benci—Exhibitions.
I. Title: Virtue and beauty. II. Brown, David Alan, 1942– III. National Gallery of Art (U.S.)

N7606.V57 2001
757′.4′09455109024 — dc21
2001030333

Cover illustrations

Front: Sandro Botticelli, *Young Woman (Simonetta Vespucci?) in Mythological Guise* (detail), c. 1480/1485, Städelsches Kunstinstitut, Frankfurt am Main (cat. 28)

Back: Domenico Ghirlandaio, *Giovanna degli Albizzi Tornabuoni* (detail), c. 1488/1490, Museo Thyssen-Bornemisza, Madrid (cat. 30)

Table of Contents

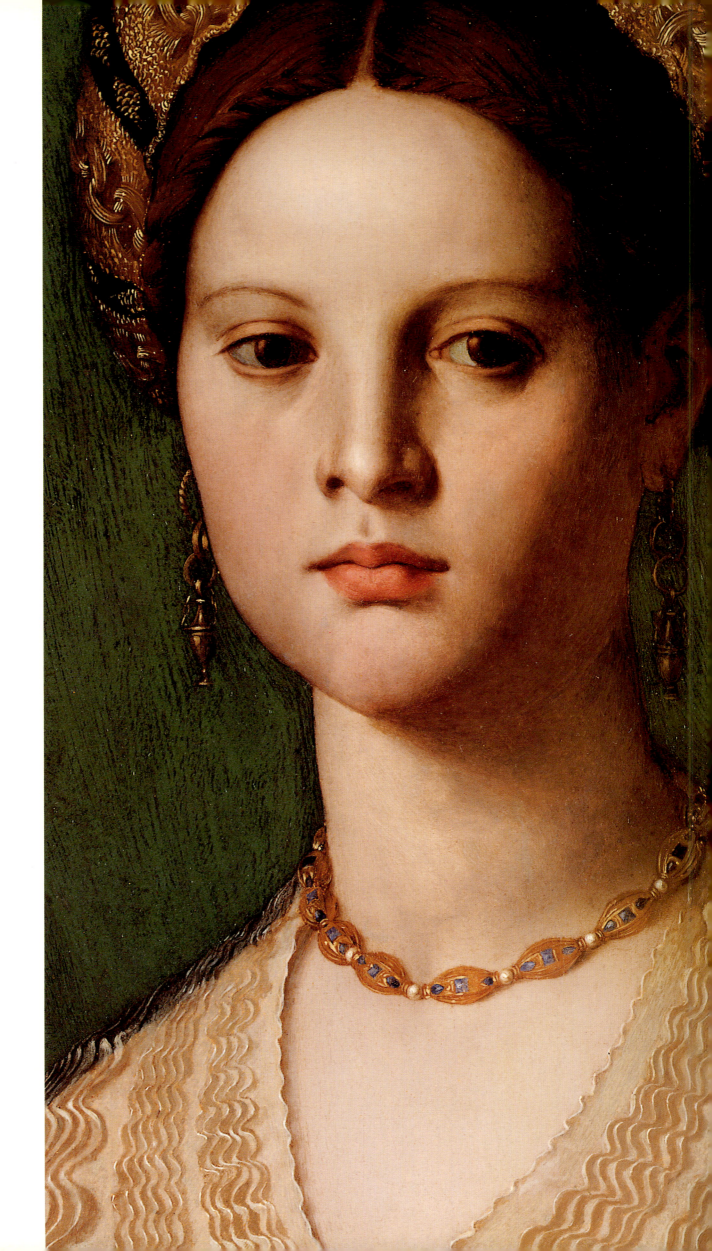

Lenders to the Exhibition

Ashmolean Museum, Oxford

The British Museum, London

The Duke of Devonshire and the Chatsworth
Settlement Trustees

The Frick Collection, New York

Galleria degli Uffizi, Florence

Galleria degli Uffizi, Gabinetto Disegni e
Stampe, Florence

The Huntington Library, Art Collections,
and Botanical Gardens, San Marino

Isabella Stewart Gardner Museum, Boston

The Metropolitan Museum of Art, New York

Museo Nazionale del Bargello, Florence

Museo Thyssen-Bornemisza, Madrid

Museum Boijmans Van Beuningen, Rotterdam

The National Gallery, London

National Gallery of Art, Washington

Philadelphia Museum of Art

Her Majesty Queen Elizabeth II

Sheldon H. Solow and The Solow Art and
Architecture Foundation

Staatliche Museen zu Berlin, Gemäldegalerie

Städelsches Kunstinstitut und Städtische
Galerie, Frankfurt

Sterling and Francine Clark Art Institute,
Williamstown

Victoria and Albert Museum, London

The Walters Art Museum, Baltimore

Foreword

Most, if not all, exhibitions evolve during the course of being planned, and *Virtue and Beauty* is no exception. This exhibition began, in fact, as a small show centering on the National Gallery of Art's portrait of *Ginevra de' Benci* by Leonardo da Vinci. It soon became clear, however, that the broadest and most illuminating context for Leonardo's painting could not be provided by his few surviving early works. The exhibition, accordingly, offers a survey of Renaissance portraits of women, focusing on the phenomenal rise of female portraiture in Florence beginning in the second half of the fifteenth century. Numbering forty-seven works, it encompasses a variety of media, not only panel paintings but also marble busts, medals, and drawings. And it includes many of the finest portraits of women (and of a few men) by Filippo Lippi, Botticelli, Verrocchio, Leonardo, Domenico Ghirlandaio, and Bronzino, to name only some of the artists represented. Prototypes and parallel works from outside Florence by such masters as Pisanello, Rogier van der Weyden, and Jacometto Veneziano shed further light on the development of female portraiture in the Renaissance. Our aim is to present the portraits not simply as beautiful objects, which they are, but also in terms of the social and cultural values and ideals they project.

David Alan Brown, the Gallery's curator of Italian Renaissance paintings, organized the exhibition and wrote the catalogue entries on the fifteenth-century paintings and drawings, while Eleonora Luciano, in the sculpture department, prepared the entries on the medals and marble busts. Aside from these two staff members, we were most fortunate that the newly appointed dean of the Gallery's Center for Advanced Study in the Visual Arts, Elizabeth Cropper, arrived just in time to write the entries on the sixteenth-century portraits. She was the perfect choice, having written a series of pioneering essays on female beauty in the Renaissance. We were also able to engage other leading experts to write introductory essays on the broader issues that the portraits pose—Dale Kent on Florentine women, Victoria Kirkham on the literary and cultural background, Joanna Woods-Marsden on Renais-

sance portraits of women in general, and Mary Westerman Bulgarella and Roberta Orsi Landini on the costumes and jewelry worn by the women in the portraits.

Italian government officials played an important role in obtaining loans. We are indebted to Ferdinando Salleo, ambassador to the United States, and to Luigi Maccotta, first counselor, for their help. Without the intervention of Antonio Paolucci, superintendent of fine arts in Florence, Verrocchio's *Lady with a Bunch of Flowers* in the Bargello Museum would not be included in the exhibition. It is here reunited with Leonardo's *Ginevra de' Benci* for the first time since the two works were together in Verrocchio's shop five hundred years ago.

Our largest debt of gratitude goes to the following directors of the lending institutions and private collectors, including Her Majesty Queen Elizabeth II, the Duke of Devonshire, and Baron and Baroness Thyssen, who have so generously agreed to share their works: Robert Anderson, Herbert Beck, Giovanna Gaeta Bertelà, Alan Borg, Christopher Brown, Michael Conforti, Chris Dercon, Anne d'Harnoncourt, Anne Hawley, Jan Kelch, Tomás Llorens Serra, Neil MacGregor, Philippe de Montebello, Edward Nygren, Annamaria Petrioli Tofani, Samuel Sachs II, Sheldon H. Solow and The Solow Art and Architecture Foundation, and Gary Vikan. We are also indebted to the Samuel H. Kress Foundation for supporting our effort to make this exhibition catalogue elegant yet affordable.

Without the generous support of Airbus, *Virtue and Beauty* would not have been possible. We are very happy to welcome Airbus back for their second sponsorship at the National Gallery of Art. On behalf of the Gallery, I would like to thank Philippe Delmas, executive vice president of Airbus, for his efforts in establishing this relationship.

Earl A. Powell III
Director, National Gallery of Art

Acknowledgments

An international loan exhibition like this one results from the contributions of numerous individuals and many National Gallery of Art departments. The exhibition would never have taken place without the support of Earl A. Powell III, director, who personally and persuasively intervened to obtain the loan of Ghirlandaio's great portrait of Giovanna Tornabuoni, not seen in the United States for nearly half a century. For their contributions to the catalogue, I would especially like to thank my co-authors: Elizabeth Cropper, Dale Kent, Victoria Kirkham, Roberta Orsi Landini, Eleonora Luciano, Mary Westerman Bulgarella, and Joanna Woods-Marsden. Though not a direct contributor, Everett Fahy kindly shared his notes and expertise on Ghirlandaio. In the department of Italian Renaissance paintings, Gretchen Hirschauer, assistant curator, deserves thanks for her efforts on behalf of our project. Elon Danziger, staff assistant, provided critical research and administrative support for the exhibition and its catalogue, taking on numerous tasks beyond the scope of his regular duties. Interns Claire Deschamps and Angela Oberer also offered assistance. John Hand and Alison Luchs, the Gallery's curators of Northern Renaissance paintings and early European sculpture, respectively, generously accommodated our requests for works under their care. In preparation for this exhibition Rikke Foulke, Culpeper fellow in painting conservation, diligently cleaned our Ercole Roberti portraits.

D. Dodge Thompson, chief of exhibitions, and Jennifer Fletcher Cipriano, exhibition officer, with Jennifer Bumba-Kongo, staff assistant, administered the loans. Christine Myers, chief corporate relations officer, Anne Lottmann, corporate relations associate, and Susan McCullough, sponsorship manager, worked closely with Airbus, the exhibition's unstinting sponsor, while Cathryn Scoville, senior development associate, and Missy Muellich, foundation relations associate, coordinated the Kress Foundation's generous support of the catalogue. Mervin Richard, deputy chief of conservation, advised on the condition and framing of a number of the paintings, and Steve Wilcox, frame conservator, provided frames as needed. In the Editors' Office, Judy Metro, editor-in-chief, and Susan Higman, editor, spent countless hours producing the catalogue.

Jane Van Nimmen served most capably as the outside reader. Sara Sanders-Buell, permissions coordinator, organized the photography. Neal Turtell, executive librarian, and his staff, in particular Ted Dalziel Jr., reference librarian, and Thomas McGill Jr., interlibrary loan assistant, provided bibliographic expertise, while Gregory Most, chief slide librarian, and Thomas O'Callaghan Jr., associate slide librarian, obtained and organized slides for the benefit of other departments. Ruth Philbrick, curator of the photographic archives, and her staff, especially Melissa Beck Lemke, archivist, helped with photographic research.

Mark Leithauser, chief of design, Gordon Anson, head of production, Donna Kirk, architect, John Olson, production coordinator, and Barbara Keyes, head of silkscreen, are responsible for the installation. The public attention the exhibition receives is due to the months-long effort of Deborah Ziska, press and public information officer, and Domenic Morea, publicist. Susan Arensberg, head of exhibition programs, provided the wall texts and other educational materials. Sally Freitag, chief registrar, and Michelle Fondas, registrar for exhibitions, planned the transportation of the objects.

We owe a further debt of gratitude to the following, in America and abroad, who assisted us in countless ways: Kenneth Bé, Shelley Bennett, George Bisacca, Andrew Butterfield, Alessandro Cecchi, Hugo Chapman, Alan Chong, Keith Christiansen, Alan Darr, Peter Day, Lien De Keukelaere, Jacqueline Dugas, Mark Evans, Elizabeth Leto Fulton, Charlotte Hale, Gisela Helmkampf, Laurence Kanter, Stephan Kemperdick, George Keyes, Dorothy Mann, Melinda McCurdy, Lucia Monaci, Theresa-Mary Morton, Antonio Natali, Christine Nelson, Nicholas Penny, Cristina Aschengreen Piacenti, Debra Pincus, Carol Plazzotta, Richard Rand, Jochen Sander, Christine Sperling, Joaneath Spicer, Stephen B. Spiro, Carl Strehlke, Stanton Thomas, Mark Tucker, Linda Wolk-Simon, Carl Wuellner, and Martin Wyld.

David Alan Brown
Curator, Italian Renaissance paintings,
National Gallery of Art

Introduction

David Alan Brown

This exhibition focuses on the extraordinary flowering of female portraiture in Florence from c. 1440 to c. 1540. It was in Florence during this period that portraiture expanded beyond the realm of rulers and their consorts to encompass women of the merchant class, who figure in scores of panel paintings, medals, and marble busts. Although scholars have conducted considerable research on this phenomenon, the exhibition aims to present it for the first time to a larger audience. The independent portraits exhibited here, as opposed to donor portraits in frescoes or altarpieces, are autonomous, freestanding works that typically depict the sitters bust length or half-length in profile, three-quarter, or frontal view. The exhibition brings together nearly all the most significant examples of the genre, with the exception of a few panels that could not safely travel. Including several male portraits as well, the works are presented in the exhibition and the catalogue in roughly chronological order and in subgroups by media. Aside from the panel portraits, there are smaller numbers of medals, drawings, and busts, together with a selection of courtly precedents, Northern analogues, and a few works specifically related to Leonardo's *Ginevra de' Benci*. In this way, progressing through the exhibition or perusing the catalogue, the viewer / reader can observe a broad shift from the painted profile to the three-quarter or frontal view. Over time the portraits of women also became larger in scale, more elaborate, and more communicative with the viewer.

Just as the portraits represent a conjunction of the patron, the sitter, and the artist, so the catalogue is the product of collaboration between historians and art historians. The first section includes two essays placing the works in their historical and cultural context, followed by a survey of female portraits not limited to Florence, and an analysis of clothing and jewelry worn by women of the period. The catalogue entries dealing with individual works explore how portrait conventions were interpreted by different artists. At a time when art is being studied contextually, the entries remind us not to lose sight of the artist's contribution.

Renaissance portraits differ in many ways from the notion of portraiture commonly held today. They are not direct likenesses completed in the sitter's presence but involve life studies (cats. 32, 34), of which only a few survive, transformed in the process of becoming portrait images. Above all, they lack the psychological dimension — the revelation of the inner self — characteristic of modern portraiture. Insofar as the portraits represent the sitter's individual nature, they reflect a different conception of identity. In the case of women in particular, the individual was seen in light of her social status and familial role as wife and mother. Character did not mean a unique complex of psychological traits but rather moral being and behavior which an individual shared with other women of the same class. The female portraits in the exhibition are, in this sense, individual variants of the society's paradigm of the "ideal woman." Such a concept was constructed visually as a more or less recognizable likeness of the sitter in contemporary dress, amplified or completed by a presentation of her character either in the form of visual metaphors or attributes or of a portrait reverse or cover employing mottoes or emblems. Many of the portraits in the exhibition, both medals and paintings, have such reverses.[1] Rather than being comprehended instantly, the portraits disclose their meaning as they are viewed first on one side and then on the other. Unlike the small bronze medals, held in the hand or worn around the neck, the panel portraits did not retain their double-sidedness but were later reframed and treated like easel paintings with the result that the labels or seals attached to their reverses may still be seen today.

Judging from their portraits, visitors to the exhibition might well conclude that Florentine women of the time all had long necks, golden hair, pearly white skin, sparkling blue eyes, and rosy lips and cheeks. But the similarity in their appearance is not simply a matter of cosmetics; it reflects a canon of corporeal beauty derived from literature. Poetic descriptions of women from Dante and Petrarch to Lorenzo de' Medici defined an ideal subsequently codified in treatises on female beauty, such as Agnolo Firenzuola's *Dialogo delle bellezze delle donne* (1548). Petrarch's *Canzoniere,* in particular two sonnets in praise of Simone Martini's (lost) portrait of his beloved Laura, became the primary source for depicting women in art and literature.

The relevance of the poets' metaphors to visual representations of women has been well established by Elizabeth Cropper and others in terms of how the images were conceived and viewed.[2] Portrayals of women were praised for being both lifelike and beautiful, implying that the subjects were truly beautiful. At the same time women, like men, had to be worthy of commemoration in the form of a portrait. Renaissance attitudes toward women differed sharply. There was, on the one hand, the deep-seated belief, going back to Aristotle, in the biological inferiority of women, who were weak, passive creatures composed of the basic elements of water and earth rather than fire and air, which animated men. An extreme view held that women were subhuman. Women also harked back to Eve, the temptress, and if a wife was not wily, her vanity and extravagance would be her husband's ruin.[3]

Unlike the misogynists who denigrated women, poets and artists celebrated the exemplary virtues of their female subjects. Qualities considered appropriate to women, as opposed to heroic male *virtù,* included modesty, humility, piety, constancy, charity, obedience, and, above all, chastity, the preeminent virtue of a woman in a society dominated by men.[4] Though they may have been in tension or even in conflict in real life, female beauty and virtue were linked in Renaissance thought and art. The classical equation of the good and the beautiful, in particular the Neoplatonic notion that physical beauty signified an inner beauty of spirit, was expounded by the Florentine humanist Marsilio Ficino. The concept of virtuous beauty posed a problem for the artist, however. Women who were not beautiful still had to look so in order to appear virtuous. The necessity of a convincing likeness had to be reconciled, in other words, with the need to present a suitably idealized image of the sitter. Artists asserted the moral significance of beauty by idealizing their subjects in poetic terms, as we have seen. Another way to express virtuous beauty was by means of the mottoes and emblems depicted on the reverse of medals (cats. 8, 11) and paintings, like *Ginevra de' Benci* (cat. 16), which make an explicit connection between the sitter's outward appearance and inner nature.[5] In Leonardo's case, the portrait reverse depicts a wreath of laurel and palm encircling a sprig of juniper. Entwined around the plants is a scroll with a Latin inscription meaning "Beauty Adorns Virtue." Closely similar emblematic reverses are found in double-sided portraits by Jacometto Veneziano, several of which (cats. 19–21) are compared with Leonardo's in the exhibition.

The images of Renaissance women confronting us here are clearly not straightforward portraits of individuals. And yet that is how they were seen by the great Swiss historian Jacob Burckhardt, whose *Civilization of the Renaissance in Italy* of 1860 was enormously influential in shaping modern attitudes toward the period.[6] The book's chapter titles, "The Development of the Individual" and "The Discovery of the World and of Man," mirror the author's concern with outstanding individuals, not society as a whole. Burckhardt's concept of the individual, moreover, was applied to women as well as men, based on his belief that "women stood on a footing of perfect equality with men" since "the educated woman, no less than the man, strove naturally after a characteristic and complete individuality."[7] Generalizing from a few exceptional figures like Isabella d'Este or Vittoria Colonna, Burckhardt exalted women of the Renaissance, and in the English-speaking world of the late nineteenth and early twentieth century, his view was popularized by an outpouring of biographies and histories with such titles as *The Women of the Renaissance* (1905), *Women of Florence* (1907), and *The Women of the Medici* (1927).[8]

Burckhardt's concept of the individual was also applied to portraiture, which, according to one author, joined in "the search for character, amounting to a passion that, in art, drew the individual out…and set him on a pedestal or in a frame…."[9] Female portraits, no less than those of men, were seen as quintessential expressions of Renaissance individualism, as when one writer characterized the subject of Pollaiuolo's *Portrait of a Lady* in the Poldi Pezzoli Museum, Milan (Woods-Marsden essay, fig. 2) as a "shrewd, practical lady, sharp-witted…and certainly not without passions."[10] This description and others like it suggest that, aside from Burckhardt, modern psychological novels, like Henry James's *Portrait of a Lady* (1881),

1

Domenico Veneziano, *Saint Lucy Altarpiece* (detail), Galleria degli Uffizi, Florence (photo: Alinari / Art Resource, N.Y.)

2

Thomas Wilmer Dewing, *Lady with a Lute,* National Gallery of Art, Washington, Gift of Dr. and Mrs. Walter Timme

3

Wilhelm von Bode with Botticelli profile, Staatliche Museen zu Berlin, Preussischer Kulturbesitz, Kunstbibliothek (photo: Dieter Katz)

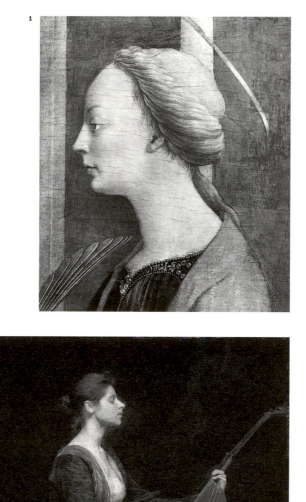

may have played a role in "reading" Renaissance portraits of women. Prevented like the fictional heroines of James or Edith Wharton from participating in business or politics, upper-class Florentine women might also have pursued individuality in private life, or so it seemed from their portraits.

The affinity felt by the Victorians and their successors for the Florentine portraits of women was not just a matter of literary parallels, however. The female profiles in particular exerted a direct appeal that reflected their origins. In the early Renaissance, the profile favored for portraits of men and women alike was practically synonymous with virtue. Especially for medals imitating ancient coins, the profile was universally preferred to commemorate the sitters for posterity. In the case of painted portraits of women, the profile had, in addition, long been adopted for donor portraits. It also served to associate the sitter with profile depictions of the Virgin or female saints (fig. 1).[11] Even without these classical and religious associations, the modestly averted gaze and stiffly upright bearing of the ladies in profile would have marked them as virtuous. The charm of the portraits, one writer explained, was due to the "extreme purity and simplicity of the profile seen against the sky" and to the "fresh and innocent grace" of the sitters.[12] The Renaissance vision of the ideal young woman resonated strongly among art lovers on both sides of the Atlantic. American painters such as Thomas Dewing or Albert Herter created profile portraits of women which, in their content and style, echo those of the fifteenth-century Florentines. Dewing's *Lady with a Lute* (fig. 2) of 1886, in the National Gallery of Art, for example, uses the musical instrument par excellence of the Renaissance, together with the profile, to invite comparison with the past.[13]

The vogue for the Renaissance profiles of women, however influential for the creation of newly minted portraits, had an even greater impact in the field of collecting. Early in the nineteenth century, the English began to acquire examples of the genre, mostly in Florence, and their efforts proved hugely successful. Early Italian paintings in general are scattered throughout the world, with many still in Italy, but almost all of the female profiles found their way north of the Alps. Only two or three remain in their

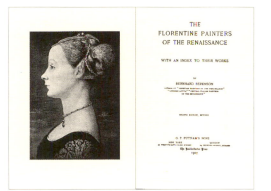

4

Frontispiece to Bernard Berenson,
Florentine Painters of the Renaissance
(New York, 1912), showing Antonio
del Pollaiuolo's *Portrait of a Lady*

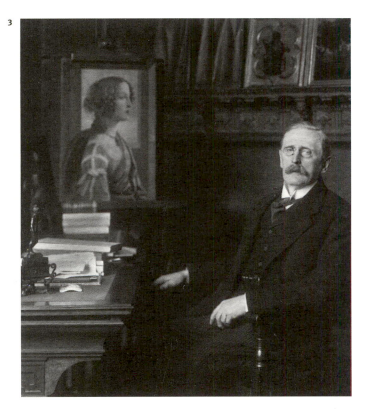

3

place of origin; the others are concentrated in London, Berlin, and New York. Baldovinetti's *Portrait of a Lady in Yellow* (Orsi Landini and Bulgarella essay, fig. 3) in the National Gallery, London, offers an example. Apropos of this portrait, one writer noted how well the profile expressed the "charm and freshness of youth."[14] The painting, still in its original frame, was purchased from a Florentine dealer in 1866.[15] Like so many of the female profiles, the London picture was attributed to Piero della Francesca until Roger Fry discovered its true author. The sitter, too, was fancifully identified, on the basis of the heraldic device on her sleeve, as a countess Palma of Urbino.[16] Another artist credited with the authorship of this and many other profile portraits (cat. 5) was the ever-popular Paolo Uccello, but among the quattrocento Florentines, it was Botticelli who most beguiled the Victorians. The Pre-Raphaelite poet and painter Dante Gabriel Rossetti purchased *Woman at a Window (Smeralda Brandini?)* (cat. 25) in 1867, when Botticelli was being rediscovered by Ruskin and Pater.[17] Championing his work from very different points of view, these two critics

were largely responsible for the cult of the artist in nineteenth-century England. There and in Germany a group of imaginary portraits of a beautiful young woman with rippling hair (cat. 28), similar to Botticelli's mythologies in the Uffizi, were eagerly sought by aesthetes and collectors. In them Botticelli may have given tangible form to Simonetta Vespucci, the beloved of Giuliano de' Medici, whom Ruskin and Pater fondly believed to be the artist's mistress. Simonetta, if it is really she whom Botticelli portrays in these works, died of consumption at the age of twenty-three in 1476, leaving behind a memory of her beauty which soon became a myth. Hers is not the only portrait in the show that is tinged with melancholy.

In its quest to acquire early Italian paintings, the National Gallery in London had a formidable rival in Wilhelm von Bode, director of the Kaiser Friedrich Museum in Berlin. Bode (fig. 3), shown here with one of the "Simonetta Vespucci" depictions on his desk, took a keen interest in the art of quattrocento Florence, not just painting but sculpture and the decorative arts as well.[18] He succeeded in acquiring for Berlin another "Simonetta Vespucci" painting in 1875, Antonio Pollaiuolo's *Profile of a Lady* (see cat. 6) in 1894, and Filippo Lippi's *Profile Portrait of a Young Woman* (cat. 4) in 1913. A scholar/curator, Bode addressed the attributional problems posed by the profiles in a series of articles spanning the first two decades of the twentieth century.[19] Bode had a rival, too, in Bernard Berenson, the American expatriate who quickly established himself as an authority, largely through the impact of his four volumes on the Italian painters of the Renaissance, with their lists of pictures the author accepted as authentic.[20] The frontispiece (fig. 4) to Berenson's *Florentine Painters of the Renaissance*, originally published in 1896, featured Pollaiuolo's masterpiece in Milan, which must have whetted the appetite of American collectors. Bode and Berenson came into open conflict over Piero Pollaiuolo's *Woman in Green and Crimson* (see cat. 6), which Isabella Stewart Gardner (1840–1924) acquired for her museum, Fenway Court, in Boston in 1907.[21] Having nearly succeeded in purchasing the picture in Florence in the mid-1870s, Bode obtained it for the Hainauer collection in Berlin about 1885, only to lose it

5
West Room of Pierpont Morgan's Library,
before 1913 (photo: Archives of the
Pierpont Morgan Library, New York / Art
Resource, N.Y.)

6
Interior of the Huntington mansion,
New York (photo: The Mariners' Museum,
Newport News, Va.)

again to Mrs. Gardner, who bought it from the famous art dealer Sir Joseph Duveen, on Berenson's recommendation, for the extraordinarily large sum of more than fifty-eight thousand turn-of-the-century dollars.

Mrs. Gardner was upstaged by another collector, J. Pierpont Morgan (1837–1913), who played a key role in the reception and collecting of the Florentine female portraits in America. Consumed with acquiring art on a grand scale but coming late to the task, Morgan wisely chose to buy whole collections. He got the choice of the paintings belonging to Rodolphe Kann, for example, when Duveen bought the Parisian collection in 1907. Among the early pictures, the prize was Ghirlandaio's portrait of *Giovanna Tornabuoni* (cat. 30), which Morgan purchased for no less than thirty-eight thousand English pounds (receipt on file at the Morgan Library). Just as the inscription in the picture echoes Petrarch, so the painting itself, when in the Pandolfini collection in Florence, was thought to represent the poet's beloved Laura.[22] The sitter was correctly identified in the nineteenth century as a posthumous likeness of Lorenzo Tornabuoni's wife. For Morgan, the portrait may even have had a poignant personal meaning, as the collector had lost his own first wife, Amelia Sturges, with whom he was deeply in love, only a few months after their marriage in 1861.[23]

Before Ghirlandaio's painting was disposed of by the Library in 1935, it was displayed on an easel in Morgan's study (fig. 5), known as the West Room. The setting of furniture and decorative arts was meant to evoke the sort of palatial interior from which the picture was believed to have come. During this period, which has been called the American Renaissance, bankers and manufacturers like Morgan spent their vast fortunes on art and in so doing considered themselves the heirs of the Renaissance.[24] For his concern with commerce and culture Morgan was even celebrated as an "American Medici." Far from being just an art object, then, Ghirlandaio's painting, together with the other works in the room, the red brocade walls, and the carved wooden ceiling, transported its owner to an ideal past of which the portrait was a potent symbol. The affinity with the Renaissance, particularly with Florence, where many art-minded

Americans visited or resided, was such that other female profiles were similarly sought out and displayed in Renaissance-style interiors.[25] Arabella Huntington (1850–1924), for example, though purchasing a number of works from the Kann collection, missed out on the *Giovanna Tornabuoni,* which went to Morgan. The lady had to content herself with a pair of male and female portraits attributed to Ghirlandaio (cats. 31A and B), which she acquired from Duveen in 1913 for the astonishing sum of $579,334.43. Now (with the receipt for their purchase) at the Huntington Library in San Marino, California, the portraits were originally hung on velvet-covered walls in a neo-Renaissance room in the family mansion (fig. 6) on the corner of Fifth Avenue and Fifty-Seventh Street in New York.[26]

Another *Portrait of a Lady* attributed to Domenico Ghirlandaio (cat. 29) was offered to Morgan by the Florentine dealer Elia Volpi in 1911.[27] Already in possession of the *Giovanna Tornabuoni,* Morgan declined, allowing Singer sewing machine heir Robert Sterling Clark (1877–1956) to acquire the picture in Florence two years later. Clark and his brother Stephen had engaged the American sculptor George Gray Barnard to act as their guide on an art-buying trip to Europe. For the portrait Clark paid the princely sum of one hundred and ten thousand dollars, including a commission to Barnard, who got a painted ceiling in the bargain.[28] Attributed to Botticelli in the Chigi Saracini collection, Siena, the picture came with a puzzle attached. Old photographs (fig. 7) reveal that it bore the attributes of Saint Catherine: the sitter wore a coronet and halo, and a spiked wheel was painted over her sleeve in the lower right.[29] By the time Clark bought the picture, the sanctifying additions had been removed. A faithful copy, including the saint's attributes, probably made by the master forger Federico Ioni to replace the original, still belongs to the Chigi Saracini collection today, while a modern fake, without the attributes, is in the museum in Geneva.[30]

This account of the vogue for the Florentine female portraits in America, however brief, would be incomplete without mentioning a few more of the numerous works of doubtful authenticity it inspired. To judge from the objects

5

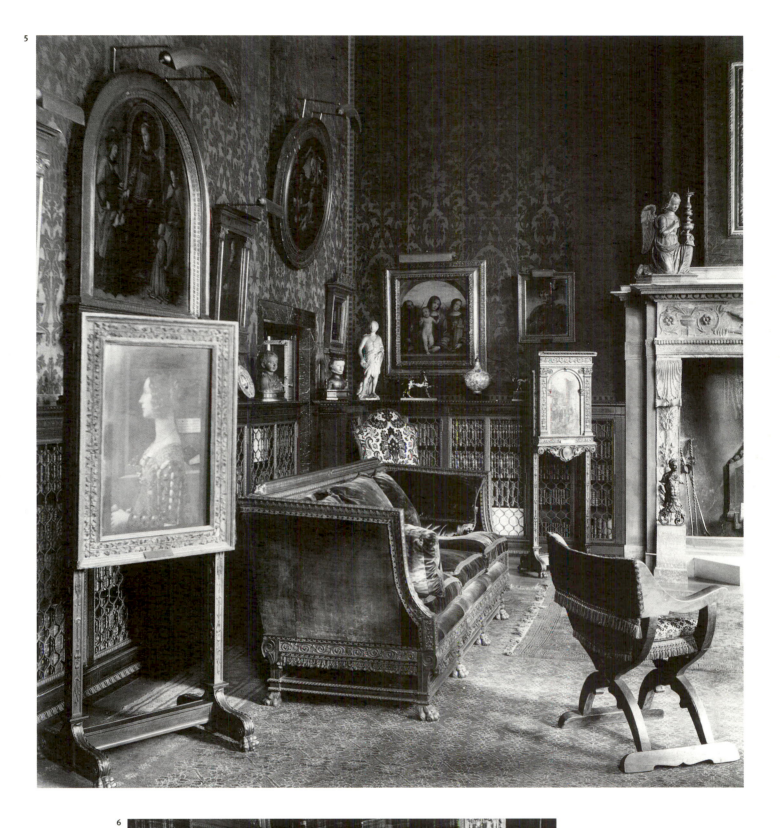

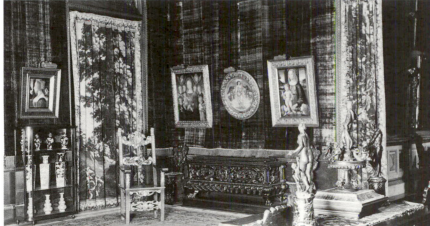

6

7

Domenico Ghirlandaio, cat. 29 as
Saint Catherine (photo: Alinari / Art
Resource, N.Y.)

7

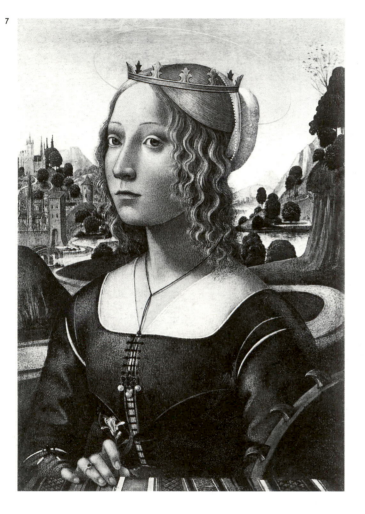

or from photographs, which is how many of them are known today, these paintings and sculpted busts are mostly outright fakes made to satisfy the demand for such portraits once the supply of the originals had dwindled or dried up. Showing what it was that collectors admired in the originals, the fakes together form a minor but intriguing episode in the history of taste and collecting. American millionaire collectors typically sought masterpieces by famous artists, and they relied on experts like Bode or Berenson for advice. In the case of the female portraits, however, collectors coveted a certain type of image with a different appeal: the youthful sitters, usually shown in profile, are charming, richly dressed, and elaborately coiffed. If these works look flagrantly inauthentic today, how do they betray themselves? The *Portrait of a Lady* (fig. 8) in the Museum of

Fine Arts, Boston, was acquired in 1940 as a work by Piero della Francesca because of its resemblance to the artist's hieratic profile of Battista Sforza before a landscape (Woods-Marsden essay, fig. 10) in the Uffizi.[31] Deceptively painted in the Renaissance medium of tempera on panel, the portrait actually replicates the head of an attendant of the queen of Sheba in Piero's fresco cycle of the True Cross in the church of San Francesco, Arezzo.[32] Another portrait of *A Young Woman* (fig. 9), acquired by the Detroit Institute of Arts in 1936 as a work by Verrocchio or Leonardo, is revealed as a probable forgery by its anachronistic materials and unorthodox construction. The Institute's director W. R. Valentiner, who made a special study of the young Leonardo in Verrocchio's workshop, compared the portrait, particularly the sitter's curls, to *Ginevra de' Benci* (cat. 16), now in the National Gallery of Art, and to the *Bust of a Lady* (cat. 23) in the Frick Collection.[33] Later scholars either supported this attribution or proposed an alternative.[34] But after a recent technical examination, the picture turns out to have been painted on what appears to be photographic paper applied to a wood panel that was repaired before it was readied for painting.[35] And at least one of the pigments employed—zinc white—is modern. Further investigation might reveal that the small-scale portrait was actually painted over a photograph of the Frick bust, formerly in the Dreyfus collection, Paris, in profile to the left. A polychromed bust from the same collection (fig. 10), formerly called a portrait of Giovanna Albizzi by Desiderio da Settignano, now in the National Gallery of Art, has been recognized as a characteristic product of Giovanni Bastianini (1830–1868), the Florentine forger of Renaissance sculpture.[36]

When the profile portraits of women began to be collected in the nineteenth century, nearly all of them were attributed, first, to Piero della Francesca, whose profile of Battista Sforza, already mentioned, graces the Uffizi, and, later, to Domenico Veneziano or Paolo Uccello.[37] Like the pictures, the women portrayed also needed names, for while the portraits were painted to preserve their memory for posterity, their identities had been lost with the passage of time. Vasari's mention of portraits of Medici women,

8

Imitator of Piero della Francesca, *Portrait of a Lady,* Museum of Fine Arts, Boston, Lucy Houghton Eaton Fund, 1940

9

Imitator of Verrocchio, *A Young Woman,* Detroit Institute of Arts, Founders Society Purchase, Edsel B. Ford Fund and General Membership Fund
© 1996 The Detroit Institute of Arts

10

Giovanni Bastianini, *Portrait of a Lady, "Giovanna Albizzi,"* National Gallery of Art, Washington, Andrew W. Mellon Collection

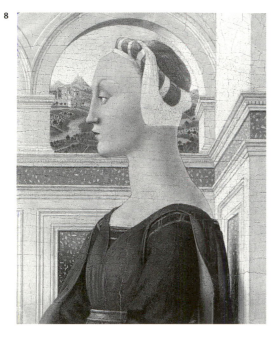

8

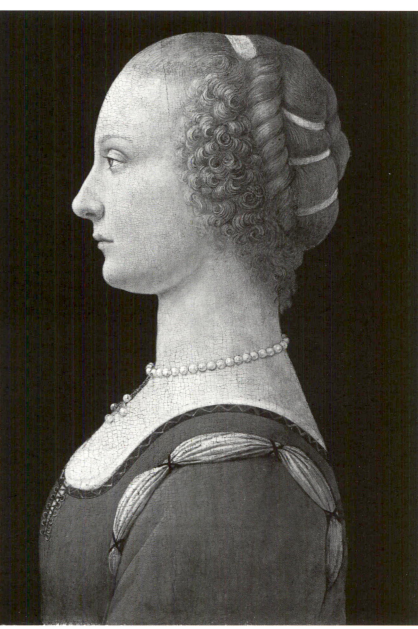

9

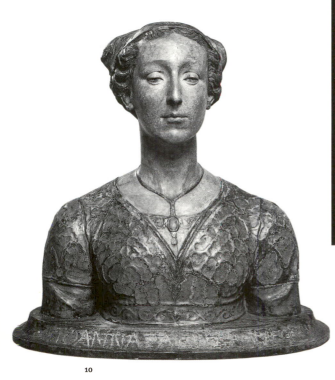

10

identified as Lucrezia Tornabuoni and Simonetta Vespucci, by Botticelli offered two candidates.[38] Another was Isotta da Rimini, well known for her romance with Sigismondo Malatesta.[39] Though the names of famous artists and women attached to the portraits obviously served a market function, the misattributions and fanciful identifications were eventually abandoned in a process of critical deconstruction that has continued to the present day. The more accurate connoisseurship reflected in Berenson's lists and in monographs on Renaissance artists demonstrated that the portraits were by different hands.[40] Sober reassessment also showed that the sitters, lacking any real clues to their identity, are mostly anonymous. Subsequent scholarship, culminating in John Pope-Hennessy's *The Portrait in the Renaissance* of 1966, further demonstrated that the female profiles, hitherto treated as a group, are actually a series dating over more than half a century.[41] The portraits were linked artistically as the artists who painted them responded to the solutions of their predecessors and contemporaries. This was especially the case with *Mona Lisa,* in which Leonardo established a compelling precedent for nearly all early sixteenth-century portraiture of men and women (see cat. 36).

Stylistic analyses, no matter how perceptive, did little to alter Burckhardt's century-old assumptions about the individualism of Renaissance portraiture. It was not until the advent of feminism and its application to historical studies in the 1970s that a radically new approach to the female portraits arose. In a seminal article of 1977, feminist historian Joan Kelly reexamined the position of women in the Renaissance and concluded that, contrary to Burckhardt, they did not enjoy equality with men.[42] Kelly's investigation and those of other feminist scholars showed that, while women of the period were the center of the home and family, they were systematically excluded from the public sphere. The ideal celebrated by Burckhardt masked the reality of the vast majority of women's separate but unequal status. It would not be too much to say that the feminists rediscovered the Renaissance woman, and their revisionist view was soon applied to representations of women in the visual arts. The fact that the Florentine portraits depicted ordinary and now mostly forgotten women made them

ideally suited to the task. The leading exponent of the feminist viewpoint is Patricia Simons who, in a series of important articles published between 1987 and 1997, analyzed the female profiles in the context of contemporary attitudes toward women and their (limited) role in society.[43] Observing the lack of individuality in the profiles, Simons took their stereotyped quality as a sign of the privileged but unempowered status of the sitters in a male-dominated society. The women were not just portrayed as decorative objects, moreover; reflecting the relation between the sexes, their profiles were subjected to the voyeuristic "male gaze."

Feminist interpretations of the Florentine portraits are open to several criticisms. Isolating female portraits as a separate category, for example, and treating the choice of the profile as a gender issue ignores the fact that men were portrayed in the same manner. Nor was the audience for the portraits exclusively male but included the sitter's family and friends of both sexes. Likewise, the patrons, the artists, and even the sitters may all have believed in the subservience of women, but the portraits were surely commissioned to commemorate, not denigrate, their subjects. Personal relations—ties of affection and respect about which we know very little but which we can presume to have existed—and not only social norms and forces must have shaped the portrait images, which in that sense are more than products of gender inequity. It is hard to believe, for example, that Ghirlandaio's hauntingly beautiful portrait of Giovanna Tornabuoni portrays her merely as her husband's property. Like the nearly identical image of the lady in Ghirlandaio's fresco of the Visitation in the Tornabuoni chapel in Santa Maria Novella in Florence, the portrait is a posthumous commemoration of Giovanna who died, during her second childbirth, in 1488. A decade later the portrait is still recorded in her husband's bedchamber in the Tornabuoni palace, where it would have served as a poignant reminder of his companion. As a posthumous likeness of a young woman who succumbed to the perils of childbirth, Ghirlandaio's portrait is by no means unique. The art theorist Leon Battista Alberti claimed that portraiture made the absent present and brought the dead to life, and his comment may well apply to other female portraits in the show as well.[44]

Viewed from a feminist perspective, the portraits lost much of the allure they once had for earlier generations of art lovers and collectors. And yet the feminists revolutionized the understanding of these works by reexamining them in a social context and demonstrating the concern they exhibit with women's character and conduct. Feminists also opened up the discussion to a younger generation of scholars who pursue it from a less ideological standpoint.[45] Interest in the female portraits presently centers on their relation to the most important event in the life of a Renaissance woman—her marriage.[46] Even before the function of the portraits began to preoccupy art historians, they were thought to be somehow connected with the sitters' betrothal or marriage. The women portrayed in profile are nearly all young and richly dressed. And marriage would have provided a motive for commissioning the portraits, just as *cassoni,* or wedding chests, were ordered to contain the bride's trousseau and *deschi da parto,* or birth trays, were made to carry gifts or refreshments to the mother of a newborn child.[47] The pictures are being scrutinized in the context of marriage rituals for clues as to who might have commissioned them—the bride's father, husband, or father-in-law—and what role, if any, they may have played in the different phases of the marriage alliance. The high point of the marriage ceremonies was the procession of the bride, dressed in all her finery, through the streets of Florence to the new household she would manage. If the portraits were not actually part of the marriage, they may well mark the occasion by fixing the sitter's image at the moment of her greatest social importance. The bride's lavish costume and ornaments displayed the families' wealth and status; the clothes and jewelry worn in the portraits are being studied, accordingly, not just from a fashion standpoint but also to determine what they signify about the sitter's social rank.[48]

Virtue and beauty, as it relates to female portraiture, is one of the main themes of the exhibition; another is the shift from the profile to the three-quarter or frontal view. At the very moment that the profile reached its apogee in the work of Antonio Pollaiuolo (cat. 6), two younger artists, both pupils of Pollaiuolo's rival Verrocchio, broke with the profile tradition and represented their subjects in three-quarter view. Botticelli and Leonardo were evidently responding to examples of Flemish portraiture, which typically showed the sitter turned at an angle to the picture plane, revealing more of the face. Both artists were also undoubtedly impressed by one of the most innovative female portraits of the quattrocento—Verrocchio's *Lady with a Bunch of Flowers* (cat. 22) in the Bargello, Florence. The sculptor's half-length treatment of the sitter, with hands, was taken over by his pupils, who placed their subjects, Smeralda Brandini and Ginevra de' Benci, in interior or exterior settings. The three-quarter view, which rapidly became de rigueur in the workshops of other artists, like Ghirlandaio, was adopted not only for aesthetic reasons: as Joanna Woods-Marsden explains in her essay, it lent the subject a greater physical and psychological presence and permitted a more intimate engagement with the viewer, who, in effect, exchanged the sitter's glance. It was a natural step, then, to the frontal view, widely adopted for the large-scale portraits that became common in the sixteenth century. The portraits from this period, catalogued by Elizabeth Cropper, also reveal another basic change with respect to the quattrocento profiles: while the Petrarchan ideal of beauty still applied, the sitters appear more mature. In an article on *Mona Lisa,* Frank Zöllner has argued that Lisa was portrayed to celebrate the birth of a child.[49] Two other portraits in the exhibition, by Pontormo (cat. 40) and Bronzino (cat. 41), include likenesses of children, in the latter case painted in after the picture was completed. These portraits and others like them are concerned with the second crucially important (and recurring) event in a woman's life—motherhood—and lineage, and they further exhibit the more courtly and aristocratic tone of Florentine society around the time that Cosimo de' Medici became duke of Florence in 1537. And yet despite all these changes, the sixteenth-century portraits, like the earlier ones, still present an ideal: they depict real women but not the intimate reality of their experience. In place of the complexities and contradictions of their private lives, the sitters are shown in their public role as ideally beautiful and virtuous young women. The actual and the ideal may well have been in conflict—it can hardly have been otherwise—but of that the portraits are silent.

NOTES

1. Angelica Dülberg, *Privatporträts. Geschichte und Ikonologie einer Gattung im 15. und 16. Jahrhundert* (Berlin, 1990).

2. Most relevant to the exhibition is Elizabeth Cropper's work on Petrarchan ideals of female beauty: "On Beautiful Women, Parmigianino, *Petrarchismo,* and the Vernacular Style," *The Art Bulletin* 48 (September 1976), 374–394; "The Beauty of Women: Problems in the Rhetoric of Renaissance Portraiture," in *Rewriting the Renaissance: The Discourses of Sexual Difference in Early Modern Europe,* ed. Margaret W. Ferguson, Maureen Quilligan, and Nancy J. Vickers (Chicago, 1985), 175–190; "Introduction" in *Concepts of Beauty in Renaissance Art,* ed. Francis Ames-Lewis and Mary Rogers (Hants, England, 1998), 1–11; and "The Place of Beauty in the High Renaissance and Its Displacement in the History of Art," in *Place and Displacement in the Renaissance,* ed. Alvin Vos (Binghamton, N.Y., 1995), 159–205.

3. Ian Maclean, *The Renaissance Notion of Woman. A Study in the Fortunes of Scholasticism and Medical Science in European Intellectual Life* (Cambridge, 1980).

4. For a comprehensive account of Renaissance views of women, see Ruth Kelso, *Doctrine for the Lady of the Renaissance* (Urbana, 1978; orig. ed. 1956), esp. 23–30 and 97–100.

5. For the medallic reverses, see Luke Syson, "Consorts, Mistresses and Exemplary Women: The Female Medallic Portrait in Fifteenth-Century Italy," in *The Sculpted Object, 1400–1700,* ed. Stuart Currie and Peta Motture (Aldershot, 1997), 43–64, esp. 49–50. Compare also Leon Battista Alberti's claim in his treatise *Della Famiglia* that "beauty in a woman must be judged not only by the charm and refinement of her face… a man must first seek beauty of mind, that is, good conduct and virtue." (Renée Neu Watkins, *The Family in Renaissance Florence* [Columbia, S.C., 1969], 115–116.)

6. Jacob Burckhardt, *The Civilization of the Renaissance in Italy,* trans. S.G.C. Middlemore, 2 vols. (London, 1960; orig. ed., Basel, 1860). For an analysis of Burckhardt's views on portraiture see Jennifer Craven, "A New Historical View of the Independent Female Portrait in Fifteenth-Century Florentine Paintings," Ph.D. diss., University of Pittsburgh, 1997, 6–35.

7. Burckhardt 1960, 240–241.

8. These books—R. de Maulde la Clavière, *The Women of the Renaissance. A Study of Feminism,* trans. George Herbert Ely (London, 1905); Isidoro del Lungo, *Women of Florence,* trans. Mary C. Steegmann (London, 1907); Yvonne Maguire, *The Women of the Medici* (London, 1927)—are all Burckhardtian in their emphasis on more or less well-known individuals.

9. George F. Hill, "Italian Portraiture of the Fifteenth Century," in *Proceedings of the British Academy* 11 (1927), 334–339.

10. Maud Cruttwell, *Antonio Pollaiuolo* (London, 1907), 179.

11. Alison Wright, "The Memory of Faces: Representational Choices in Fifteenth-Century Portraiture," in *Art, Memory, and Family in Renaissance Florence* (Cambridge, 2000), 92–93 and note 24, 109.

12. Hill 1927, 341.

13. Franklin Kelly in Franklin Kelly, Nicolai Cikovsky, Jr., et al., *American Paintings of the Nineteenth Century, Part I,* The Collections of the National Gallery of Art Systematic Catalogue (Washington, 1996), 127–130; Barbara Dayer Gallati, "Beauty Unmasked. Ironic Meaning in Dewing's Art," in *The Art of Thomas Wilmer Dewing: Beauty Reconfigured,* ed. Susan A. Hobbs [exh. cat., Brooklyn Museum] (Washington, 1996), 51–59, cat. 29, 148–149. About Herter's *Woman with Red Hair* of 1894, in the Smithsonian American Art Museum, Washington, see Richard N. Murray, "Painting and Sculpture," in *The American Renaissance: 1876–1917* [exh. cat., Brooklyn Museum] (New York, 1979), 167 and fig. 135.

14. Charles Holmes, *The National Gallery. Italian Schools* (London, 1935), 55–56.

15. Martin Davies, *National Gallery Catalogues. The Earlier Italian Schools,* 2d rev. ed. (London, 1961), no. 758, 42–43.

16. Eliot Rowlands ("Baldovinetti's Portrait of a Lady in Yellow," *Burlington Magazine* 122 [September 1980], 624–626) adduced new evidence in favor of Francesca degli Stati, wife of a poet and diplomat named Agnolo Galli.

17. See Michael Levey, "Botticelli and Nineteenth-Century England," *Journal of the Warburg and Courtauld Institute* 23 (1960), 291–306; and Gail Weinberg, "Ruskin, Pater, and the Rediscovery of Botticelli," *The Burlington Magazine* 129 (January 1987), 25–27.

18. *Wilhelm von Bode Museumsdirektor und Mäzen,* Staatliche Museen (Berlin, 1995).

19. Wilhelm von Bode, "Domenico Venezianos Profilbildnis eines Jungen Mädchens in der Berliner Galerie," *Jahrbuch der Königlich preussischen Kunstsammlungen* 18 (1897), 187–193; "Ein Frauenbildnis von Fra Filippo Lippi," *Jahrbuch der Königlich preussischen Kunstsammlungen* 34 (1913), 97–98; and "Italian Portrait Paintings and Busts of the Quattrocento," *Art in America* 12 (December 1923), 3–13. Echoing Burckhardt, Bode linked the rise of the independent portrait with the growth of individualism in fifteenth-century Florence, where, he noted, the female profiles represented a new class of bourgeois subjects, with their "cheerful, playful temperament, their fine manners and natural charm" (1923, 6). He gave most of the profiles, previously ascribed to Piero della Francesca, to Domenico Veneziano.

20. For the competition between Bode and Berenson, see David Alan Brown, "Bode and Berenson: Berlin and Boston," *Jahrbuch der Berliner Museen* 38 (1996), 101–106 (the whole issue devoted to Bode).

21. Philip Hendy, *European and American Paintings in the Gardner Museum* (Boston, 1974), 186–188.

22. Leopoldo Cicognara, *Storia della scultura dal suo risorgimento in Italia fino al secolo di Canova,* 2d ed., 7 vols. (Venice, 1823), 3: 323.

23. Jean Strouse, *Morgan. American Financier* (New York, 1999), 78–108.

24. When Burckhardt's *Civilization of the Renaissance in Italy* was published in New York in 1879, a reviewer claimed that "we are all children of the Renaissance" (quoted in exh. cat. Brooklyn 1979, 39).

25. Compare cats. 2A and B, 3, and 5 in the present catalogue. Much of the furnishings for these interiors was supplied by the Florentine dealers Stefano Bardini and Elia Volpi (Roberta Ferrazza, *Palazzo Davanzati e le Collezioni di Elia Volpi* [Florence, 1994]). Though Renaissance rooms were, in fact, rather sparsely furnished, the Americans struck a compromise between modern comfort, historical allusion, and ostentatious display.

26. Robert R. Wark, "Arabella Huntington and the Beginnings of the Art Collection," in *The Founding of the Henry E. Huntington Library and Art Gallery. Four Essays* (San Marino, Calif., 1969), 309–331; and Isabelle Hyman, "The Huntington Mansion in New York: Economics of Architecture and Decoration in the 1890s," *Syracuse University Library Associates Courier* 25 (fall 1990), 3–29.

27. Ferrazza 1994, 112, 257–258.

28. About the role of Barnard, better known as the architect of the Cloisters, New York, see Harold E. Dickson, "The Origin of the 'Cloisters,'" *The Art Quarterly* 28 (1965), 264.

29. Edmund G. Gardner, *The Story of Siena and San Gimignano* (London, 1902), 251. In an expertise, dated 4 September 1913, on the back of a photograph of the picture, minus the attributes, on file at the museum, Bode attributed it to Ghirlandaio and referred to the sitter as a member of the Rucellai family. His comments seem to have been meant to reassure Clark, who, after acquiring the portrait the preceding April, was astonished to discover that it had previously depicted a saint (letter of 12 August 1913, filed at the museum).

30. Giovanni Mazzoni in *Sembrare e Non Essere. I Falsi nell'Arte e nella Civiltà,* ed. Mark Jones and Mario Spagnol (Milan, 1993), cat. 196, 222–225; Mauro Natale and Claude Ritschard, *L'art d'imiter. Images de la Renaissance italienne au Musée d'art et d'histoire* (Geneva, 1997), cat. 27, 173–177.

31. For the acquisition of the panel (no. 40.237), now designated as by a Piero imitator in the museum, see G. H. Edgell, "A Profile Portrait of a Lady by Piero della Francesca," *Bulletin of the Museum of Fine Arts* 38 (October 1940), 64–66.

32. The Boston portrait is one of several forgeries inspired by Piero. See Daniela Pagliai, "I falsi ritratti di Piero della Francesca," in *Piero Interpretato. Copie, giudizi e musealizzazione di Piero della Francesca,* ed. Cecilia Prete and Ranieri Varese (Ancona, 1998), 65–71.

33. W. R. Valentiner, "Verrocchio or Leonardo," *Bulletin of the Detroit Institute of Arts of the City of Detroit* 16 (January 1937), 50–59. Valentiner tentatively attributed all three works to Leonardo, noting that hair so similar in the Detroit painting and the sculpted bust "can hardly be found in any other two Florentine portraits of the period."

34. Emil Möller ("Leonardos Bildnis der Ginevra dei Benci," *Münchner Jahrbuch der bildenden Kunst,* n.s. 12 [1937/1938], 185–209) gave the painting to Sebastiano Mainardi, while Piero Adorno (*Il Verrocchio. Nuove proposte nella civiltà artistica del tempo di Lorenzo Il Magnifico* [Florence, 1991], 141–142) identified it as Verrocchio's lost portrait of Lucrezia Donati.

35. The portrait (inv. no. 36.90), presently called "Ghirlandaio workshop," is painted in oil on a panel measuring 14¼ × 10 inches. Thanks go to the author's colleagues, who are responsible for the Institute's otherwise stellar collection of Italian art, for undertaking the preliminary technical analysis of the picture, which showed that worm holes, indicating the panel's age, were filled before it was gessoed.

36. John Pope-Hennessy, "The Forging of Italian Renaissance Sculpture," in his *The Study and Criticism of Italian Sculpture* (New York, 1980), 258, 260.

37. Jacob Burckhardt, *Beiträge zur Kunstgeschichte von Italien* (Basel, 1898), 182.

38. Giorgio Vasari, *Lives of the Most Eminent Painters, Sculptors and Architects,* trans. by Mrs. Jonathan Foster, 6 vols. (London, 1892–1898), 2: 238.

39. Eleonora Luciano, "*Diva Isotta* and the Medals of Matteo de' Pasti. A Success Story," *The Medal* 29 (autumn 1996), 3–17.

40. See, for example, Ruth Wedgwood Kennedy, *Alesso Baldovinetti. A Critical and Historical Study* (New Haven, 1938), 131.

41. The portraits are treated in slightly different sequences centering on major artists by Jean Lipman, "The Florentine Profile Portrait in the Quattrocento," *Art Bulletin* 18 (March 1936), 101–102; Josée Mambour, "L'évolution esthétique des profils florentins du Quattrocento," *Revue belge d'archéologie et d'histoire de l'art* 38 (1969/1971), 43–60; and John Pope-Hennessy, *The Portrait in the Renaissance* (Princeton, 1966), esp. 40–50.

42. Joan Kelly Gadol, "Did Women Have a Renaissance?" in *Becoming Visible Women in European History,* eds. Renate Bridenthal and Claudia Koonz (Boston, 1977), 137–164.

43. Patricia Simons, "A Profile Portrait of a Renaissance Woman in the National Gallery of Victoria," *Art Bulletin of Victoria* 28 (1987), 34–52; "Women in Frames: The Gaze, the Eye, the Profile in Renaissance Portraiture," *History Workshop: A Journal of Socialist and Feminist Historians* 25 (spring 1988), 4–30, reprinted in *The Expanding Discourse: Feminism and Art History,* ed. Norma Broude and Mary D. Garrard (New York, 1992), 39–58; "Alert and Erect: Masculinity in Some Italian Renaissance Portraits of Fathers and Sons," in *Postures of Dominance and Submission in History* (Binghamton, N.Y., 1994), 163–175; "Portraiture, Portrayal, and Idealization. Ambiguous Individualism in Representations of Renaissance Women," *Language and Images of Renaissance Italy,* ed. Alison Brown (Oxford, 1995), 263–311; "Homosociality and

Erotics in Italian Renaissance Portraiture," in *Portraiture: Facing the Subject,* ed. Joanna Woodall (Manchester, 1997), 29–51. Simons' essay, "Patronage in the Tornabuoni Chapel, Santa Maria Novella, Florence," in *Patronage, Art and Society in Renaissance Italy,* ed. F. W. Kent and Patricia Simons (Canberra, 1987), 221–250, has no pronounced ideological bias.

44. L. B. Alberti, *On Painting and Sculpture,* ed. and trans. C. Grayson (London, 1972), 60.

45. In addition to Syson 1997, Craven 1997, and Wright 2000, see Adrian Randolph, "Public Woman: The Visual Logic of Authority and Gender in Fifteenth-Century Florence," Harvard University, Ph.D. diss., 1995; and Paola Tinagli, *Women in Italian Renaissance Art: Gender, Representation, Identity* (Manchester, 1997).

46. Christiane Klapisch-Zuber's pioneering studies of women, marriage, and family, applied by Simons to female portraiture, have been collected in her *Women, Family, and Ritual in Renaissance Florence,* trans. Lydia Cochrane (Chicago, 1985).

47. Belonging, like *cassoni* or *deschi,* to the category of domestic art, the portraits were apparently displayed in the refurbished bedchamber of the *palazzo* occupied by the newlywed couple (John Kent Lydecker, "The Domestic Setting of the Arts in Renaissance Florence," Ph.D. diss., Johns Hopkins University, 1987, 39, 61–79, 165–175).

48. Carole C. Frick, "Dressing a Renaissance City: Society, Economics and Gender in the Clothing of Fifteenth-Century Florence," Ph.D. diss., University of California, Los Angeles, 1995.

49. Frank Zöllner, "Leonardo's Portrait of Mona Lisa del Giocondo," *Gazette des Beaux-Arts* (1993), 121–123.

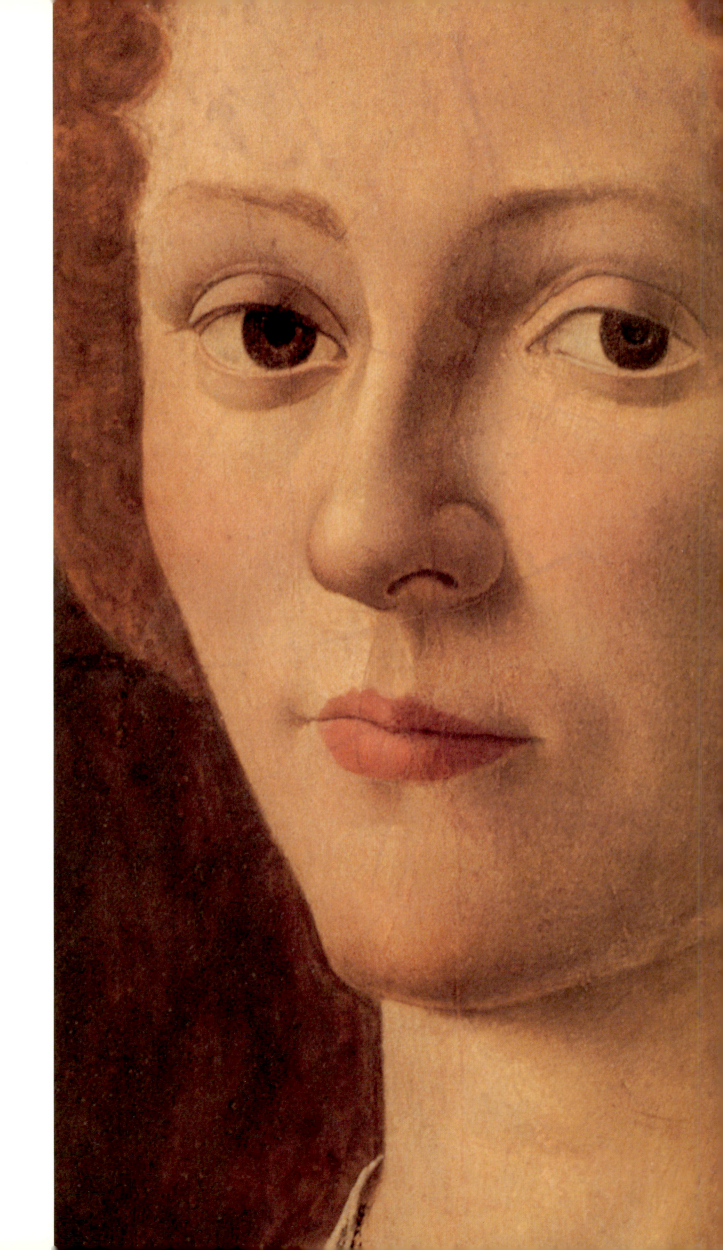

Women in Renaissance Florence

Dale Kent

The modern conception of the Renaissance was shaped essentially by Jacob Burckhardt's 1860 study, *The Civilization of the Renaissance in Italy.* Burckhardt envisioned Renaissance men as rejecting the corporate values that had determined personal identity in the Middle Ages, and Renaissance women as enjoying a new equality with men. He characterized fifteenth-century Italy as the birthplace of modern individualism, often seen as literally represented in Renaissance portraits.[1]

In the last thirty years or so, feminist scholars have reappraised female experience in Renaissance Italy, as elsewhere. Gender is now generally viewed as a social construct as much as a biological given, and women as universally constructed in accordance with the male needs and ideals of the specific societies in which they lived.[2]

Art historians have reassessed the representation of women by male writers and artists of the Renaissance in the light of psychological insights derived from critical writing on the cinema, in which males are seen to assert power through the privileged subjective action of looking at females, the passive, powerless objects of their controlling gaze, she the eternal "other" to his "self."[3]

Social historians, studying the structure and ideology of the male lineage and of the Florentine republic, have explored the social and legal constraints on women and demonstrated that female destiny was almost entirely in the hands of men; indeed, women had very limited rights and few opportunities for any autonomous action.[4]

They have also shown that, in fact, neither men nor women were free, as Burckhardt imagined, to fashion an individual self,[5] a personal identity independent of the values and demands of a society still structured around the communities of family, state, and an all-pervasive Church. Their values determined the very different roles of men and women in a social scenario to which both sexes were committed. Portraits, like most Renaissance images, represent a complex amalgam of real and ideal, signified by idealized features and stylized attributes, in the presentation of a self as defined by society.[6]

"Don't be born a woman if you want your own way."[7] This dictum of Nannina de' Medici, from a letter to her brother Lorenzo the Magnificent, written after an altercation with her father-in-law, Giovanni Rucellai, shortly after her marriage to his son Bernardo, holds true of even the most privileged of Florentine upper-class women, the social stratum represented in the portraits in this exhibition. Indeed, Florence was among the more unlucky places in Western Europe to be born a woman. In the princely courts a woman could inherit wealth and a measure of power with her noble blood, and her significance might then be as much dynastic as domestic, even political.

In Florence, inheritance was through the male line only. The merchant republican society of that city was committed to communal, Christian, and classical values. These all prescribed that the honor of men should reside in their public image and service, and in the personal virtue of their wives; women were excluded from public life, and sequestered in the home to ensure their purity and that of the blood line through which property descended.[8]

In their portraits women appear framed in the windows of their houses (cats. 3, 25, 31 B). In 1610 a French traveler commented after a visit to Florence that "...women are more enclosed [here] than in any other part of Italy: they see the world only from the small openings in their windows."[9] On more than one occasion a householder, filing his tax return that had to include the name, age, and condition of all those living under his roof, noted that a woman, in her eagerness perhaps to extend her horizons, had fallen from a window and been injured.[10]

Historians are often hard put to rescue the testimony of women's experience from the silence imposed on them by the limitations of evidence produced largely by men. In Florence, the best documented society of early modern times, men restricted women's lives, but as almost obsessive record keepers kept account of them. In the words of Renaissance laws, tax returns, and sermons, as well as women's own letters and devotional writings, we may still hear something of their voices.

Women's lives throughout Europe during the Middle Ages and Renaissance were strongly shaped by the ambivalent attitudes of a powerful Church whose moral prescriptions were enforced not only in the confessional,

1

Simone Martini, *Annunciation*, Galleria
degli Uffizi, Florence (photo: Alinari /
Art Resource, N.Y.)

but also by the laws of the state.[11] Eve was the villainess of
Christian history, the cause of original sin and of man's Fall.
God created her from Adam's rib, subordinate. But she was
tempted by the serpent, and tempted Adam to sexual sin.
Thus Everywoman dwelt in the shadow of the fallen Eve,
justly sentenced to the pain of childbirth and the labor of
motherhood. The stereotype of woman as Eve was that she
was weak, foolish, sensual, and not to be trusted.[12] Women
were the scapegoats for the physical impulses that warred
perpetually with the spiritual in men, a conflict sometimes
depicted as an allegory of marriage. Self-disgust and revul-
sion against women are typically mingled in an adage of
the humanist scholar Marsilio Ficino: "Women should be
used like chamber pots: hidden away once a man has pissed
in them."[13]

Conversely, Christian teaching held the potential
for an immense respect for women and specifically female
functions elevated to their highest degree in the life of the
Virgin Mary. Even if, according to an early Christian writer,
"Alone of all her sex / She pleased the Lord,"[14] she who was
ultimately pure, born of an Immaculate Conception and
destined to be the virgin mother of Christ, opened the way
to a more positive view of women by redeeming the sin
of Eve. Contemplating the Annunciation, the influential
philosopher and theologian Peter Damian reflected: "That
angel who greets you with 'Ave' / Reverses sinful Eva's
name. / Lead us back, O holy Virgin / Whence the falling
sinner came."[15]

Devotional images depicted the Virgin Mary in
roles which were the common lot of womankind: the An-
nunciation of her pregnancy, giving birth in the stable
of the Nativity, the Madonna and child, the infant cradled
in his mother's arms, her grief at his death at the Crucifix-
ion. These archetypal images framed society's views of
real women, furnishing exemplars for their behavior. San
Bernardino, the most popular of Tuscan preachers in the
fifteenth century, enjoined his female listeners to model
themselves on the Virgin as depicted in Simone Martini's
Annunciation (fig. 1): "Have you seen that [Virgin] Annun-
ciate that is in the Cathedral, at the altar of Sant' Ansano,
next to the sacristy? . . . She seems to me to strike the most

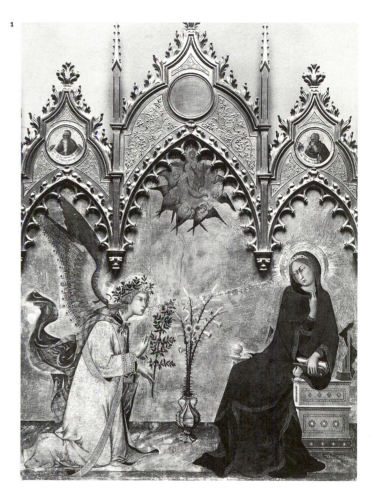

1

beautiful attitude, the most reverent and modest imagina-
ble. Note that she does not look at the angel but is almost
frightened. She knew that it was an angel. . . . What would
she have done had it been a man! Take this as an example,
you maidens."[16]

Marriage and the dowry system were the major
determinants of female destiny. Rather than the consensual
union of two individuals, marriage was a social and eco-
nomic contract between families that answered to their
interest and that of the state in replenishing a population
threatened by recurring episodes of plague.[17] As Francesco
Barbaro stressed in his famous treatise concerning wives
presented to Cosimo de' Medici's brother Lorenzo when
he married Ginevra Cavalcanti, the first duty of a man
was to marry and increase his family.[18] A woman's primary
function was to serve as the vessel by which the lineage

was maintained. A woman's secondary function was as the means of attaching to the lineage by marriage allies from other Florentine families with desirable attributes—wealth, nobility, and political influence; she acted as "a sort of social glue."[19]

As anthropologists have observed, the exchange of women in traditional societies is a conversation between men; it is also the basis of all symbolic exchange.[20] The symbolic exchanges associated with marriage were negotiated in meetings between the men of the two families. Their alliance was sealed in a series of social rituals centered on the contracts preceding it, the exchange of gifts and rings, and wedding banquets intended as a conspicuous display of the groom's social position and assets.[21] In a *spalliera* panel painted for the marriage of Giannozzo Pucci and Lucrezia Bini in 1483 (private collection), expensive plate is displayed in the foreground, the coats of arms of the couple are prominently placed on the exterior columns, and Lorenzo de' Medici, who arranged the match, is represented by his family arms on the central column, by the symbolic laurel bushes and by his device of the diamond ring.

Although the new couple might receive a blessing when they next attended Mass, the marriage celebration did not require a priest. And while her marriage was surely the most significant event of a young bride's life, determining the site and circumstances of the remainder of its course, her part in the wedding ceremonies was relatively minor. In the "triptych" of scenes representing the wedding, spread over a period of up to a year, the initial negotiations have been compared to the predella, and the public meeting between the two groups of male kin, at which no women were present, to the first panel. The bride's first essential appearance was in the second panel, on "the ring day" when the nuptial band was placed on her hand at her house, gifts were exchanged, and she gave her formal consent to the union; it was often consummated at this time. In the third panel the marriage was "publicized" before the community; the bride was removed from her father's house and escorted by his male friends to the house of her husband, where she was welcomed with festivities that might last several days.[22] A mid-fifteenth-century painted panel,

probably to decorate a bedchamber, depicts the marriage procession in the public setting of the piazza of the Baptistery; the lily of Florence on the banners attached to the instruments of the accompanying musicians underscores the civic significance of the union. Elaborately dressed guests perform a dance, and preparations for a banquet are also visible (fig. 2).

The dowry was the major component of the marriage exchange, but in Florence it was augmented with gifts from the bride's kin and counter-gifts from her husband and his family.[23] The expenses of contracting an honorable union were considerable on both sides. Patrician men postponed marriage until their early thirties, waiting, perhaps, to accumulate a respectable fortune. Young women were usually betrothed between twelve and eighteen, to ensure that they came to the wedding bed as virgins.[24] Clerics, among them San Bernardino, attributed to the dowry system a variety of social ills, including the prevalence of homosexuality among bachelors, the premature widowhood of wives, and the practice of fathers using their savings to marry off pretty daughters and consigning the ugly ones to convents without benefit of vocation.[25]

Most upper-class women married men almost twice their age, and there are traces in the sources of the problems this caused. One man complained that his wife called him "a doddering old fool,"[26] and many popular stories and proverbs turned on the temptations rife in homes where a young bride whose husband's sexual powers were failing was surrounded by his handsome young sons of her own age. Having married much older men, almost a quarter of Florentine women were widows; their lot was a miserable one, as preachers like San Bernardino and Savonarola pointed out in enjoining respect and compassion for them.[27]

"'Birds of passage' in a no-woman's land between the two male lineages to which they half belonged,"[28] women were caught between competing kinship strategies.[29] At her husband's death a woman had either to return to her natal family, which was sometimes unwilling or unable to reshoulder the financial burden of her support, or to remain, often under sufferance, with her in-laws; women were considered far too dangerous and untrust-

2

Lo Scheggia, *Wedding Procession*
(detail), Galleria dell'Accademia, Florence
(photo: Alinari / Art Resource, N.Y.)

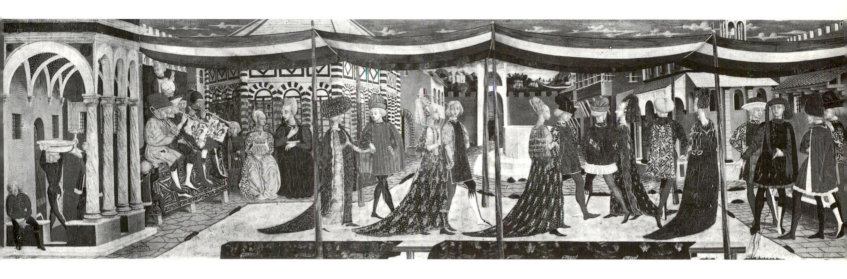

worthy to be allowed to live alone. "It was of course the dowry that tangled the threads of a woman's fate."[30] Theoretically, the dowry that a woman brought her husband was attached to her for life, to provide for their household during his lifetime and for her after his death. But since the potential loss if she left with her dowry threatened the economic equilibrium of her deceased husband's household, it was usually in the interests of his heirs to persuade her to remain with them. If she was over forty, the unlikelihood of finding her a new husband, due to the premium placed on virginity at marriage and the potential to produce heirs, and the difficulty of assembling dowries, discouraged her own family from intervening.

If she were still young, however, a widow might be pressured to return to her family of birth and once again become a card to play in their matrimonial strategies. In this case she left with her dowry, but without her children. Some Florentine sons resented the "inconstancy" of mothers who "abandoned" them as "cruel"; others expressed their gratitude to mothers who had endured personal hardship to devote themselves to their children's welfare, becoming, in effect, "both mother and father" to them.[31]

The fifteenth century saw the extreme inflation of the sum of money required by a bride's family to procure a groom of suitable status. Since many fathers came to dread the birth of daughters, not only because of their intrinsic lack of worth, but also because of the financial burdens they

represented, to encourage the institution of marriage the Florentine state established a dowry fund—the Monte delle Doti.[32] Some historians maintain that a comparatively small investment matured in a period of between five and fifteen years to provide the dowry,[33] but contemporary testimony suggests that it might still represent a major outlay for the bride's family.

Complicating the financial arrangements of marriage were the subsidiary exchanges it involved.[34] The money paid out by the bride's family for the dowry was accompanied by the trousseau *(donora),* which consisted of clothes and small personal items. This was scrupulously divided into two parts, those items "counted" or "not counted" by the officiating notary. Legally belonging to the bride, her "personal property" was nevertheless not hers to dispose of as she wished, and at the death of either spouse it was often hotly contested. Some small everyday objects like dolls, needles, and prayer books, often depicted in portraits to signify a woman's possession of the female virtues (cats. 30, 31 B), might be passed on to her female descendants. The dowry reverted to the males of her lineage after her death, and there are few examples in Florence of its successful bequest according to the woman's wishes, especially as women had no power to execute legal acts except through a male agent.[35]

Presentations to the bride from the bridegroom and his family functioned as a "counter-dowry," returning

equilibrium to an unbalanced economy of exchange. The husband's gifts to the bride were also divided legally into two parts, including a cash gift corresponding symbolically to the dowry, addressed to the bride's kin, and the *mancia* ("tip," in modern Italian) traditionally given to proclaim the consummation of the marriage. The groom's gifts to the bride appropriately consisted of body ornament, the sumptuous clothes and jewels—shoulder brooch, head brooch, and pendant—displayed in portraits (cats. 3, 5, 30, 31 b). "Marking" her with dresses and jewels, often bearing his crest, by bestowing on her a ritual wedding wardrobe the husband introduced his wife into his kin group and signaled the rights he had acquired over her. Most of these items remained the property of the husband, who might later bequeath them to his wife or repossess them;[36] if he needed capital, they could be sold.[37]

Although sumptuary laws proved perennially difficult to enforce, throughout the history of the republic officials of the state made periodic attempts to restrict extravagant private displays of wealth and honor in marriage gifts, wedding banquets, baptisms, and funerals.[38] Those responsible for administering the laws were known as the Officials of the Women, since it was women against whom many laws were explicitly directed, and who were regularly bullied and intimidated by notaries sent out on patrol to observe violations and impose heavy fines. Among several possible explanations for the persistence of such laws in the face of the acknowledged importance of display in Florentine culture is this patriarchal society's negative attitude toward women.[39]

In 1424, in Florence to preach the Lenten sermons, San Bernardino chastised the women of the city for asking their husbands to buy them more clothes than they needed, invoking the "thousands of young men who would take wives if it were not for the fact that they had to spend the entire dowry, and sometimes even more, in order to dress the women."[40] On another occasion the Sienese preacher demanded: "By what means is a virtuous woman recognized? By her appearance. In the same way one recognizes the shop of the wool-merchant by his sign. . . . What is outside shows what is inside. . . . Concerning

this I want to say of the woman who wears whorish clothing, I don't know her interior, but what we see outside seem to me filthy signs."[41]

While Bernardino with his mercantile metaphor linked the decorated female body to commerce and exchange, in a sermon of 1490 Savonarola compared women to beasts. Commenting on the then-fashionable Flemish style of dresses with daring décolletage, long trains, and pointed headdresses, he pleaded with mothers not to allow their daughters to become like cows: "Let them go about with their breasts covered, and let them not wear tails like cows or have horns like cows." San Bernardino had likened long trains to the tails of serpents.[42]

Framed and justified in terms of this weak and bestial nature of women was the government's admission, in approving the election in 1433 of a new group of "Women's Officials," that women as the objects of exchange in marital commerce had a major role to play in the demographic economy of the state. The law spoke of the need

to restrain the barbarous and irrepressible bestiality of women who, not mindful of the weakness of their nature, forgetting that they are subject to their husbands, and transforming their perverse sense into a reprobate and diabolical nature, force their husbands with their honeyed poison to submit to them. These women have forgotten that it is their duty to bear the children sired by their husbands and, like little sacks, to hold the natural seed which their husbands implant in them, so that children will be born. . . . For women were made to replenish this free city and to observe chastity in marriage; they were not made to spend money on silver, gold, clothing and gems. For did not God Himself, the master of nature, say this?[43]

Women were indeed ingenious in finding ways to dress fashionably while avoiding prosecution, generally observing the letter, if grossly exceeding the spirit, of the laws. Many used their privileged social position to seek special exemptions.[44] Clearly, however, extravagant display was linked less to female vanity than to honor, which was mostly male. As Alessandra Strozzi wrote to her son Filippo: "Get the jewels ready, and let them be beautiful, for we have found you a wife. Being beautiful and belonging to Filippo Strozzi, she needs beautiful jewels, for

just as you have honor in other things, you do not want to be lacking in this."[45]

Both men and women in this society were preoccupied with personal appearance because dress was a way of displaying and distinguishing status and dignity, occupation and occasion, not simply wealth. Cosimo de' Medici pressed upon Donatello a gift of clothing appropriate to the dignity of his artistic genius, and Machiavelli, after a day spent hunting, gambling, gossiping, and whoring at the tavern, shed his everyday raiment at night when he entered his study to commune with the ancient Roman authors whom he revered, "putting on garments regal and courtly," appropriate to the weight of this occasion.[46] At least one woman, although not a Florentine, but rather the learned and beautiful lover of the lord of Bologna, in 1453 made an eloquent appeal for the abolition of sumptuary laws in similar terms. Citing Roman law that limited female participation in the public world, she declared: "Magistracies are not conceded to women; nor do they strive for priesthoods, triumphs or the spoils of war, because these are considered the honors of men. Ornament and apparel, because they are our insignia of worth, we cannot suffer to be taken from us."[47]

A progressive relaxation of the prescriptions of Florentine sumptuary laws from the beginning of the fifteenth century to the 1460s was followed in the 1470s and 1480s by a reaction—possibly to the failures of enforcement of the preceding half-century—and many fourteenth-century limitations were restored. In the absence of any clearly explanatory evidence, one might speculate that the crackdown in the 1470s was related to a possible wish on Lorenzo's part to curb competitive displays by his fellow oligarchs.[48] In view of the claim that extravagance in female dress cut into the groom's accession of capital, the spate of bank failures that hit many upper-class families hard in the early 1470s might also be seen as relevant.[49]

Much legislation insisted on the primacy of maintaining what were seen as the traditional Florentine values on which the republic had been built, thrift and austerity, at a time of rapidly expanding consumerism.[50] Above all, fluctuating sumptuary law parallels the constant tension between a view of women as objects of desire, which encompasses a male wish to use female bodies to display the accumulation of wealth and power, and fear, both of women and of God's wrath at excessive ostentation. Always a theme of clerical comment, by the end of the century, in a climate of increasingly intense religious observance and awareness of sin, concern about women's appearance climaxed in Savonarola's movement for the "self reform of women" and in his "bonfires of the vanities."[51]

The obligations of marriage, in accordance with familial and Christian expectations, were outlined in popular literature—stories, poems, sermons, and works directed specifically toward women. Manuals on marriage, household management, and the raising of children were dedicated in the fifteenth century by the Dominicans Giovanni Dominici and Archbishop, later saint, Antoninus, to the women of the Medici, Alberti, Salviati, and Tornabuoni families; in 1502 Caterina Bongianni had a copy of Fra Bartolommeo's text on marriage in her trousseau.[52] From the Church's point of view, the duties of a husband were to instruct, correct, cohabit, and support; his wife was to respect, serve, obey, and if necessary admonish. Their reciprocal obligations were affection, fidelity, honor, and the marital debt.[53] While wifely admonitions were to be pleasant—she might cajole him into better behavior —if she would not listen to reason, he might resort to "blows, or a real beating and thrashing."[54]

Once she had been removed to her new family, a stranger within its ranks, a wife's identity derived entirely from that of her husband, whose interests she was expected to put before those of father, brothers, or even children. Her movements were circumscribed by the walls of the family palace. A treatise on marriage of 1520 called "The Nuptial Forest," evoking the medieval image of woods as dark and perilous places in which one might easily lose one's way,[55] quoted a popular saying deriding women seen in places outside the home: "Women are saints in church, demons in the house, owls at the window, magpies at the door, and goats in the garden."[56]

Within her home, the physical conditions of a woman's life were determined by constant childbirth.

3

Piero della Francesca, *Madonna
del Parto,* Santa Maria a Momentana,
Monterchi (photo: Alinari / Art
Resource, N.Y.)

4

Bernardino di Antonio Detti, *Madonna
della Pergola* (detail), Museo Civico,
Pistoia (photo: Scala / Art Resource, N.Y.)

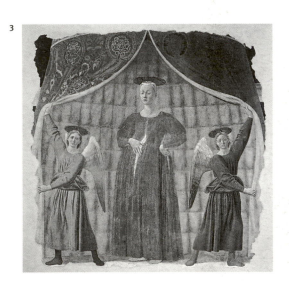

An endless cycle of pregnancies was interrupted only by periods of lactation, and for wealthy women who were expected to employ wet nurses rather than suckling children themselves, not even this offered respite (see fig. 13).[57] High fertility was in the interests of the male lineage, and given the extremely high rate of mortality (approximately half of all children born died before the age of two, and half of those who survived their first two years were dead before they reached sixteen), women bore the brunt of the need to produce male heirs. As Martin Luther observed in the early sixteenth century: "Even if they bear themselves weary, or bear themselves out…this is the purpose for which they exist."[58] Images of the pregnant Virgin reinforced the message that the greatest honor a woman could enjoy was to bring forth life. The cemetery in which Piero della Francesca's *Madonna del Parto* was located became an important devotional site for pregnant women to visit (fig. 3).[59]

The Florentine merchant Gregorio Dati recorded in his diary his marriages to four wives, with details of the dowries they brought him, the birth of twenty-six children, the deaths of all but eight by the end of the diary, and the deaths of his first three wives, one after a miscarriage, another after the difficult birth of her eighth child, and the third in childbirth. It should be noted that his business-like attitude to marriage and procreation did not preclude personal affection. Describing the death of his third wife,

Ginevra, who bore him eleven children in fifteen years, after "lengthy suffering which she faced with remarkable strength and patience," he observed that "her loss has sorely tried me," and he chronicled the passing of the children whom God "had lent us" with expressions of love and grief.[60] Another Florentine woman, Antonia Masi, who died in 1459 at age fifty-seven, gave birth to thirty-six children; nine males survived her.[61]

Many artifacts of the Florentine household attest to the importance of childbearing. Just as often a child was ceremonially placed in the bride's arms during the wedding festivities, "holy dolls," usually dressed as the Christ child or a saint, formed part of the trousseau of young brides like Nannina de' Medici (fig. 4).[62] Apart from the childish comfort they may have brought a twelve-year-old girl abruptly torn from the bosom of her family, they served several of society's purposes for women. They were intended to lead women and children to God through play in which they felt and relived the childhood of Jesus, acquiring at the same time an apprenticeship in maternal attitudes; they also served as fertility devices by which it was hoped the young woman might magically engender a child with the virtues of the sacred person represented by the object.[63]

Husbands' household inventories and diaries record extensive expenses for many objects. Some, like birthing chairs and swaddling clothes, were utilitarian. Most were

5 and 6
Bartolomeo di Fruosino, birth tray
(recto and verso), private collection,
New York (photo: Sotheby's, New York)

intended to decorate the mother, the child, and the bedroom in honor of the event. There were special garments for the mother to wear during her lying in, and other, more sumptuous ones for receiving congratulatory visits; the bed was equipped with special sheets for the labor, and then with rich coverings to celebrate a successful delivery. Silver spoons were presented to the child, and decorated maiolica dishes made to depict the event. Husbands purchased large quantities of poultry, a luxury food considered particularly good for pregnant women and nursing mothers. Sweetmeats and wine were provided to offer after the birth.[64]

The enduring symbolic object associated with childbirth was the painted wooden tray for the ceremonial presentation of food and drink to the mother after the delivery; these appear in most Florentine inventories of the bedchamber. Many trays depicted a scene of successful and idealized childbirth, probably to allay the anxiety of expectant mothers. On the obverse of the earliest surviving birth tray, by Bartolomeo di Fruosino,[65] the mother, wearing elaborately decorated garments and sitting up in a bed dressed with luxurious sheets, receives a tray and is entertained by a female harpist, while outside a procession of visitors bearing gifts approaches the house (fig. 5). These visits were a duty of women to one another; the Tornabuoni family frescoes in Santa Maria Novella also portray women attending a confinement (see fig. 13).[66] Such idealized scenes mediated between the real and ideal worlds;[67] they also constitute some of the fullest representations of women in their domestic environment.

Not medically understood, the process of birth was mysterious and dangerous. A significant proportion of the deaths of young women resulted from childbearing, and an equally large number of newborns died within days of birth. An expectant mother often wrote her will before she came to term, and her relatives insured her to cover the loss of their dowry investment if she died while giving birth.[68] Florentines employed talismans and rituals designed to keep childbearing under control. Fearing "visual contagion," they protected pregnant women from horrific scenes and tried instead to "visually imprint" positive images, like the beautiful naked men and women depicted on the

7

Lo Scheggia, *Triumph of Fame*, Medici-Tornabuoni birth tray, The Metropolitan Museum of Art, New York, Purchase, in memory of Sir John Pope-Hennessy: Rogers Fund, The Annenberg Foundation, Drue Heinz Foundation, Annette de la Renta, Mr. and Mrs. Frank E. Richardson, and the Vincent Astor Foundation Gifts, Wrightsman and Gwynne Andrews Funds, special funds, and Gift of the children of Mrs. Harry Payne Whitney, Gift of Mr. and Mrs. Joshua Logan, and other gifts and bequests, by exchange, 1995. All rights reserved

insides of *cassone* lids for the bride to contemplate in the hope that her child would be conceived in their likeness.[69] On the reverse of the birth tray painted by Bartolomeo di Fruosino is a talismanic male child wearing a coral amulet around his neck; he is an image of fertility, with the family arms and an inscription invoking good fortune: "May God grant health to every woman who gives birth and to the father…May [the child] be born without fatigue or peril. I am an infant who lives on a [rock?] and I make urine of silver and gold" (fig. 6).

While constant childbearing exhausted women and imperiled their lives, childlessness was a fate still worse, depriving them of worth and honor. Lists of household expenses include payments for various remedies for infertility; popular prescriptions for herbal concoctions or spices, fertility belts with appeals to the saints inscribed on them, disbursements for special masses for pregnant women, and votive offerings, sometimes of silver, to give thanks if the remedies proved successful.[70]

Some birth trays bore representations of the family's aspirations for themselves and their children based on Petrarch's well-known poem, which elided classical and Christian virtue in the successive triumphs of Chastity, Love, and Fame. An image of Chastity on a birth tray underscored the importance of a wife remaining faithful to her husband and bearing children only of his blood. The Triumph of Fame, the subject of the birth tray presented by Piero di Cosimo de' Medici to his wife Lucrezia Tornabuoni at the time of their son Lorenzo's birth in 1449, imaged the ambitions of their dynasty (fig. 7). Among the other decorative and didactic images in the marital chamber were devotional paintings that served as an aid and focus for personal prayer as well as self-improvement.[71]

Furniture was painted with scenes blending classical, Christian, and familial imagery for the moral edification of both sexes, but particularly women. Wall panels, decorated backs for beds and couches, and the numerous chests *(cassoni* or *forzieri)* used to transport the bride's trousseau

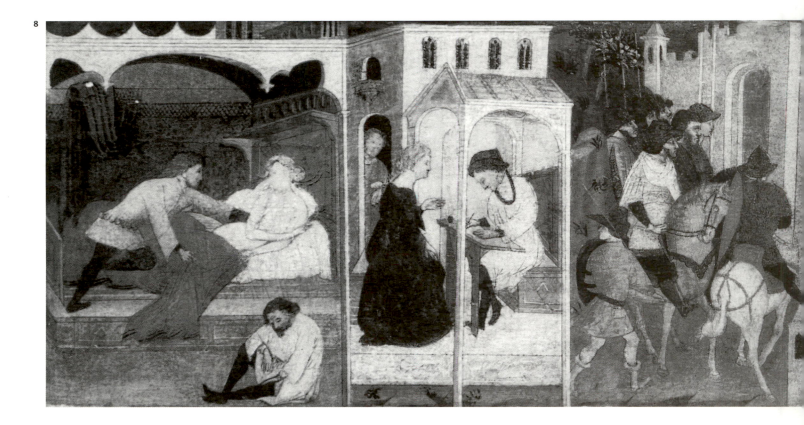

8

8

Florentine, *Story of Lucrezia*, Ashmolean
Museum, Oxford, Presented by the Revd.
Greville John Chester, 1864

and to store most household goods illustrated the lives
of exemplars drawn from Ovid and Plutarch, from *novelle*
like Boccaccio's *Decameron*,[72] or from the Bible.[73] Parti-
cularly popular were the Old Testament heroines Susanna,
Esther, and Judith, the last a virtuous young widow content
to remain chaste while heroically consenting to appear
sexually available to the tyrant besieging her city in order to
kill him in his chamber.[74] Another favorite was the Roman
matron Lucrezia, honored by Boccaccio in his treatise
Concerning Famous Women; she killed herself after she was
raped rather than bring dishonor to her family (fig. 8).[75]

Botticelli's *Primavera,* painted as a headboard for
Lorenzo de' Medici's uncle, and long understood as an
allegory of love, has been recently reinterpreted as a wed-
ding commission, its image of rape indicating that sub-
mission to the male by the female was necessary to guaran-
tee a stable society and the perpetuation of the species.
This was certainly the message of the many *cassone* panels
depicting the story of the Sabine women, whose people

had occupied the original site of Rome. Although they
properly attempted to protect their chastity by plunging
into the Tiber River, in the end they were raped by their
conquerors in order to ensure the survival of Romulus' new
settlement.[76] Despite the grim, even brutal treatment of
women in these moral tales, Lucrezia Tornabuoni turned
them into devotional poetry; these examples showed women
what they needed to be, if not actually to do.

While the home was particularly the province of
women, in Florence the distinction between a private, female
realm and the public, male world is not so easily made as
some have argued. Wealthy households could be small com-
munities harboring several generations of the lineage and
many servants and slaves. Architectural evidence does not
at all support a frequent assumption that men and women
had separate rooms. On the contrary, apart from halls in-
tended for dining and entertaining large numbers of people,
the living quarters of the family consisted of a suite of
rooms comprising bedchamber, antechamber, and some-

9

Sano di Pietro, *San Bernardino Preaching
in the Piazza del Campo*, Cathedral,
Siena (photo: Scala / Art Resource, N.Y.)

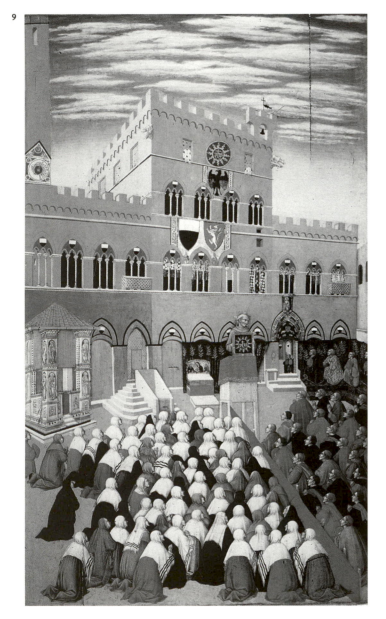

9

times a study; there were no spare rooms for the exclusive use of women. In these shared spaces the possessions of men and women, and the swaddling clothes of infants, were kept together in *cassoni* and cupboards.[77]

Moreover, while women undoubtedly spent a disproportionate amount of time in them, bedrooms were by no means off-limits to visitors; indeed, men customarily entertained and consulted with relatives, allies, business

associates, and even strangers in their chambers. A well-born Florentine woman had no place in the public life of the streets and palaces of government, but the mistress of a large and wealthy patrician household was far from isolated; the world, in a sense, came to her.[78] When their husbands were absent from home—temporarily away on business or exiled, or permanently, having died—women like Alessandra Strozzi showed that they were strong and shrewd enough to maintain the family's business and political interests, with the aid of these same friends, associates, and allies. Such cases proved what women were capable of, but not usually allowed to do.[79]

Normally, a woman left her house mainly to go to church. The sermon was almost the only sanctioned occasion for female public appearances (fig. 9). Beyond the portals of the family palace, female behavior was closely observed. Church law decreed that "a woman ought to cover her head since she is not the image of God. She ought to wear this sign in order that she may be shown to be subordinate and because error was started through woman." Saint Antoninus, archbishop of Florence in the mid-fifteenth century, warned against excessive church-going by women. Many moralists feared, in the words of one, that "A woman goes to see sermons / Often only to show herself.... Therefore, if you don't go for God alone / It is far better to stay at home."[80]

And indeed, despite their segregation by a curtain, there is plenty of visual and verbal evidence that men enjoyed the opportunity to look at women in church and vice versa. Dante records in his *Vita nuova* how in church, "where words about the Queen of Glory were being spoken," he was devastated by the vision of Beatrice. Their exchange of gazes was the sign of their sexual commitment. This first encounter with the beloved in church became a poetic topos adopted by Petrarch and by Boccaccio, whose stories were the model and standard for fifteenth-century men recounting their own amorous fantasies and experiences.[81] Some scholars argue that women were painted in profile to disempower the erotic female gaze, liable to wound.[82] No wonder Antoninus, addressing his *Rules for Living Well* to Lucrezia Tornabuoni, advised her to "go to the church and

take good care of your sight, holding it well and mortified so as not to mar your spirit with scandal. Walk with the eyes so low that you do not see beyond the ground upon which you must place your feet."[83]

On a more pedestrian level, both men and women took the opportunity in church of admiring the latest fashions in dress. Mothers went to church to observe their sons' prospective brides. Alessandra Strozzi spoke of "going Sunday morning to the Ave Maria in Santa Reparata (the cathedral) for the first Mass, as I had done a few mornings of the feast period in order to see the Adimari girl....I found the Tanagli girl there...she seemed to me to have a beautiful body, and well made: she is big, like Caterina [her own daughter], or larger; good flesh, but not of that white type...."[84]

However, many Florentine women were intensely religious, and men often delegated to them the chief responsibility for charity and other pious works to ensure the collective salvation of the lineage. Female instruction focused on moral and spiritual perfection, and although it was limited by comparison with the education given to men, it equipped women quite well enough to read the books of the offices of the Virgin which they often owned, and the moral tracts with which they were presented. Women were also significant producers of devotional literature.[85] For some, among them Lucrezia Tornabuoni, this was a means of self-expression acceptable to men.

Conversely, men sometimes regarded women as natural conduits of divine wisdom because they were not learned; an ability to speak wisely without human instruction was seen as proof of their miraculous converse with God. This belief was buttressed by reference to biblical exemplars like the active Martha and her contemplative sister Mary, as well as the reformed sinner Mary Magdalene. Quite a few Florentine women, and their sisters from elsewhere in Tuscany, were revered as religious icons, beatified, and even canonized, the most notable example being Saint Catherine of Siena.[86]

As we have seen, devotional images played a large part in the lives of women. Men were the chief patrons of religious art, but the order book of a workshop such as

Neri di Bicci's records many more modest commissions from women, often widows. Giovannni Dominici, in his advice to Diamante Salviati "On the Education of Children," urged her to "have pictures of saintly children or young virgins in the home, in which your child, still in swaddling clothes, may take delight and thereby be gladdened by acts and signs pleasing to childhood....Little girls should be raised in the contemplation of the eleven thousand Virgins as they discourse, pray and suffer.... And other such representations as may give them, with their milk, love of virginity."[87]

For all the talk of female imbecility, vanity, and corruption in the sumptuary laws, other sources abound with stories of female asceticism. Iacopone da Todi, himself an author of spiritual poems, recounted how his beautiful wife dutifully wore the finery that served as a mark of family rank and status; only after her sudden death when still very young did her husband discover that her fashionably elegant attire had always concealed a hair shirt.[88] Religion offered women access to power that was otherwise denied them, and since the Church and the world were inextricably intertwined, this was by no means a marginal prize.[89]

Boccaccio's treatise *Concerning Famous Women*—like portraits and Castagno's pictorial cycle of nine famous men and women for the Carducci family villa—represented society's expectations of women rather than their real lives.[90] The latter are more plainly visible in the evidence relating to the well-documented Medici wives. Those who married into what became in the fifteenth century Florence's leading family were indubitably privileged, but by no means atypical examples of their sex. They conformed closely to the standard expectations of women, and their exercise of the power and influence they derived from that of their menfolk was circumscribed by society's views on the behavior appropriate to women.[91]

Contessina, wife of Cosimo de' Medici, was more conventional than her more famous daughter-in-law Lucrezia, to whom she was devoted. Her correspondence reveals her most clearly as the competent coordinator of her extensive household, comprising three generations

of men and their wives and children, particularly as it moved, according to the rhythms of the seasons, between the urban palace and the Medici country villas where most of the family spent the summers, and the men went to hunt in fall and winter. She was the provisioner of these trips, on one occasion being importuned by Cosimo's secretary to prepare for their arrival at Cafaggiolo not pork rinds (then as today in the nearby Romagna a popular savory snack) but chestnut cake, still a Florentine favorite, which his sweet tooth preferred.[92]

Along with her daughters and daughters-in-law Contessina dispensed charity to the poor, visited widows and the sick, and participated in devotional activities of importance to family and city. She and her brother-in-law's widow Ginevra went to see the miracle-working image of the Black Madonna of Impruneta when it was brought to Florence so that citizens could pray for better fortune.[93]

Contessina's letters to husband and sons were often concerned with their clothing, sending items they requested or she thought they should have to Rome or Ferrara or Venice, where the Medici bank had offices. Once when Cosimo complained that his protective medal of Saint Elena was missing from his luggage, she investigated the matter and put him in touch with the servant who had packed it. Many of her letters comment on the fragile health of Cosimo and her sons, Piero and Giovanni, or the welfare of their wives, left behind at home, often ill or pregnant.[94]

She also took an interest in her sons' first steps in the world of business and politics, enjoining them to follow the example of their elders, to be obedient, and do all they could to make themselves useful. As she wrote to her younger son Giovanni in Ferrara: "You must be happy to be there, simply to be in the business and to learn something.... I would really like to know if you are doing anything at the bank, you or Piero, and if Cosimo is using Piero to do anything. See that you write to me about this."[95]

In return for these maternal and wifely services, Contessina commanded the evident respect and affection of a husband as austere and taciturn as Cosimo de' Medici. They spent quite a lot of time together, especially in his last years, playing with their small grandson Cosimino.[96]

The patriarch associated her with some of his religious patronage, and after his death her male relatives allowed her to use the whole of her dowry to rebuild the convent of S. Luca in Via San Gallo, just up the road from the Medici palace.[97] During Cosimo's lifetime they were joint patrons of an altarpiece by Fra Filippo Lippi for the convent of Camaldoli in a mountainous area of the countryside not far from where Contessina was born. The elderly couple depicted in the *Deposition of Christ* on one of Donatello's pulpits, his last commission from Cosimo, bearing witness to the holy scene, has been identified as Cosimo and Contessina.[98]

Lucrezia Tornabuoni de' Medici was almost certainly represented by Ghirlandaio (fig. 10); this portrait was probably the one mentioned in the 1497 inventory of her brother Giovanni Tornabuoni's household possessions. A painted panel portrait of her is also noted in the Medici inventory made after the death of her son Lorenzo in 1492. A marble bust of a woman by Mino da Fiesole, who made the first portrait busts of the Renaissance, of Lucrezia's husband Piero and his brother Giovanni, has been identified as the matching bust of Lucrezia described in the 1492 inventory as set above a doorway in the Medici palace, opposite that of her husband.[99]

Born in 1427 of a distinguished Florentine family already bound to the Medici by marriage and business ties, Lucrezia Tornabuoni wed Piero de' Medici in 1444. A friend's letter offers a brief glimpse of her youthful accomplishments, learning to play and sing a popular ballad to entertain house guests,[100] but by 1445 she had succumbed to the chronic illness requiring the curative baths she frequented for the rest of her life.

For the next twenty years of her marriage there is limited evidence of Lucrezia's life, that of a conventional wife occupied with charity and child rearing. A letter from Rome to her husband Piero in 1467 concerning her inspection of a bride for Lorenzo is similar in tone and content to the several letters of Alessandra Strozzi on this subject. Having gone to the church of San Piero to meet with the girl and her mother, Lucrezia reported: "We stood there quite a long while, talking.... As I say, she is large in stature and

10

Domenico Ghirlandaio, *Lucrezia*
Tornabuoni, **National Gallery of Art,**
Washington, Samuel H. Kress
Collection

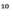

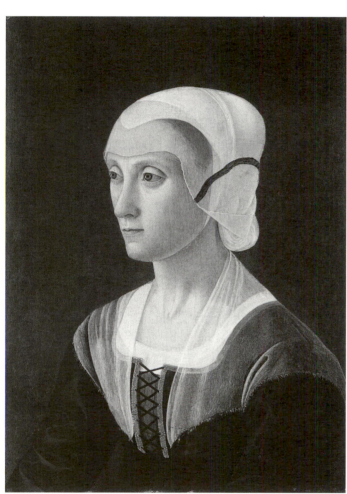

of Christ who interceded with him on behalf of the sinners who appealed to her mercy, Lucrezia intervened with her son, the most powerful citizen of Florence, to assist the objects of her patronage. On account of her extensive and imaginative charity[103] and the piety of her devotional writings, she acquired a reputation as "Mother of the poor and merciful toward all the destitute," on occasion described as "sainted Lucrezia."[104]

Lucrezia was unusually well educated, and well connected to the leading literary figures of Florence, but the subjects of her sacred poetry were those recommended to all Florentine women and depicted in panel paintings as part of their domestic furniture: Esther; the chaste Susanna; John the Baptist, patron saint of the city of Florence, who occupied a prominent place in the altarpiece painted by Fra Filippo Lippi for the chapel in the Medici palace;[105] and Judith, of whom Lucrezia appealingly wrote, "I found her story written in prose, / and I was greatly impressed by her courage: / a fearful little widow, / she had your help, and she knew what to do and to say; / Lord, you made her bold and helped her plan succeed. / Would that you could grant such favor to me, / so that I may turn her tale into rhyme, / in a manner that would please." In the opening verses of her Life of the Baptist, she invoked the intercession of the Virgin: "Because I want to speak of this worthy saint, / I also pray to the true Mother of God / that she help me find good matter for my writing / and enable me to succeed in my design."[106]

When Lucrezia died in 1482, Lorenzo wrote to the duchess of Ferrara that he had lost not only a mother, "but an irreplaceable refuge from my many troubles," testimony to his respect and admiration for her wisdom and intelligence. A Florentine friend's consolation to Lorenzo suggests that these attributes served essentially to make her not so much a remarkable woman in her own right, but a better mother; she "was the faithful guardian of your person, nor did she think of anything else than your protection and to remove the perils and fears and intrigues that important people face."[107] Like the mother of God himself, Lucrezia's efficacy and identity was ancillary to that of father, husband, and son.

white-skinned, and she has a sweet manner, though not however as nice as our own daughters; but she is very modest, and will soon adapt to our customs."[101]

After her husband's death in 1469 Lucrezia emerged as one of a small number of fortunate widows freed by wealth and the goodwill of sons and brothers to cultivate her own concerns. These included business interests in developing the site of the curative baths near Volterra as a major commercial establishment, acquiring through her charity and influence with her powerful son a patronage group of her own friends and clients,[102] and the production of a large corpus of sacred poems and songs.

In various ways she fulfilled the injunction to women of Florentine clerics and educators, among them Saint Antoninus, to emulate the Virgin. Like the mother

Despite male disparagement of women as "imperfect men" or "walking wombs,"[108] and frequent expressions of female frustration, women who conformed to the broad parameters of what society and their families expected of them obviously found some fulfillment in these designated roles, especially given a measure of flexibility to manipulate the rules along with the male relatives in whom they often inspired deep affection. This is particularly apparent among the coterie of influential upper-class families whose female members are represented in the portraits in this exhibition: the Medici, Tornabuoni, Albizzi, Benci, and Salviati.

Marriage seems likely to have been the occasion for many of these portraits, but the limited evidence available suggests that others were painted so that husbands, fathers, or brothers would have a likeness by which to remember beloved wives, daughters, and sisters if they should die young, as was eminently likely.[109] Alberti, that eloquent and influential spokesman for the arts, observed how through portraiture "the absent [were made] present" to their friends, and "the faces of the dead go on living for a very long time."[110]

The poet Petrarch declared himself frustrated by the inadequacy of Simone Martini's portrait of his beloved Laura to evoke her real self as well as his words could do;[111] Leonardo da Vinci, taking up this challenge, claimed the painter's skill was such that "lovers are impelled toward the portraits of the beloved, and speak to the paintings."[112] In an age where life was often all too brief, especially for women, images in the realistic likeness of living flesh could confer immortality.

While Leonardo sought to capture beauty in all its forms, Domenico Ghirlandaio, on the frescoed walls of the family chapels of the Sassetti and Tornabuoni, produced portraits of individuals embedded in the groups of kinsmen, friends, and neighbors that were their social context. Commissioned in 1485 by Giovanni Tornabuoni, Lucrezia's brother, who was papal treasurer and manager of the Medici bank, the frescoes in Santa Maria Novella represented the patron's conception of his family, distinguished citizens offering prayers to God for the preservation of the lineage in this world and its salvation in the next.[113]

Flanking the chapel window are the portraits of the donor and his deceased wife, Francesca di Luca Pitti. Francesca Pitti's tomb, a unique monument to a beloved wife who died in childbirth in 1477, was the most extreme expression by a Florentine man of uxurious love, and grief at its loss. A marble relief for the tomb from the workshop of Andrea Verrocchio depicts the tragedy; the dead child, the bereaved husband, the mourning women around Francesca's bed (fig. 11). Giovanni wrote to his nephew Lorenzo de' Medici: "I am so oppressed by grief and pain for the most bitter and unforeseen fate of my most sweet wife that I myself do not know where I am."[114]

In the chapel, however, Giovanni and Francesca preside eternally over an affirmation of the continuity of life and the family and the city of Florence, represented by scenes of the Birth of John the Baptist and from the life of the Virgin. In these scenes, at once holy and domestic, may be identified the portraits of many of the Tornabuoni women, among them Giovanni's daughter Lodovica, attending at the *Birth of the Virgin.* His sister Lucrezia Tornabuoni, patron of a chapel dedicated to the Visitation in the Medici parish church of San Lorenzo, may appear in the Tornabuoni *Visitation,* along with both the first and second wives of the patron's son Lorenzo (fig. 12).[115]

Lorenzo's first wife, Giovanna degli Albizzi, was portrayed after her death in a portrait by Ghirlandaio (cat. 30), wearing the same dress as in the fresco (fig. 12), and on a medal in the style of Niccolò Fiorentino (cat. 11). She may be identified also in the *Birth of Saint John* (fig. 13), but by contrast with the Tornabuoni men, less on the basis of her features than by her distinctive pendant that appears in her commemorative portrait, and in both the chapel fresco panels. Lorenzo's second wife, Ginevra Gianfigliazzi, appears in Botticelli's frescoes for Giovanni Tornabuoni's country house, the Villa Lemmi (fig. 14). This graceful, lighthearted scene for the decoration of a bedroom depicts a garden of love, a courtly and classical poetic theme. Ginevra receives flowers from Venus and her attendant graces, symbolizing the female virtues, especially that of fertility.[116] The number and nature of the portraits commissioned by Tornabuoni men of their womenfolk, even when these are recognizable

11

11
Workshop of Andrea del Verrocchio,
The Death of Francesca Pitti Tornabuoni,
Museo Nazionale del Bargello, Florence
(photo: Alinari / Art Resource, N.Y.)

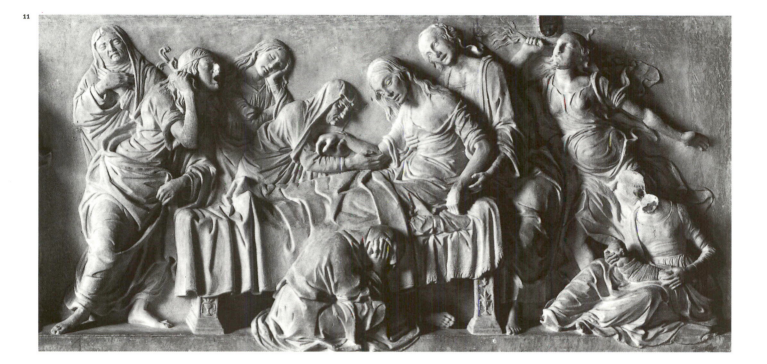

as much by dress as physiognomy, indicate their value to the lineage and a strong desire to preserve their memory.

A doggerel verse of 1536 listed "thirty-three perfections" of the ideal woman, among them: "Three long: hair, hands, and legs; Three short: teeth, ears, and breasts: Three wide: forehead, chest, and hips; Three narrow: waist, knees, and where nature places all that is sweet."[117] These desiderata were similar to those expressed in the preceding three centuries by writers from Petrarchan poets to putative mothers-in-law.

The idealism of courtly love, finding its most sublime expression in Dante's meeting with Beatrice at the gates of Paradise, envisioned the beloved guiding her lover toward the love and knowledge of God, physical beauty being merely the outward and visible sign of an inner virtue. In the second half of the fifteenth century humanists set these ideas in the more sophisticated Christian context of Neoplatonism, which viewed the entire material world as merely a reflection of its ideal form in the mind of God. Marsilio Ficino, mentioned earlier as the man who compared women to chamber pots, was the leader of this intellectual movement in Florence and the spiritual adviser

to Lorenzo's circle. He wrote a letter of consolation to Sigismondo della Stufa, Lorenzo's closest friend, at the death of his beautiful fiancée Albiera degli Albizzi, sister of Giovanna who also died young: "Cease looking for your Albiera degli Albizzi in her dark shadow...she is far more lovely in her Creator's form than in her own."[118]

Real Florentine women seem to have diverged considerably from social as well as Christian ideals. Nevertheless, these powerfully influenced their behavior and governed the decorum of their appearance in portraits. In the early sixteenth century, as the Medici moved toward the establishment of their family as dukes of Florence in 1534, portraits of women in their circle were presented as icons of public virtue as well as living beings.[119] It is often observed that women are nearly always seen by men to represent something other than themselves—ideals, symbols, allegories.[120] Renaissance literature and art represented women as symbolic beings performing signifying functions within the allegorical world of texts or paintings.[121] This was part of their exemplary effect, as Renaissance people saw the world naturally in symbolic and allegorical terms learned from the Bible and church liturgy.[122]

12
Domenico Ghirlandaio, *Visitation*,
Tornabuoni Chapel, Santa Maria
Novella, Florence (photo: Scala /
Art Resource, N.Y.)

13
Domenico Ghirlandaio, *Birth of Saint
John the Baptist*, Tornabuoni Chapel,
Santa Maria Novella, Florence
(photo: Scala / Art Resource, N.Y.)

14
Botticelli, *Ginevra Gianfigliazzi Receiving
a Gift of Flowers from Venus*, Musée
du Louvre, Paris (photo: Daniel Arnaudet,
Réunion des Musées Nationaux / Art
Resource, N.Y.)

12

13

14

Domenico Ghirlandaio, *Visitation*,
Tornabuoni Chapel, Santa Maria
Novella, Florence (photo: Scala /
Art Resource, N.Y.)

Domenico Ghirlandaio, *Birth of Saint
John the Baptist*, Tornabuoni Chapel,
Santa Maria Novella, Florence
(photo: Scala / Art Resource, N.Y.)

Botticelli, *Ginevra Gianfigliazzi Receiving
a Gift of Flowers from Venus*, Musée
du Louvre, Paris (photo: Daniel Arnaudet,
Réunion des Musées Nationaux / Art
Resource, N.Y.)

Leonardo da Vinci's *Ginevra de' Benci* (cat. 16) fuses real and ideal in a portrait of a woman with a historical identity and personal attributes that lent themselves to this process.[123] The Venetian humanist Bernardo Bembo chose her as the object of his platonic love, she was idealized in the Petrarchan poetry of several men in the Medici circle, her father and uncles were among the most prolific writers and codifiers of Florentine vernacular poetry, and she herself enjoyed the reputation of an accomplished poet. Ginevra is often seen as a personification of nature of which she is a part in her portrait;[124] a prickly personality, like the leaves of the juniper bush that stands for her name, may be revealed in her poetry, of which a single telling line survives: "I ask your forgiveness and I am a mountain tiger."

Both the Renaissance ideal of women and their actual experience were shaped by the needs and expectations of the male lineage, the republican state, the Christian church, and the humanist and vernacular cultures that provided admired exempla for this society that revived and revered the art and literature of antiquity, and whose governors, like Lorenzo de' Medici, wrote love poetry in the "sweet style" of the creators of the Tuscan language, the three crowns of Florence: Dante, Petrarch, and Boccaccio.

All these forces combined to represent chastity as the chief virtue of women, and their idealized beauty as ideally residing in the possession of this virtue, essential to the honor of their men. This is a fundamental distinction in the representation, in either words or images, of men and women. Notably, although the reverse of Ginevra's portrait bears the poet's laurel and the palm of fame, Ginevra's motto, *Virtutem Forma Decorat,* derived from Bembo's *Virtus et Honor,* represents a crucial shift of emphasis. In women even beauty is but the adornment of personal virtue; honor is a public virtue that pertains only to men.

Female portraits cannot simply be used as evidence of the real experience of women, but they do tell us much about the context and content of Renaissance women's actual lives. At the same time representations, either artistic or literary, were admired in highly cultured Renaissance Florence for *inventio* as well as *mimesis,* and were governed by the rules of the genre and the artist's aims. What women's portraits may ultimately best represent is the complex and subtle dialogue between life and art in fifteenth- and sixteenth-century Florence.

NOTES

1. Jacob Burckhardt, *The Civilization of the Renaissance in Italy* (1860; English ed., New York, 1954).

2. See Norma Broude and Mary D. Garrard, eds., *The Expanding Discourse: Feminism and Art History* (New York, 1992), introduction; Joan Scott, "Gender: A Useful Category of Historical Analysis," *American Historical Review* 91 (1986), 1053–1075.

3. See Patricia Simons, "Women in Frames: The Gaze, the Eye, the Profile in Renaissance Portraiture," *History Workshop: A Journal of Socialist and Feminist Historians* 25 (1988), 4–30; repr. in Broude and Garrard 1992, 39–58. Freud and Lacan are applied to the exploration of representation and spectatorship in film by Laura Mulvey, *Visual and Other Pleasures* (Bloomington, 1989). John Berger, *Ways of Seeing* (London, 1972), makes a similar argument, though he emphasizes female complicity.

4. For a survey of Florentine family studies up to the early 90s, see F.W. Kent, "La famiglia patrizia fiorentina nel quattrocento. Nuovi orientamenti nella storiografia recente," in *Palazzo Strozzi: Metà Millenio 1489–1989*, ed. Daniela Lamberini (Rome, 1991), 70–91. For a general view of women in the Renaissance, see Margaret King, *Women of the Renaissance* (Chicago, 1991). Reassessments of Burckhardt's thesis include Joan Kelly-Gadol, "Did Women have a Renaissance?" in *Becoming Visible: Women in European History*, ed. R. Bridenthal and Claudia Koonz (Boston, 1977), 139–164; David Herlihy, "Did Women have a Renaissance? A Reconsideration," in *Medievalia et Humanistica*, n.s. 13 (1985), 1–22.

5. See Stephen Greenblatt, *Renaissance Self-Fashioning: From More to Shakespeare* (Chicago, 1980), on constructing the literary self.

6. On self-conscious social impression management, see Erving Goffman, *The Presentation of Self in Everyday Life* (Garden City, N.J., 1959). Simons (1988) observes: "Few if any artistic images offer female self-representation; the great majority of images of women present them according to an elaborate set of social codes that governed their expected behavior as wives and mothers." For Renaissance individuality as a social, not a private construct, see B. Debs, "From Eternity to Here: Uses of the Renaissance Portrait," *Art in America* 63 (1975), 48–55. Sarah Beverley Benson, "Giovanni Boccaccio's *De mulieribus claris* and Female Portraiture: A Proposal for Reading Renaissance Women," M.A. thesis, University of Texas at Austin, 1994, stresses that whereas men could choose their own identity from the socially acceptable options, women's identity was invariably created for them.

7. Quoted in F.W. Kent, "Sainted Mother, Magnificent Son: Lucrezia Tornabuoni and Lorenzo de' Medici," *Italian Culture and History* 3 (1997), 6.

8. On Florentine society and values, see Gene Brucker, *Renaissance Florence* (New York, 1969). On the Florentine family, F.W. Kent, *Household and Lineage in Renaissance Florence: The Family Life of the Capponi, Ginori and Rucellai* (Princeton, 1977); Kent 1991; Christiane Klapisch-Zuber, *Women, Family and Ritual in Renaissance Italy*, collected essays, trans. Lydia G. Cochrane (Chicago, 1985); Christiane Klapisch-Zuber, "Images without Memory: Women's Identity and Family Consciousness in Renaissance Florence," in *Fenway Court: Imaging the Self in Renaissance Italy* (n.p., 1990–1991), 37–44; Thomas Kuehn, *Law, Family and Women: Towards a Legal Anthropology in Renaissance Italy* (Chicago, 1993).

9. Quoted in Natalie Tomas, *"A Positive Novelty": Women and Public Life in Renaissance Florence, Monash University Publications in History* (Clayton, Victoria, 1992), 67.

10. See, for example, Archivio di Stato, Florence, Catasto, 817, fol. 403v.

11. On women and the Church in its various aspects, see Daniel Bornstein and Roberto Rusconi, *Women and Religion in Medieval and Renaissance Italy* (Chicago, 1996).

12. See King 1991, chap. 1.

13. In Paul Oskar Kristeller, *Supplementum Ficinianum*, 2 vols. (repr. Florence, 1973) 2: 188.

14. Quoted in Marina Warner, *Alone of All Her Sex: The Myth and Cult of the Virgin Mary* (London, 1976), xvii.

15. Quoted in H. Diane Russell, *Eva/Ave: Woman in Renaissance and Baroque Prints* [exh. cat., National Gallery of Art] (New York, 1990), 12.

16. Quoted in Ronald Rainey, "Dressing Down the Dressed-Up: Reproving Feminine Attire in Renaissance Florence," in *Renaissance Society and Culture: Essays in Honor of Eugene F. Rice, Jr.*, ed. J. Monfasani and R.G. Musto (New York, 1991), 237.

17. See David Herlihy and Christiane Klapisch-Zuber, *Tuscans and Their Families: A Study of the Florentine Catasto of 1427* (New Haven, 1985), 81–83.

18. On this work, see Margaret King, "Caldiera and the Barbaros on Marriage and the Family: Humanist Reflections of Venetian Realities," *Journal of Medieval and Renaissance Studies* 6 (1976), 19–50.

19. Heather Gregory, "Daughters, Dowries and the Family in Fifteenth-Century Florence," *Rinascimento* 27 (1987), 231. She cites a letter, 217, of Marco Parenti concerning the birth of a child to his Strozzi brother-in-law, who had clearly wished for a boy: "It seems to me that as you have a boy... you should rejoice at this one being a girl, as much as if it were a boy, because...you will make a fine marriage alliance [sooner] than if it were a boy."

20. See Claude Lévi-Strauss, *L'homme nu* (Paris, 1971).

21. On marriage rituals, see Klapisch-Zuber 1985.

22. Klapisch-Zuber 1985 ("Nuptial Rites").

23. See Klapisch-Zuber 1985 ("Nuptial Rites"); Ronald Rainey, "Sumptuary Legislation in Renaissance Florence," Ph.D. diss., Columbia University, 1985; Adrian Randolph, "Performing the Bridal Body in Fifteenth-Century Florence," *Art History* 21 (1998), 182–200. On state regulation of these gifts, see Paul Watson, "Virtu and Voluptas in Cassone Painting," Ph.D. diss., Yale University, 1970, appendix II.

24. For the precise statistics, see Herlihy and Klapisch-Zuber 1985, 131–155; also Klapisch-Zuber 1985, chap. 1.

25. In fact many women found the single state much more favorable to their spiritual lives than marriage, and enjoyed far more freedom and power within the convent than their sisters did in the confines of the marital home. Home and family remained an almost insuperable impediment to the truly holy life, as Angela of Foligno made brutally clear when she expressed the "great consolation" she felt at the deaths of her mother, husband, and children, for which she had "devoutly prayed." See Daniel Bornstein, "Women and Religion in Late Medieval Italy: History and Historiography," in Bornstein and Rusconi 1996, 4. Kent 1997, 7, observed that Madonna Scolastica Rondinelli, the abbess of a great convent such as Le Murate, could be a significant figure even in the civic world.

26. Kent 1997, 8.

27. Klapisch-Zuber 1985 ("The Cruel Mother"). For San Bernardino's remarks about women, including widows, see Iris Origo, *The World of San Bernardino* (London, 1964); Roberto Rusconi, "St. Bernardino of Siena, the Wife and Possessions," in Bornstein and Rusconi 1996, 182–196.

28. Kent 1997, 6.

29. For a vivid account of these, and the unusual success of one widow, Lena Davizzi, in combating them, see Isabelle Chabot, "Lineage Strategies and the Control of Widows in Renaissance Florence," in *Widowhood in Medieval and Early Modern Europe,* ed. Sandra Cavallo and Lyndan Warner (London, 1999), 127–144.

30. Klapisch-Zuber 1985, 121.

31. The phrase is used by Giovanni Rucellai, as quoted in Kent 1977, 40. The same might have been said of Alessandra Strozzi, by contrast with Giovanni Morelli's "cruel mother," for whom the essay in Klapisch-Zuber 1985 was titled (see esp. 127–128). See also Isabelle Chabot, "Widowhood and Poverty in Late Medieval Florence," in *Continuity and Change* 3 (1988), 291–311.

32. On the Florentine dowry fund, see J. Kirschner, "Pursuing Honor while Avoiding Sin: the Monte delle Doti of Florence," *Studi Senesi* 41 (1978), 177–258; J. Kirschner and Anthony Molho, "The Dowry Fund and the Marriage Market in Early Quattrocento Florence," *Journal of Modern History* 50 (1978), 403–438.

33. Kirschner and Molho 1978, 406–409.

34. On these, see particularly Randolph 1998.

35. See J. Kirschner, "Materials for a Gilded Cage: Non-Dotal Assets in Florence, 1300–1500," in *The Family in Italy: From Antiquity to the Present,* ed. David I. Kertzer and Richard P. Saller (New Haven, 1991), 184–207; Kuehn 1993; also E.G. Rosenthal, "The Position of Women in Renaissance Florence: Neither Autonomy nor Subjection," in *Florence and Italy: Renaissance Studies in Honour of Nicolai Rubinstein,* ed. Peter Denley and Caroline Elam (London, 1988), 369–381, for examples of women who succeeded in executing their wishes in bequests.

36. Klapisch-Zuber 1985 ("Dowry and Marriage Gifts"); Randolph 1998.

37. On the bridal wardrobe, see particularly Carole Collier Frick, "Dressing a Renaissance City: Society, Economics and Gender in the Clothing of Fifteenth-Century Florence," Ph.D. diss., University of California, Los Angeles, 1995.

38. On sumptuary laws, see Klapisch-Zuber 1985 ("Dowry and Marriage Gifts"); Rainey 1985, 1991; also Diane Owen Hughes, "Sumptuary Laws and Social Relations in Mediterranean Europe," in *Disputes and Settlements,* ed. John Bossy (Cambridge, 1983), 69–99, and "Regulating Women's Fashion," in *A History of Women in the West,* ed. Georges Duby and M. Perrot (Cambridge, Mass., 1992), 2: 136–158.

39. See Rainey 1991, esp. 237.

40. Quoted in Rainey 1991, 231–234. In fact, ever later marriage for men was a trend observable throughout Europe at this time, and quite possibly determined chiefly by the desire to restrict the number of heirs and to avoid the partitioning of estates among too many sons; on this, see David Herlihy, "The Medieval Marriage Market," *Medieval and Renaissance Studies* 6 (1976), 19.

41. Quoted in Randolph 1998, 182.

42. Quoted in Rainey 1991, 236.

43. Quoted in Rainey 1991, 232. On theories of women as identified with nature, see Mary Garrard, "Leonardo da Vinci. Female Portraits, Female Nature," in Broude and Garrard 1992, 58–85.

44. See Kent 1997, 24, for Lucrezia Tornabuoni's attempt to have Pisan sumptuary laws suspended for a Genoese friend.

45. Alessandra Strozzi, *Selected Letters of Alessandra Strozzi,* in Italian and English, translated with introduction and notes by Heather Gregory (Berkeley and Los Angeles, 1997), 150–151.

46. See Vespasiano da Bisticci, *Le Vite,* ed. A. Greco, 3 vols. (Florence, 1970–1976), 2: 194; Niccolò Machiavelli, letters, in P. Bondanella and M. Musa, *The Portable Machiavelli* (New York, 1979), 69.

47. Quoted in Diane Owen Hughes, "Invisible Madonnas? The Italian Historiographical Tradition and the Women of Medieval Italy," in *Women in Medieval History and Historiography,* ed. Susan Mosher Stuard (Philadelphia, 1987), 26.

48. On the general theme of Lorenzo's ritual strategies, see Richard Trexler, *Public Life in Renaissance Florence* (New York, 1980).

49. See Gene Brucker, "The Economic Foundations of Laurentian Florence," in *Lorenzo il Magnifico e il suo mondo,* ed. Gian Carlo Garfagnini (Florence, 1994), 3–15. See also Rainey 1985, 234, for the preamble to a sumptuary law of 1511, and the comment of the chronicler Cambi on another of 1528 imposing limits on the cost of fabrics and ornaments, "so that husbands could use the dowries as capital."

50. Rainey 1985; on Florentine consumerism, see Richard Goldthwaite, "The Empire of Things: Consumer Demand in Renaissance Italy," in *Patronage, Art and Society in Renaissance Italy,* ed. F. W. Kent and Patricia Simons (Oxford, 1987), 153–175.

51. On Savonarola and women, see F. W. Kent, "A Proposal by Savonarola for the Self-Reform of Florentine Women," *Memorie Domenicane,* n.s. 14 (1983), 335–341; Tomas 1992, chap. 4, "A Preacher for Women?"

52. See Jacqueline Musacchio, *The Art and Ritual of Childbirth in Renaissance Italy* (New Haven, 1999), 20.

53. See Rusconi in Bornstein and Rusconi 1996; Catherine King, *Renaissance Women Patrons: Wives and Widows in Italy, c. 1300–1550* (Manchester and New York, 1998), 22–29.

54. Fra Cherubino da Siena, quoted in King 1998, 30.

55. See, for example, the opening lines of Dante, *Inferno* 1, ll. 1–3: "In the middle of the journey of our life / I came to myself in a dark wood / where the straight way was lost."

56. Quoted in King 1998, 27.

57. See Klapisch-Zuber 1985 ("Blood Parents and Milk Parents").

58. Quoted in King 1991, 3.

59. Musacchio 1999, 44.

60. See Gene Brucker, ed., *Two Memoirs of Renaissance Florence: The Diaries of Buonaccorso Pitti and Gregorio Dati* (New York, 1967), 107–141.

61. King 1991, 3.

62. Klapisch-Zuber 1985, 311.

63. Klapisch-Zuber 1985 ("Holy Dolls").

64. On these, see Jacqueline Musacchio, "Imaginative Conceptions in Renaissance Italy," in *Picturing Women in Renaissance and Baroque Italy,* ed. Geraldine A. Johnson and Sara F. Matthews Grieco (Cambridge, 1997), 42–60; Musacchio 1999, particularly appendix C.

65. On this, see Paul Watson, "A desco da parto by Bartolomeo di Fruosino," *Art Bulletin* 61 (1974), 4–9.

66. Once when Lucrezia Tornabuoni was ill, her mother-in-law Contessina wrote to reassure her that she and the other women of the Medici household would make the visit to a friend who had just given birth; see Lucrezia Tornabuoni Medici, *Lettere,* ed. Patrizia Salvadori (Florence, 1997), 98.

67. Musacchio 1999, 15.

68. Herlihy and Klapisch-Zuber 1985, 274–279; Musacchio 1997, 42.

69. Musacchio 1997, 48–49.

70. Musacchio 1997, 54–58.

71. The best description of these effects of devotional images is by Giovanni Morelli in his *Ricordi,* to which Richard Trexler first drew attention (1980, chap. 5); see also Dale Kent, *Cosimo de' Medici and the Florentine Renaissance* (New Haven, 2000), chap. 7.

72. See, for example, Cristelle Baskins, "Griselda, or the Renaissance Bride Stripped Bare by Her Bachelor in Tuscan Cassone Painting," *Stanford Italian Review* 10 (1991), 153–175; for the significance of the Griselda tale, see also Klapisch-Zuber 1985 ("Dowry and Marriage Gifts").

73. On *cassoni,* see particularly Ellen Callmann, *Apollonio di Giovanni* (Oxford, 1974); on headboards and wall panels, see Anne B. Barriault, *Spalliera Paintings of Renaissance Tuscany: Fables of Poets for Patrician Homes* (University Park, Pa., 1994). On the decoration of *cassoni* with tales of love and virtue, and details of the betrothal gifts some of them contained, see Watson 1970. For a general survey of the subject of painted furniture, see Paola Tinagli, *Women in Italian Renaissance Art: Gender, Representation, Identity* (Manchester, 1997), chap. 1.

74. See Cristelle Baskins, "La Festa di Susanna: Virtue on Trial in Renaissance Sacred Drama and Painted Wedding Chests," *Art History* 14 (1991), 329–344, and "Typology, Sexuality, and the Renaissance Esther," *Sexuality and Gender in Early Modern Europe. Institutions, Texts, Images,* ed. James Grantham Turner (Cambridge, 1993), 31–54; Elena Ciletti, "Patriarchal Ideology in the Renaissance Iconography of Judith," in *Refiguring Woman: Perspectives on Gender and the Italian Renaissance,* ed. Marilyn Migiel and Juliana Schiesari (Ithaca, 1991), 35–70.

75. See, particularly, Barriault 1994, 124–128; Ellen Callmann, "The Growing Threat to Marital Bliss as seen in Fifteenth-Century Florentine Paintings," *Studies in Iconography* 5 (1979), 73–92.

76. See Lilian Zirpolo, "Botticelli's *Primavera*: A Lesson for the Bride," in Broude and Garrard 1992, 100–109.

77. See Marco Spallanzani and Giovanna Gaeta Bertelà, *Libro inventario dei beni di Lorenzo il Magnifico* (Florence, 1992); Marco Spallanzani, *Inventari Medicei, 1417–1465: Giovanni di Bicci, Cosimo e Lorenzo di Giovanni, Piero di Cosimo* (Florence, 1996); also Musacchio 1999, appendices. On domestic furnishings see John Kent Lydecker, "The Domestic Setting of the Arts in Renaissance Florence," Ph.D. diss., The Johns Hopkins University, 1987; Richard Goldthwaite, "L'interno del Palazzo e il consumo dei beni," in *Palazzo Strozzi* 1991, 59–66; Attilio Schiaparelli, *La casa fiorentina e i suoi arredi nei secoli xiv e xv,* ed. Maria Sframeli and Laura Pagnotta, 2 vols. (reprint ed., Florence, 1983).

78. On palace architecture and the usage of rooms, see Brenda Preyer, "Planning for Visitors at Florentine Palaces," *Renaissance Studies* 12 (1998), 357–374; also F. W. Kent, "Palaces, Politics and Society in Fifteenth-Century Florence," *I Tatti Studies* 2 (1987), 59–60. The household, extended to include friends and neighbors, was the essential context of the personal patronage exercised by the Medici women; while sharp distinctions between public and private are to be avoided, it does not seem to me that this patronage qualifies as "public" activity in the sense understood by Florentines, as suggested by Sharon Strocchia, "La famiglia patrizia fiorentina nel secolo xv: la problematica della donna," in *Palazzo Strozzi* 1991, 126–137, or more cautiously by Kent 1997.

79. On Alessandra's activities, see Mark Phillips, *The Memoir of Marco Parenti: A Life in Medici Florence* (Princeton, 1987); on the Alberti women, Susannah Foster Baxendale, "Exile in Practice: The Alberti Family In and Out of Florence 1401–1428," *Renaissance Quarterly* 44 (1991), 720–756.

80. See Adrian Randolph, "Regarding Women in Sacred Space," in *Picturing Women in Renaissance and Baroque Italy,* ed. Geraldine A. Johnson and Sara F. Matthews Grieco (Cambridge, 1997), 19–20.

81. See the letter to Lorenzo from one of his youthful cronies, Braccio Martelli, in Kent 2000, 426.

82. Simons 1988.

83. Quoted in Randolph 1997, 35.

84. Quoted in Randolph 1997, 35–36. This appraisal of a prospective bride closely resembles that of Lucrezia Tornabuoni, also conducted in church, quoted below, pages 38–39.

85. See Bornstein 1996, 4; also Katherine Gill, "Women and the Production of Religious Literature in the Vernacular, 1300–1500," in *Creative Women in Medieval and Early Modern Italy: A Religious and Artistic Renaissance,* ed. E. Ann Matter and John Coakley (Philadelphia, 1994), and, specifically for Florence, Kent 2000, chaps. 6 and 13.

86. See Bornstein 1996, 4–5; also Hughes 1987, 36–39, on Catherine and Umiliana de' Cerchi, a thirteenth-century daughter of a famous Florentine family who was still revered in devotional societies and tracts of the late fifteenth century.

87. Giovanni Dominici, *Regola del governo di cura familiare,* ed. D. Salvi (Florence, 1860); trans. and intro. A. B. Coté, in *On the Education of Children* (Washington, D.C., 1927), 34.

88. Hughes 1992, 152.

89. Bornstein 1996, 1–2.

90. See Benson 1994, reframing Boccaccio's treatise as poetic allegory rather than the misogynist tract described by Constance Jordan, "Boccaccio's In-Famous Women: Gender and Civic Virtue in the 'De mulieribus claris,'" in *Ambiguous Realities: Women in the Middle Ages and Renaissance,* ed. Carole Levin and Jeanie Watson (Detroit, 1987). On the Castagno cycle as representing an allegory of virtues, not unlike Botticelli's frescoes for the Tornabuoni family's Villa Lemmi, see Creighton Gilbert, "On Castagno's Nine Famous Men and Women: Sword and Book as the Basis for Public Service," in *Life and Death in Fifteenth-Century Florence,* ed. Marcel Tetel, Ronald G. Witt, and Rona Goffen (Durham, 1989), 174–192.

91. See Natalie Tomas, "Neglected Spaces: Gender, Power and the Medici Women in Renaissance Florence," Ph.D. diss., Monash University, 1997, esp. iii.

92. See the Medici correspondence, Archivio di Stato, Florence, Medici avanti il Principato, v, 466.

93. Medici avanti il Principato, xx, 60; see also Richard Trexler, "Florentine Religious Experience: The Sacred Image," *Studies in the Renaissance* 19 (1972), 7–41.

94. Medici avanti il Principato, xi, 227; 148, 30.

95. Medici avanti il Principato, xvi, 9; see also Yvonne Maguire, *The Women of the Medici* (London, 1927), chap. 4.

96. Medici avanti il Principato, xi, 531.

97. A. D'Addario, "Lotta, detta Contessina Bardi (Medici)," in *Dizionario biografico degli italiani* (Rome, 1964), 6: 305–307.

98. See Kent 2000, 327, 382.

99. See Shelley Zuraw, "The Medici Portraits of Mino da Fiesole," in *Piero de' Medici "il Gottoso" (1416–1469): Kunst im Dienste der Mediceer* (Berlin, 1993), 317–339. The bust Zuraw identifies with Lucrezia is now in the Palazzo dell'Opera della Primaziale, Pisa, a city where the Medici bank had an office and where Lucrezia herself had important business interests. On this, see Tomas 1997; Kent 1997.

100. See the introduction to Lucrezia Tornabuoni, *Poemetti Sacri,* ed. Fulvio Pezzarossa (Florence, 1978), 13–15.

101. Tornabuoni Medici 1993, 62–63.

102. On her business and patronage, see Kent 1997.

103. See Katherine J. P. Lowe, "A Matter of Piety or of Family Tradition and Custom?: The Religious Patronage of Piero de' Medici and Lucrezia Tornabuoni," in *Piero de' Medici "il Gottoso"* 1993, 55–69. However, the parish priest Arlotto, known for his irreverent comments on the socially eminent, wrote that when Lucrezia boasted of her largesse, claiming that "I know of no greater charity than to marry off young girls and free those who are in prison and above all those who are there on account of debt," he replied that he could think of an even greater charity: "Not to deprive others of their goods, their labor, or their sweat, above all the poor." See Piovano Arlotto, *Motti e facezie,* ed. Gianfranco Folena (Milan, 1953), 103.

104. Tomas 1997, 69; also Kent 1997.

105. Kent 2000, 324–328.

106. The translation is from *Gender and Religion in Renaissance Florence: The Sacred Poetry of Lucrezia Tornabuoni de' Medici,* ed. and trans. Jane Tylus, forthcoming.

107. Kent 1997, 1, 20.

108. Sara F. Matthews Grieco, "The Body, Appearance and Sexuality," in *A History of Women in the West* (Cambridge, Mass., 1992), 3: 47.

109. Lydecker 1987, 159, observes that what little evidence survives in account books and inventories relates the portrait not to marriage but to the death of a family member. If no portrait existed at this time, a death mask might be used as the basis for one.

110. Leon Battista Alberti, *Della Pittura: On Painting,* trans. Cecil Grayson, with introduction and notes by Martin Kemp (London, 1991), 60. Evelyn Welch, "Sforza Portraiture and SS. Annunziata in Florence," in *Florence and Italy: Renaissance Studies in Honour of Nicolai Rubinstein,* ed. Peter Denley and Caroline Elam (London, 1988), 235–240, describes Sforza's search for a keepsake portrait of his father, Muzio Attendolo, in Florence. Giovanni de' Medici clearly concurred with Alberti's view, recommending in a letter to a friend the skill of the sculptor Mino da Fiesole, responsible for his own portrait bust and that of his brother Piero and Piero's wife Lucrezia Tornabuoni. He employed, not as a learned citation, but as if it were his own insight a classical topos, popularized in Florence by Petrarch, that these portraits seemed almost to breathe or to speak. See Francesco Caglioti, "Bernardo Rossellino a Roma: I: stralci del carteggio mediceo (con qualche briciola sul filarete)," *Prospettiva* 64 (1991), 50.

111. See Elizabeth Cropper, "The Beauty of Woman: Problems in the Rhetoric of Renaissance Portraiture," in *Re-writing the Renaissance: the Discourses of Sexual Difference in Early Modern Europe,* ed. Margaret W. Ferguson, Maureen Quilligan, and Nancy J. Vickers (Chicago, 1986), 182.

112. See Patricia Simons, "Portraiture, Portrayal, and Idealization: Ambiguous Individualism in Representations of Renaissance Women," in *Language and Images of Renaissance Italy,* ed. Alison Brown (Oxford, 1995), 277. See also John Shearman, *Only Connect…Art and the Spectator in the Italian Renaissance* (Princeton, 1992), for the argument that in the High Renaissance there was a general shift toward the transitive mode that allowed the viewer a more engaged relationship with the subject of a portrait.

113. These prayers are articulated in the inscriptions of the Tornabuoni panels; see Patricia Simons, "Patronage in the Tornaquinci Chapel, Santa Maria Novella, Florence," in *Patronage, Art and Society in Renaissance Italy,* ed. F. W. Kent and Patricia Simons (Oxford, 1987), 239–240.

114. Quoted in Patricia Simons, "Portraiture and Patronage in Quattrocento Florence with Special Reference to the Tornaquinci and Their Chapel in S. Maria Novella," Ph.D. diss., University of Melbourne, 1985, 128.

115. For the identification of these female portraits, see Simons 1985, 298–317.

116. See R. Lightbown, *Sandro Botticelli,* 2 vols. (London, 1978), 1: 93–97.

117. Quoted in Matthews Grieco 1992, 58–59.

118. See Simons 1985, 37, for the citation from Ficino's letter and the poems by Scala, Bracci, and Poliziano mentioning a marble bust of Albiera.

119. See Harry Berger, "Fictions of the Pose: Facing the Gaze of Early Modern Portraiture," *Representations* 46 (1994), 87–120. In the sixteenth century Medici wives behaved more like the wives of other Italian princes than their republican foremothers; see Tomas 1992, chap. 5; Tomas 1997; Natalie Tomas, "Alfonsina Orsini de' Medici and the 'Problem' of a Female Ruler in Early Sixteenth-Century Florence," *Renaissance Studies* 14 (2000), 70–90; Sheryl E. Reiss, "Widow, Mother, Patron of Art: Alfonsina Orsini de' Medici," in *Beyond Isabella: Secular Women Patrons of Art in Renaissance Italy* [*Sixteenth Century Essays and Studies* 54], ed. Sheryl E. Reiss and David G. Wilkins (Kirksville, Mo., forthcoming).

120. See, for example, Maureen Quilligan, *The Language of Allegory: Defining the Genre* (Ithaca, N.Y., 1979); Marina Warner, *Monuments and Maidens: The Allegory of the Female Form* (New York, 1985); and Mary Ryan's remarks on early American parades in Lynn Hunt, ed., *The New Cultural History* (Berkeley and Los Angeles, 1989), chap. 6.

121. Benson 1994.

122. See Simons 1995 and Kent 2000, chap. 7.

123. See David Alan Brown, *Leonardo da Vinci. Origins of a Genius* (New Haven, 1998); on Ginevra's ideal beauty, see Cropper, 1986, 183–189.

124. See particularly Garrard 1992.

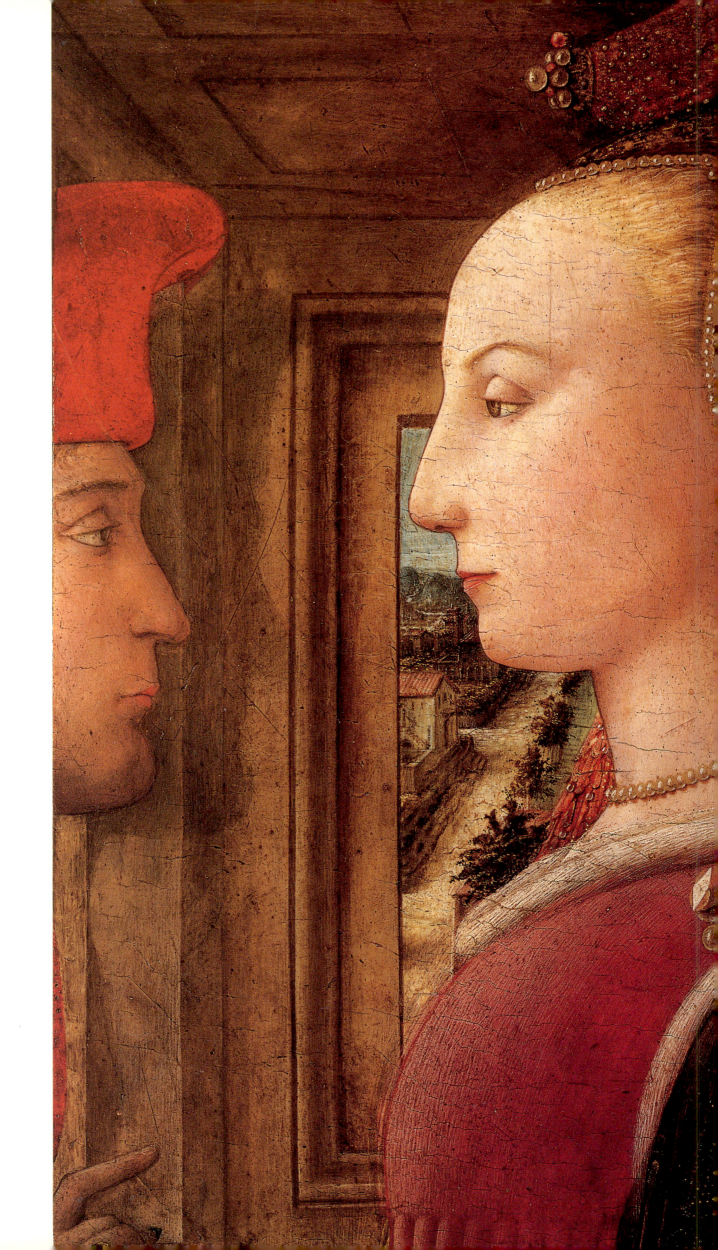

Poetic Ideals of Love and Beauty
Victoria Kirkham

Marvelously
love squeezes me tight
and holds me all the time.
As a painter locks his gaze
on a model to make a painted likeness,
so, fair lady, do I,
who within my heart
carry your face.

Giacomo da Lentini, c. 1230–1240

Giacomo da Lentini lived nearly eight hundred years ago in Palermo, where he worked drafting legal documents at the cosmopolitan court of the "baptized Sultan," Emperor Frederick II. In this poem he does not identify the lady who had invaded his heart with such visual intensity. He tells us only that she was "the most beautiful, / the flower of lovesome women, / blonder than beaten gold." By contrast, his own name stands out clearly in the closing verses, as he coaxes her with a beckoning gesture: "Your love, which is dear, / give it to the Notary / who was born of Lentino."[1] A whimsical logic requires him to sign the poem, so that the fair-haired beauty will know where to reply with her favors. But his more serious motive was surely to express pride, for "The Notary" from the little Sicilian town of Lentini, though of amateur status, was a master poet, credited with inventing the Italian sonnet.

Giacomo and his followers had inherited from the troubadours a fully developed lyric corpus based on a courtly code of love, which in the second half of the thirteenth century migrated from the Sicilian school to Tuscany, and thence via Dante, Petrarch, and Boccaccio into the flourishing cultural milieu of quattrocento Florence. By the second half of the fifteenth century, Medici adherents could boast that a new golden age had dawned on the world under Lorenzo the Magnificent, whose farsighted patronage supported a brilliant constellation of artists, poets, and scholars. By that time, more than two hundred and fifty years had elapsed since the origins of Italian vernacular literature, enough time for men of letters to look back and reassess the past that conditioned their present. As they redefined their own poetic ideals, fired by innovative intellectual currents flowing from the Neoplatonism of Marsilio Ficino, new canons of classics emerged.

Lorenzo de' Medici himself, as fine a poet as a prince, played a key role in this development when, in 1476, with the assistance of his palace humanist, Angelo Poliziano, he produced an Italian lyric anthology known as the *Aragonese Collection*. It was a gift to Frederic of Aragon, son of the king of Naples—the latter an antagonist on the political scene, with whom Lorenzo needed to jockey diplomatically. This presentation manuscript, designed to assert the supremacy of the Tuscan language, began with an epistle that connected contemporaries with the revered heritage of the ancient world. Crafted by Poliziano, the letter elevates poetry to an art that bestows immortality. Who would remember Achilles, the writer asks, were it not for Homer? But not even Homer would have survived had it not been for an enlightened ruler, Pisistratus of Athens, who collected and preserved the bard's precious epics.[2] In the obvious modern parallel, Lorenzo now fulfills his responsibility as custodian of culture by distilling the finest of Italy's vernacular patrimony.

Although the contents of the *Aragonese Collection* are uncertain, insight into this literary sampler may be gleaned from another jewel of the period, Poliziano's *Homage to My Wet Nurse (Nutricia)*, a Latin poem. Lest anyone wonder why a pioneer in philology should devise verse for his wet nurse—*a fortiori* in Latin—Poliziano was not honoring some robust country nanny, but a nurturer more ethereal, Lady Poetry. Composed as the introductory lecture for his 1486 series at the University of Florence, *Nutricia* is a tour de force of memory and artistry. After praising the civilizing power of poetry, Poliziano summarizes its universal history in an encyclopedia of several hundred names from Pan, Apollo, Orpheus, Sappho, Moses, and David, down through the ages in an unbroken chain of inspired tradition. His inventory comes to a close with the moderns:

But I could not deprive of my tribute Dante Alighieri,
who beneath the fair eyes of the maiden Beatrice flies
into the underworld, the heavens, and along the ledges of Purgatory;
Petrarch, who goes again singing the *Triumph of Love;*
the man who recounts one hundred short stories in ten days;
and he who unveils the arcane causes of love;
whence to you, fertile Florence, powerful in wisdom and in wealth,
there came the vaunt of glory without end.
And you, Lorenzo, guide of Tuscany, who open before yourself a road
to eternal fame, following in the footsteps of Cosimo. . . .[3]

Poliziano's genealogy articulates a modern canon of four, each characterized by a defining work, plus one more, a present-day poet. He is the professor's patron Lorenzo,

privileged end point of an intellectual dynasty reaching back into the mists of remotest times. Significantly, all five are Florentine: Dante for the *Divine Comedy*; Petrarch for his *Triumphs* and, more generally, his love poetry; Boccaccio for the *Decameron*; Guido Cavalcanti for his esoteric philosophical *canzone* "A Lady Asks Me"; and Lorenzo himself for his sonnets. A common theme connects members of this quintet, who epitomize prevailing ideals: love. Dante appears in Poliziano's inventory with Beatrice, the lady who leads him to heaven; "love's triumph" defines Petrarch; Boccaccio's proem to the *Decameron* promises "tales of love, both pleasant and bitter"; Cavalcanti, considered the most subtle authority on the psychology of love, defines its complex nature; and Poliziano's patron Lorenzo was compiling two collections of his own, accomplished love poetry.

Known from its expository frame as the *Commentary on Some of His Sonnets*, Lorenzo's work uses a prose gloss to link the forty-one lyrics in imitation of Dante's youthful *Vita nuova*. An idealized diary of his love for Beatrice, Dante's "New Life" centers paradoxically on the lady's death. Around that earth-shaking event, the poet narrates his experience of this "miraculous" creature, from the time he first beheld her in childhood, through phases of deepening understanding, until at last, when one of his sighs floats skyward to meet her blessed soul, he vows to write of her "that which has never been written of any other woman." Herald of the *Divine Comedy*, Dante's *Vita nuova* marks the transcending moment of a "Sweet New Style," forged a generation earlier by Guido Guinizelli and Cavalcanti. If the troubadours, living in a northern feudal society, had sung of amorous vassalage to pedestaled ladies whose identity they pretended to hide with a code name, or *senhal* (cf. English "sign"), the *Dolce stil nuovo* enunciated a new Tuscan ideology of love, set forth aphoristically in the first verse of Guinizelli's famous *canzone*, "Love repairs to the gentle heart." Woman, elevated to angelic status, fosters the nobility of spirit that conjoins true lovers, who are no longer an aristocracy of blood, but a "genteel" elite set apart by their virtue, which, as if by a natural force, compels love to inhabit their hearts.

Dante's *Vita nuova,* written in the 1290s, narrates this inner drama through a sequence of poems interspersed with prose commentary, staging for the first time in Italian literature a female protagonist as the agent of her lover's redemption. Yet, strangely, he reveals practically nothing about her appearance or the settings of their rare encounters. He first meets her as a nine-year-old girl dressed in "blood red," then again nine years later garbed in white; he will see her a total of nine times. One day she grants him her "salutation"; another she denies it, a privation that devastates him. Once she walks in the city preceded by Cavalcanti's lady, Giovanna, whose poetic nickname was Primavera or "spring." Dante's prophetic vision of her death, in the delirium of a nine-day illness, is apocalyptic: shrieks of mourning fill the air, the sky goes black, the earth quakes. From the beginning, mysterious signs surround Beatrice. Dante will finally understand that Beatrice is accompanied by the number nine, whose root three is the number of the miraculous Trinity, in order to signify that she herself is "a miracle." She descended from heaven and for a time, before returning to God, lived among men to save all those whom her beneficence touched. No wonder her "salutation" was so fraught; it prefigures his "salvation" (the two words are the same in Italian, *"salute"*):

> …where she goes
> Love drives a killing frost into base hearts
> that freezes and destroys what they are thinking,
> should such a one insist on looking at her,
> he is changed to something noble or he dies.
> And if she finds one worthy to behold her,
> that man will feel her power for salvation
> when she accords to him her salutation.[4]

If "her color is the pallor of the pearl…the best that Nature can achieve," that, like the white gown she wore at eighteen, must point to her purity. Far more meaningful than any tangible clothing are her moral vestments of chastity and humility. All important are her eyes, which shower grace upon her beholders. Her very name is a sign, for it illustrates a medieval axiom, "Names are the consequence of things." Beatrice is Dante's "blessed lady," his "beatitude."

1

*Dante and Beatrice in the Heaven of
the Moon (Paradiso 3),* from a series made
for the *Divine Comedy,* The Newberry
Library, Chicago

2

Lorenzo di Niccolò, *Episodes from
the Comedia delle Ninfe Fiorentine,* birth
salver, The Metropolitan Museum
of Art, New York, Rogers Fund. All rights
reserved

For all that Dante reveals, however, he conceals still more. His discerning reader must loosen the knots of more abstruse symbolism. Why, for example, does Giovanna-Primavera walk ahead of Beatrice? It will not do to say, as one modern annotator did, that the women stroll in single file because "in the narrow streets of Florence, with their even narrower sidewalks, two people cannot easily walk abreast."[5] Anyone who has visited Florence knows that this is perfectly true, but challenged pedestrians are hardly Dante's point here. Giovanna is the feminine form of Giovanni, or John. Her *senhal,* Primavera, is a pun on the phrase "prima verrà," or, "the person who comes first." So if a Giovanna precedes a Beatrice, their succession is that of an archetypical Johannine figure who prepared the way for one who followed. Giovanna and Beatrice reenact the parts of John the Baptist and Christ. Beatrice is salvific, her death central to Dante's "new life," because of her Christ-like being. That similitude accounts for her "blood red" dress in girlhood, which foreshadows the Savior's wounds at the Crucifixion, so vividly adumbrated in Dante's hallucinatory vision. In theological terms, Beatrice has wrought his conversion from *concupiscentia* to *caritas,* from selfish desire to Christian charity.

Dante's formidable powers as poet will reconvene Beatrice for a culminating encounter in the *Divine Comedy.* After his spiral descent into Hell and the arduous climb up Mount Purgatory, he reaches Eden at its summit. There, costumed in full color amid a "cloud of flowers" scattered by angels, Beatrice awesomely confronts him: "olive-crowned over a white veil a lady appeared to me, clad, under a green mantle, with hue of living flame" (*Purgatorio* 30, vv. 31– 33).[6] These details of dress might at first make the lady seem "real," but they are calculated for an opposite effect, to establish her as a symbol. Again, as in the *Vita nuova,* the number of the miraculous Trinity accompanies her, and she appears in the likeness of the Lord. Dante dresses her in the three theological virtues—white for faith, green for hope, and red for charity. He crowns her with olive, the tree sacred to Minerva, goddess of wisdom. Beatrice, to whom Dante never gives a surname, may have been a Florentine maiden (Boccaccio, his most ardent early admirer, believed

that she belonged to the Portinari family), but in the *Vita nuova* and *Comedy,* call her what we will—Wisdom, Salvation, Faith, Theology, or Revelation—she lives and breathes the air of allegory.[7]

Lifting off into the spheres, Dante and Beatrice rise as a twosome, her gaze turned upward, his eyes on hers. She looks straight into the sun, even more unwaveringly than an eagle, a Christ figure fabled in the bestiaries for just that ability—"never did eagle so fix his gaze."[8] Her physical tolerance for light alludes to her powers of metaphysical insight, which she imparts gradually to Dante-pilgrim as he follows her in his guided journey to the final vision of God. Fifteenth-century readers fortunate enough to own an illustrated copy of the *Comedy* could have contemplated their traveling arrangement in woodcuts like an image that precedes the third canto of *Paradiso* (fig. 1). Refulgent in a full-body halo, Beatrice precedes Dante, who wears the squirrel-skin cape and tailed hat of a scholar. They have reached their first station along the way, the heaven of the Moon, a large orb at top center. Its inscribed face signals the local planetary deity, Diana, goddess of chastity. Amid a carpet of stars, smiling homunculi kneel, naked to indi-

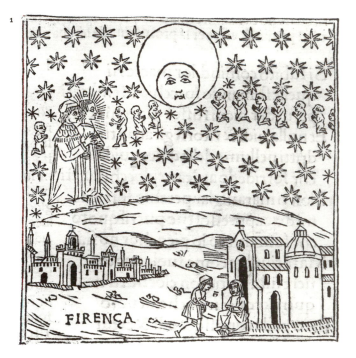

1

FIRENÇA

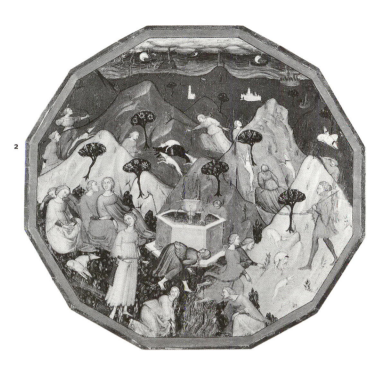

cate they are out of the body. Barely discernible to Dante, as if reflections on water or "like a pearl against a white forehead," these are the souls of the inconstant. Their representatives, nuns who through no fault of their own broke vows of chastity, betray Dante's vein of medieval misogyny. Spokeswoman for the community is Piccarda Donati, who gesticulates as she relates to Dante how kinsmen wrenched her from the cloister and forced her to marry, a fate like that of her companion in the afterlife, ironically named Costanza ("Constance"), who late in her child-bearing years gave birth to the future emperor Frederick II.

If love poets through successive generations from the troubadours to Dante had idealized their ladies to ever higher degree—from woman on a pedestal, to woman as angel, to woman as the instrument of her lover's Christian salvation, Dante's closest heir, Boccaccio, would enrich the tradition with earthier females. Sometimes called *Ameto* after its protagonist, Boccaccio's pastoral *Comedy of the Florentine Nymphs* exhibits its author's fondness for tucking a Christian truth under fiction that at surface could hardly be more remote. The unusual plot, telescoped into simultaneous narrative, finds visual expression in an early fifteenth-century Florentine birth salver, a marriage object indicative of Boccaccio's reputation as a moralist (fig. 2). Ameto, a coarse shepherd who enjoys hunting forays in the hills of prehistoric Tuscany ("Etruria"), one day encounters some nymphs. Each tells her story, all with the same thrust: she abandoned Diana's strictures and cuckolded her husband, discovering true happiness in the service of Venus. Afterward, they wash and reclothe Ameto. Suddenly, he realizes they are the Seven Virtues—Faith, Hope, Charity, Wisdom, Temperance, Fortitude, and Justice. Allegorically, Ameto's bath is a baptism, the cleansing act that opens the way to salvation. His transformation from brute to

well-groomed man (the Florentine dandy at far right in the salver) symbolizes his conversion from carnal lust in a "beastly" state of existence to love as charity and "new life" in Christ.

Rhetorical and sensual relish characterize Boccaccio's portraits of these seductive nymphs. We view them through Ameto's eyes in a ploy that is one of the author's favorites, posing the lover as voyeur. Into a shaded, flowering meadowscape, where Lia as Faith sits beside a fountain, her sisters process at rhythmic intervals. Typical of Boccaccio's meticulous care with these cameos is his description of the first lady to enter Ameto's field of vision:

[He sees] that she has her hair wrapped around her head with uncommon artistry, caught in pleasing knots from the puffs of the breeze with delicate gold that matches it in color, and garlanded with the greenest ivy picked from her dear oak; and below that, she displays her wide, flat, white forehead, without any visible wrinkle, in the lower part of which he discerns the thinnest of eyebrows, not widely separated, in the shape of a bow the color of black Styx; from which at a suitable height there look out caringly, neither hidden nor overly prominent, two eyes — nay, divine lights rather; and between her round, white cheeks, diffused with a suitable Martian tint, he sees rise in a straight line her odoriferous nose, below which, as far as is fitting, her fair mouth, content with little space, its unswollen lips bright with natural vermilion, covers her small, gracefully ordered ivory teeth, and as it presides at a decorous distance over her most beautiful chin, which holds a small dimple, it scarcely allows Ameto's eyes to descend to consider her white throat ringed with pleasing but not excessive plumpness, and the delicate neck and the generous breast and the shoulders straight and even.[9]

The still unbaptized Ameto approvingly continues his visual survey, down to her "tiniest" feet. Needless to say, the parts under wraps below the neck, like her "celestial apples," which he can only erotically imagine as he undresses her in his mind's eye, prove correspondingly enticing. Boccaccio's programmatic female portraits, drawn in solemn Ciceronian prose, exemplify ideals of beauty that prize artful coiffures, youth, the high forehead, pale skin, rosy cheeks, and red lips (but not cosmetically aided), the whole combined in perfect proportions, diminutive

3

Africo with Nymphs, from Boccaccio,
Nymphs of Fiesole (stanzas 57–59),
The Newberry Library, Chicago

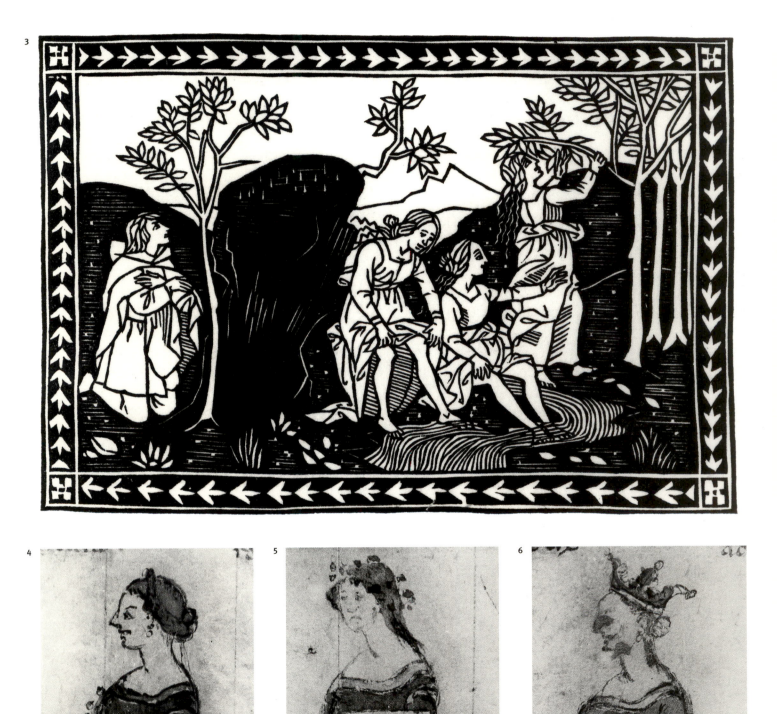

4

Giovanni Boccaccio, *Iancofiore,* from
Decameron holograph (8.10), Ms.
Hamilton 90, fol. 95v, Staatliche Museen
zu Berlin, Preussischer Kulturbesitz,
Staatsbibliothek (photo: Bildarchiv Foto
Marburg / Art Resource, N.Y.)

5

Giovanni Boccaccio, *Bartolomea,* from
Decameron holograph (2.10), Ms.
Hamilton 90, fol. 31v, Staatliche Museen
zu Berlin, Preussischer Kulturbesitz,
Staatsbibliothek (photo: Bildarchiv Foto
Marburg / Art Resource, N.Y.)

6

Giovanni Boccaccio, *Alatiel,* from *Deca-
meron* holograph (2.7), Ms. Hamilton 90,
fol. 23v, Staatliche Museen zu Berlin,
Preussischer Kulturbesitz, Staatsbiblio-
thek (photo: Bildarchiv Foto Marburg /
Art Resource, N.Y.)

where desirable (the pencil-thin, semicircular eyebrows, the dainty lips and miniature teeth, the small feet) and full where physical bounty belongs (in the flesh ringing the throat, the firm breast). Strained as the relationship may seem, this seductive outer body reflects the nymph's inner virtue. Attracting man with her physical beauty, woman directs his desires beyond the flesh, to moral values that will save his soul.

With variations, this Boccaccian moment often repeats itself. In his *Nymphs of Fiesole,* a pastoral jewel written just about four years after *The Comedy of the Florentine Nymphs,* Boccaccio shifts register, feigning the style of popular minstrels who sang in the piazzas, the *cantastorie.* Like Ameto, young Africo comes upon nymphs of Diana who sing and wade in the wild, illustrated in a fifteenth-century woodcut series that also served Poliziano's *Orpheus* (fig. 3). Africo hopes to find Mensola, with whom he fell in love at first sight:

> The nymph was maybe fourteen years old,
> her hair blond like gold and long,
> and she wore clothes of white linen;
> two bright eyes shone in her head,
> no one who sees them ever sorrows;
> angelic of face and fleet of foot,
> she held in her hand a fine sharp arrow.[10]

Her age and the effects of her eyes, like the "angelic" quality of her face, are details reminiscent of Dante's *Vita nuova.* They jostle pleasantly with her physical features—the color of her hair, naturally golden; her gown, which though of country cloth is regulation white for virginity. What Boccaccio has created is a false primitive. His eclectic language hints at high literary forms, preserving the top-down order of feminine description, but it is shot through with oral formulas pat in their phrasing: "blond like gold," "two eyes in her head"—where else would they be? Africo, inhabiting a land more primal than Ameto's, rapes Mensola, and so they must die, punished by Diana. Still, poetry allows them to survive through an Ovidian metamorphosis into two rivers that bear their names in Boccaccio's myth.

Boccaccio's first work, *Diana's Hunt,* had been a nymphal. Ladies at the court of King Robert in Naples become nymphs-for-a-day, bagging a menagerie native to the bestiaries, including an elephant, an ostrich, a snake with six snakelings, a leopard, a lion, and a wolf. To lasso the unicorn, helplessly drawn to virgins, one damsel dresses in white and waits until the animal surrenders to her. Not until the final revelations is it learned that the narrator is a stag—or was, before the huntresses summoned Venus, who resuscitates all the dead animals as handsome young lovers. He, too, in a transformation that anticipates Ameto's, undergoes a metamorphosis, "changed from a stag into a human creature and rational being."[11]

Camouflaged as seven Florentine ladies who retreat to the country for storytelling during the Black Death of 1348, the Virtues appear again in Boccaccio's masterwork, the *Decameron.* Sparkling eyes and tinkling laughter, impressions only, emanate from the women, veiled under *senhals* and more like icons on a gothic frieze than living people. Here, too, but in submerged allegory, Boccaccio orchestrates a psychomachia, or "mind-battle," between good and evil, setting Pampinea (Wisdom, who leads the group) to preside over the day when stories are told about foolishness, Filomena as Fortitude over inconstancy, and so on. The decorum of these narrators is a foil to all the escapades of countless imperfect mortals in the novelle. Boccaccio himself sketched characters from his gallery of humanity to decorate the catchwords of a *Decameron* manuscript he copied during his last years. Madame Iancofiore (fig. 4) is a high-class Palermo prostitute, "one of those women most beautiful in body but enemies of honesty," whose dubious dealings Boccaccio suggests with a row of popping buttons. In his bust of Bartolomea (fig. 5), shown before her rescue by a vigorous pirate from marriage to a decrepit Pisan, everything droops—her mouth, her hair, and even the oddly limp sleeve of her dress, a humorous reminder of her doddering husband's inadequacies. The word she frames, appropriately, is "licentia" ("license"). Similar visual and verbal punning spice Boccaccio's amusing picture of Alatiel, the Sultan's daughter (fig. 6), who after being

bounced around the Mediterranean from one man to another, for "perhaps 10,000" sexual couplings, passes herself off as a virgin when delivered back to her father. Across a low-cut bodice stretched over her prominent bosom, the scribe banners his catchword "vivere" ("to live"). She and Bartolomea both personify ravenous sexuality and fickleness, the same female weaknesses hinted at in Dante's heaven of the moon. They belong to the negative examples of inconstancy whom Fortitude, the opposing virtue, ideally conquers on the second day of storytelling.[12] Boccaccio's own ideal is the Aristotelian mean, Temperance, whom he embodies in Fiammetta, his poetic mistress. Privileged to rule on the central fifth day of the *Decameron*, Fiammetta has a *senhal* "Flamelet" that refers to the "little flame" of love that burns under the moderating influence of chastity, when Diana tempers Venus. In the first novella on her day, Boccaccio reappropriates a motif now familiar from his *Hunt* and *Ameto*. Cimone, an incorrigibly loutish fellow whom his despairing father exiles to the country to live among the beasts, one day happens upon a sleeping beauty, Ifigenia. Thunderstruck by love, he reforms forthwith and refashions himself as a consummate gentleman.[13]

Poliziano was obviously remembering his Boccaccio, from the stag-narrator of *Diana's Hunt* to Cimone's metamorphosis, when, to celebrate the tournament of 1475, he composed his *Stanzas Begun for the Joust of the Magnificent Giuliano de' Medici*. To the "well-born Laurel" (Lorenzo the Magnificent, whose *senhal* is *"Laur"*), Poliziano dedicates this enchanted masquerade. Rare poetic grace lifts Medici Florence into mythic Etruria, where Giuliano haunts the forests as the mighty hunter Julio, utterly scornful of love. A miffed Cupid reasserts his authority, much as he had with Apollo and Daphne, by setting an ambush with the fair Simonetta. Deep in the woods, he fashions from thin air "the image of a haughty and beautiful doe." She leads Julio on a breathless chase that ends abruptly with an amorous epiphany: "He came upon a green and flowry meadow; / Here, veiled in white, there appeared before him / a lovely nymph, and the doe vanished away."

> White is her skin and white her dress,
> though adorned with roses, flowers, and with grass;
> the ringlets of her golden hair
> descend on a forehead humbly proud.[14]

Fantasy spins gender reversals. The quarry is not a stag but a doe; the "nymph" is not a huntress but the trophy. As if she were springtime itself, at one with the magical landscape, Simonetta is a picture of feminine perfection and a font of human virtue. Allegorically, the *Stanzas* describe a Neoplatonic ascent from sensual to contemplative life, through the doe (fleeting, illusory vanities of the world), to Simonetta (rational love of earthly virtue), to the realm of Venus, depicted in the incomplete second book of the *Stanzas* (angelic, intellective contemplation of the highest good). Poliziano's virtuoso display merges the best of many poets, from Ovid's golden age to Dante's Eden, a medley that forecasts the *Nutricia*. The dominant modern is Petrarch, whose *Triumphs* left their imprint on the rising conceptual structure that runs through the *Stanzas,* and whose "Scattered Rhymes" return there in bits and pieces to shine as tiles in Poliziano's eclectic mosaic.

With equal mastery of his predecessors (as many as were known a century before Poliziano) Francesco Petrarca had carried Italian vernacular verse from origins already sophisticated to a summit of refinement. Without benefit of prose connectors or commentary, he committed a fictionalized spiritual autobiography to 366 poems, the *Rime sparse*—"nuggets," he calls them, and "scattered," because each is a freestanding compositional unit. Mostly sonnets, they form an ideal calendrical cycle, through which the poet confesses his obsessive, unreciprocated love of Laura, for twenty-one years while she lived and another decade after she died. In his frustrated desire, Petrarch parallels Apollo, lovestruck by Cupid for Daphne but unable to catch her, who to preserve her chastity fled the god and was turned into a laurel. So, too, Laura forever eludes Petrarch, yet her *senhal* promises the "laurels" he hopes to win by writing about her. Laura, a literary daughter of Daphne, has heavenly origins that put her as well in Beatrice's line of descent, and her beauty demands a portrait, as it had for Giacomo

7

Triumph of Chastity, from Francesco
Petrarca, *Trionfi e canzoniere,*
The Newberry Library, Chicago

7

enshrine her in his *Triumphs,* an ambitious allegory that circulated jointly with his *Rime* and was widely illustrated during the period of its vogue, in the fifteenth and sixteenth centuries. Behind enormous floatlike structures, parades of people represent six stages of a medieval hierarchy: first come Cupid's victims in the *Triumph of Love;* then exemplars of chastity, which conquers love; then death, more powerful than chastity; then fame, stronger than death; then time, which outlasts death and yields to eternity, God's final triumph. The *Triumph of Chastity* in a Venetian incunable (fig. 7) depicts a team of unicorns pulling the triumphal cart, on which Laura towers over Cupid, submissively bound and blindfolded. Brandishing Medusa's shield and the palm of her victory, she comes as queen of the virtues, demure females in decorous gowns and poses. "Honesty" and "Shame," qualities that encompass temperance, purity, and modesty, lead their company, as all march under the ensign of the ermine, whose prized white fur earned its status as a symbol of chastity.[17]

If Petrarch's verse scatters the moments of his romance, so also he fragments his lady, focusing on her body piecemeal—her blond tresses, her fair face, her ivory skin, her cheeks like roses, her lips like coral, her sweet smile, her dainty hand, her holy feet, and above all, her mesmerizing eyes, source of the solar rays that brighten and torment his existence.[18] He suffers a springtime enamorment, canonical in the amatory tradition from as far back as the troubadours, and thereafter sees her everywhere in nature's universal theater—in his fantasies, in his dreamlife, in a forest, under a laurel, by a river, at a fountain, in a meadow. To capture in words this vanishing lady, Petrarch describes her with endless, minimal variations, his lexicon distilled to the most elevated semantics and figurative displacement. Laura has no such unpoetic features as a "nose" or a "stomach" or "legs" at all, and literally speaking, she is completely toothless, for the "roses" of lips hide a treasure of "pearls."

da Lentini. Petrarch wishes it might come to life, like the female statue that Pygmalion sculpted and loved so terribly, when he reports how his friend, the Sienese artist Simone da Martini, painted the image:

> But certainly my Simon was in Paradise,
> whence comes this noble lady,
> there he saw her and portrayed her on paper,
> to attest down here to her lovely face.[15]

Simone's portrait (if it ever existed) has not been found, but it inspired many apocryphal "Lauras," companion pieces to pictures of Petrarch, both in manuscript miniatures and panel paintings.[16] Petrarch will again

Along with Poliziano, Lorenzo de' Medici gave an influential benediction to the rarefied Petrarchan idiom in his own sonnets, as the two men led a quattrocento revival of Italy's classic poets. A pair of wood intarsia doors

8
Giuliano da Maiano and Francione, from
figure designs attributed to Botticelli
and Filippino Lippi, *Dante and Petrarch*,
Sala de' Gigli, Palazzo Vecchio, Florence

(photo: courtesy of the Italian Ministry
of Culture, Superintendency for Artistic
and Historical Resources, Florence, Pisa
and Pistoia)

in the Palazzo Vecchio, with facing depictions of Dante
and Petrarch over cabinets that contain their books (fig. 8),
reflects this climate of literary preservationism, a cultural
mood that prompted the *Aragonese Collection* and Polizi-
ano's *Homage to My Wet Nurse*. Lorenzo helped recertify
the old-fashioned poets with another kind of flattery. He
parodied the courtly tradition in his *Nencia da Barberino,*
a rustic romp often considered his best work. Written
before 1470, this false primitive has a Tuscan antecedent
in Boccaccio's *Nymphs of Fiesole,* but mainly what it does,
systematically and to marvelous humorous effect, is turn
Petrarch inside out with a character called Vallera, the
bumpkin undone by a lass named Nencia, who bears all
the beauty of her tiny native Barberino. "It was in April
that you made me fall in love with you," he serenades her,
"when I saw you picking salad greens." If Petrarch views
Laura, solitary and motionless beneath a laurel, Vallera goes
looking for Nencia on errands at the village mill. Africo
espied nymphs bathing, but Vallera is more like a Peeping
Tom, as he finds ways to stare through the bushes at Nencia
while she beats grain on the threshing floor. A fine dancer,
Nencia can touch her hand to her shoe, "hops about like
a kid goat," and "whirls more than a millwheel." Lorenzo
mocks the tradition, as old as Pygmalion, that demands
a lover have an image of his lady, when Vallera rhapsodizes
about Nencia's very anti-Petrarchan "nose" with nostrils
that must have been bored out by an artisan's drill. As for
teeth, Nencia is admirably provided:

> Her red lips look like coral,
>
> and inside them she has two rows of teeth
>
> that are whiter than a horse's,
>
> and on each side she has more than twenty.[19]

From the Petrarchan lexicon of coral lips, we plunge jar-
ringly to comic registers in juxtapositions that skip any
middle range and exploit effects of linguistic estrangement.
With such an equine dental apparatus her mouth can
hardly be diminutive, and to have so precise a count of
its contents, Vallera must have often heard snorted giggles,
coy lip-curling whinnies, and hearty wide-open guffaws.

8

In the high style, teeth can never be bared, even if the mouth is open to indicate sweet singing. Only a mental gaze, like that of Boccaccio's Ameto, knows they are there, in perfect order. Stepping back, to picture the whole, Petrarch adores Laura from a distance, pure in her pallor and eternally unattainable. Nencia, though, is a cozier, more malleable wench, her milky skin an excuse for similes from the kitchen. What a catch as wife this "fleur-de-lys without leaves" would be, her swain Vallera enthuses, "whiter than the finest baking flour," "so soft and white that she seems like a mass of dough," "so soft and white that she looks like a ball of lard."

Lorenzo de' Medici's *Nencia da Barberino,* like a fun-house mirror, ripples and distorts the Italian classics to comic effect. At the same time the more serious poetry he was writing continues the old tradition with a major new cultural overlay, the Neoplatonism whose animator was Marsilio Ficino. In the collected rhymes of his *Canzoniere,* Lorenzo operates a gender reversal on Petrarch, creating a story fitted to contemporary tastes for emblematic, chivalric entertainments. Lucrezia Donati, the lady he honored in the joust of 1469 and to whom he pays poetic court, flits chastely through his verse, sometimes a nymph with the *senhal* Diana (it has the same initial "D" as Donati), sometimes as "luce" or "light" (with letters like those in Lucrezia). In the latter capacity, she plays Apollo, while the part of Laura falls to Lorenzo, poetically "Laur" and hence a laurel figure.[20]

Lorenzo openly formulates a Neoplatonic platform in a second, more ambitious anthology, the *Comento,* conjecturally assigned to three periods of activity, 1473–1474, 1482–1484, and c. 1490. Dante's *Vita nuova* provides a model for its structure, sonnets encased in a prose commentary that tell an ideal love story through fiction obviously beholden to Petrarch and focused again on Lucrezia Donati. In a learned proem, the author acknowledges explicitly his literary debts, a list that solidifies the Tuscan canon: Guinizelli for his pronouncement that "love and the noble heart are one"; Cavalcanti for exploring the painful psychology of love; Dante, the master whose language ranged across all three stylistic registers (high, middle, and humble);

Petrarch, maker of rhymes "serious, beautiful, and sweet"; and Boccaccio, "most learned and most eloquent." To this community of Italian forefathers, Lorenzo convokes "the Platonists," whose views on love come to him filtered through Ficino, striking chords in consonance with the Sweet New Style.

Not only is love among fellow men not reprehensible, rather it is almost the necessary and truest proof of nobility and greatness of spirit, and above all the cause that invites men to worthy and excellent things, and to exercise and put into act those virtues that are potentially present in our souls. Whoever considers the matter carefully will find that the true definition of love is the appetite for beauty.[21]

The Platonists, he explains, define three kinds of "true and laudable beauty," that of the soul, the body, and the voice. Only the mind can crave the first, which consists in the soul's perfection through virtue. Bodily beauty, the second, comes from a well-proportioned and pleasing appearance and appeals to the eyes, while the third kind, harmonious sounds of words well spoken, reaches us through the ears. Such pleasing visual and auditory stimuli have the effect of uplifting the mind and thus bringing us nearer to God, the supreme good. For the human spirit to begin this ascent, a man must love faithfully one perfecting object. Lorenzo defines her as a woman who possesses not only natural beauty, vulnerable to the ravages of time, but inner qualities that do not fade—intelligence, courtesy, honesty, elegance of manner and gesture, skill with wise and sweet words, love, constancy, and fidelity. The more virtues a woman has, the more beautiful her soul and the greater her trans-humanizing power. In a radical departure from misogynistic strains of thought, Florentine high culture of the quattrocento fuses Platonism with the older lyric tradition, declaring woman the agent of beauty that draws men to love, and through love, to God.

NOTES

1. For the Italian text, see *Poeti del Duecento,* ed. Gianfranco Contini, 2 vols. (Milan, 1960), 1: 55–57, my translation. In form, Giacomo da Lentini's poem "Meravigliosamente" is a *canzonetta* ("little song"), so named because the lines of verse are shorter than in the classic *canzone.*

2. A lucid overview of Lorenzo's life and works is presented by Sara Sturm, *Lorenzo de' Medici* (Boston, 1974). For the *Raccolta aragonese,* see esp. 29–32. Poliziano drafted the letter. See Vittore Branca, *Poliziano e l'umanesimo della parola* (Turin, 1983), 281–282, note 154.

3. *Nutricia,* vv. 720–730, my translation, from Angelo Poliziano, *Silvae,* ed. Francesco Bausi (Florence, 1996), 246–248.

4. Dante Alighieri, *Vita nuova,* trans. Mark Musa (Bloomington, 1973), 33. For interpretation, see the essay by Musa accompanying his translation (which I have slightly modified), and Charles S. Singleton's seminal volume, *An Essay on the Vita Nuova* (1949; reprint ed., Cambridge, Mass., 1958).

5. See the notes on Dante's *Vita nuova,* trans. Barbara Reynolds (Harmondsworth, 1971).

6. Dante Alighieri, *The Divine Comedy,* trans. and comm. Charles S. Singleton, 6 vols. (Princeton, 1970–1975).

7. The commentary tradition has assigned her many allegorical names, all of which transcend the intellectual possibilities represented by Virgil as Reason, who guides Dante until she takes over.

8. *Paradiso,* 1.48. The half-column woodcut illustration appears on a folio erroneously bound with Francesco Petrarca, *Trionfi* (Venice, 1490), in the Newberry Library copy, where it is inserted in the *Triumph of Death.*

9. Giovanni Boccaccio, *Comedia delle ninfe fiorentine,* ed. Antonio Enzo Quaglio, in *Tutte le opere* (Milan, 1964), 2: 9.13–16; 18–19, translation mine. For the whole in English, see Judith Powers Serafini-Sauli, trans., *L'Ameto* (New York, 1985). For discussion of the birth salver, see Paul F. Watson and Victoria Kirkham, "Amore e Virtù: Two Salvers Depicting Boccaccio's 'Comedia delle Ninfe Fiorentine' in the Metropolitan Museum," *Metropolitan Museum Journal* 10 (1975), 35–50. Boccaccio's impact on the visual arts, greater than for any other European writer, has generated a major new catalogue with interpretative essays, edited by Vittore Branca, *Boccaccio visualizzato,* 3 vols. (Turin, 1999).

10. Giovanni Boccaccio, *Ninfale fiesolano,* ed. Armando Balduino, in *Tutte le opere* (Milan, 1974), 3: 30.1–7. For the woodcut, see *Il Ninfale fiesolano di Giovanni Boccaccio con le figure di una perduta edizione fiorentina del Quattrocento ora riunite da vari libri del Cinquecento e reincise in legno* (Verona, 1940). Branca 1983, fig. 8, reproduces another cut from the series that was used for Poliziano's *Orfeo.*

11. For extensive discussion of the allegory, see Anthony K. Cassell and Victoria Kirkham, ed. and trans., *Diana's Hunt. Caccia di Diana. Boccaccio's First Work* (Philadelphia, 1991), esp. 13–19, 28–38. On the unicorn, see canto 7 and commentary, 173–175.

12. The symbolic resonance of the seven female narrators is discussed by Victoria Kirkham, "An Allegorically Tempered *Decameron,*" in *The Sign of Reason in Boccaccio's Fiction* (Florence, 1993), 131–171. The ladies' three male escorts recall the three parts of the Aristotelian-Thomistic psyche: Reason, Concupiscence, and Wrath. Before page numbering became customary in book production, catchwords were used to connect properly the gatherings, or quinterns, of the codex. At the bottom of the last folio in a gathering, the scribe wrote the first word of the next, so that all the quinterns could be assembled and bound in the proper order. As Boccaccio was copying out his late revision of the *Decameron,* he whimsically embedded the catchwords in miniature human busts. These catchwords are reproduced in a full-color foldout in Giovanni Boccaccio, *Decameron. Edizione diplomatico-interpretativa dell' autografo Hamilton 90,* ed. Charles S. Singleton, with Franca Petrucci, Armando Petrucci, Giancarlo Savino, and Martino Mardersteig (Baltimore, 1974). See now also Branca 1999.

13. Vittore Branca (1999, 1: 39–50) has traced magisterially the fortunes of this story in the visual arts.

14. *The Stanze of Angelo Poliziano,* trans. David Quint (Amherst, 1979), 21–23, stanzas 37 and 43. I have slightly modified the translation. The *Stanze* were left incomplete after the death of Simonetta Cattaneo, the beautiful young wife of Marco Vespucci (a cousin of Amerigo), and Giuliano's murder in the Pazzi conspiracy of 1478. As Branca (1983, 44–46) argues, the author's more compelling reason for abandoning them was a shift from Neoplatonism in his philosophical orientation toward Aristotelianism.

15. Petrarch refers to Simone's portrait in a pair of sonnets, *Rime sparse,* nos. 77 and 78. See Robert M. Durling, trans. and ed., *Petrarch's Lyric Poems* (Cambridge, Mass., 1976), 176–179.

16. The classic study is Prince d'Essling and Eugène Müntz, *Pétrarque, ses études d'art, son influence sur les artistes, ses portraits et ceux de Laure, l'illustration de ses écrits* (Paris, 1902). For a more recent meditation, see Alessandro Bevilacqua, "Simone Martini, Petrarca, i ritratti di Laura e del poeta," *Bollettino del Museo Civico di Padova* 68 (1979), 107–150.

17. Francesco Petrarca, *Trionfi* (Venice, 1490), bound together in the Newberry copy with Petrarch's *Sonetti e canzoni* (Venice, 1492). For a modern edition with extensive commentary, see Francesco Petrarca, *Triumphi,* ed. Marco Ariani (Milan, 1988). Love conquered by chastity is the theme of images that reflect the influence of Petrarch's *Triumphs,* such as the *Chastisement of Cupid,* attributed to Baccio Baldini, a Florentine engraving of the 1470s, reproduced in Patricia Lee Rubin and Alison Wright, *Renaissance Florence: The Art of the 1470s* (London, 1999), 340.

18. Nancy Vickers, "Diana Described: Scattered Woman and Scattered Rhymes," *Critical Inquiry* 8 (winter 1981), 265–279.

19. *La Nencia da Barberino,* ed. Rossella Bessi (Rome, 1982), 141, stanza 4, my translation. An excellent linguistic and stylistic analysis with the philological problems of their history precedes the texts.

20. See Lorenzo de' Medici, *Canzoniere,* ed. Paolo Orvieto (Milan, 1984). Orvieto's notes, rich in discussion of Lorenzo's Neoplatonism, dissect the poetry to identify its sources and the phases in his poetic career, allegiance to Petrarch in an earlier period and later to Dante.

21. *Comento del Magnifico Lorenzo de' Medici sopra alcuni de' suoi sonetti,* in *Tutte le opere,* ed. Gigi Cavalli (Milan, 1958), 2: 105. See also Sturm 1974, 63–76. For an accessible compendium of Ficino's philosophy, see Sears Reynolds Jayne, *Marsilio Ficino's Commentary on Plato's Symposium* (Columbia, Mo., 1944). These ideas as they relate to the portraiture of women have been brilliantly analyzed by Elizabeth Cropper in her essays "On Beautiful Women, Parmigianino, *Petrarchismo,* and the Vernacular Style," *The Art Bulletin* 58 (1976), 374–394; and "The Beauty of Woman: Problems in the Rhetoric of Renaissance Portraiture," in *Rewriting the Renaissance. The Discourses of Sexual Difference in Early Modern Europe,* ed. M.W. Ferguson et al. (Chicago, 1986), 175–190.

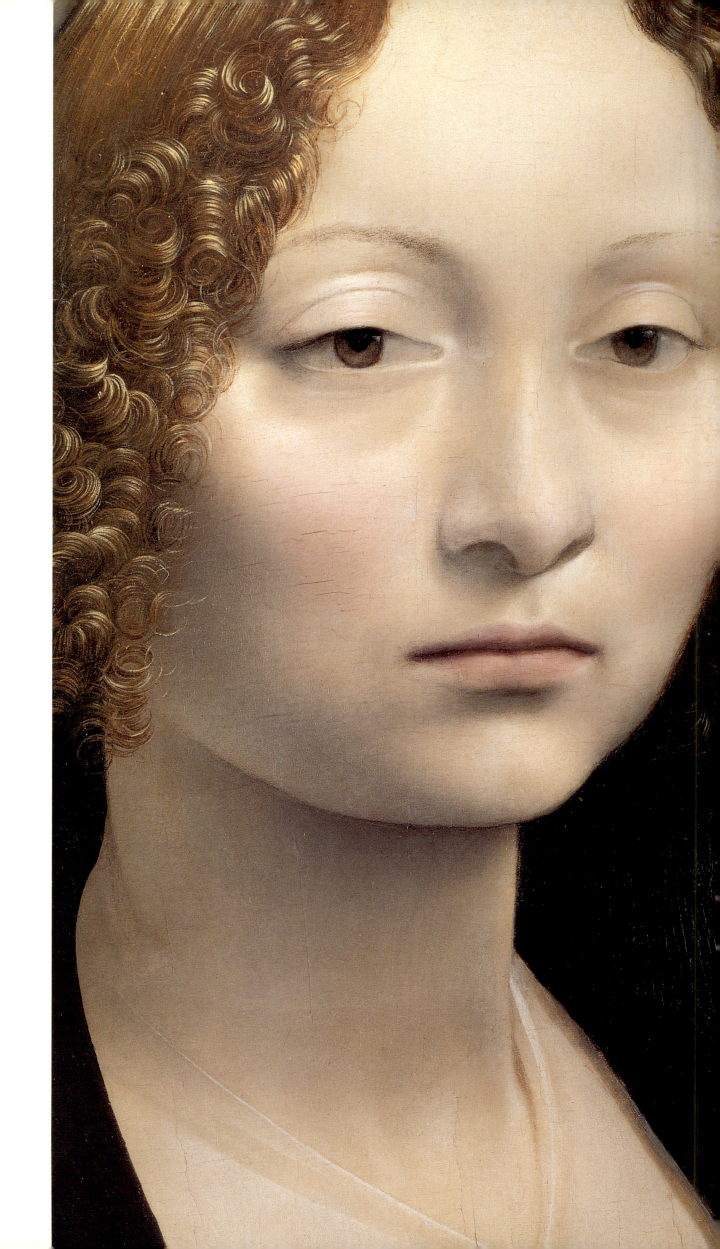

Portrait of the Lady, 1430–1520

Joanna Woods-Marsden

Surrounded by faces glowing from television screens, billboards, and the glossy page, we have difficulty imagining a world devoid of visual representations of the familiar features of living people. Yet such was the case in the period we call the Renaissance. Until the second quarter of the fifteenth century, Italian painting was devoted almost exclusively to religious ends, consisting primarily of altarpieces and frescoes that depicted the Virgin and child with saints and scenes from their lives. Only the features of the holy were available for pictorial scrutiny. Thus, the invention in the early quattrocento of an artform whose primary purpose was to record—or rather construct—the features of a living person—sinner, not saint—must have caused wonder in its first viewers. It is hard to exaggerate the degree of modernity informing the invention of the independent, profane portrait in the early Renaissance.

Portraiture in this period was class-specific; only the features of the socially and economically privileged were recorded, most of the population lacking either the means or the motivation to indulge in such an enterprise. The frequent use of the somewhat old-fashioned—not to say politically incorrect—term "lady" throughout this essay is an attempt to reflect this factor of class and rank. From the beginning women seem to have been depicted as frequently as men, but the genders were usually portrayed at different times in their lives. Unlike portraits of men, which were normally commissioned after the sitter had attained political and economic maturity, surviving likenesses of women suggest that they were almost exclusively portrayed in early, nubile adolescence.[1] Of the key moments in the female life cycle then—marriage, childbirth, widowhood— only the first was commemorated in portraiture.

What were the primary values and aspirations of the Florentine society for which these works were created? The modern American can easily grasp the predominant value of the place in which capitalism was invented: wealth or, at the very least, its appearance. Patrician honor was demonstrated through manifest expenditure of the almighty florin. By the fifteenth century the earlier values of burgher thrift and sobriety had given way to a culture of display, in which one's rank in society was evaluated by the size of one's abode and the luxury of one's dress.[2] Family status depended on an ability to project a public image of financial success on those occasions—holidays, rites of passage— when wealth paraded its power.[3]

VIRTVTEM FORMA DECORAT, "Beauty Adorns Virtue," is inscribed on the reverse of Leonardo's portrait of Ginevra de' Benci, echoing the earlier inscription FORMA ET VIRTVTE, "Beauty and Virtue," on the medal created by Matteo de' Pasti for Isotta degli Atti of Rimini in 1446.[4] Virtue translated above all as chastity, but also included the qualities of obedience, modesty, and silence that would ensure sexual innocence before marriage—a "dowry of virtue," as one contemporary put it.[5] As the female role was strictly procreative, only virginity before marriage and fidelity after it could guarantee the purity of the husband's lineage. To convey these qualities to the world the lady had to demonstrate her "grave demeanor and self-restraint," in Leon Battista Alberti's words, by her consistently dignified comportment and measured movements.[6]

How was the female persona fashioned in the first century of portraiture? While overt concern with the ideology of female sexual virtue, to which the entire culture subscribed, was consistently embodied in the iconography, we will see that the likenesses' forms evolved very rapidly between 1430 and 1520: from a profile view of the dowry-bedecked woman, to Leonardo's vision of a mobile, responsive human being, to Giulio Romano's eroticization of the sitter.[7] This essay considers the portrait of the dowry, the fantasy beauty, profile and three-quarter conventions, the portrait of the person and the princess, the lady enthroned and eroticized, patronage and original location, and the portrait reverse and cover. I will conclude that, since identity for the Renaissance female resided in the male, father or husband, who was responsible for her conduct and demeanor, her portrait inevitably embodied the Renaissance social construct of the patrician female ideal.[8]

Marriage was the biggest event in a Renaissance woman's life.[9] The patrician family sought to arrange a good marriage for their daughters when they were between fourteen and twenty, with sixteen being the ideal age.[10] Since most men delayed marriage until their thirties when

they were better able to afford the cost of setting up a new household, the groom was usually much older.[11] Marriage involved payment of a dowry, which could represent an enormous capital debt for the bride's family and capital gain and honor for the groom's.[12] The financial gift was accompanied by the material gift of the trousseau, called the *donora,* which was reciprocated by the groom's gift to the bride of a counter-*donora.*

Both *donora* and counter-*donora* directly addressed adornment of the bride's body.[13] Stationed at the boundary between the self and the other, dress, it has been observed, marks the distinction between the private and the public, the individual and the social.[14] As it happens, Renaissance Florentines drew a sharp distinction between how they displayed the self when venturing into the public piazza, where dressing well was understood as a sign of dignity and social prominence, and what they wore within the privacy of the home. Saint Bernardino made the point through hyperbole: at home women dressed "like baker-women, wearing rags"; outside, they went to the other extreme (he thought), wearing "crimson overgarments and fine linen undergarments, of cloth so soft and fine that [your] flesh stays smooth and fat."[15]

The bride quite literally carried her family's honor on her back during the elaborate series of ritual events that constituted marriage in the Florentine republic. Luxury fabrics represented a huge financial investment, and the amount spent on the bride's clothing could equal forty percent of her natal family's worth, while the purchase of clothes constituted one of the groom's largest expenses.[16] The bride's trousseau and counter-trousseau were part of the elaborate exchange of material goods that served as concrete public testimony to the alliance; thus, her clothes would be interpreted as a sign of the honor with which she was being received into the groom's family as well as the prestige she bore from her natal home.[17]

Yet in a culture in which honor depended on the ostentatious display of material luxury, sumptuary laws were continually being enacted to curtail that very splendor. On more than thirty occasions in the course of the quattrocento, legislators limited in minute detail the number of gems and the amount and kind of fabric that Florentine

women were permitted to display in public.[18] In the early part of the century, however, the laws pertained to older women or matrons, and relatively few of the restrictions applied to brides. Until married, young girls were spared the harsh code that would regulate their corporeal decoration later in the life cycle.[19] Even after marriage, the sumptuary laws took some years to take full effect. For three years after marriage, for instance, the bride could continue to adorn herself in public with necklaces and at least two brooches; for the next three years she was permitted only one necklace and one brooch; after that, she was not supposed to display any jewelry at all.[20]

Portrait of the Dowry. Renaissance preoccupation with the mode of self-presentation to the wider community is directly reflected in sitters' self-presentation in portraits. No documentary evidence confirms that Florentines commissioned likenesses when they married, but a strong case can be made that the function of most visual representations of women in the quattrocentro was to celebrate the *donora* and counter-*donora*—that demonstration of economic and social honor for both families—during this liminal period up to six years following marriage.[21]

Fra Filippo Lippi's portrait of Angiola Sapiti (cat. 3), one of the earliest surviving female likenesses, typifies the newlywed girl's ideal construction at the moment when, no longer a virgin, she has not yet been categorized as a matron.[22] That none of these early likenesses can be associated with the period of betrothal prior to marriage is proven by the hairstyles: virgins and brides wore their hair flowing and loose as a symbol of innocence, but married women wore theirs decorously bound and restrained. As unbound hair had erotic connotations, to conceal it was a matter of propriety.[23]

Angiola is transformed by the somatic gifts of fashionably cut clothes in sumptuous pearl-encrusted fabrics, dyed in the highest quality, and therefore most expensive, crimson *(chermisi).*[24] Sleeves were a potential flamboyant fashion statement, and, according to Lippi, Angiola's overgarment *(giornea)* incorporated the very full sleeves *a gozzi* (gathered into a wide wristband to create the bag shape of

1

Botticelli, *Primavera* (detail), Galleria degli Uffizi, Florence (photo: Scala / Art Resource, N.Y.)

2

Antonio del Pollaiuolo, *Portrait of a Lady,* Museo Poldi Pezzoli, Milan (photo: Scala / Art Resource, N.Y.)

3

Antonio del Pollaiuolo, *Portrait of a Lady,* Galleria degli Uffizi, Florence (photo: Scala / Art Resource, N.Y.)

1
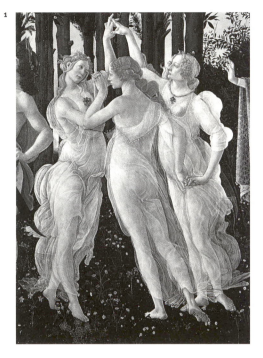

3
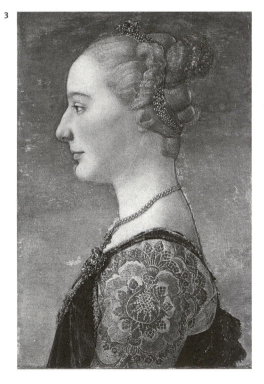

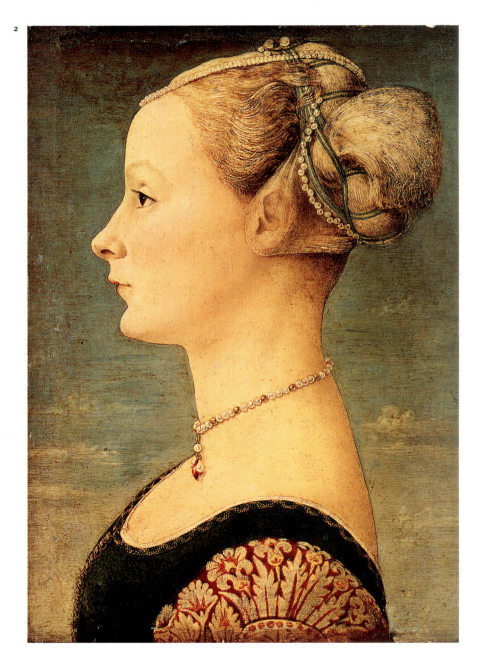

a bird's crop), which allowed the contrasting dark figured velvet of the dress *(gamurra)* beneath to show to particularly fine effect.[25]

Angiola's opulent outfit is accompanied by rich gems covering her head, shoulder, neck, and fingers.[26] Many patricians invested in jewels as a form of liquid capital—forty-three percent of Luigi Martelli's movable wealth, for instance, was concentrated in gems—and the flaunting of jewels was another public expression of the exchange of material goods that took place at marriage.[27] The jewels adorning the bride were read as visible proof of the size of her dowry. To give the impression of a larger dowry—and therefore endow the match with greater prestige—the groom had only to adorn the bride yet further, as Marco Parenti is known to have done when marrying Caterina Strozzi.[28]

Brooches and pendants, according to *ricordanze,* that hybrid of diary and account book, were particularly popular as counter-*donora* gifts. Recorded examples include the gold shoulder brooch *(brocchetta di spalla)* with two sapphires and three pearls, worth thirty-nine florins, that Parenti gave his bride in 1447, and the brooch of rubies and pearls Giovanni Rucellai acquired for his new Medici daughter-in-law in 1466, for which he paid the huge sum of one thousand florins.[29] Angiola wears perhaps an equally magnificent shoulder brooch of a diamond surrounded by pearls, as well as a prominent ruby and pearl head brooch *(brocchetta di testa).* Pearls were by far the costliest gems for the quattrocento Florentine, and their reiterated use in this portrait—pearl necklace, hundreds of seed pearls decorating the headdress and the chivalric motto LEALTÀ (loyalty) on the sleeve, the pearl-edged close-fitting cap *(cuffia)* that conceals both hair and ears—amounts to an unmistakable pictorial statement of the wealth and splendor of the Sapiti-Scolari alliance, and hence the social standing of both families.[30]

Beyond their monetary and ornamental significance, the gems worn were interpreted allegorically. As a well-known symbol of purity associated with the Virgin, costly pearls were the attributes of brides as well as saints.[31] Sapphires, too, rendered the wearer chaste.[32] Emeralds, said to splinter when a virgin was violated, were seen as safe-guarding those it adorned, and in addition to miraculously retaining beauty, also carried good luck for happiness and marital success.[33] Along with emeralds, rubies were the gems most frequently given to brides, as they were thought to benefit the wearer by promoting bodily strength and prosperity and by negating lust and *tristesse.*[34]

Most Italians have the dark coloring of those living in Mediterranean countries, but, like most other ladies depicted in the early Renaissance, Angiola's hair is as fair as that of any Scandinavian. Among fashionable women in quattrocento Italy, there was only one acceptable hair color and it was not brown. Even in the Renaissance, it seems, *signori* preferred blondes. Dye was used to color the hair so that it would resemble the cultural ideal, familiar from the Petrarchan poetic tradition, of the beloved's golden locks—visually embodied in the Three Graces' golden tresses in Botticelli's *Primavera* (fig. 1).[35] Around 1490, blonde hair ceased to be de rigueur, especially in Northern Italy, and portraits of women began to show them with their natural hair color. As was customary, Angiola's hair has also been plucked ostentatiously back at the hairline to increase the expanse, and hence the elegance, of her forehead.

Fashions in coiffures and head coverings had changed by the time Pollaiuolo depicted the elegant young ladies now in Milan and Florence (figs. 2, 3).[36] The fair hair of both girls was bound with ribbons into a chignon, from which the extreme end, often crimped, has been allowed to escape in a kind of "ponytail." The hairstyles are enhanced by the conspicuous restraining bridle *(frenello)* of strings of pearls that culminate in pearl head brooches. The belief that the Virgin conceived through the ear may explain the shielding of that orifice with veils and caps in many early portraits. While the lady in Milan wears a string of pearls that describes an oval arc on her forehead *(lenza),* the lady in Florence sports a magnificent gold shoulder brooch consisting of an enameled angel holding a cluster of diamonds, rubies, and sapphires.[37]

In a slightly earlier portrait by the Master of the Castello Nativity in Boston (cat. 5), the lady's hair and ear are concealed by a tight-fitting cap encrusted with flowers of seed pearls and gold studs.[38] Her head brooch features

4

Piero di Cosimo, *Testa (Allegorical Head)*
of Cleopatra, Musée Condé, Chantilly
(photo: Giraudon / Art Resource, N.Y.)

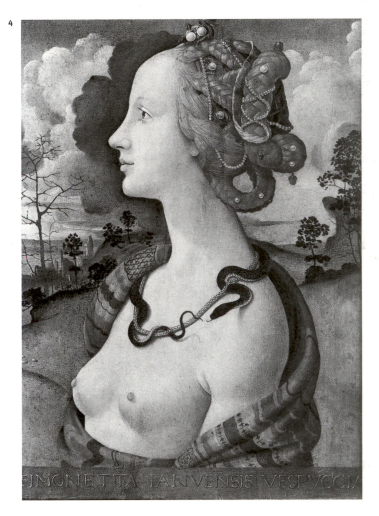

4

a magnificent ruby, and her pearl necklace, with its three superimposed rows, outdoes in opulence the simpler ones seen in the portraits by Pollaiuolo. Here the artist used the "ponytail" to full decorative effect by feathering the escaping blonde lock against a black ground.

The Fantasy Beauty. The features of the nubile adolescents in these portraits neither could be nor were as highly differentiated as those of mature men. Yet no matter how idealized the likenesses, the sitters' profiles are sufficiently idiosyncratic and—within the range of what was normative—their coiffures, dress, and jewels are sufficiently differentiated for them to be recognizable as specific individuals. The conventions of naturalism of facial lineaments and somatic decoration that informed mid-century dowry portraits contrasts with the idealization of two pseudoportraits, attributed to Botticelli (cat. 28) and Piero di Cosimo (fig. 4), respectively, characterized here as erotic fantasies created to fulfill dreams of nubile glamour and princely dowries with which no human bride could compete.[39]

Many images of Mary Magdalen and Venus demonstrate the erotic connotations of ornate coiffures for the Renaissance.[40] In 1554, for instance, Luigini characterized hair falling on the shoulders as *capelli fuori di legge,* "unlawful" or "lawless."[41] The profusion of chestnut-golden locks, whether real or cosmetic—not dissimilar to the hairstyles of the Three Graces in the *Primavera* (fig. 1)—that cascade around the bland, generalized features of the larger-than-life Botticellian "pinup" can be read as suggesting the ultimate in sex appeal for the quattrocento (cat. 28). The image emphasizes both the erotic potential of hair—especially that which is alternatively tightly braided and spilling wantonly loose—for the culture, and the extent to which this source of eroticism was held within decorous bounds in the dowry portraits just considered.[42]

Ropes of large pearls silhouette the glamorous head and punctuate the braids and hairpieces that would have borne only a tenuous connection to her real hair; a pictorial fortune in the shape of hundreds of pearls is shown as sewn diagonally across the side of her head from braid to supporting braid. Two "ponytails" erupt behind her head.[43]

This paragon of beauty—so much grander in scale than contemporary likenesses of real women—is crowned by a head brooch like a large flower with golden petals and huge pearl stamen to which—the final touch—heron feathers have been attached.[44]

Most unusual for fifteenth-century portraiture, her breasts have been separated and her cleavage emphasized by the meeting there of pearl-studded braids. Piero di Cosimo's *testa* ("head," as such images were called in inventories), on the other hand, wears nothing other than a striped drape carefully arranged to point up her very lack of covering (fig. 4).[45] The woman can be identified, not, as traditionally, Simonetta Vespucci, but as Cleopatra by the snake that alludes to the manner of her death and the two huge pearls crowning her head brooch that were, according to Pliny, the largest in history.[46]

In this erotically charged pseudo-portrait Cleopatra's ornamented coiffure as much as her nudity openly contravenes the conventions of contemporary female portraiture.

In the late Middle Ages, Cleopatra was renowned for her lust as well as her beauty and fabulous wealth, and Piero's image concentrates on the culture's perception of the Egyptian queen's dangerous—but exciting—lasciviousness in an image that subverts the usual chaste significance of pearls. The intricate pearl-studded braids and the crisscrossing ropes of pearls, as sensuously intertwined as the serpent wrapped sinuously around her neck, create a Medusa-like image of female sexuality that sits at the opposite pole to the inanimate, decorous profiles and chastely controlled hair in portraits of newlyweds.[47]

Profile and Three-Quarter Conventions. The ladies by Lippi and Pollaiuolo are fashioned pictorially in profile, the format used for all Italian portraits, male and female, until around 1470.[48] Powerful artistic precedents, deriving from both late medieval and classical sources, were responsible for the pose. Kneeling donors in religious paintings were traditionally seen in profile praying to a centralized, frontal Virgin or saint, and Roman coins invariably presented the rulers, whether republican or imperial, in profile. The weight of tradition of these artistic sources from the worlds of Christianity and antiquity—the sanction of devotional imagery combined with the prestige of humanist forms— was sufficient to establish the profile presentation as the norm for both men and women in the new artform of independent portraiture. A further benefit of showing the female image in profile was the greater visibility of the elaborate coiffure and/or jeweled headdress than was possible in a frontal pose focused on the face. In addition, since the culture dictated that the lady give the impression that her body was contained and protected and her limbs controlled, a sideways presentation with arms circumscribed within the torso silhouette embodied the gendered ideal.[49] The profile was, of course, also eminently suited to those warned against too much eye contact with the men they encountered.[50]

With few exceptions, the likenesses portray the profiled lady facing left.[51] In pendant portraits such an orientation located the lady to the right of the pair—the position known as the heraldic sinister because it was on God's left hand. The husband would thus be fittingly placed on the hierarchically superior heraldic dexter—or God's right hand (cat. 2 A, B). The profile to the left, as well as being the woman's usual place in the greater scheme of things, also revealed her left shoulder. This was the side on which the shoulder brooch was always placed (cat. 3; fig. 3), and when, in particularly elaborate sleeves, the embroidery was confined to one arm only, it was also always the left one that was so favored (cat. 3).[52] Throughout the Middle Ages, it was commonplace to discriminate between the two sides of the body; because the morally superior right side was understood as guarded by God, the left could be safely exposed. As a primary location for ornament, then, left shoulder and sleeve were important visual sites of meaning in art as in life.[53]

Elsewhere in Europe, however, the profile was not the standard format for likenesses. In Flanders, for instance, portraits by Robert Campin and Jan van Eyck in the 1430s habitually presented both men and women in a three-quarter pose. Flemish paintings were greatly admired in Florentine high society—in 1492 as many as forty-two such works, for instance, hung in Medici properties, mostly the Medici palace—and members of the Italian mercantile community in Flanders often seized the opportunity to commission portraits that may have been known back in Florence from local artists.[54] Soon after his marriage at the age of thirty-eight to the fourteen-year-old Maria Maddalena Baroncelli in 1470, Tommaso Portinari, manager of the Medici bank in Bruges, commissioned a triptych from Memling in which the (lost) Virgin and child was flanked by pendants of the new spouses, hands clasped in prayer, facing the central image.[55] Placed on the heraldic sinister, Maria Maddalena was portrayed in the height of Burgundian fashion with hair concealed under a black headdress *(hennin)* edged with black velvet and covered with a gray veil, her velvet bodice trimmed with white ermine (fig. 5). Encircling her neck is the fabulous collar of alternating twisted gold chain and enamel roses of rubies, sapphires, and pearls, bordered with black pearls, that she would wear again in the triptych commissioned some ten years later from Hugo van der Goes for the high altar

5

Hans Memling, *Maria Maddalena
Baroncelli, Wife of Tommaso Portinari,*
The Metropolitan Museum of Art,
New York, Bequest of Benjamin Altman,
1913. All rights reserved.

6

Petrus Christus, *Young Girl,* Staatliche
Museen zu Berlin, Preussischer Kulturbe-
sitz, Gemäldegalerie (photo: Jörg P.
Anders)

5
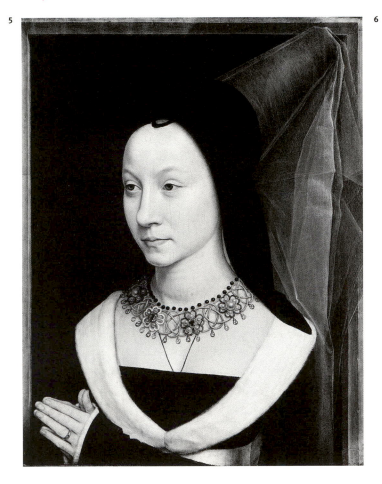

6
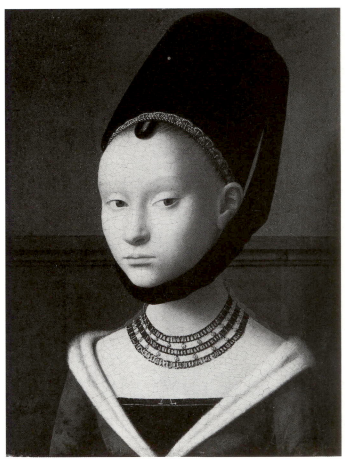

for S. Egidio in Florence.[56] Such spectacular Flemish gold-smithery must have been famous in Florence as the center-piece of the counter-*donora*.[57] Such typically ostentatious Italian self-presentation contrasts sharply with the more somber self-images offered by Burgundian aristocrats: the only major adornment of the fashionably dressed court lady painted by Van der Weyden around 1460 is the intri-cate gold buckle on the vermilion silk belt (cat. 13).

Petrus Christus' only surviving female portrait may have been well known in Florentine patrician circles as a highly valued Medici possession (fig. 6).[58] Whether or not it was the same work, the "small panel with the head of a French [Burgundian] lady in oils" by Christus which Lorenzo de' Medici kept in his study is unlikely to have been very different from the small likeness, probably de-picting a member of the Talbot family of England in the

late 1460s.[59] In Memling's triptych Maria Baroncelli gazes toward the central panel, and Van der Weyden's lady mod-estly casts her eyes down, but those of Christus' alert Lo-lita acknowledge the presence of a viewer in a manner that must have greatly intrigued its (Italian) beholders, given that such a pose was virtually unprecedented in Italian painting at that date.[60]

Portrait of the Person. In the first half of the 1470s, the very young and very talented Botticelli and Leonardo da Vinci each painted a female likeness that departed radically from the prevailing conventions, in that both sitters, emulating Flemish models, direct their gazes boldly out at their audi-ence (cats. 25, 16). The separation between depicted object and viewing subject that had been implied by the sideways pose was at an end. Since it is the eyes, seen from the front,

that suggest the sitter's nature, the profile view, in which only one eye, seen moreover from the side, is visible, had tended to conceal rather than reveal the sitter's humanity. The pose could be equated to an address to the world in the third person, a distancing similar to the use of the formal Italian *Lei*—presumably an advantage to an ideology of gender that insisted on the lady's self-control and inaccessibility. The new three-quarter or frontal pose in which the sitter makes pictorial eye contact with the viewer, on the other hand, resonates like an address in the more intimate *tu,* proposing a relationship that in Renaissance Florence was only possible between close family members.

What modification of values and self-understanding underlay this radical shift in format, apart from the influence of Northern exemplars? The emergence of humanism in the early Renaissance, placing a new emphasis on man's place in the universe and the meaning of individual experience, had clearly promoted the invention and development of portraiture.[61] In addition, however, the humanists, by fostering human agency and sanctioning subjectivity, can be said to have further encouraged the kind of personal interaction represented by the frontal gaze of the new format. Remarkably, the assertive frontal pose appeared in portraits of the culturally passive female sitter at the same time as it did in those of the culturally aggressive male sitter.

Botticelli had been apprenticed to Filippo Lippi, whose portraits in the late 1430s and early 1440s also located the female sitter within a palace interior (cats. 3, 4). Angiola Sapiti stands in front of a beautifully molded *piano nobile* (first floor) window frame giving a bird's-eye view of the Florentine suburbs. In his next portrait, Lippi simplified the view of the outside world from townscape to cloud-filled sky (cat. 4) and eliminated extraneous detail to focus on the two-toned *pietra serena* stonework and white *intonaco* that make obvious reference to Brunelleschi's contemporary buildings.[62] Lippi's sitters luxuriate in beautifully appointed palace interiors, specifically identifiable as Florentine.

Lippi's successors greatly simplified his formula, eliminating not only the setting but also drastically reducing the amount of the body depicted, including the hands. Even the number of clouds in the sky was reduced in Pol-

laiuolo's portraits in Milan and Florence (figs. 2, 3), so that the lady's bejeweled head could be isolated against a more uniform blue ground.[63] He and other mid-century artists may have recognized that the elaborate settings provided by Lippi were unnecessary to—and may even have diminished from—the central message of the dowry portrait. To convey the essence of wealth and honor, all the artist needed was the female head and bust on which to drape precious gems and luxury fabrics. Significantly, fashions emphasized the upper torso at the expense of the lower body, with shifts in style focusing on the head, neckline, and sleeves.[64] At mid-century, then, the female portrait can be said to have been reduced to its "dowry essence."

Such a context renders particularly dramatic Botticelli's return not only to his master's use of a complex architectural backdrop but also the inclusion of the body to below the waist and an expressive use of hands (cat. 25). To the left of the lady called Smeralda, a column creates a loggia or bifurcated window; behind her is another opening to the world outside.[65] Standing as if on an upper-floor loggia, she appears to look back into her palace through an open window casement, on which she leans a conspicuous hand. The trompe l'oeil window frame would seem to articulate the Albertian dictum that a painting was like an "open window."[66] The background window behind Lippi's Angiola Sapiti (cat. 3) and his Berlin lady (cat. 4) has here been shifted by Botticelli to the foremost picture plane, where it coincides with, and defines the margins of, the scene depicted. Proposed by Alberti as a matrix *through* which the viewer could contemplate the *historia,* Botticelli here employs the liminal window casement as an opening *from* which the female sitter, wedged into place by the converging lines of quattrocento perspective construction, can look back from her fictional loggia at the guests inside her real palace. Given that the culture explicitly forbade the lady from appearing at or near a window, Alberti's use of the window as metaphor helps to justify Lippi's pictorial inclusion of this charged motif in these female likenesses.[67]

Nothing could form a greater contrast with the Euclidean geometry of Smeralda's measured architectural

7

Later copy after Botticelli, *Portrait of
a Plainly Dressed Lady*, Galleria Palatina,
Palazzo Pitti, Florence (photo: Alinari /
Art Resource, N.Y.)

8

Attributed to Fra Bartolommeo,
*Costanza de' Medici, Wife of Giovan-
francesco Caetani*, National Gallery,
London

spaces than the natural setting in which Ginevra de' Benci, who married Luigi Niccolini in 1474 at the age of sixteen, stands (cat. 16). Woman, as microcosm of nature—a theme reinforced by the small posy of flowers that Ginevra probably held—is surrounded by motifs from the natural world, whether the identifying foil of juniper—yet another symbol of chastity—that provides a spiky halo, or the distant vista of water, trees, and mountains that acts as a metaphor for the greater macrocosm of the universe.[68] The artist's interest in identifying the lady with nature is reflected by the unity of the colors she wears, brown and blue, with those in the landscape.[69]

Botticelli's pictorial fiction can be said to have been informed by the reality of the female role in society and the actual enclosure of women. A profound difference existed between inside and outside of the house, the public and private boundaries, for the respectable Renaissance female. Just as the piazza was the customary forum for the male oligarchs who ran the city, so the palace was the preferred domain for their wives and daughters. Only by confining his womenfolk, indoors, out of sight, could a woman's father or husband ensure her chastity, the virtue on which the family's honor depended.[70]

Leonardo's "portrait in nature," on the other hand, can be read as constructing another aspect of the reality of female existence in this period. The woman's role in society was procreative: to give birth to sons who inherited the family name and fortune and daughters who allied it to other lineages. The backdrop of teeming, fertile nature against which Ginevra is portrayed could have been read by the contemporary viewer as an embodiment of her fertility as wife of Luigi Niccolini.[71] Leonardo would further develop this concept of nature as a metaphor for the unity between the universe and the female generative principle in his later portrait of Mona Lisa (fig. 13).[72]

Smeralda greets her interlocutor in an expensive crimson-dyed *cotta* covered by a sheer, loose-fitting *guarnello*—a garment apparently only worn within the privacy of the home.[73] She wears no rings and only a modest silver collar without gems: there was, after all, no need to uphold family honor by a display of wealth *within* the house.

Ginevra's complete lack of jewelry, however, would seem to subvert the very raison d'être of the female portrait, to judge by tradition. While rings may have originally adorned Ginevra's fingers, no gemmed necklace or pendant encircles her neck. The dress, too, that harmonizes so beautifully with the landscape is not only devoid of ornamentation other than minimal gold stitching at the neckline and eyelets but is also dyed the cheap brown-red known as *monachino,* after the color of a monk's robe.[74] In a culture in which the newly married woman's appearance represented the apex of economic and social honor for her natal and conjugal families, Ginevra's image presents hers as deprived of the usual status.

The only other quattrocento image of a woman as plainly dressed as Ginevra is a portrait from the Botticelli circle from the 1490s, in which the unadorned lady wears a plain woolen *gamurra* of the same homely *monachino* hue, an outfit that, by the standards of high fashion, was only appropriate in the privacy of the home (fig. 7).[75] Hypothetically, this lady, who wears an everyday dress without "vanities" and is posed in profile, by then old-fashioned, may have represented a female image acceptable to Savonarola, whose sermons, many of which included vitriolic condemnations of female finery, greatly influenced Botticelli's work in the 1490s.

How to account for the discrepancy between Leonardo's portrait of Ginevra and the dazzling, bejeweled surfaces and play of color of figured fabrics flaunted in all earlier portraits—although, if dated to the mid-1470s, it figures a sitter who was a newlywed? Should Ginevra's "impoverished" appearance from the patron's standpoint be read as primarily a reflection of Leonardo's known preference for dark, monochromatic hues?[76] Or should this work be interpreted as reflecting contemporary legislation?[77] In 1471/1472 (old style / new style), a few years after Lorenzo de' Medici became the de facto political leader of Florence on his father's death, new, draconian sumptuary legislation was enacted. Addressing the very women who had previously been exempt from such laws, the new dress code drastically revised what women under thirty were permitted to wear in public. Reversing earlier rules that allowed brides

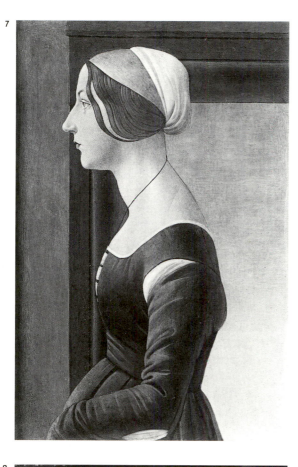

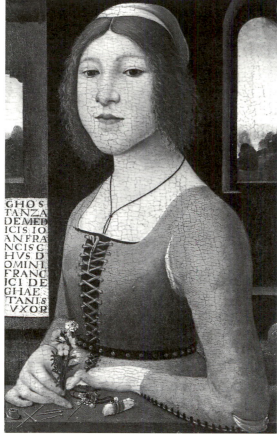

GHOS
TANZA
DEMED
ICIS IO
AN FRA
NCISC
HVS D
OMINI
FRANC
ICI DE
GHAE
TANIS
VXOR

to wear as much jewelry as they pleased, the new laws forbade, with the exception of a single brooch and three rings, all ornaments of gold or silver, jewels, or pearls; cloth dyed crimson; and furs.[78] When fashions changed, and shoulder brooches were increasingly worn as pendants later in the century, these too were forbidden.[79] The new sumptuary laws raise the issue of the reflexive relationship between art and society in the construction of historical meaning: to what extent was legislation ostensibly effecting actual self-presentation in the public piazza relevant to posed self-presentation in constructed works of art that were displayed in the privacy of the home, and were seen only by family and friends?[80]

Adoption of the three-quarter-view convention also coincided with a major shift in Florentine hairstyle and headdress that lasted for the rest of the century, as well as with the new prohibitions against opulent apparel. As modeled by Smeralda and Ginevra, hair was no longer restrained by an elaborate net of pearls and veils. Now only the chignon was covered with a plain white cap while the hair on either side of a central part was cut short and crimped into curls that framed the face.

These portraits established the three-quarter view of female face and body as the Florentine norm. While many of the likenesses produced by Ghirlandaio's circle in the 1480s and 1490s depict the young woman very simply— at bust length against a neutral ground without a setting— some, such as that of Costanza de' Medici Caetani (c. 1490), expand the setting and multiply the lady's repertoire of attributes while at the same time seeming to conform to the dictates of the sumptuary code (fig. 8).[81] Framed between two openings of a *piano nobile* hall, Costanza, uniquely identified by a prominent inscription, stands at a third opening that overlooks the viewer's world, into which she juts an assertive elbow.[82] The parapet that borders the baseline was a Flemish invention used extensively in Venice as a liminal device to demarcate the boundary between the viewer's world and the pictorial space. "Feminizing" the abstract space marker, the artist fashioned Costanza as delicately resting her hands and posy amid the jewels—pendant of gold, gems, and pearls and three rings on a little

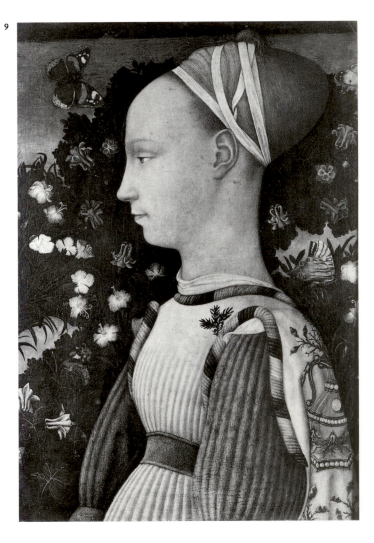

bolster—that she ostentatiously does *not* wear on her person. Even the pendant, on a black silk cord, is hidden, tucked unseen inside her bodice. The domestication of the portrait is suggested by the cat in the background and is confirmed by the highly original addition of five gold pins, thimble, and threaded needle to Costanza's array of attributes, items often inventoried as part of the bride's trousseau. Throughout the early modern period needlework and sewing, symbols of the domestic life, were considered synonymous with female virtue.

Two other portraits from the same workshop expand on the repertoire of female attributes as well as proposing a different location for their display. In Ghirlandaio's likeness of Giovanna degli Albizzi Tornabuoni—her upright carriage redolent of control and chastity—she wears a *gamurra* of crimson brocade and a *giornea* of opulent cloth of gold, covered with a rich pendant of sapphires, rubies, and pearls.[83] Her upper torso is beautifully framed by a niche that contains another juxtaposed *donora* or counter-*donora* pendant, canted to ensure full view of the large square-cut ruby surrounded by sapphires and pearls that is surmounted by a sapphire-encrusted winged dragon (cat. 30).[84] The elegant Brunelleschian niche also contains the coral beads that so often encircle the necks of Ghirlandaio's sitters and a closed book, probably intended to be read as religious.[85] The *donora* and/or counter-*donora* of this sitter, who died after only two years of marriage, can be read as enshrined like a pictorial inventory in the niche.

In the case of Mainardi's lady (cat. 31 b), the display niche, shifted to one side, allows the sitter to flaunt her trousseau while distancing herself from it: another eye-catching pendant featuring the virgin huntress Diana and a shadow-throwing nuptial ring rest on the shelves.[86] The lady's modesty is implied by the simple necklace of blue and ocher crystal beads, her chastity by the transparent glass water vessel (often used to symbolize the Virgin's purity), and her domestic virtue by the needle protruding sharply into space.

Portrait of the Princess. The portraits considered hitherto depicted women living in the Republic of Florence. Under what circumstances was the "fair sex" pictured at the absolutist courts of Ferrara, Urbino, and Milan? In general, female portraiture at court seems to have had the same postmarital associations as in Florence. Pisanello's portrait of the fifteen-year-old daughter of marchese Niccolò III d'Este of Ferrara, for instance, probably created to celebrate the alliance between Ferrara and Rimini that resulted in her marriage to Sigismondo Malatesta in 1434, may be read as an early quattrocento state version of the Florentine dowry likeness (fig. 9).[87]

The teenage princess in this earliest Italian surviving female likeness is identified as Ginevra by the sprig of juniper embroidered on her left shoulder, and marked dynastically as an Este by the pearl-embroidered emblem of an urn containing branches, roots, and anchors on the left sleeve of her *giornea*. Emulating the Virgin's enclosed garden *(hortus conclusus),* a tapestry of animated leaves, perfumed blossoms, and fluttering butterflies acts as a foil for her adolescent features. With carnations as the traditional flowers of betrothal, columbines symbolizing the passion of love, and butterflies a metaphor for the human spirit, few more poetic evocations of love and youth were created in the entire Italian Renaissance.[88]

9

Pisanello, *Ginevra d'Este,* Musée du
Louvre, Paris (photo: Giraudon / Art
Resource, N.Y.)

10

Piero della Francesca, *Pendant
Portraits of Federico da Montefeltro
and Battista Sforza,* Galleria degli
Uffizi, Florence (photo: Nicolo Orsi
Battaglini / Art Resource, N.Y.)

11

Ambrogio de' Predis, *Bianca Maria
Sforza-Visconti,* National Gallery of Art,
Washington, Widener Collection

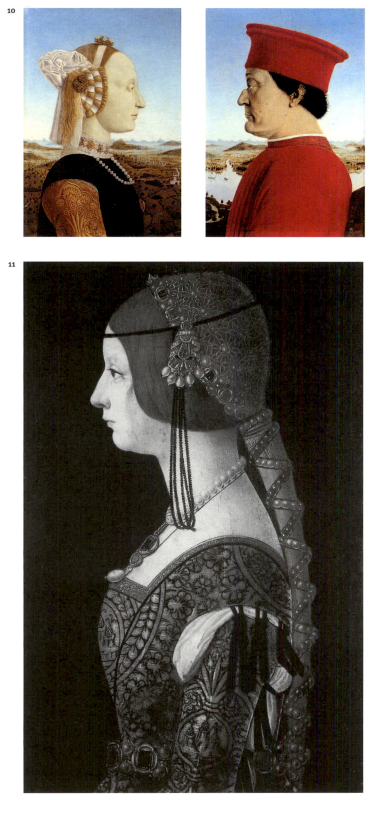

10

11

What was the meaning of the profile for the absolutist rulers of Ferrara and Rimini as distinct from Florentine patricians? Pisanello's introduction into court culture of humanist-inspired portrait medals emulating Roman coins profoundly influenced portraiture conventions in these centers. The profile pose favored by the caesars for their coinage carried dynastic and political significance for the *condottieri*-princes that would have been unimaginable to a Florentine citizen, no matter how rich and influential. The profile embodied connotations of far-flung empire as well as legitimacy of governance for the ruler who sought not only to preserve, but also to enlarge, his state. Given the princely search for political legitimacy and hunger for land and empire, it is understandable that territorial rulers—particularly those who, like the Sforza, were illegitimate usurpers—should have been slow to accept any other portrait format.[89]

There were no Italian precedents, iconographic or formal, for Pisanello's portrait. Although no sumptuary laws impinged on the life or adornment of the court lady, ironically Pisanello chose to focus on the grace and transitory beauty of the fruits of nature as symbols of the teenage princess' luminous youth, rather than on Este wealth or Malatesta honor. Inevitably, perhaps, this artistic experiment had no successors. No fragrant flowers or enticing butterflies compete for attention with the precious gems featured in the state portraits of Battista Sforza, countess of Urbino (fig. 10), or Bianca Maria Sforza of Milan, consort of the holy roman emperor (fig. 11). Instead, each demonstrates the honor of her respective dynasty and state through the parade of thousands of ducats' worth of fabulous jewels.

Painted posthumously, after twelve years of marriage, Battista Sforza's portrait, datable c. 1473, was based on a death mask.[90] No matter how expensive the crimson-dyed garb in which her husband, the count of Urbino, presented himself, only the bejeweled adornment that weighs down his consort's dead body could, it seems, supply the honorific statement that he sought with this diptych. Piero's design principle is based on the circle: the concentric blonde hair around her ear, the "ponytail" fixed by a circular ruby and

12

Leonardo da Vinci, *Portrait of Lady
with Ermine,* Princes Czartoryski Founda-
tion, Cracow

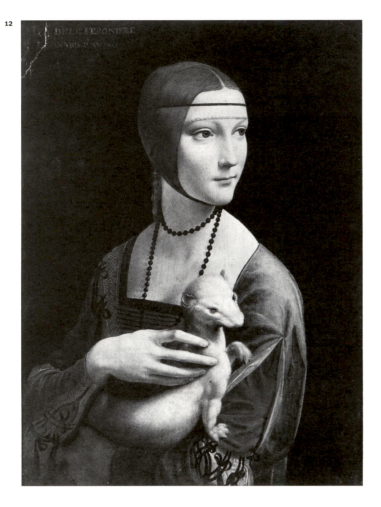

12

vico, much like our modern politicians, promised to sweep the peninsula clean of corruption—on her headdress alone were valued at six hundred ducats.[93] Bianca Maria's jeweled belt (a symbol of chastity), gem-encrusted hair netting, necklace and pendants, and ropes of black and white pearls crisscrossing the long queue of hair should be read as proclaiming the fabulous wealth of Sforza Milan. As a metaphor for Milanese purchasing might, this state portrait amounts to the ultimate "dowry" image.

Leonardo's second extant female likeness, painted c. 1490 at this same court, depicted an individual of less exalted rank than the duke of Milan's niece: his mistress (fig. 12).[94] Cecilia Gallerani's lack of political standing must have been a crucial factor in allowing the artist to experiment with the role of the body in portraiture. Certainly her lesser status released him from the necessity of following the rigid conventions of state portraiture.

Hitherto, female hands, when shown, had inconspicuously clasped the fabric of skirt (Angiola) or handkerchief (Smeralda), or been placed decorously on heart or womb (Angiola and Smeralda) (cats. 3, 25).[95] Never before Leonardo's portrait had the female hand been given such importance. Where Flemish artists often enlarged the head, Leonardo expanded the lady's hand. Suspended on display, it was given the ostensible function of caressing an allegorical animal that is also represented as larger than life. The portrait of the living ermine, whose fur was much sought after, served a threefold purpose: its designation in Greek, *galee,* was a pun on the sitter's family name; it was a well-known symbol of purity because it was believed too fastidious to soil itself; and it was a heraldic emblem of the duke of Milan.

Leonardo moved beyond the static three-quarter view of Ginevra de' Benci that conveyed the social ideal of the female body as upright and contained by experimenting with the daring concept of that same body as flexible and mobile.[96] Cecilia is fashioned as spiraling gracefully in contrapposto from left to right, toward the light, to greet a visitor who approaches from the right outside the confines of the painting. We are probably meant to read the visitor as her Sforza lover, whose body she already symbolically cradles in her arms. This flexed pose, unprecedented

emerald brooch, the head brooch that forms a miniature crown looming over the Montefeltro territory, the opulent gemmed collar bordered by large round pearls, and the pearl necklace sustaining a circular ruby pendant.

The nuptial carnation tucked into the belt of Bianca Maria Sforza—who, at twenty-one in 1493, would barely have been considered nubile—confirms that the work celebrates the alliance with which, after forty years of illegitimacy, her uncle the duke purchased Sforza investiture of Milan by marrying her to his overlord, Emperor Maximilian.[91] Her enormous dowry amounted to more than one hundred thousand ducats, of which the *donora* of jewels and clothes was valued at seventy thousand ducats.[92] The rubies, turquoise, emeralds, diamonds, and five outsize pearls in the heraldic device of brush *(scopetta)*—with which Lodo-

in European painting, locates her head on a different axis from that of her body and adds a narrative component to the hitherto iconic portrait.

No animal—here marker for both sitter and patron—had previously shared the portrait limelight, and few can have since been put to better artistic use. While concealing the lady's heart, and its sentiments for her ducal lover, the ermine, its own paw lifted in greeting, is in turn protected by his lover, whose sensitive, attenuated fingers endow the sense of touch with new significance.[97] The nervous charm, as well as the physical torsion, of beauty and beast can be seen as having been assimilated the one to the other.[98]

The Lady Enthroned. Leonardo's likeness of Ginevra and several other portraits had sited the sitter against a distant landscape without a transition between the two spaces (cats. 16; fig. 10).[99] In his portrait of Mona Lisa (c. 1503–1506)—probably a depiction of twenty-four-year-old Lisa Gherardini, wife of Francesco del Giocondo—Leonardo rationalized this relationship, and separated Lisa from the landscape, by locating her in a narrow loggia in front of a low wall—a parapet *behind* the figure, as it were—that sustains the bases and shafts of two colonnettes (fig. 13). The concept of sitter placed high in a loggia overlooking a landscape derives from either a Flemish example, such as Memling's portrait of Benedetto Portinari (1487), well known in Florence, or an Italian imitation, such as Mainardi's pendant portraits (cats. 31A, B).[100] Lisa is portrayed as locked into place between the loggia wall and the barrier of the arm of her chair as firmly as Smeralda had been by the perspective construction of *her* palace loggia (cat. 25).

How else does the portrait differ from earlier instances? Probably for the first time Leonardo rendered the seated pose explicit. Rejecting the parapet as a way of bringing the portrait to a halt at its lower margin (as Ghirlandaio did in cat. 29), Leonardo combined the source of support for Lisa's body with that for her hands and arms, by locating the arm of her chair parallel to the picture plane.[101] Whereas Smeralda stands frontally before the viewer, Lisa's mobile body emulates Cecilia's spiraling per-

formance, whereby her lower body in profile shifts to a frontal view of her face. Just as Cecilia swiveled toward her lover, so Lisa turns in her loggia to greet the visitor approaching her, ostensibly from the palace within.

Lisa's portrait is a synthesis of twenty-five years of research, and the pose of her hands is so deceptively simple that the originality of Leonardo's solution may not be immediately apparent. Here the artist brought Cecilia's ermine-sustaining hands together, not tightly clasped as in so many Netherlandish likenesses (cat. 13), but relaxed on the arm of the chair, one resting on the wrist of the other.[102] The hands and, especially, the arms bring the painting to a halt, provide a monumentalizing base for the bust, and form a discrete barrier that, like the old parapet, keeps the viewer at a safe distance.

In Mediterranean cultures the image of the figure is valued over that of nature, and the sitter's head in these early Italian works invariably dominates over the image of land (fig. 10; cat. 29). In Lisa's case, however, the horizon line is placed not at the level of her neck but at that of her eyes, so that her figure is linked structurally to the universe enveloped in mist behind her. As a result, the distinction between woman and nature is blurred so that she seems to personify the mysterious forces embodied in the mystical vision of untamed nature behind her—one that belongs to a different order of reality from the domesticated landscape that serves as a backdrop for Ginevra de' Benci.[103]

Displayed as a beautiful work of nature, Lisa's soft, supple hands—seen from above, not foreshortened, as in Rogier van der Weyden's portrait (cat. 13)—create a mood of tranquillity and serenity.[104] The relaxation of the hands reinforces the relaxation of the facial muscles above them that is responsible for the transitory expression of friendship and amiability that lightens her face, an intimation of pleasure at the viewer's arrival that was adumbrated in Botticelli's portrait of Smeralda (cat. 25).[105] Thirty years after Ginevra de' Benci's gaze of indifference, Leonardo introduces the illusion of emotional warmth to the female portrait.[106]

Two striking anomalies in Lisa's self-presentation were already present in Leonardo's recent portrait cartoon

13
Leonardo da Vinci, *Lisa Gherardini,*
Wife of Francesco del Giocondo, Musée
du Louvre, Paris (photo: Lewandowski /
LeMage, Réunion des Musées Nationaux /
Art Resource, N.Y.)

14
Raphael, *Lady Holding a Unicorn,*
Museo Galleria di Villa Borghese, Rome
(photo: Alinari / Art Resource, N.Y.)

15
Raphael, *Pendant Portrait of Madda-*
lena Strozzi, Wife of Angelo Doni,
Galleria Palatina, Palazzo Pitti, Florence
(photo: Alinari / Art Resource, N.Y.)

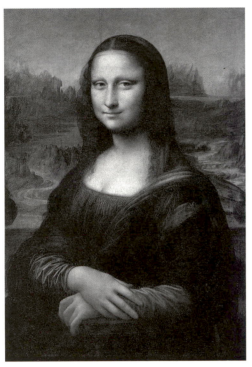

for Isabella d'Este, marchesa of Mantua, in 1499–1500: the loose hair that tumbles indecorously down on her shoulders and the absence of jewelry.[107] As noted earlier, only unmarried virgins wore their hair loose; wives were expected to conceal this marker of sexuality as a matter of decorum.[108] The exception to this rule, however, were Northern queens, who are thought to have worn their hair loose as a sign of regality, if only on the most formal occasions, and the marchesa of Mantua's conspicuously loose locks can be interpreted as an attempt to appropriate an ideal of regal comportment and monarchical glamour.[109] Such an interpretation is obviously irrelevant to a portrait of a private citizen who was merely the wife of a minor Florentine merchant. Given that loose hair implied loose morals, one wonders how Lisa's unconventional—indeed unique—hairstyle could have been read by contemporaries as other than a somewhat negative comment on her virtue, despite the transparent veil that sits lightly on her head.

It is highly unlikely that Isabella d'Este, whose gold medal by Giancristoforo Romano is unclassically embellished with diamonds and who was in any case unconstrained by sumptuary laws, would have accepted any finished portrait that denuded her of her birthright of gemmed glory and honor. In Lisa's portrait the usual ornamentation is restricted to minimal gold stitching on the neckline of her dark green velvet *gamurra*.[110] Although she came from a family with only a modest income, and her small dowry of 170 florins may have included few jewels, it seems inconceivable that any husband active, like Francesco del Giocondo, in the marketplace would have concurred with this suppression of all markers of rank.[111]

Although profoundly influenced by some of Leonardo's portrait innovations, the young Raphael nonetheless rejected others. His *Lady Holding a Unicorn* (fig. 14) combines elements from Leonardo's portraits of Lisa—wall and colonnettes of loggia that here overlook a Flemish-inspired landscape—and of Cecilia—the allegorical animal that here nestles in the sitter's virginal lap—but without the spiraling pose or mobility of either lady or beast.[112] Leonardo's newfound flexed body remained without pictorial successors as did the artifice of pleasure in communication. Offering a more passive construction of gender, Raphael

domesticated the older artist's inventions, rendering them either more explicit (the architectural setting) or less intensely personal (the landscape), and restoring the dominant proportional relationship established earlier between figure and nature, whereby the head is once again silhouetted against the sky.[113]

In Raphael's diptych of the Doni couple, the sumptuous textures and coloristic ostentation of Maddalena Strozzi's orange-red watered-silk bodice and skirt, deep blue damask sleeves, gold buttons, and chain belt signal a reversion to the portrait's quattrocento function as a performance of high fashion that demonstrates economic honor (fig. 15).[114] Raphael used Leonardo's motif of crossed hands on the arm of the chair less as an artifice of relaxation and tranquillity than to display Maddalena's nuptial rings, linked by the double row of gold buttons to the nuptial pendant of sapphire, ruby, and unicorn-set emerald that sustain the very large shadow-casting pearl.[115]

This work is exactly contemporary with Leonardo's Mona Lisa, but there is nothing enigmatic about Maddalena's stolid self-presentation to the world. If Leonardo drew the female portrait in the direction of fantasy and poetry, the young Raphael pulled it firmly back in that of realism and prose. The central role that naturalism played in Raphael's aesthetic—his interest in the specifics of Maddalena's somatic adornment and lineaments—underline his different understanding of the role of the portrait. Raphael returned the artform to Alberti's conception of it as a sign of the sitter's role in society, in which identity was politically and, in the case of women, socially determined.[116] Unlike Leonardo's female portraits, Raphael's function as signs of the lady's position in society.

As Mona Lisa's image is as shorn as Ginevra de' Benci's of the prestige pertaining to the display of material wealth that is so evident in Maddalena Strozzi's, we may speculate that Leonardo was able to impose this unadorned state on his sitters, just as he was apparently able to impose his preference for dark, monochromatic color schemes on their wardrobes in a culture that favored bright colors.[117] Thus, while the role of the sumptuary laws in women's lives can speculatively be seen as reflected, on some level, in the female portraits by the Ghirlandaio circle in the 1480s

16
Giulio Romano and Raphael, *Dona
Isabel de Requesens i Enriquez de Cardona-
Anglesola*, Musée du Louvre, Paris
(photo: Herve Lewandowski, Réunion des
Musées Nationaux / Art Resource, N.Y.)

and 1490s (fig. 8; cats. 30, 31 B), the primary concerns in Leonardo's likenesses, including that of Ginevra de' Benci, appear to be aesthetic. Anticipating the later cinquecento, his works would seem to embody the artist's rather than the patron's interests. Why Leonardo never delivered his anomalous portrait of Mona Lisa to Francesco del Giocondo is unknown, but comparison with other, contemporary likenesses reveals a number of elements that may have made the patron reluctant to accept it.

The Lady Eroticized. A new chapter in the history of Italian female imagery is signaled by Giulio Romano's monumental likeness of the vicereine of Naples (fig. 16).[118] It was commissioned not by the sitter, her spouse, or her natal or conjugal families, but by a prince of the church as a diplomatic gift for a king who collected images of female beauty designed for his delectation. Cardinal Bibbiena, personal friend and counselor to Pope Leo X, asked Raphael to paint a portrait for King Francis I of the princess who, despite nine years of marriage and two pregnancies, was still reputed for her beauty. The famous but overburdened artist sent the nineteen-year-old Giulio to Naples in his stead.[119] Giulio fashioned the twenty-year-old Dona Isabel de Requesens (formerly identified as Joanna of Aragon) as majestically enthroned, facing left, in a splendidly appointed architectural interior. In the upper half of the composition, her head is balanced by an opening to a loggia overlooking a lush pleasure garden. Porphyry columns with gold capitals sustain a vault with quotations from the classical love story painted by Raphael in the actual Loggia di Psiche of banker Agostino Chigi's contemporary Villa Farnesina in Rome. The motifs quoted show a nude Venus pointing out Psiche to Amor, and the nude lovers, Amor and Psiche, lying side by side at their nuptial banquet.

Isabel's slender body seems lost within the many *braccia* of deep red velvet, the color of love for Petrarch and of *amoroso piacere* (pleasures of love) for Dolce.[120] Her gold-embroidered white *camicia* billows sensuously through the slits and ample openings of the huge, gold-lined sleeves, from which two languorous hands emerge. A marten fur lies suggestively over one shoulder, and a red velvet hat, its halo-simulating brim bearing precious jewels, crowns her long, golden tresses, that otherwise float regally— and erotically—loose.

Quoting from one of Michelangelo's *ignudi* on the Sistine Ceiling, one mannered hand is self-consciously exhibited against the velvet setting of her skirt, while the fingertips of the other toy lightly with the fur on her shoulder. Hitherto female hands and arms, decorously placed together, formed a visual barrier between the female object and the male subject/viewer.[121] Isabel's widely separated arms, on the contrary, expose her torso, rendering it vulnerable. Furthermore, for the first time in Central Italian portraiture, the female body is extended below the knees; here the pose of Isabel's legs reflects that of her arms. The knees are unmistakably spread apart, separated by a deep, wide trough of red velvet.

The prominent blue sleeves that frame Maddalena Strozzi's person elegantly terminate that composition at its lower margin (fig. 15).[122] Like Mona Lisa, Maddalena is pictorially anchored in space, close to the viewer yet inaccessible. Interrupted at her religious devotions by the viewer's arrival, the handsome young matron in a likeness attributed to Bugiardini shields her body with a prayer book (cat. 36A).[123] This demarcation between (female) sitter and (male) viewer is eliminated in Giulio's composition. Isabel's left hand on her knee stresses the ambiguity of the liminal area between the world of the painting and the world of the viewer, by drawing attention to the lower margin's incapacity to either contain the represented sitter or to bring the image to a halt. The absoluteness of the picture surface as an imaginary boundary between the two worlds is called into question; the regal connoisseur is invited to take that one step past the liminal threshold that will enable him to place his own hand beside hers on the velvet-encased knee.

Fashioned to undergo royal scrutiny, the poised protagonist is shown returning her collector's gaze—the only part of Giulio's design that Raphael, fully cognizant of the comparisons that would be made to Leonardo's portrait of Mona Lisa, already in the French king's collection, found necessary to rework himself.[124] Giulio can be said to have

16

provided Francis I with a female pictorial presence that was at once regal and erotic, decorous yet exposed. The artist created a seductive object of desire in the very process of producing another object of desire—any painting by Raphael. The contemporary viewer cannot have failed to recognize the *pictorial* eroticization of this princess—whose real virtue was surely never in question—conveyed by the placement of arms and legs, gestures taken from a well-known (nude) (male) (athlete), and by the quotations from Raphael's erotically imbued retelling of the Ovidian love story of Amor and Psyche in the loggia, the site in which so many of the sitter's painted predecessors had been positioned. This high-born lady is given as eroticized a presentation as that of the anonymous beauties in the pseudo-portraits attributed to Botticelli and Piero di Cosimo (cat. 28; fig. 4). Of the two qualities required of the pictured Renaissance lady, the rhetoric of beauty, it seems, has overtaken the rhetoric of virtue.

Patronage and Original Location. The evidence provided by those few identifiable female likenesses points to the postnuptial years as the moment of commission, and hence to the sitter's husband rather than father as the typical commissioning agent. The identified portraits of the Florentines Angiola Sapiti, Maria Baroncelli, Ginevra de' Benci, Costanza de' Medici, Giovanna degli Albizzi, Lisa Gherardini, and Maddalena Strozzi, it has been argued, were all painted after the nuptial vows were taken (cats. 3, 16, 30;

figs. 5, 8, 13, 15). In addition, the images of Angiola Sapiti, Maria Baroncelli, and Maddalena Strozzi present them in the company of their husbands, that is as wives (cat. 3; figs. 5, 15). The state images of Ginevra d'Este and Bianca Maria Sforza celebrate their respective marriage alliances, although the latter was probably commissioned prior to the actual wedding (figs. 9, 11). Only the portrait cartoon of the marchesa of Mantua can be said both to lack any nuptial association whatsoever (Isabella d'Este married Francesco Gonzaga in 1490) *and* to have been commissioned by its female sitter, empowered by her position as ruling consort. As we have just seen, the image of the beautiful Dona Isabel falls outside these generalizations.

Ghirlandaio's *Giovanna degli Albizzi* is the only surviving identifiable female portrait of the quattrocento whose original location is known. In 1498, ten years after Giovanna's death, her image was hanging in the *chamera del palcho d'oro* in the Palazzo Tornabuoni, one of a suite of rooms belonging to her husband Lorenzo.[125] While there is no way of calculating the proportional relation of surviving portraits to those created in the period, portraits were rarely recorded in inventories.[126] Those that were invariably hung in the camera or anticamera along with the other portable furniture and paintings, such as the daybed *(lettuccio)* with painted *spalliera,* great chests *(cassoni),* birth plates *(deschi da parto),* and religious tondi of the Virgin and child or Crucifixion.[127] Raphael's portraits of the Doni couple, for instance, may have hung in their palace in the same camera as Michelangelo's tondo of the Holy Family.[128] As the engendering and symbolic center of the household, the camera that held the marriage bed was decorated as the richest room in the house and the place where guests were received.[129] Thus the audience addressed by portable, independent portraits, male and female, were the sitters' families, friends, and peers.

Many of the portraits on a smaller scale than Ghirlandaio's *Giovanna degli Albizzi* were probably never hung on the wall but kept wrapped inside a chest or *studiolo* cupboard along with such precious objects as medals, gems, and antiquities; this was almost certainly the case for most portraits with painted reverses.[130]

17

Piero della Francesca, *Triumphal Processions of Federico da Montefeltro and Battista Sforza*, details of the reverses of fig. 10, Galleria degli Uffizi, Florence (photo: Alinari / Art Resource, N.Y.)

17

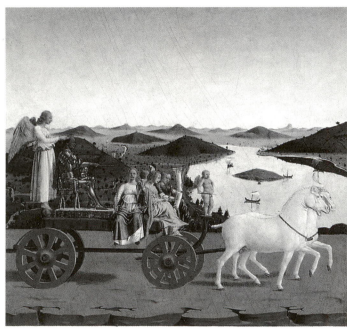 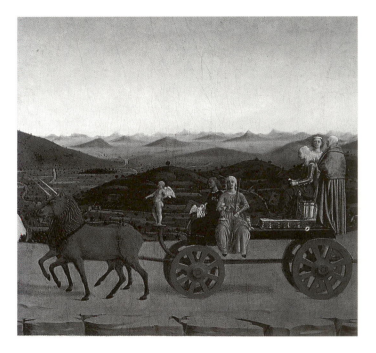

The Portrait Reverse and Cover. The portrait reverse originated in the two-sided bronze medal, the humanist art form that was virtually reinvented by Pisanello in Ferrara in the 1430s.[131] The medal reverse provided an equivalent space on which to expand the portrait on the obverse, by further image or inscription. In the case of (the relatively few) female subjects, the reverse imagery tends to focus on the familiar themes of beauty or virtue. The reverse of Pisanello's beautiful medal of Cecilia Gonzaga, the first to be devoted to a woman, shows a personification of Chastity seated beneath Diana's sickle moon with a unicorn, the mythical beast that could only be caught by a virgin; the imagery would be echoed in Raphael's portrait sixty years later (figs. 14, 17). Emulating Botticelli's *Primavera* (fig. 1), the reverse of Giovanna degli Albizzi's medal, on the other hand, focuses on that lady's charms by depicting Venus' attendants, the Three Graces; significantly, however, the inscription above them reads CHASTITY as well as BEAUTY and LOVE (cat. 11).[132]

Several of the portraits considered include elements that could have been appropriately located on the painting's reverse: the inscription identifying Costanza de' Medici (fig. 8), for instance, or the aphorism affixed to the niche

that frames Giovanna degli Albizzi's posthumous image (cat. 30).[133] The heraldic devices of Este urn and Sforza brush that identify Ginevra d'Este and Bianca Maria Sforza (figs. 9, 11) could have been translated into reverses as elegant as that commenting on Ginevra de' Benci's virtue, where the laurel and palm combined with motto, placed against a simulated porphyry ground that no doubt symbolized the "stony obduracy of her chastity," were standard motifs (cat. 16).[134]

The best known portrait reverses of the century depict allegorical scenes of the count and countess of Urbino in triumphal processions (fig. 17).[135] Battista is constructed on a float pulled by the unicorns of Chastity, in the company of Faith, Hope, and Charity, the last-named honoring the duchess through her black dress of mourning and the self-sacrificing pelican, which was supposed to feed its chicks with its own blood, in her lap. (Similarly, Ginevra d'Este's color scheme—cream *giornea*, pink sleeves, and olive belt—also proclaimed her piety by evoking the colors of the theological virtues [fig. 9].) Whereas a book carried by a secular male sitter in a portrait is seldom interpreted as religious, those in female likenesses are usually read as signifying faith and its obser

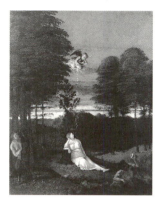

18
Lorenzo Lotto, *Portrait Cover: Allegory of Chastity*, National Gallery of Art, Washington, Samuel H. Kress Collection

vance. The small scale of the deceased Battista's volume suggests a book of hours, similar to the one that, clearly identified by Christ's monogram on its cover, is consulted by the pious lady in Bugiardini's portrait (cat. 36 A).

The Urbinate Raphael must have recalled the count's diptych when he came to develop the historiated reverses for the Doni pendant portraits, although the scenes were painted by another artist. The overt theme of fertility is unique for a portrait reverse and the choice of iconography —a fecundity myth recounted by Ovid—abstruse.[136] Behind Angelo's portrait, Jupiter and other Olympians hover above a classical version of the biblical deluge. Behind Maddalena's likeness, the two survivors, Deucalion, Prometheus' son, and Pyrrha, give life to a new human race under the aegis of the earth goddess Themis; eschewing the usual time-honored method of procreation, they throw stones over their shoulders, producing a pile of women on one side and men on the other. Maddalena, who had married in 1504, may have had a series of miscarriages; in any event the couple remained childless until the birth of Maria in September 1507. The diptych, probably painted before Maria's arrival, may date from early 1507.[137]

The custom of using a painting as a protective cover for a portrait derives from Northern Europe and seems to have been developed in Venice by Jacometto Veneziano as heir to, or alternative for, the painted reverse.[138] Lorenzo Lotto's allegory of chastity (fig. 18), believed to have been the cover for a bust-length portrait of a woman, forcefully articulates the culture's fixation on female sexual purity. A clear distinction is made between vice—a dark-skinned naked satyress straddling a tree while ogling a wine-guzzling satyr—and virtue—a blonde maiden swathed from neck to ankle in white and gold, whose averted gaze would seem to deny the very existence of female lust.[139]

Conclusion. One portrait cover is tellingly inscribed SVA CVIQVE PERSONA, "to each his own mask or role" (cat. 36 B). The mask, persona, that signified the role or character type of the actor in Greek drama was ever present in Renaissance imaging. How was the role or persona of woman—as represented by the upper-crust lady

and as constructed here—fashioned pictorially in the first century of early modern portraiture?

On an iconographic level, the symbolism of chastity prevailed through much of the period, whether taken from the world of religion—transparent glass vessels, enclosed gardens, impregnable architectural interiors—or the world of allegory and myth—the unicorn's phallic symbol that could (ironically) only be tamed by a virgin, or the special properties attributed to particular gems. Nonetheless, on a formal level, the female pictured presence evolved at breathtaking speed in this period of artistic revolution: from the Pollaiuolesque inanimate clotheshorse of material glitter to the Leonardesque vision of a mobile, responsive human being —involving the subject's emotional as well as physical presence—to the Giuliesque eroticization of even a regal sitter.

What role can the female sitter be said to have played in the first century of her portraiture? Is Castiglione's metaphor of the aristocratic sitter as a self-conscious performer undertaking a carefully rehearsed performance as relevant to the female image as it seems to be to the male? How much power *did* the female sitter have to fashion the self in the mirror of her likeness? Recently, scholarship has directed attention away from the style and performance of the painter to the style and performance of the sitter as participant in the act of portrayal.[140] This emphasis on the importance of the sitter's performance for the outcome of the portrait fails, however, to consider adequately questions of empowerment in relation to gender difference. Renaissance women, I would argue, were no more empowered in art than in life. Rather than mediating the women's life experiences, their portraits usually embody the Renaissance social construct of the patrician female ideal. Certainly, the mediating artist's power to position his (female) sitter to his own ends is proven by the vastly differing, although contemporary, constructions of Lisa Gherardini by Leonardo and Maddalena Strozzi by Raphael—not to mention Giulio's later image of the vicereine of Naples. Isabella d'Este is perhaps the exception who proves the rule: the only female sitter with both the power and the knowledge to effect the artistic outcome—ironically, seldom to her satisfaction.[141]

NOTES

I want to thank David Alan Brown for inviting me to write this essay; Elon Danziger for his indispensable help; Jean Cadogan and Carole Collier Frick for their scholarly generosity; and Lorne Campbell, Nicholas Penny, and Susanna Avery-Quash for discussing National Gallery paintings with me. Drafts were read by Paul Barolsky, Elizabeth Carter, David Kunzle, Carolyn Malone, and Elaine Svenonius; I am profoundly indebted to their critical insights. I also wish to thank Dawson Carr, Nassim Rossi, Mary Stark, Vanessa Walker-Oakes, and Jennie Wehmeier, in UCLA art history seminar 230 in fall 2000, made many valuable suggestions. Christine Sellin and Natalie Operstein diligently and efficiently accomplished an immense amount of bibliographic research, the latter through the generosity of the Center of Medieval and Renaissance Studies at UCLA. The libraries consulted include the Getty Research Institute in Los Angeles, the Biblioteca Berenson and the Kunsthistorisches Institut in Florence, and the Warburg Institute in London, as well as those of my home institution; I am deeply grateful to all of their staffs and to the interlibrary loan department of UCLA. This essay is for Margaret and Dyrk who don't get thanked nearly enough.

1. Wilhelm v. Bode, "Italian Portrait Paintings and Busts of the Quattrocento," *Art in America* 12 (1923), 3–4. Exceptions include Ghirlandaio, attributed, *Lady in Mourning, called Lucrezia Tornabuoni,* c. 1475, National Gallery of Art, Washington; Giorgione, *La Vecchia,* c. 1505, Accademia, Venice, which is, however, probably a portrait cover rather than a portrait.

2. Ronald E. Rainey, "Sumptuary Legislation in Renaissance Florence," Ph.D. diss., Columbia University, New York, 1985, 11; Gene A. Brucker, *Renaissance Florence* (New York, 1969), 121.

3. On the display culture, see Patricia Simons, "Women in Frames: The Gaze, the Eye, the Profile in Renaissance Portraiture," in *The Expanding Discourse: Feminism and Art History,* ed. Norma Broude and Mary D. Garrard (New York, 1992), 41–43; Paola Tinagli, *Women in Italian Renaissance Art: Gender, Representation, Identity* (Manchester, 1997), 51.

4. Stephen K. Scher, ed., *The Currency of Fame: Portrait Medals of the Renaissance* (New York, 1994), cat. 12.

5. Simons 1992, 44. The quotation comes from Vespasiano da Bisticci.

6. Leon Battista Alberti, *The Family in Renaissance Florence,* trans. R. Neu Watkins of *I Libri della Famiglia* (Columbia, S.C., 1969), 229; Sharon Fermor, "Movement and Gender in Sixteenth-Century Italian Painting," in *The Body Imaged: The Human Form and Visual Culture Since the Renaissance,* ed. Kathleen Adler and Marcia Pointon (Cambridge, 1993), 129–145.

7. The Florentine theme of the exhibition, as well as limitations on the essay's length, precluded discussion of the female portrait in Venice.

8. For the earlier scholarship, see references in Tinagli 1997, chaps. 2 and 3.

9. Carole C. Frick, "Dressing a Renaissance City: Society, Economics and Gender in the Clothing of Fifteenth-Century Florence," Ph.D. diss., University of California, Los Angeles, 1995, 32.

10. Julius Kirshner and Anthony Molho, "The Dowry Fund and the Marriage Market in Early Quattrocento Florence," *Journal of Modern History* 50 (1978), 420.

11. Heather Gregory, "Daughters, Dowries, and the Family in Fifteenth-Century Florence," *Rinascimento* 27 (1987), 215, 236; Anthony Molho, *Marriage Alliance in Late Medieval Florence* (Cambridge, 1994), 139.

12. Christiane Klapisch-Zuber, *Women, Family, and Ritual in Renaissance Italy* (Chicago, 1985), chap. 10; Adrian Randolph, "Performing the Bridal Body in Fifteenth-Century Florence," *Art History* 21 (1998), 184.

13. Randolph 1998.

14. Karen Hanson, "Dressing Down Dressing Up: The Philosophic Fear of Fashion," in *Aesthetics in Feminist Perspective,* ed. Hilde Hein and Carolyn Korsmeyer (Bloomington, 1993), 239.

15. Rainey 1985, 434, 481, 483, 509 note 128, 510 note 135.

16. John Kent Lydecker, "The Domestic Setting of the Arts in Renaissance Florence," Ph.D. diss., Johns Hopkins University, Baltimore, 1987, 153; Frick 1995, xxi.

17. Diane Owen Hughes, "From Brideprice to Dowry in Mediterranean Europe," in *The Marriage Bargain: Women and Dowries in European History,* ed. Marion A. Kaplan (New York, 1985), 13; Diane Owen Hughes, "Regulating Women's Fashion," in *A History of Women in the West. II Silences of the Middle Ages,* ed. Christiane Klapisch-Zuber (Cambridge, Mass., 1992), 141; Randolph 1998, 185.

18. Rainey 1985, 431.

19. Carole C. Frick, *Dressing a Renaissance City: Economics, Fashion, and Social Place in Florence,* Baltimore, forthcoming, chap. 12.

20. Klapisch-Zuber 1985, 227; Rainey 1985, 440 note 27; Adrian Randolph, "Public Woman: The Visual Logic of Authority and Gender in Fifteenth-Century Florence," Ph.D. diss., Harvard University, Cambridge, Mass., 1995, 98. See also in this volume Roberta Orsi Landini and Mary Westerman Bulgarella, "Female Costume in Fifteenth-Century Florentine Portraits," note 31.

21. Lydecker 1987, 159; Jennifer Craven, "A New Historical View of the Independent Female Portrait in Fifteenth-Century Florentine Painting," Ph.D. diss., University of Pittsburgh, 1997, v; Randolph 1998. I strongly disagree with the conclusion reached by Tinagli 1997, 49, that the majority of the portraits were commissioned posthumously, on the basis of the two posthumous portraits of male sitters mentioned by Lydecker 1987, 160.

22. Jeffrey Ruda, *Fra Filippo Lippi: Life and Work with a Complete Catalogue* (New York, 1993), 85–88, 385–386, cat. 16; John Pope-Hennessy and Keith Christiansen, "Secular Painting in Fifteenth-Century Tuscany: Birth Trays, Cassone Panels, and Portraits," *Metropolitan Museum of Art Bulletin,* series 2, 38 (1980), 59. Only Ruda 1993, 385, cat. 16, dates the work to 1435–1437. For portraits by Lippi, see Megan Holmes, *Fra Filippo Lippi: The Carmelite Painter* (New Haven, 1999), 128–134.

23. Mary Rogers, "The Decorum of Women's Beauty: Trissino, Firenzuola, Luigini and the Representation of Women in Sixteenth-Century Painting," *Renaissance Studies* 2 (1988), 63 ff; Daniel Arasse, "Il vello di Maddalena," in *La Maddalena tra Sacro e Profano,* ed. Marilena Mosco (Milan, 1986), 58; Simons 1992, 42; Rona Goffen, *Titian's Women* (New Haven, 1997), 22.

24. Frick 1995, 264.

25. Frick 1995, 16, 400, 403.

26. For the ritual function of rings, see Klapisch-Zuber 1985, 231 ff.

27. Lydecker 1987, 134; Randolph 1998, 187.

28. Randolph 1995, 101.

29. Jacqueline Herald, *Renaissance Dress in Italy 1400–1500* (London, 1981), 179; Randolph 1995, 93, 98; Frick 1995, 408; Frick forthcoming, chap. 12.

30. Frick 1995, 320.

31. Patrizia Castelli, "Le virtù delle gemme," in *L'Oreficeria nella Firenze del Quattrocento* (Florence, 1977), 339, cat. 217, 337, cat. 214. See Agostino Ricci, *Storia delle Pietre,* c. 1500: "soavemente con queste perle s'adornano [le belle et gratiose spose] i bei crini, così l'orecchie e i candidi colli loro, oltre si le delicate braccia."

32. Ronald Lightbown, *Botticelli* (New York, 1989), 130.

33. Castelli 1977, 345–346, cat. 226.

34. Castelli 1977, 345, cat. 225.

35. Joseph Manca, "Blond Hair as a Mark of Nobility in Ferrarese Portraiture of the Quattrocento," *Musei Ferraresi* 17 (1990–1991), 51–60. Rogers 1988, 47; Mary Rogers, "Reading the Female Body in Venetian Renaissance Art," in *New Interpretations of Venetian Renaissance Painting,* ed. Francis Ames-Lewis (London, 1994), 80.

36. Craven 1997, cat. 13.

37. Castelli 1977, 298, cat. 193.

38. Philip Hendy, *European and American Paintings in the Isabella Stewart Gardner Museum* (Boston, 1974), 267–269.

39. Michelle W. Vanderzant, "Piero di Cosimo's Simonetta Vespucci: A Fantasy Portrait," M.A. thesis, Michigan State University, East Lansing, 1983, 61 ff; Tinagli 1997, 73–77. On generic beautiful women, see Elizabeth Cropper, "The Beauty of Women: Problems in the Rhetoric of Renaissance Portraiture," in *Re-writing the Renaissance: The Discourses of Sexual Difference in Early Modern Europe,* ed. Margaret Ferguson, Maureen Quilligan, and Nancy J. Vickers (Chicago, 1986), 175–190.

40. Sharon Fermor, *Piero di Cosimo: Fiction, Invention and Fantasia* (New Haven, 1993), 94.

41. Rogers 1988, 63.

42. Rogers 1994, 80; Joan Cadden, *Meanings of Sex Difference in the Middle Ages* (Cambridge, 1993), 182.

43. See Ronald Lightbown, *Sandro Botticelli: Life and Work* (Berkeley and Los Angeles, 1978), 164; Lightbown 1989, 130; Patricia Simons, "Portraiture, Portrayal, and Idealization: Ambiguous Individualism in Representations of Renaissance Women," in *Language and Images of Renaissance Italy,* ed. Alison Brown (Oxford, 1995), 308–309. See also the disheveled hair in the female portrait in Berlin attributed to Botticelli (color illus. in Norbert Schneider, *The Art of the Portrait* [Cologne, 1994], 29).

44. In 1439 the sumptuary laws forbade feathers of any kind placed anywhere on the female body (Rainey 1985, 448).

45. Elisabeth de Boissard, *Chantilly, Musée Condé. Peintures de l'École italienne* (Paris, 1988), 118–120, 61; Anne Derbes, "Questions of Identity: Piero di Cosimo, Simonetta Vespucci and Cleopatra," in *Italian Renaissance Studies in Arizona,* ed. Jean R. Brink and Pier R. Baldini (River Forest, 1989), 113–129. Fermor, *Piero,* 1993, 94 ff; Simons 1995, 303–306; Craven 1997, cat. 19. See also Monika A. Schmitter, "Botticelli's Images of Simonetta Vespucci: Between Portrait and Ideal," *Rutgers Art Review* 15 (1995), 33–57.

46. Derbes 1989, 116; Castelli 1977, 341, cat. 220. The inscription dates from the sixteenth century, and there is no basis for believing that the portraits identified by nineteenth- and twentieth-century art historians as "Simonetta Vespucci" necessarily represent that lady. The painting is often identified as the image of Cleopatra by Piero di Cosimo that Vasari saw in Francesco da Sangallo's house ("una testa bellissima di Cleopatra con un aspide avvolto intorno al collo") (Giorgio Vasari, *Le Vite de' più eccellenti pittori, scultori ed architettori,* ed. Gaetano Milanesi, 9 vols. [Florence, 1906], 3: 452).

47. Derbes 1989, 117; Fermor, *Piero,* 1993, 96.

48. Male portraits had already been created using the three-quarter pose: *Portrait of a Man* by Castagno, before 1457 (Washington), and by Mantegna, *Portrait of Cardinal Trevisan,* c. 1460 (Berlin).

49. Fermor, "Movement," 1993, 143.

50. As late as 1547, Dolce wrote that "my honest young woman does not seek to look about nor even to be looked at by anyone, and she does not turn her eyes here and there" (Goffen 1997, 45). Simons 1992 was the first to analyze profile portraits of women as gender-based constructions. For the profile pose, see also Jean Lipman, "The Florentine Profile Portrait in the Quattrocento," *Art Bulletin* 18 (1936), 54–102; Fermor, *Piero,* 1993, 100.

51. See also Craven 1997, 118.

52. Herald 1981, 185.

53. Frick 1995, 408.

54. Paula Nuttall, "The Medici and Netherlandish Painting," in *The Early Medici and Their Artists,* ed. Francis Ames-Lewis (London, 1995), 135–152.

55. Maryan Ainsworth and Keith Christiansen, *From Van Eyck to Bruegel: Early Netherlandish Painting in The Metropolitan Museum of Art* (New York, 1998), cat. 27.

56. Lorne Campbell, *Renaissance Portraits: European Portrait-Painting in the Fourteenth, Fifteenth and Sixteenth Centuries* (New Haven, 1990), figs. 29 and 30.

57. See the similar collars worn by Maria Hoose, wife of Jan de Witte, by the Bruges Master of 1473 (Musée royaux des beaux-arts, Brussels), and Margaret of Denmark, consort of James III of Scotland, by Hugo van der Goes, 1473–1478 (National Gallery of Scotland, Edinburgh), illustrated in Margaret Scott, *A Visual History of Costume. The Fourteenth and Fifteenth Centuries* (London, 1986), pls. 110 and 111.

58. Maryan Ainsworth and Maximilian Martens, *Petrus Christus: Renaissance Master of Bruges* (New York, 1994), 166–169, cat. 19; Marco Spallanzani and Giovanna Gaeta Bertelà, *Libro d'inventario dei beni di Lorenzo il Magnifico* (Florence, 1992), 52. It was given the extraordinarily high valuation of forty florins (Nuttall 1995).

59. The circumstances surrounding the commission of the work by Christus in Bruges in the late 1460s are unknown. Joel Upton, *Petrus Christus: His Place in Fifteenth-Century Flemish Painting* (University Park, Pa., 1990), 29–31.

60. For exceptions, see note 48.

61. Joanna Woods-Marsden, *Renaissance Self-Portraiture: The Visual Construction of Identity and the Social Status of the Artist* (New Haven, 1998), 13 ff.

62. Ruda 1993, 412–413, cat. 30.

63. Alison Wright, "The Memory of Faces: Representational Choices in Fifteenth-Century Florentine Portraiture," in *Art, Memory, and Family in Renaissance Florence,* ed. Giovanni Ciappelli and Patricia L. Rubin (Cambridge, 2000), 98, describes the blue as "celestial."

64. Frick 1995, 356.

65. Craven 1997, 163, 253. The identity of Botticelli's sitter, deriving from an inscription that postdates 1530 and may date much later, is almost certainly spurious (Patricia L. Rubin and Alison Wright, *Renaissance Florence: The Art of the 1470s* [exh. cat., National Gallery] [London, 1999], cat. 83). The inscription was part of a self-glorifying campaign for increased social status undertaken by the Florentine sculptor Baccio Bandinelli that included writing an autobiographical *Memoriale* as well as appropriating this lady into his family genealogy (Woods-Marsden 1998, chap. 14). Botticelli's fashionably dressed palace-dwelling patrician lady cannot represent Bandinelli's grandmother Smeralda (although the designation will be retained here for convenience), because his grandfather was a blacksmith and only the upper classes had their features recorded in fifteenth-century Italy.

66. Leon Battista Alberti, *On Painting and On Sculpture,* trans. Cecil Grayson (London, 1972), 54–55, para. 19; Daniel Arasse, "L'Opération du Bord: Observations sur trois peintures classiques," in *Cadres et Marges: Actes du 4ième Colloque du Cicada, Université de Pau* (Pau, 1995), 23.

67. Simons 1992, 45. According to Fra Cherubino (*Regola della Vita Matrimoniale,* dating between 1450 and 1480), the fact that "[your wife] likes being at the window" was a good reason for thrashing her (Julia O'Faolain and Lauro Martines, *Not in God's Image* [New York, 1973], 177).

68. Mirella Levi d'Ancona, *The Garden of the Renaissance: Botanical Symbolism in Italian Painting* (Florence, 1977), 197–199. The possibility that the portrait terminated in a parapet cannot be ruled out.

69. David Alan Brown, *Leonardo da Vinci. Origins of a Genius* (New Haven, 1998), 101–121, especially 114.

70. Molho 1994, 140–142.

71. Ironically, the Niccolini had no children.

72. Mary Garrard, "Female Portraits, Female Nature," in *The Expanding Discourse: Feminism and Art History,* ed. Norma Broude and Mary D. Garrard (New York, 1992), 74.

73. As Wright (2000, 104) argues in relation to Verrocchio's marble bust in the Bargello.

74. Frick 1995, 292.

75. Craven 1997, cat. 26; Frick 1995, 458. The quattrocento status of this painting is currently in question. See Roberto Bellucci et al., "Il ritratto di giovane donna della Galleria Palatina di Firenze: risultati di un'indagine preliminare," *OPD Restauro* 3 (1988), 64–73; Roberto Bellucci et al., "Ancora sulla 'Bella Simonetta,'" *OPD Restauro* 4 (1989), 120–128.

76. John Shearman, "Leonardo's Colour and Chiaroscuro," *Zeitschrift für Kunstgeschichte* 25 (1962), 13–47.

77. See Craven 1997, chap. 7.

78. Rainey 1985, 516 ff, 584 note 1. The date was 29 February 1471/1472.

79. Rainey 1985, 563.

80. See page 81.

81. Craven 1997, cat. 34; Martin Davies, *The Earlier Italian Schools* (London, 1961), 223 f. For the attribution to Fra Bartolomeo, see Everett Fahy, "The Earliest Works of Fra Bartolommeo," *Art Bulletin* 51 (1969), 150.

82. For the significance of the elbow, see Joneath Spicer, "The Renaissance Elbow," in *A Cultural History of Gesture from Antiquity to the Present Day,* ed. Jan Bremmer and Herman Roodenburg (Oxford, 1991), 84–128.

83. Fermor, "Movement," 1993, 143.

84. John Shearman, *Only Connect… Art and the Spectator in the Italian Renaissance* (Princeton, 1992), 110–113; Jean Cadogan, *Domenico Ghirlandaio* (New Haven, 2000), cat. 46; Maria K. DePrano, "Uxor Incomparabilis: The Marriage, Childbirth and Death Portraits of Giovanna degli Albizzi," M.A. thesis, University of California, Los Angeles, 1997; Randolph 1995, 114–115. Dated the year Giovanna died, her "independent likeness" appears to derive from her medals and her portrait in the *Visitation* (Tornabuoni Chapel, Santa Maria Novella, Florence), which may or may not have been painted from life. Thus, the profile format here was probably a special case; had the sitter been alive at the moment of depiction, it seems highly likely that she would have been depicted in three-quarter view, as were most of Ghirlandaio's female sitters. See Levi d'Ancona 1977, 242–244, and Deprano 1997, 45, for the funerary connotations of the narcissus that is featured on Giovanna's sleeve.

85. A jewel similar to the one worn by Giovanna, described in a letter from Giacomo Trotti to the duke of Ferrara in 1491, was valued at 10,500 ducats (Castelli 1977, 296–297, cat. 189; F. Malaguzzi Valeri, *La corte di Lodovico il Moro* [Milan, 1913–1923], 382). Coral beads traditionally warded off evil spirits (Castelli 1977, 334, cat. 30).

86. Randolph 1998, 196.

87. *Pisanello: le peintre aux sept vertus* [exh. cat., Musée du Louvre] (Paris, 1996), cat. 105; Craven 1997, cat. 1.

88. Fernand Mercier, "La valeur symbolique de l'oeillet dans la peinture du moyen-âge," *Revue de l'Art Ancien et Moderne* 71 (1937–1938), 233–236; André Chastel, "Les jardins et les fleurs," *Revue de l'Art* 51 (1981), 45; Mirella Levi d'Ancona, *Botticelli's Primavera: A Botanical Interpretation including Astrology, Alchemy, and the Medici* (Florence, 1983), 74, 58 note 116; Tinagli 1997, 52; Dominique Cordellier, *La princesse au brin de genévrier* (Paris, 1996), 32–33. In Greek, the term for butterfly also means soul.

89. Joanna Woods-Marsden, "Per una tipologia del ritratto di stato nel Rinascimento italiano," in *Il Ritratto e la memoria. Materiali 3,* ed. Augusto Gentili, Philippe Morel, and Claudia Cieri Via (Rome, 1993), 31–62. This is discussed extensively in Joanna Woods-Marsden, "Piero della Francesca's Ruler Portraits," in *Companion to Piero della Francesca,* ed. Jeryldene M. Wood, Cambridge, in press.

90. Woods-Marsden, in press.

91. Fern R. Shapley, *Catalogue of the Italian Paintings. National Gallery of Art* (Washington, 1979), 380; Paola Venturelli, "Un gioiello per Bianca Maria Sforza e il ritratto di Washington," *Arte Lombarda* 116 (1996), 50–53. I am grateful to David Alan Brown for allowing me to read his entry on this work for a forthcoming systematic catalogue of Italian paintings in the National Gallery of Art.

92. Yvonne Hackenbroch, *Renaissance Jewellery* (New York, 1979), 11.

93. Venturelli 1996.

94. Janice Shell and Grazioso Sironi, "Cecilia Gallerani: Leonardo's Lady with an Ermine," *Artibus et Historiae* 25 (1992), 47–66; David Alan Brown, "Leonardo and the Ladies with the Ermine and the Book," *Artibus et Historiae* 22 (1990), 47–61.

95. The gesture of hand on womb is not, in my view, an adequate basis for describing the sitter as pregnant.

96. Daniel Arasse, *Léonard de Vinci: le rhythme du monde* (Paris, 1997), 393 ff. Mantegna had given a similar pose to Lodovico Gonzaga in the court scene of the *camera dipinta* in the castello in Mantua in 1474.

97. Arasse 1997, 393 ff.

98. Paul Barolsky, "La Galerani's Galee," *Source* 12 (1992–1993), 13–14. For the influence of this work on Costa's *Portrait of a Lady with a Dog* at Hampton Court, see Brown 1990, 54.

99. Janet Cox-Rearick, *The Collection of Francis I: Royal Treasures* (Paris, 1996), cat. IV-5. Born in 1479 and married in 1495, Lisa was considerably older than the other Florentine female sitters discussed here.

100. Charles de Tolnay, "Remarques sur la Joconde," *La Revue des Arts* 2 (1952), 21; Woods-Marsden, in press. For the (reconstructed) portrait of the *Old Man and Old Lady* seated on a visible balcony, see Campbell 1990, 54, fig. 59. For portraits by Leonardo, see Carlo Pedretti, *Leonardo: il Ritratto,* supplement to *Art Dossier* 13 (October 1998).

101. Tolnay 1952, 19–20, figs. 3 and 4; Arasse 1997, 391.

102. Tolnay 1952, 23–24.

103. Laurie Schneider and Jack D. Flam, "Visual Convention, Simile and Metaphor in the Mona Lisa," *Storia dell'Arte* 29 (1977), 21. For the landscape, see also Webster Smith, "Observations on the Mona Lisa Landscape," *Art Bulletin* 67 (1985), 183–199. For the analogy between woman and nature, see Garrard 1992, 68–69.

104. Tolnay 1952, 23–24.

105. For the sociable portrait, see Shearman 1992, chap. 3.

106. Garrard 1992, 63, reads Ginevra's expression as "sober, dignified"; Cropper 1986, 188, as "withdrawn." In Venice, Antonello da Messina had introduced smiles and frowns into male portraiture in the 1470s.

107. For the cartoon, see Françoise Viatte, *Léonard de Vinci, Isabelle d'Este* (Paris, 1999).

108. Goffen 1997, 22; Rogers 1988, 62.

109. Catherine Reynolds, "Reality and Image: Interpreting Three Paintings of the 'Virgin and Child in an Interior' Associated with Campin," in *Robert Campin: New Directions in Scholarship,* ed. Susan Foister and Susie Nash (Turnhout, 1996), 188. I am grateful to Lorne Campbell for discussing this point with me and bringing the reference to my

attention. A similar hairstyle to that of Isabella d'Este is featured in Boltraffio's *Portrait of an Unknown Woman* in the Castello Sforzesco, Milan.

110. Lisa's dark color scheme should not be read as mourning. A curious component of the outfit is the length of cloth she wears over her left shoulder, variously referred to in the secondary literature as "shawl," "veil," or "scarf," that I have not observed in other, contemporary likenesses.

111. Frank Zöllner, "Leonardo's Portrait of Mona Lisa del Giocondo," *Gazette des Beaux-Arts* 121 (1993), 119.

112. *Ra aello nelle raccolte Borghese* [exh. cat., Galleria Borghese] (Rome, 1984), 20–28. The work has also been attributed to Ridolfo del Ghirlandaio (Sydney J. Freedberg, *Painting of the High Renaissance* [Cambridge, Mass., 1961], 79, pl. 82).

113. See Roger Jones and Nicholas Penny, *Raphael* (New Haven, 1983), 29.

114. *Ra aello a Firenze* [exh. cat., Pitti Palace] (Florence, 1984), cat. 9.

115. Ettore Camesasca, *Tutta la pittura di Ra aello* (Milan, 1962), 47.

116. Alberti 1972, 79, para. 40.

117. Shearman 1962. Since Leonardo gave gems to the Virgin in his pictures of her, it is unclear why they should not have been equally appropriate for the lady in her portraits. I thank Paul Barolsky for his valuable comments on this issue.

118. Michael P. Fritz, *Giulio Romano et Raphael, La vice-reine de Naples* (Paris, 1997); Goffen 1997, 95. Titian had already used a life-size format for his portrait of the so-called Schiavona of c. 1510 (National Gallery, London).

119. Cox-Rearick 1996, 214 ff, cat. VI-5; Paul Joannides, "Opere giovanili di Giulio Romano," *Paragone* 36 (1985), 18–19; Fritz 1997.

120. *Raphael dans les collections françaises* [exh. cat., Grand Palais] (Paris, 1984), 100, cat. 12.

121. Arasse 1997, 397.

122. Campbell 1990, 74–75.

123. Antonio Natali, *La Piscina di Betsaida. Movimenti nell'arte fiorentina del Cinquecento* (Florence, 1995), 116–137. The painting was formerly attributed to Bugiardini (Freedberg 1961, 207, pl. 269).

124. Sylvie Béguin, *Raphael dans les collections françaises* (Paris, 1983–1984), 54–57; Paris 1984, 98–101, 421–422, for changes to the face revealed by x-ray and infrared photography.

125. Simons 1992, 55 note 49; Cadogan 2000, cat. 46.

126. Lydecker 1987, 167. Portraits were not included among the usual commissions of furniture with which the camera was decorated.

127. Lydecker 1987, 64 ff, 169 ff.

128. Andrée Hayum, "Michelangelo's Doni Tondo: Holy Family and Family Myth," *Studies in Iconography* 7–8 (1981–1982), 209–233.

129. See Lydecker 1987, 174; Richard A. Goldthwaite, "L'interno del Palazzo e il consumo dei beni," in *Palazzo Strozzi. Metà Millennio 1489–1989,* Atti del convegno di studi 1989 (Rome, 1991), 159–166; Tinagli 1997, 35; Peter Thornton, *The Italian Renaissance Interior, 1400–1600* (New York, 1991), 265, 285. The concept of the "bedroom" as private is modern. At the court of Mantua, meetings were held and documents witnessed in the *camera dipinta* that contained a bed.

130. Tinagli 1997, 60; Woods-Marsden, in press.

131. See Angelica Dülberg, *Privatporträts: Geschichte und Ikonologie einer Gattung im 15. und 16. Jahrhundert* (Berlin, 1990).

132. See also Luke Syson, "Consorts, Mistresses and Exemplary Women: The Female Medallic Portrait in Fifteenth-Century Italy," in *The Sculpted Object: 1400–1700,* ed. Stuart Currie and Peta Motture (Hants, 1997), 43–64.

133. On the painting reverse, see Claudia Cieri Via, "L'immagine dietro al ritratto," in *Il Ritratto e la Memoria. Materiali 3,* ed. Augusto Gentili, Philippe Morel, and Claudia Cieri Via (Rome, 1993), 9–29.

134. See Joanna Woods-Marsden, review of David Alan Brown, *Leonardo da Vinci: Origins of a Genius,* 1998, in *Renaissance Quarterly* 51 (1999), 1152–1153. The quotation comes from Cropper 1986, 188.

135. Woods-Marsden, in press.

136. *Metamorphoses,* V, 260–415. Florence 1984, cats. 8 and 9; Hayum 1981–1982, 220. I thank Paul Barolsky for his important comments on the Ovidian myth.

137. Alessandro Cecchi, "Agnolo e Maddalena Doni committenti di Raffaello," in *Studi su Ra aello,* ed. Micaela Sambucco Hamoud and Maria Letizia Strocchi (Urbino, 1987), 1: 437. John Shearman, "On Raphael's Chronology, 1503–1508," in *Ars naturam adiuvans: Festschrift für Matthias Winner,* ed. Victoria v. Flemming and Sebastian Schütze (Mainz, 1996), 205, dates the Doni diptych to 1508.

138. For the use of sliding portrait covers in the sixteenth century, see Tinagli 1997, 117 note 10.

139. David Alan Brown, Peter Humfrey, and Mauro Lucco, *Lorenzo Lotto: Rediscovered Master of the Renaissance* [exh. cat., National Gallery of Art] (New Haven, 1997), cats. 4 and 5.

140. Harry Berger, Jr., "Fictions of the Pose: Facing the Gaze of Early Modern Portraiture," *Representations* 46 (1994), 87–120.

141. Brown 1990.

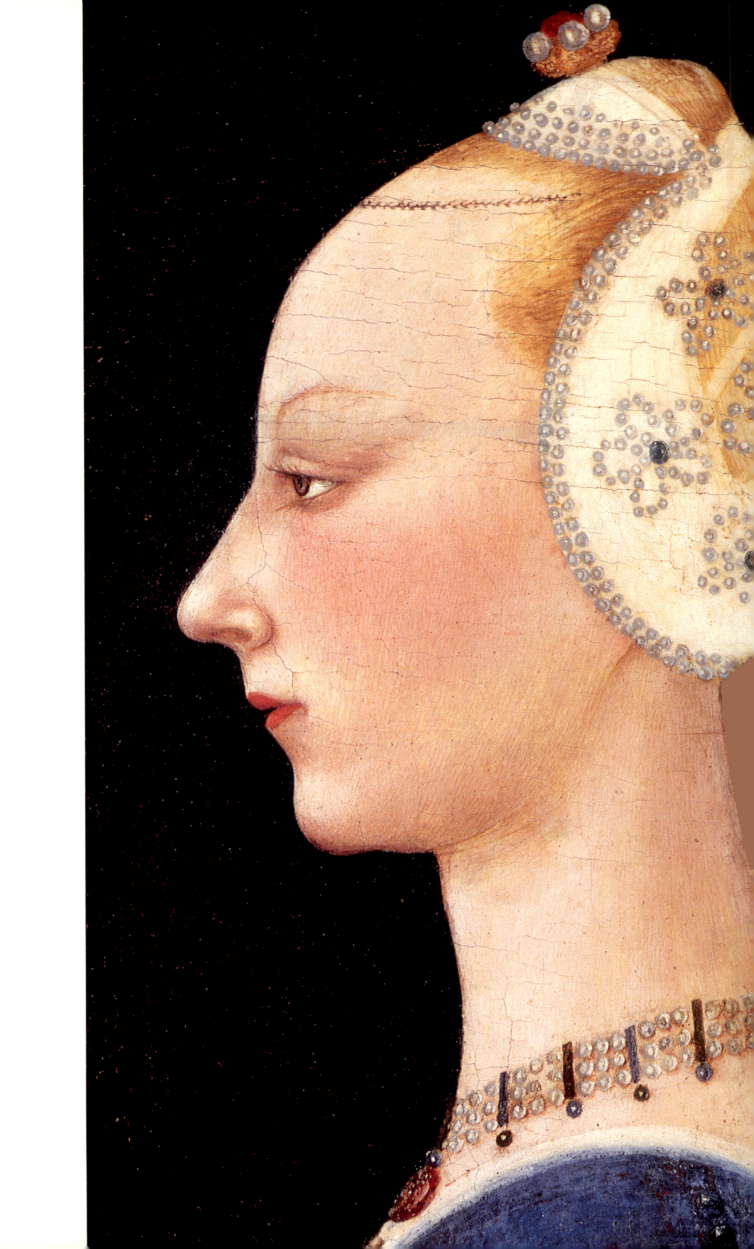

Costume in Fifteenth-Century
Florentine Portraits of Women

Roberta Orsi Landini

Mary Westerman Bulgarella

1

Antonio del Pollaiuolo, *Profile Portrait
of a Young Woman,* Staatliche Museen
zu Berlin, Preussischer Kulturbesitz,
Gemäldegalerie (photo: Jörg P. Anders)

2

Agnolo or Donnino del Mazziere,
Portrait of a Young Woman, Staatliche
Museen zu Berlin, Preussischer
Kulturbesitz, Gemäldegalerie

In her portrait (cat. 16) by Leonardo da Vinci, Ginevra de' Benci is depicted in a plain, everyday dress, called a *gamurra*. This type of garment conveyed modesty, an important virtue for a fifteenth-century woman to possess. Even its color, cinnamon, denotes demureness, but that impression is offset by closer analysis of other details. The cloth, for example, a rich light wool, molds to her body without constraint. A silk *coverciere*,[1] the neckline and shoulder covering prescribed by the sumptuary law of 1464, is fastened with a small gold button or pin and veils her décolletage. Necklines, as mandated by law, could be no lower than 1⁄16 of a "braccio," or about 3.3 centimeters, from the base of the neck, and the *coverciere* had to be of a plain-weave silk, linen, or wool without embroidery or decoration. Ginevra's covering is too fine and transparent to conceal her skin as required, but the use of such sheer fabric rather than one more opaque seems typical of the period (see cats. 25, 29).[2] Leonardo paints every detail of the dress with accuracy, and his choice of muted colors conveys a subtle elegance that emphasizes quality of material over ostentation.

Florence was one of the most important centers for the production of wool clothing, while the most beautiful silk veils, so frequently painted by Florentine artists, were a specialty of Bolognese weavers, who could very well have produced Ginevra's. At the time the portrait was painted, the art of silk veil weaving was new to the city. Cosimo Dini and his workshop, which employed at least thirty female weavers, had practiced the skill exclusively since 1476. He had brought this technique to Florence from Bologna, where he had learned the secrets of the trade,[3] but the production could not have been great enough to satisfy the enormous demand for thin silk veils on the fashionable Florentine market.

Like Ginevra, many other contemporary Florentine women were depicted wearing a *gamurra*. In public, such a garment would have been worn with an overdress, either a *giornea* or a *cioppa*. The *gamurra* generally laced up the bodice[4] in a manner called *accordellata* and could be simple or elaborate according to the occasion.[5] The red *gamurra* in the *Portrait of a Lady* attributed to Ghirlandaio (cat. 29)

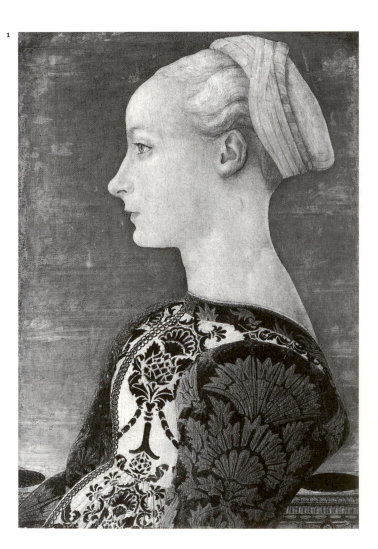

perfectly synthesizes the garment's tailoring: squared neckline, central opening closed with lacing, straight cut, slightly raised waistline, and a gathered skirt. A belt emphasizes the joining of the skirt to the bodice. The bodice opening might be purely decorative, ending in a point at the waist, or functional, if placed on the sides and continued on the skirt, as illustrated in many images.[6]

A variety of sleeve shapes and their tailoring details may also be observed in portraits of Florentine women. The more important the dress, the more decorative the sleeves. Sleeves could be partly (cat. 30) or completely sewn to the bodice (fig. 1), or detachable as depicted in the *Young Woman* by Agnolo or Donnino del Mazziere (fig. 2). There the sleeves are fastened to the bodice with ties end-

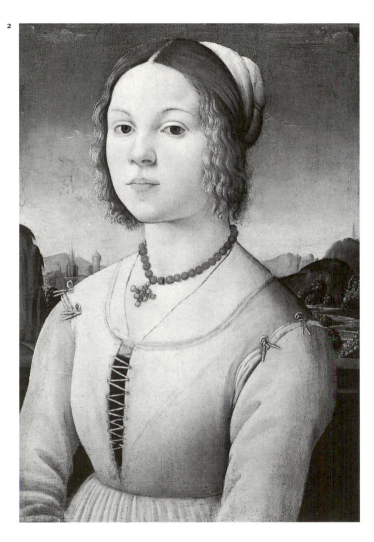

ing in silver aglets, which pass through three metal, perhaps silver, eyelets per sleeve. Detachable sleeves were useful not only to ease arm movements, but also to modify and enhance the dress. Sleeves could be cut in one or two pieces, with decorative slits, either completely or partially at the elbow, down the length of the arm (cats. 29, 30), or just below the elbow to the wrist (cat. 25). The slits were generally secured with lacing but loops and buttons were also used,[7] adding to the ornamentation. Close-fitting sleeves with decorative slits were typical during the second half of the century. Prior to that, sleeves were more commonly cut in two, with the upper part gathered and the lower part fitted from the elbow to the wrist, similar to those of the dress worn by the Scolari bride in the painting by Filippo Lippi (cat. 3).

Between the sleeves and bodice, at the neckline and under the lacing, the shirt—always white and often enriched with fine lace or embroidery—was visible. Painters often dwelled on the rendering of refined shirt borders (fig. 3; cats. 4, 25, 28). The lightest and best quality shirts were of linen from Cambrai, Reims, or Holland, and constituted an important part of a bride's dowry. From the fifteenth century onward shirts are described in the contemporary documents as decorated *ad reticellas,* that is, with drawn threadwork, and were sometimes embroidered in

gold or black and red silk.[8] The commissioning and meticulous care of shirts, as of all the personal and domestic linens, were among the principal occupations of the *mater familias,* as the letters from Alessandra Strozzi to her children clearly tell us.[9] A beautiful shirt, like those seen in fifteenth-century Florentine portraits, indicated the wearer's role as a perfect housekeeper.

Similar to the long shirts are the white linen dresses that Sandro Botticelli and his followers so often painted on their allegorical or mythological female figures.[10] Though the painter must have partially invented aspects of the dress, the accuracy with which the tailoring construction and details are depicted indicates that they must have derived from real apparel (cat. 28). The trimmings are woven in silver thread with a clear and identifiable pattern, and the delicate needlework at the neckline, described with the same accuracy as the shirt's lace, is immediately recognizable. The rich garment, actually an overdress, is worn atop a fine red embroidered silk gown, which is over an exquisite white shirt. The "five linen shirts, or rather dresses embroidered in gold" registered among objects confiscated from the Medici in 1497[11] were perhaps garments of this kind, or at least indicate that they did exist at that time.

There can be no doubt about the authenticity of the transparent garment worn over a red silk gown trimmed in gold in *Woman at a Window,* also by Botticelli (cat. 25). A similar garment must have been the "*cioppa di mosca-voliere* with the sleeves embroidered with gold thread"[12] listed with the precious articles among the gifts to Nannina de' Medici, betrothed to Bernardo Rucellai in 1461. The *moscavoliere* was probably a very light veil, more commonly used around beds for protection from mosquitoes and flies. Smeralda's *cioppa* was clearly made from a very light silk veil of this kind. A silk even more sheer covers her décolletage, similar to the *coverciere* worn by Ginevra. Following a practice diffused in Florence in this period,[13] which spread in the following centuries, she is holding in one hand a precious handkerchief, probably of fine muslin with a thin gold trim. Nannina de' Medici also received a linen handkerchief refined with gold and another with pearls and silver among her wedding gifts.

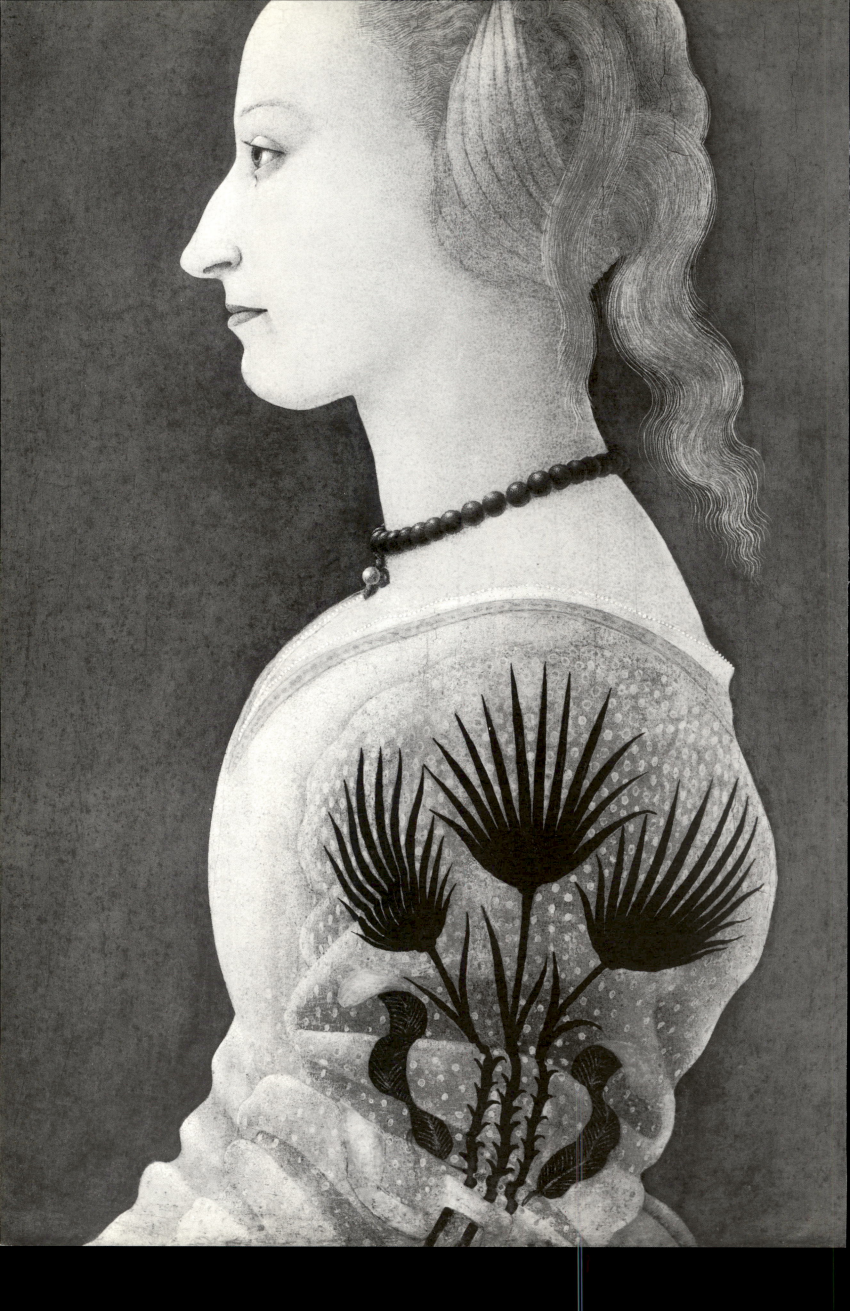

3
Alessio Baldovinetti, *Portrait of a Lady in
Yellow* (detail), National Gallery, London

The *cioppa* could be substituted by the *giornea,* both being overdresses worn for formal occasions and to promenade. The *giornea* was sleeveless and opened at the sides, as seen in Andrea del Verrocchio's marble bust of a young woman (cat. 23) and Domenico Ghirlandaio's portrait of Giovanna Tornabuoni (cat. 30)—and therefore more appropriate for summer. The *cioppa's* sleeves, on the other hand, were ample and ornamental and the most important part of the garment. It could be made of fine wool cloth, the best being dyed in red (cat. 3), but also of splendid silk velvet, and fur-lined for winter wear. The *cioppa* worn by the lady in the portrait by Filippo Lippi (cat. 4) is in pale green wool, the richness of which is suggested by the quantity of cloth needed to construct it. A series of deep pleats, starting at mid-breast and completely surrounding the chest, are pulled into the waist by a white belt of a soft and pliable material that curves to the waistline. The same type of pleating and belting is visible on the red *cioppa* worn by the Scolari bride (cat. 3). The sleeves of the green *cioppa* widen at the cuffs to reveal the sleeve of the matching *gamurra,* under which the shirt, decorated in needlework, can be seen. The neckline is trimmed with white fur *(lattizi),* which was most likely repeated at the lower hem. The tailoring of the *cioppe* these two ladies wear seems to be almost the same with the exception of the sleeves. Those of the Scolari bride are far more important and rich, with their "goiter" shape *(a gozzo)* and lavish embroidery spelling out "LEALTA" (loyalty) in precious metal.[14] The bizarre outer sleeve opening, lined with white fur, as was probably the entire garment, exposes the opulence of the *gamurra,* cut in one of the most precious velvets produced in Florence. The velvet seems to be a pile on pile with brocaded design and *alluciolato* effects, a technique limited to only a few weavers who could produce no more than about sixty meters a year.[15] This ensemble is clearly bridal attire, for which the groom spent a true fortune.

From the family logbooks *(libri di ricordanze)* held by the Florentine *pater familias,* we know how large an investment was made to create garments similar to the ones depicted in the Lippi portrait. The lengthy story of the *cioppa* that Francesco Castellani made for his second bride,

Lena Alamanni, is significant in this respect.[16] The dress was a "family project" involving all the husband's relatives and friends in choosing not only the cloth (a magnificent pile-on-pile velvet in kermes red) but also the design of the embroidery, which was to further embellish it. The husband chose the motif that would richly decorate the shoulders and sleeves: a sun with long rays and an eagle that flew toward it signifying the rebirth of the bird as well as himself. Every detail was discussed with the artisans. He bought gold and the pearls necessary for the embroidery, keeping a careful account of all the money spent in his logbook.[17]

It was the groom's task to dress the bride in a fashion appropriate to his social status. Sometimes the expenses made to dress the wife corresponded to as much as fifty percent of her dowry[18] and covered the manufacture of the dress and the overdress (a *gamurra* or *cotta* and a *cioppa* or *giornea*), as well as the purchase of precious textiles; materials such as pearls, gold, and threads for the decoration; and the services of the tailor and embroiderer. To these costs was added that of suitable jewelry, sometimes numerous rings with precious gemstones, two brooches—one for the head, one for the shoulder—and a necklace, often with a pendant. The apparel of the bride must have been completed with a large number of pearls and sometimes gold decoration worn on her head in a variety of headdresses (cats. 3, 4, 5), with such imaginative names as "garland" *(grillanda),* "saddle" *(sella),* "beehive" *(vespaio),* or "cap" *(cappuccio).*

In letters to her son in Naples, in 1447, Alessandra Strozzi described the upcoming wedding of her daughter Caterina. She stated that the groom had spent four hundred florins for her headdress alone, a garland of peacock feathers and pearls. He then ordered a *cotta* in kermes-dyed figured velvet, and a *cioppa* with large sleeves lined with marten, all embroidered in pearls.[19] Referring to wedding gifts, the mother noted in another letter: ". . . when the young bride goes out she wears the value of her entire dowry in silks and jewels."[20]

The Scolari bride wears not a garland, but rather a *sella alla fiamminga,* a headdress in fashion from the second quarter of the fifteenth century until the 1470s.[21] Her *sella* is on a *cappuccio* trimmed with pearls and covered with tiny

feathers (cat. 3). A similar decoration appears to be embroidered in pearls and gold on the actual *sella,* which features a large pearl head brooch at its center. From each side of the *sella* hang two *becchetti* of different lengths richly embroidered with gold threads, sequins, and probably pearls.[22] A number of small objects for this kind of embroidery— peacock eyes *(occhi di pavone),* spangles *(tremolanti),* tiny stars *(stelluzze),* rays *(raggi),* and sequins *(piastroline)*— were commissioned from goldsmiths,[23] but pearls were the preferred ornament for bridal attire.[24] Here they are strung around the sitter's neck and encircle the large diamond shoulder brooch. Pearls, with their round shape and white color, symbolized perfection and purity, one of the most important virtues of the bride.

Wearing pearls and rings with precious stones testified to the marital status of the young women portrayed.[25] In Florence, the gifting of rings was more than a formal declaration of marriage, it was a wedding ceremony, even if privately celebrated, in which the agreement between the two families was legally sanctioned and the dowry price and payment terms were established. During this period the groom had time to prepare the elaborate new garments, headdresses, and suitable jewels. After the bride's father finished paying the dowry, the public wedding took place and the bride was taken to the husband's home with great celebration and fanfare. She could receive more rings from the female members of her new family. Rings, belts, necklaces, or objects of circular shapes were a reminder to the new bride of her position and duties in the new family's circle and labeled her as one of them. The jewels, which always remained the husband's possession, could be worn by the new bride only for a few years, after which they could be used as gifts to other brides in a continuous exchange that solidified the family ties.[26] Rings are not the only objects denoting a bride in the portraits: head brooches or the precious necklace pendants had the same function. The jewels, which denote honor,[27] are proof of the union and the public manifestation of the exchange of property between families.[28]

The textiles, in some cases more expensive than the jewels, had the same significance.[29] Many women's portraits of the fifteenth century displayed the most precious silks produced by Florentine workshops, the most beautiful in the Western world. The dress worn by a woman in a Pollaiuolo portrait (fig. 1) is a perfect example of textiles as the focus of the painting rather than the sitter. The sleeves are of a gold-brocaded crimson velvet with an embroidered ground, and the rest of the dress is a polychrome velvet on a white ground. This precious kind of velvet was a Florentine specialty.

Wool and silk were the primary sectors in the cloth industry from which the most powerful and richest Florentine families derived their wealth. The marriage was an occasion to transform the bride into a showpiece of the glories of their production. Textiles were actually the synthesis of a very complex financial, industrial, and mercantile process from which entire fortunes were created and sustained. It is no wonder that the artist put all his skill in visually describing figured silks and brocaded velvets; indeed, the artists commissioned to paint the portraits may have been asked to furnish designs for the most precious and expensive textiles. In the case of the Medici, the artists' patron, the banker, and the *setaiolo* (silk producer and merchant), were often one and the same.

Silk patterns in the Renaissance had symbolic significance, almost always referring to Christ, his Passion, and Resurrection.[30] For bridal wear, pinecone or pomegranate motifs, relating to the Resurrection, fertility, and eternity, were preferred over the curled thistle leaves recalling the Passion. Patterns with stylized fruits, bursting with seeds and accompanied by blossoms and flowers, were most auspicious for a young bride to bear many children to carry on the family name (cats. 3, 31b). But these expensive fabrics were produced primarily for sale on the foreign market, which took in the whole of Europe and reached many of the Muslim countries. The Florentines used them only on special formal occasions in which it was socially necessary to show off the family's political and financial importance and thus display their honor. A wedding was, of course, one of these occasions.

The sumptuary laws respected such a need. During the fifteenth century they may have changed every twenty

years or so, in a vain attempt to control the extravagant new fashions, but they all allowed the bride to wear her opulent apparel for a limited time after the marriage. She had to progressively diminish the wealth of her wardrobe,[31] however, eventually reducing it to simple and plain dresses that were more suited to the virtues of a married woman and a *mater familias*: modesty, demureness, and decency.[32]

Just as the lavish dress and jewels in the Florentine portraits denote wedding attire, so too a plain dress with few or no jewels generally signal a wife some years after the wedding. Even so, it seems that the patron asked the artist to depict the important jewels he had given his bride for their marriage even if wearing them was forbidden by the sumptuary laws. Giovanna Tornabuoni (cat. 30),[33] portrayed a few years after her wedding, wears a superb pendant with a diamond, ruby, and three large pearls, as well as rings; a brooch, notable for its stones and goldsmith work, occupies a ledge behind her. The same device is used by Sebastiano Mainardi (cat. 31b). Like Ghirlandaio, he placed in the background the jewels that are reminders of both the husband's and the father's gifts: an opulent brooch, a ring, the jewelry box, a coral necklace, and a devotional book.[34] In this case the wedding must have taken place some years earlier, as the young woman, like Ginevra, wears a refined but not particularly expensive dress with only a necklace of crystal and gold, as well as a simple hairstyle. Other than the displayed gifts, Giovanna's *giornea* of rich patterned silk clearly testifies to the link between the two families united through her marriage. The "L" of the husband Lorenzo Tornabuoni is interlaced with the eagle of the Albizzi family. But it was usually the husband who gave his brand to the bride's dress with his *impresa,* woven or embroidered and generally placed on the left sleeve (fig. 3; cat. 3).[35]

On the bride's sleeve and headdress the complex social and cultural meanings of the union were concentrated. Thus, brides were necessarily portrayed in profile,[36] as the pose, even if only in half-bust, allowed the best view of jewels worn on the head and sufficient exposure of the textiles and embroidery to convey the value of the dress. The accurate rendering of the bride's jewels, dress, and head gear also constituted a further visual testimony of the husband's property, which could be useful in the event of a legal dispute for repossession should the husband predecease his wife.[37]

In a letter of 10 November 1466, to her sons, Alessandra Strozzi wrote: "Never before have people spent such quantities of wealth for dressing women."[38] Yet the jewels and even the dresses made for them were not a woman's possessions, but that of her husband. When the time conceded by the sumptuary law to wear them had passed, he could sell them without even consulting her. The luxurious wedding apparel of Caterina Strozzi so admired by her mother Alessandra ended up this way some years after the ceremony.[39] It can be surmised, therefore, that one aim of sumptuary laws, forbidding the wife to use her wedding gifts after a determined period, was to allow the husband to repossess a portion of the great cost he spent for them and give him the opportunity to invest it in a more profitable way. The wedding was the only moment in a woman's life when she acquired social visibility as public personification of the ties between two families. She was only a medium, and in her profile portrait seems to be no more than a support for the signs of her husband's power and wealth.

NOTES

1. Curzio Mazzi, ed., *Due Provvisioni Suntuarie Fiorentine* (Florence, 1908), *Statuti del 1464*, 15 and 16, 7.

2. For comparative examples, see the *Portrait of a Young Woman* by Domenico Ghirlandaio in the National Gallery, London, where a similar *coverciere* is fastened with an identical round gold button.

3. Umberto Dorini, *Statuti dell'Arte di Por Santa Maria del tempo della Repubblica* (Florence, 1934–1942), 653–656 and 686. The municipality of Florence gave him many privileges for increasing his activity, allowing him, his son, and his nephews to carry weapons night and day and be protected from the Bolognese silk guild by four bodyguards.

4. Ornella Morelli, "I Costumi," in *Gli abiti di Carlo Crivelli*, ed. Michele Polverati (Ancona, 1990), 50.

5. The difference between the *gamurra* and the *cotta* is not clear. Some authors base the distinction between the two on materials, with a heavier cloth denoting the *gamurra* and a lighter one for the *cotta*, the latter being preferred for summer wear. For this distinction, see E. Polidori Calamandrei, *Le vesti delle Donne Fiorentine nel Quattrocento* (Rome, 1973), 36–40, and Rosita Levi Pisetzky, *Storia del Costume in Italia* (Milan, 1964), 2: 246–248. Some authors propose the *cotta* as an extraordinary dress, made generally for weddings (see Aurora Fiorentini Capitani and Stefania Ricci, *Il costume al tempo di Lorenzo il Magnifico Prato e il suo territorio* [Milan, 1992], 68–70 and Morelli 1990, 53). In the contemporary documents we find *cotte* made of velvet, certainly not a summer cloth. For examples of the 1464 sumptuary law forbidding *cotte* of pile-on-pile velvet, see Mazzi 1908, 5, and Carol Collier Frick, "Dressing a Renaissance City: Society, Economics and Gender in the Clothing of Fifteenth Century Florence," Ph.D. diss., University of California, Los Angeles, 1995, 555.

6. See in Domenico Ghirlandaio, *Birth of Saint John the Baptist*, Florence, Santa Maria Novella, the figure of the nurse on the left (see Kent's essay, fig. 13). For the tailoring of fifteenth-century clothes, see Elisabeth Birbari, *Dress in Italian Painting 1460–1500* (London, 1975).

7. See also the sleeve of *Prudence*, by Antonio Pollaiuolo, Uffizi Gallery, Florence.

8. Curzio Mazzi, *La camicia. Ricerche d'antico costume italiano* (Florence, 1915), 10 and 18. For the number of shirts in the trousseau, see Mazzi 1915, 10, and Polidori Calamandrei 1973, 101; Levi Pisetzky 1964, 285. Generally there were a dozen in a trousseau, but their number and richness grew until, by 1515, Lucrezia Borgia had two hundred in her dowry.

9. Alessandra Macinghi Strozzi, *Lettere ai figlioli* (Florence, 1914).

10. See Simonetta Vespucci in *The Primavera*, Uffizi Gallery, Florence; Venus in *Mars and Venus*, The National Gallery, London.

11. Mazzi 1915, 23: "5 chamice overo veste, di tela ricamate d'oro."

12. See Maria Ludovica Lenzi, *Donne e Madonne. L'educazione femminile nel primo Rinascimento italiano* (Turin, 1982), 151, and G. Marcotti and G. Barbera, *Un mercante fiorentino e la sua famiglia nel secolo XV* (Florence, 1881), for the complete list of the gifts given to Nannina for her wedding.

13. Polidori Calamandrei 1973, 102.

14. The name Scolari appears to be among the debtors of a tailor called Antonio di Jacopo, nicknamed Barberino, in the years between 1445 and 1457. Barberino was at the service of the best Florentine families, such as the Bardi, Pucci, Capponi, Strozzi, Salviati, Soderini, Peruzzi, as well as Benci. See Frick 1995, 546.

15. Roberta Orsi Landini, "Il trionfo del velluto. La produzione italiana rinascimentale," in *Velluto Fortune Tecniche Mode*, ed. Fabrizio de' Marinis (Milan, 1993), 28; Roberta Orsi Landini, "Il fasto rinascimentale: la ricerca dell'inimitabilità," in *Velluti e Moda tra XV e XVIII secolo*, ed. Annalisa Zanni (Milan, 1999), 45–48.

16. The story is analyzed by Frick 1995, 16–24.

17. The amount of time it took to create such an important garment made it impossible for poor Lena to wear it either at or after her wedding; meanwhile, the embroiderer had died so that her husband had to repossess all the precious materials and sell them to recover some cash.

18. *Statuta Populi et Communis Florentiae* (Friburgi Apud Michaelem Kluch, 1415), 156, rubrica LXI.

19. Macinghi Strozzi 1914, 10. In that case Parente Parenti, the groom, spent much more than half of the value of the dowry of Caterina Strozzi, which amounted to one thousand florins. The details of these expenses are analyzed by Frick 1995, 52–55.

20. Macinghi Strozzi 1914, 154, letter of 11 January 1466: "Non è si gran dota, che quando la fanciulla va fuori, che tutta l'ha in dosso, tra seta e gioie...."

21. Levi Pisetzky 1964, 290. *Selle* are forbidden by the sumptuary law of 1456. See also Ronald Rainey, "Dressing Down the Dressed-Up: Reproving Feminine Attire," in *Renaissance Society and Culture. Essays in Honor of Eugene F. Rice*, ed. John Monfasani and Ronald G. Musto (New York, 1991), 219.

22. The same kind of *sella* can be seen in the embroidered panel designs of Antonio Pollaiuolo in the Opera del Duomo Museum, Florence, in particular those of *Saint John Preaching Before Herod* and *The Feast of Herod*.

23. Alessandro Guidotti, "Accessori d'abbigliamento in documenti inediti fiorentini della prima metà del XV secolo," in *Il costume nell'età del Rinascimento*, ed. Dora Liscia Bemporad (Florence, 1988), 322.

24. Macinghi Strozzi 1914, 122.

25. Christiane Klapish-Zuber, *La famiglia e le donne nel Rinascimento* (Rome, 1995), 190: since 1373 the right to bring rings and silver belts is reserved for the fiancée or married women.

26. Klapish-Zuber 1995, chaps. 5 and 6, for the meanings of nuptial rites and the significance of the ring.

27. Jane Bridgeman, "'Condecenti et netti...': Beauty, Dress and Gender in Italian Renaissance Art," in *Concepts of Beauty in Renaissance Art*, ed. Francis Ames-Lewis and Mary Rogers (Hants, England, 1998), 48–49: the artist's task was to render the sitter's status (social and economic) completely legible with appropriate jewelry and dress.

28. Adrian Randolph, "Public Woman: The Visual Logic of Authority and Gender in Fifteenth Century Florence," Ph.D. diss., Cambridge, 1995, 101.

29. See Diane Owen Hughes, "Regulating Women's Fashion," in *A History of Women in the West*, ed. Christiane Klapish-Zuber (Cambridge, 1992), 139, who points out textiles as a sign of social mobility.

30. For the significance of the classic motifs of fifteenth-century textiles, see Roberta Orsi Landini, "Alcune considerazioni sul significato simbolico dei velluti quattrocenteschi," *Jacquard* 33 (1997), 2–6.

31. Mazzi 1908, 5: "...and they can wear these things for three years after the wedding...and when the three years have ended, they can wear only the necklace and a brooch for another three years and then it is completely forbidden to wear them...." This seems to be the more permissive law in the century.

32. Lenzi 1982, 73 and 88.

33. The sumptuary laws were generally respected also by the members of such important families as the Medici or Strozzi. Catherine Kovesi Killerby, "Practical Problems in the Enforcement of Italian Sumptuary Law, 1200–1500," in *Crime, Society and the Law in Renaissance Italy,* ed. Trevor Dean and K. J. P. Lowe (Cambridge, 1994), 118.

34. On the meanings of the father and husband gifts, see Klapish-Zuber 1995, 193–211, and Frick 1995, 275–277. Coral strings were generally a gift from the father.

35. Rosalia Bonito Fanelli, "The Textiles of Italian Renaissance Dress as Seen in Portraiture: A Semiological Interpretation," *Bulletin C.I.E.T.A.* 74 (1997). In this way the dress portrayed accomplishes its task to not only identify the social status, but also the family and the person. See also Diane Owen Hughes, "Sumptuary Law and Social Relation in Renaissance Italy," in *Disputes and Settlements: Laws and Human Relations in the West,* ed. John Bossy (Cambridge, 1983), 84–91.

36. Lorne Campbell, *Renaissance Portraits* (New Haven, 1990), 75–81.

37. The husband's gifts belonged to the family, so the widowed wife could not take them with her if she returned to her natal family or if she remarried. As they were clearly painted in the wedding portrait, there could be no voluntary or casual mistake about who owned the objects.

38. Macinghi Strozzi 1914, 154.

39. Frick 1995, 62.

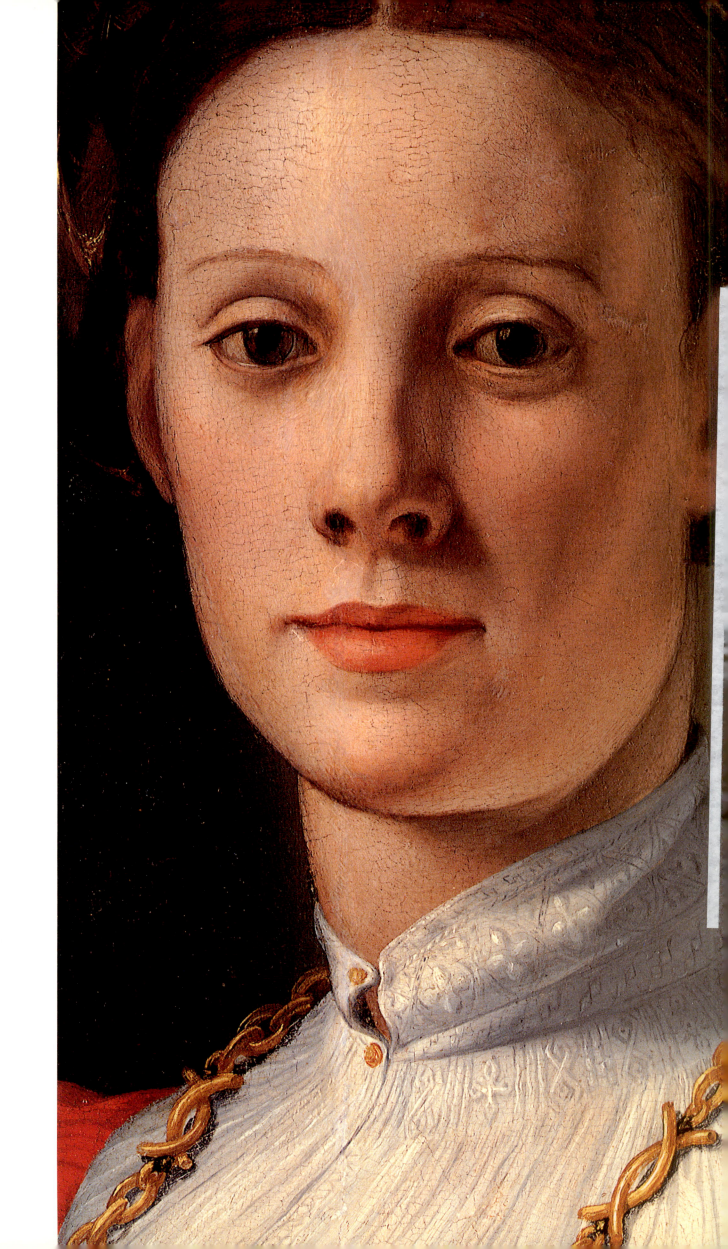

Catalogue of the Exhibition

Franco-Flemish Artist | c. 1410, tempera and / or oil on panel | National Gallery of Art, Washington,
53 × 37.6 (20⅞ × 14¹³⁄₁₆) | Andrew W. Mellon Collection,
1937.1.23

I *Profile Portrait of a Lady*

SELECTED BIBLIOGRAPHY

Berenson, Bernard. *Italian Pictures of the Renaissance,* 462. Oxford, 1932.

Degenhart, Bernhard. *Antonio Pisanello,* 39–40, 69. Turin, 1945.

Fifteenth Century Portraits [exh. cat., Knoedler and Co.] (New York, 1935), cat. I.

Franco, Tiziana. In *Pisanello. Una poetica dell'inatteso,* cat. 22. Ed. Lionello Puppi. Milan, 1996.

Hand, John Oliver and Martha Wolff. *Early Netherlandish Paintings,* cat. I, 90–97. National Gallery of Art. Washington, 1986.

Hill, George F. *Dessins du Pisanello,* 13. Paris, 1929.

Panofsky, Erwin. *Early Netherlandish Painting. Its Origins and Character,* 82, 171, 392, fig. 92. Cambridge, 1953.

Valentiner, Wilhelm R. "The Clarence H. Mackay Collection." *International Studio* 81 (August 1925), 335–345.

Valentiner, Wilhelm R. *Unknown Masterpieces in Public and Private Collection,* I: 9. London, 1930.

Venturi, Adolfo. "Antonio Pisano of Verona, called Pisanello." *The Connoisseur* 71 (April 1925), 195–200.

Venturi, Lionello. *Italian Paintings in America,* I: note to pl. 128. 3 vols. New York, 1933.

Independent portraits of women are extremely rare before the mid-fifteenth century; this example is one of the very few such likenesses known to survive. The portrait belongs to the International Style, whose chief practitioner in Italy was Pisanello. It is not surprising, therefore, that when the dealer Duveen sold the picture to the American collector Clarence H. Mackay in 1924, it was compared with Pisanello's *Portrait of an Este Princess* in the Louvre and declared the artist's masterpiece (Venturi 1925; Valentiner 1925 and 1930). Technical evidence suggests, moreover, that the painting was deceptively restored while in Duveen's hands in 1922–1923 to support the Pisanello attribution: the lady's hair was extended at the back, and her headdress was repainted to resemble a turban. In fact, much of what we see today is the result of past restoration: the panel was enlarged and the background repainted, and the gold of the dress and beads was renewed (Wolff in Hand and Wolff, 1986). Thus altered, the picture was frequently exhibited and published as Pisanello's work in the late 1920s and early 1930s. Bernard Berenson (1932) endorsed the attribution, and the importance of the portrait was further enhanced when Lionello Venturi (1933) proposed to identify the sitter as Isotta degli Atti, the mistress of Sigismondo Malatesta, lord of Rimini. In April 1935 the painting was exhibited at Knoedler's in New York as Pisanello's portrait of Isotta da Rimini.

The Pisanello attribution was rejected, nevertheless, by two experts on the artist, George Hill (1929) and Bernhard Degenhart (1945), who preferred a Northern origin for the picture. Erwin Panofsky (1953) went on to compare it to the work of the Limbourg brothers. Indeed, numerous parallels in costume and style can be made between the profile portrait and the miniatures in the *Très riches heures* in the Musée Condé, Chantilly, dating from before 1416. Turning the sitter's torso in three-quarter view, the artist has rendered costume details, like the blue and gold dress and the chain of gold beads attached at the shoulders, with careful attention. The choker and the belt are apparently made of metallic foil, and attached to the collar there may once have been a pendant with a heraldic device that would have indicated the sitter's lineage and helped to identify her. The lady's identity remains a mystery, but her lavish costume and hauteur suggest that she may have been a person of considerable rank at the French court, perhaps Isabeau or Margaret of Bavaria, Margaret of Flanders, or Yolande of Anjou (Wolff in Hand and Wolff, 1986).

Portraits were commonly made of prospective partners in marriages arranged by noble and royal families (documented cases cited by Wolff in Hand and Wolff 1986), and the Gallery's portrait may well have played a role in negotiating such an alliance. The profile view was preferred for rulers and their families not only for its association with ancient coins and medals, but also because it allowed the sitter to avoid direct contact with the viewer, thus lending him or her an air of authority. Given the importance of likeness in presenting the potential bride, the sitter's features were emphasized, as they are here, by the high forehead with a fashionable plucked hairline and by the contrast between the pale fleshtones and the dark background. That the sitter was plain-featured scarcely mattered; her wealth and status constituted her attraction. Though probably never numerous, works like the *Profile of a Lady,* because of their prestige and the way they circulated, established the courtly type of female portrait north and south of the Alps. DAB

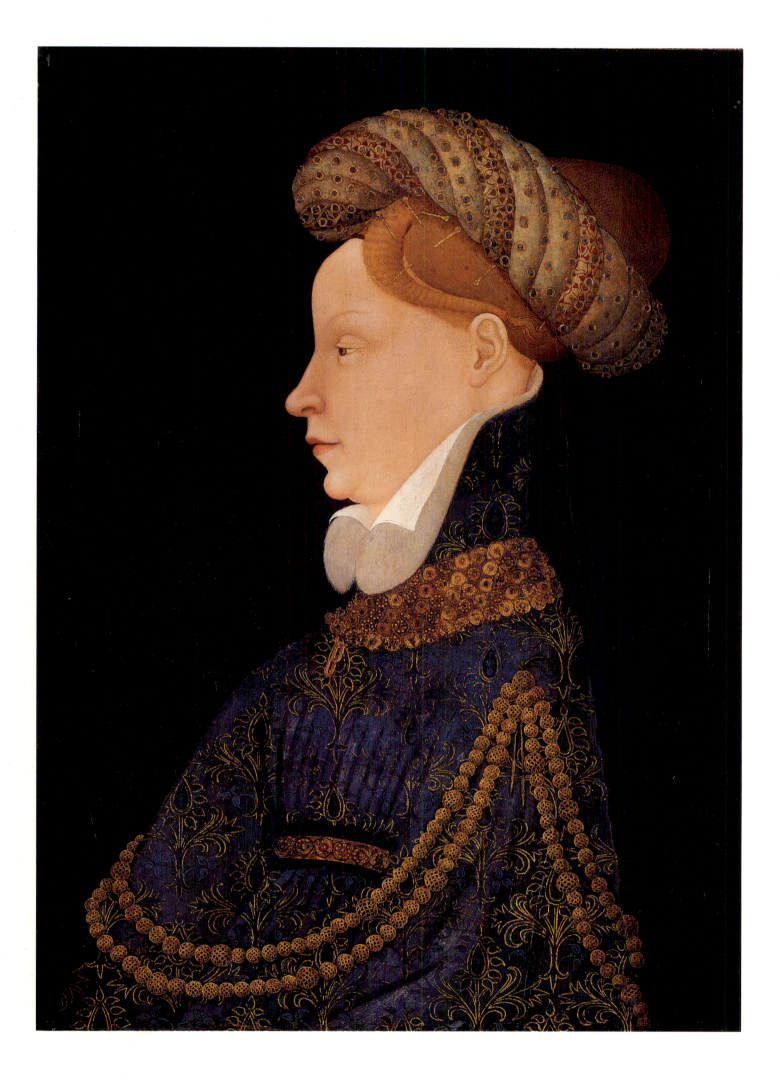

Ercole de' Roberti

A c. 1475, oil on panel
53.7 × 38.1 (21⅛ × 15)
National Gallery of Art, Washington,
Samuel H. Kress Collection,
1939.1.219

B c. 1475, oil on panel
53.7 × 38.7 (21⅛ × 15¼)
National Gallery of Art, Washington,
Samuel H. Kress Collection,
1939.1.220

2 *Giovanni II Bentivoglio* (A) *Ginevra Sforza Bentivoglio* (B)

SELECTED BIBLIOGRAPHY

Bacchi, Andrea. "Ercole Roberti." In
La pittura in Italia. Il Quattrocento,
2: 747. Ed. Federico Zeri. 2 vols. Venice,
1987.

Berenson, Bernard. *Italian Pictures
of the Renaissance. Central Italian and
North Italian Schools,* 1: 122. 3 vols.
London, 1968.

Cole, Bruce. *Piero della Francesca.
Tradition and Innovation in Renaissance
Art,* 146–147. New York, 1991.

Manca, Joseph. *The Art of Ercole de'
Roberti,* 34–35, cat. 5, 104–106. Cam-
bridge, 1992.

Molteni, Monica. *Ercole de' Roberti,*
cat. 15, 128–129. Milan, 1995.

Shapley, Fern Rusk. *Catalogue of the
Italian Paintings,* nos. 300 and 331,
406–407. 2 vols. National Gallery
of Art. Washington, 1979.

Venturi, Lionello. *Italian Paintings
in America,* 1: note to pl. 128. 3 vols.
New York, 1933.

Acquired from the Dreyfus collection, Paris, by the
dealer Duveen and sold to Samuel H. Kress in 1936,
this pair of portraits, representing Giovanni II Benti-
voglio and his wife Ginevra Sforza, was attributed in
the past to Francesco del Cossa (Venturi 1933). It is
now generally believed, however, that Ercole Roberti
(c. 1455/1456–1496) painted the portraits in the mid-
1470s, when he was still under the influence of his
former teacher and when the sitters were in their thir-
ties (Manca 1992). Recent conservation treatment at
the Gallery revealed that, although the figures are
quite well preserved, the curtains and the sky in the
two paintings are abraded. With the dark repaint
removed, the curtains now display what remains of
their original color—a bright azurite blue. Essen-
tially, the portraits conform to the tradition for repre-
senting rulers and their families bust length in strict
profile, with an emphasis on the sitter's features
and elaborate dress. Also following the conventions
for portraying the wives and daughters of rulers,
Ginevra's pale complexion and blonde hair, con-
trasted with the ruddier tints employed for her hus-
band, signify her beauty and rank.

Though framed separately, the Bentivoglio portraits
must originally have formed a diptych inspired by
the one Piero della Francesca painted of Federico
da Montefeltro and his wife Battista Sforza (Woods-
Marsden essay, fig. 10). The sitters' biographies
indicate that they were bound by ties of blood and
marriage, just as the court centers of Milan, Ferrara,
Mantua, Bologna, and Urbino, over which they
ruled, were culturally interrelated. Giovanni II Benti-
voglio governed Bologna from 1462 to 1506, when
he was ousted by Pope Julius II. His wife was born
Ginevra Sforza, daughter of Alessandro Sforza,
the half-brother of Francesco Sforza, duke of Milan;
she was the half-sister of Battista Sforza. For all these
self-made men and their wives, portraits offered a
visually effective means of asserting their authority.

Piero's diptych celebrates the couple's virtues: Fede-
rico was a *condottiere* or mercenary commander
who created a state and ruled it wisely; Battista died
in 1472 after producing a male heir to the duchy.
Her portrait is probably posthumous.[1] While male
rulers were almost invariably depicted on the more
important dexter side (viewer's left), Federico is on
the right because of a disfiguring injury. In Piero's
double portrait, husband and wife are shown bust
length in profile; they face each other but do not in-
teract. Combined with the heraldic stiffness of their
poses, the couple's position high up over a distant
landscape symbolizes their elevated social status and
joint rule (Battista acted as regent while Federico was
off fighting) over the dominion pictured in the back-
ground. Their profiles are silhouetted against the sky.

Drawing on this metaphor, Ercole Roberti also por-
trays his husband-and-wife rulers in profile against
a backdrop of their territories. The landscape vistas
are mostly obscured by curtains behind the sitters,
however. The curtains are also symbolic of rulership,
but Roberti's couple lacks the compelling presence
of Piero's monumental figures towering over the land-
scape. Ginevra Sforza, in particular, as Roberti has
depicted her, appears to be a lady of fashion. The
jewels which her sister Battista was said to have worn
reluctantly may be more conspicuous, but Ginevra's
dress, with the white veil bunched in elaborate folds,
is more decorative. Roberti has not only idealized
his female sitter in the accepted manner, but, we may
believe, flattered her as well. DAB

NOTES

1. The date of Piero's diptych is disputed; Ronald Lightbown
(*Piero della Francesca* [New York, 1992], 228–243) plausibly
dates it c. 1472–1473.

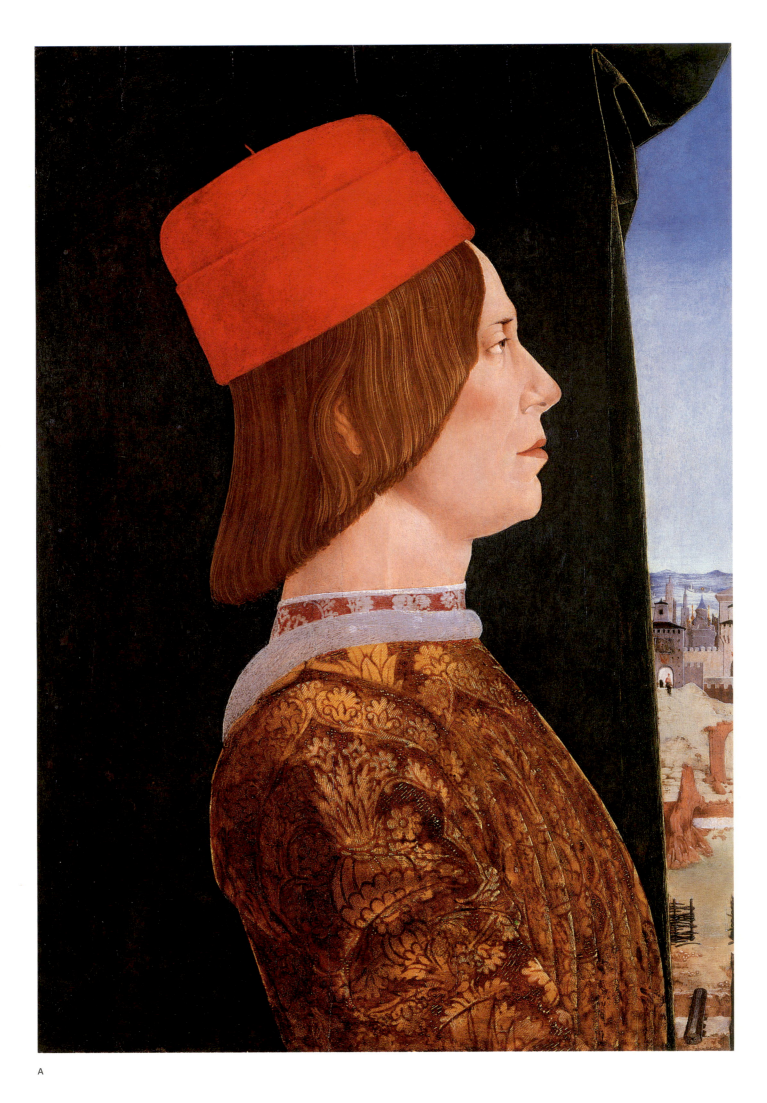

A

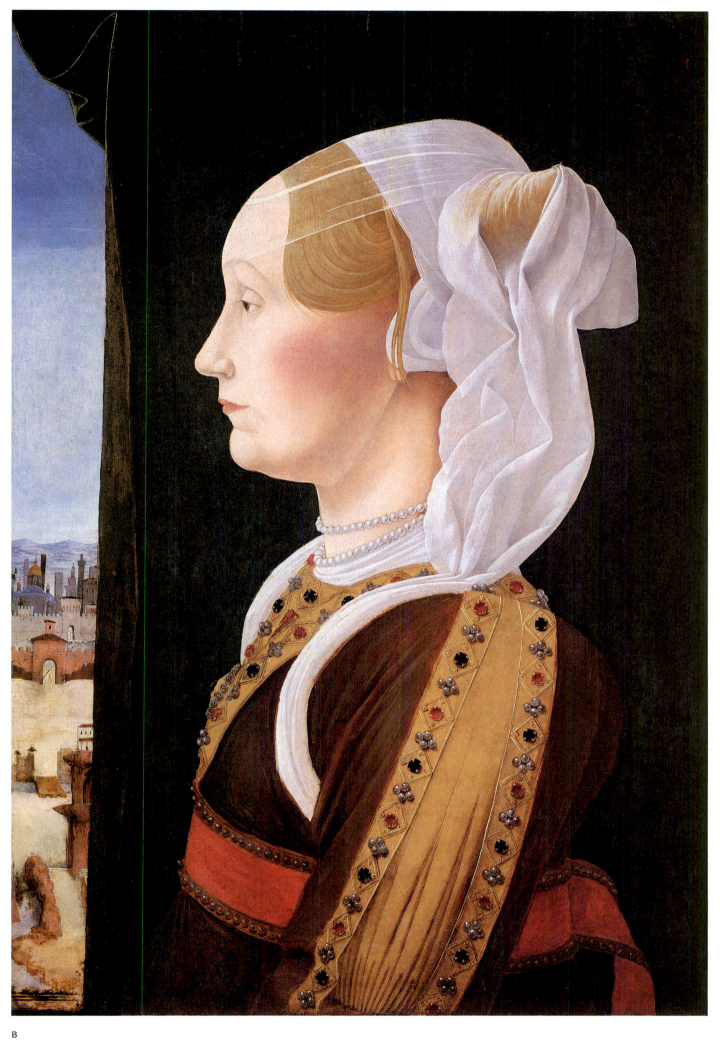

B

Filippo Lippi | c. 1438 / 1444, tempera on panel
64.1 × 41.9 (25 ¼ × 16 ½) | The Metropolitan Museum of Art,
New York, Marquand Collection,
Gift of Henry G. Marquand, 1889

3 *Woman with a Man at a Window*

SELECTED BIBLIOGRAPHY

Brandt, Kathleen Weil-Garris. *Leonardo e la scultura* (XXXVIII Lettura Vinciana, 1998), 34–35. Florence, 1999.

Breck, Joseph. "A Double Portrait by Fra Filippo Lippi." *Art in America* 2 (December 1913), 44–55.

Berenson, Bernard. *Italian Pictures of the Renaissance,* 288. Oxford, 1932.

Craven, Jennifer E. "A New Historical View of the Independent Female Portrait in Fifteenth-Century Florentine Paintings." Ph.D. diss., University of Pittsburgh, 1997.

Holmes, Megan. *Fra Filippo Lippi. The Carmelite Painter,* 128–135. New Haven, 1999.

Mannini, Maria Pia and Marco Fagioli. *Filippo Lippi. Catalogo completo,* cat. 12, 92–93. Florence, 1997.

Pope-Hennessy, John and Keith Christiansen. "Secular Painting in 15th-Century Tuscany: Birth Trays, Cassone Panels, and Portraits." *The Metropolitan Museum of Art Bulletin* 38 (summer 1980), 56–57, 59–61.

Ringbom, Sixten. "Filippo Lippis New Yorker Doppelporträt: Eine Deutung der Fenstersymbolik." *Zeitschrift für Kunstgeschichte* 48 (1985), 133–137.

Ruda, Jeffrey. *Fra Filippo Lippi. Life and Work with a Complete Catalogue,* 85, 88, and cat. 16, 385–386. London, 1993.

In a pattern typical of the Florentine profiles of women, Lippi's picture was purchased as a Masaccio by the English collector the Reverend John Sanford in Florence in the 1830s and sold by his descendants to the American millionaire Henry Marquand, who displayed it in his French Renaissance–style mansion in New York before donating it to the museum.[1] Bernard Berenson (1932) glamorized the portrait by identifying the sitters as a Medici married to a Portinari. In reality, this is the most innovative and complex portrait of a woman painted before Botticelli's *Woman at a Window* (cat. 25) three decades later. Lippi (c. 1406–1469) has enriched the type of strict profile of the Gallery's Franco-Flemish *Lady* (cat. 1) by expanding the format to include not only the woman's hands but also an interior setting that encompasses a likeness of her husband or suitor. The man's hands rest on the coat of arms of the Scolari family of Florence, and the two figures have been plausibly identified (Breck 1913) as Lorenzo di Ranieri Scolari and Angiola di Bernardo Sapiti, who were married in 1436.[2] The painting, datable stylistically to the late 1430s or early 1440s, is thought to commemorate the couple's wedding or the birth of their son in 1444.

Lippi's painting is the earliest independent female portrait from Florence to survive.[3] In creating it, the artist was clearly aware of earlier ruler portraits, perhaps through illuminated manuscripts. A prestigious source such as this, rather than the sitter's social status, explains both the profile view Lippi chose to represent her and probably also her proud bearing. The young woman, lavishly dressed in the French fashion, wears an elaborate saddle-shaped headdress called a *sella*.[4] A green and gold brocaded sleeve appears beneath the sitter's red fur-trimmed *cioppa* or overdress, the cuff of which is embroidered in gold and pearls with the motto "lealt[a]," meaning "loyalty." The woman also wears several rings and a jeweled shoulder brooch.

However impressive, Lippi's picture fails, nevertheless, to integrate the sitter's hieratic profile with the architectural setting the artist borrowed from his own early religious works. The domestic interior with its awkward perspective does not recall Flemish prototypes so much as Lippi's placement of the Virgin and child in an interior setting in the *Tarquinia Madonna* of 1437, in the Palazzo Barberini, Rome.[5] Even closer is the interior with a landscape view in Lippi's *Miracle of Saint Ambrose* in the Gemäldegalerie, Berlin, part of the predella of the *Coronation of the Virgin,* commissioned in 1439 and completed by 1447, in the Uffizi.[6] The expanded half-length format, however, allowed the artist to include a secondary male portrait in the composition. The woman holds up the folds of her dress and faces a doorway on the left as if she were about to pass through it, while her male counterpart leans through a window in the manner of several other "intruder" portraits in Lippi's works.[7] The greater prominence of the female has long puzzled commentators on the picture; it might suggest that the portrait was commissioned by the woman's family to celebrate her betrothal. In any case, the male, shown wearing a red *berretta* and displaying his lineage, is not an afterthought, as might be supposed: the brown paint of the architecture continues up to, but not under, his figure, which was left in reserve. Also indicating that the man was part of the artist's original conception, an underdrawing for the contour of his profile, slightly enlarged in the painting, has been revealed by infrared reflectography. His face is of particular interest for the shadow it casts on the wall behind him. Ancient writers told—and Leon Battista Alberti retold in his *Treatise on Painting* of 1435 / 1436—the story of how the art of painting originated with the outlining of a man's shadow.[8] Lippi, whose fame as a portraitist reached Vasari, may well have been referring to this recently related classical topos about the origin of painting (and portraiture) in creating his own highly original contribution to the genre.[9] DAB

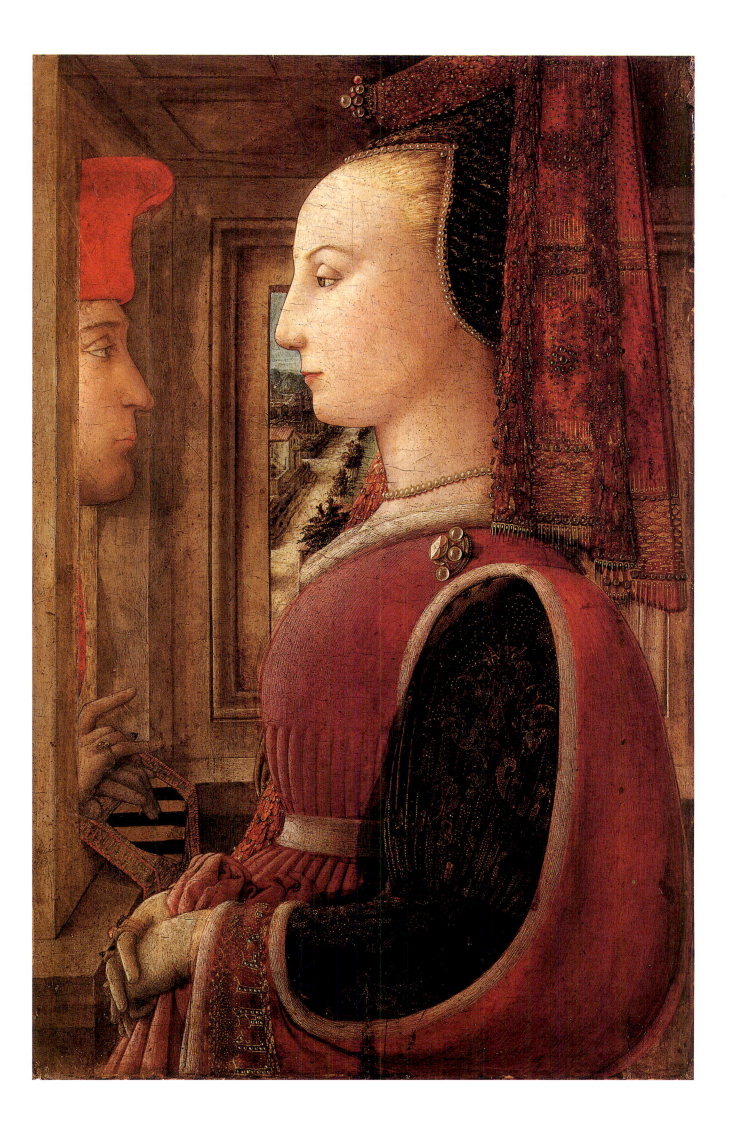

BIBLIOGRAPHY (CONT.)

Tietzel, Brigitte. "Neues vom 'Meister-der Schafsnasen' überlegungen zu dem New Yorker Doppelbildnis des Florentiner Quattrocento." *Wallraf-Richartz-Jahrbuch* 52 (1991), 17–42.

Tinagli, Paola. *Women in Italian Renaissance Art: Gender. Representation. Identity,* 52–53. Manchester, 1997.

Zeri, Federico and Elizabeth E. Gardner, *A Catalogue of the Collection of the Metropolitan Museum of Art. Italian Paintings. Florentine School,* 85–87 (with bibliography). New York, 1971.

NOTES

1. Benedict Nicolson, "The Sanford Collection," in *The Burlington Magazine* 97 (July 1955), 207–214.

2. Dieter Jansen ("Fra Filippo Lippis Doppelbildnis im New Yorker Metropolitan Museum," *Wallraf-Richartz-Jahrbuch* 48/49 [1987/1988], 97–121) unconvincingly identifies the sitters as the Piedmontese Giacomo Ferrero and Yolande of Savoy.

3. An odd-looking portrait of a woman offering a flower to a subordinate male figure, attributed to Lippi by Miklós Boskovits ("Fra Filippo Lippi, i carmelitani e il Rinascimento," *Arte Cristiana* 74 [July–August 1986], 249–250), would be earlier if it were not an imitation, which appears to be the case.

4. The woman depicted in profile in a unique mid-fifteenth-century Florentine engraving wears the same kind of headdress (*Das Berliner Kupferstichkabinett. Ein Handbuch zur Sammlung,* ed. Alexander Dückers [Berlin, 1994], cat. v.5, 247–248). A similar peaked headdress also recurs in the puzzling *Profile Portrait of a Lady* in the National Gallery of Victoria (Ursula Hoff, *European Paintings before 1800 in the National Gallery of Victoria* [Melbourne, 1995], cat. 10, 167–168). Traditionally said to be a portrait of Isotta da Rimini by Piero della Francesca, the painting is now generally regarded as Florentine c. 1450–1475. As such, it formed the starting point for Patricia Simons' study of Florentine profiles of women ("A Profile of a Renaissance Woman in the National Gallery of Victoria," *Art Bulletin of Victoria* 28 [1987], 34–52). Nevertheless, the sitter's headdress, which went out of fashion after the mid-fifteenth century, and her shoulder brooch, of the type found in works dating from the 1470s and 1480s, appear to be chronologically incompatible, and the painting technique is likewise said to consist of both tempera and oil. The picture warrants further investigation to determine whether it does, in fact, belong to the group of female profiles with which it is usually associated.

5. Ruda 1993, 88–101 and pl. 47. On the problem of Flemish influence, see 126–132.

6. Ruda 1993, 174–177 and pl. 99.

7. Compare the Barbadori altarpiece in the Louvre (Ruda 1993, pl. 58) and the *Annunciation* in Palazzo Barberini, Rome (Ruda 1993, pl. 84) for portraits of men looking and gesturing from behind a stone ledge.

8. *The Elder Pliny's Chapters on the History of Art,* trans. and ed. K. Jex-Blake and E. Sellers (London, 1896), 84–85 (XXXV, V, 15); *The Institutio Oratoria of Quintilian,* trans. H.E. Butler, 4 vols. (London, 1936), 4: 78–79 (X, ii, 7); and Leon Battista Alberti, *On Painting,* trans. and ed. John R. Spencer (New Haven, 1966), 64.

9. Alison Wright, "The Memory of Faces: Representational Choices in Fifteenth-Century Portraiture," in *Art, Memory, and Family in Renaissance Florence,* ed. Giovanni Ciappelli and Patricia Rubin (Cambridge, 2000), 96. Kidnapped by pirates, Lippi is said to have won his freedom by painting a portrait of their leader (Giorgio Vasari, *Le Vite de' più eccellenti pittori scultori ed architettori,* ed. G. Milanesi, 9 vols. [Florence, 1878–1885], 2: 614–615).

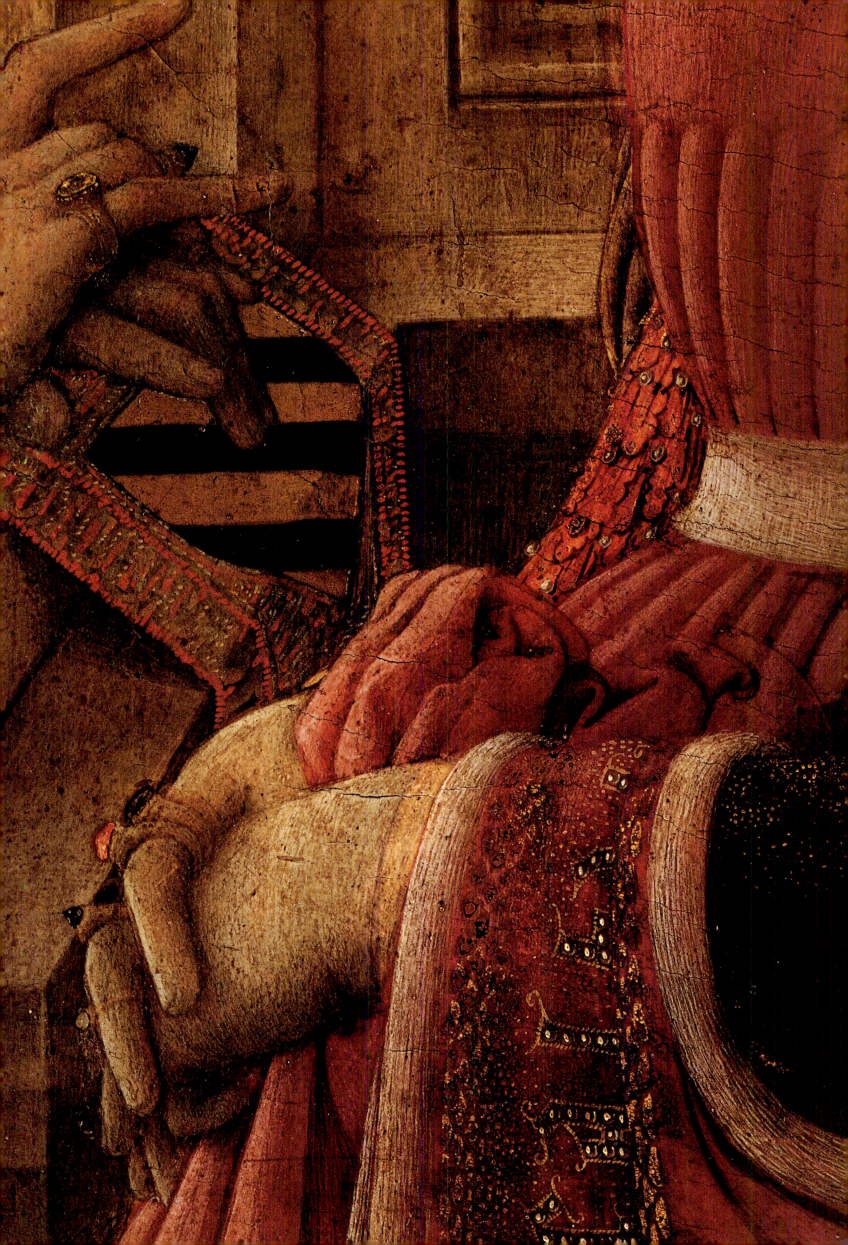

Filippo Lippi

c. 1450–1455, tempera on panel
49.5 × 32.7 (19 ½ × 12 ⅞)

Staatliche Museen zu Berlin,
Gemäldegalerie

4 *Profile Portrait of a Young Woman*

REVERSE

Fictive marbling in black and brick red

SELECTED BIBLIOGRAPHY

Bode, Wilhelm von. "Ein Frauenbildnis von Filippo Lippi." *Jahrbuch der Königlich preussischen Kunstsammlungen* 34 (1913), 97–98.

Brandt, Kathleen Weil-Garris. *Leonardo e la scultura* (XXXVIII Lettura Vinciana, 1998), 16–17. Florence, 1999.

Campbell, Lorne. *Renaissance Portraits. European Portrait-Painting in the 14th, 15th, and 16th Centuries,* 115, 117. New Haven, 1990.

Catalogue of Paintings 13th–18th Century, no. 1700, 234–235. Trans. Linda B. Parshall. Gemäldegalerie, Staatliche Museen. 2d rev. ed. Berlin, 1978.

Craven, Jennifer E. "A New Historical View of the Independent Female Portrait in Fifteenth-Century Florentine Paintings," cat. 3, 223–225. Ph.D. diss., University of Pittsburgh, 1997.

Holmes, Megan. *Fra Filippo Lippi. The Carmelite Painter,* 129–135. New Haven, 1999.

Mannini, Maria Pia and Marco Fagioli. *Filippo Lippi. Catalogo completo,* cat. 13, 93. Florence, 1997.

Ruda, Jeffrey. *Fra Filippo Lippi. Life and Work with a Complete Catalogue,* 181–182 and cat. 30, 412–413. London, 1993.

Notorious for his liaison with a nun, Fra Filippo Lippi also distinguished himself as the painter of two female portraits that are the first of their kind in Florence. In the earlier of the two portraits (cat. 3), Lippi (c. 1406–1469) was experimenting with the new genre; in this one he established the standard profile type for portraying Florentine women. Like so many of the female profiles, Lippi's was formerly attributed to Piero della Francesca when it was auctioned in London in 1912.[1] Soon afterward, however, Wilhelm von Bode (1913) recognized the painting's true author and acquired it for the Berlin museum. Bode's attribution has been almost universally accepted, but scholars still disagree about the date of the picture, which ranges from c. 1440 to c. 1465 (Ruda 1993). With the sitter unknown and no document recording the commission, the portrait cannot be precisely dated; close parallels can be found for it, however, in Lippi's works of the early to mid-1450s.[2] Painted on a panel that preserves its original dimensions, the picture is, moreover, in excellent condition. It exhibits a mixed technique of broad brushstrokes and precise dots throughout the composition, even along the edges. Little white dots and dashes are all that define the distant landscape, for example, and in the sitter's cap, sleeve, belt, and rings, as well as in the shell above her head, more tiny dots once glittered with gold (the mordant gilding, and in some cases the paint beneath it, has since come detached).

The Berlin portrait is distinctly different from its predecessor not only in size (it is smaller) but also in style and conception. Both works share the same formula of a half-length figure facing left before a window. But with the secondary male eliminated, attention is now focused exclusively on the female subject. Missing, too, are the narrative element and the courtly air of the double portrait, established by the man's coat of arms and motto and the extraordinarily rich costume and jewelry worn by his companion. In the Berlin portrait the single figure and the setting are unified. Significantly, a preliminary underdrawing for both has been revealed by infrared reflectography. In particular, the Brunelleschian-type architecture of the later portrait has been harmonized with the woman's profile: the green of her dress is even repeated in the molding. Most important, a series of visual metaphors serve to characterize the sitter. The shell lunette, which appears in several of Lippi's Madonnas, including one in the National Gallery of Art, was often used as a kind of architectural halo for sacred figures in painting and sculpture. Similarly, the open window framing the sitter's profile and the view of blue sky and a remote shore shrouded in haze, which it affords, were apparently intended, unlike the realistic landscape in the double portrait, to symbolize eternity. And when the young woman raises her right hand to her breast, it is not only to display her rings but also to draw together her elegantly fluttering diaphanous veil in a gesture indicative of modesty or decorum. Lippi's sophisticated use of visual metaphors even extends to the reverse of the panel, where the warm reddish marble of the window sill behind the sitter is recalled.[3] Signifying immutability, the black and brick red fictive marble of the reverse is a direct precedent for Leonardo's double-sided portrait (cat. 16) representing Ginevra de' Benci (Brandt 1999). The modern paper labels attached to the marbleized reverse reflect a misunderstanding of Lippi's panel, which, when turned around, was meant to be viewed on the back as well as the front side. DAB

NOTES

1. Christie's, London, 8 July 1912, lot no. 22.

2. Compare the tondo of the *Madonna and Child with the Birth of the Virgin* in the Palazzo Pitti, Florence (Holmes 1999, fig. 182) and the Medici *Annunciation* in the National Gallery, London (Holmes 1999, fig. 225).

3. Angelica Dülberg (*Privatporträts. Geschichte und Ikonologie einer Gattung im 15. und 16. Jahrhundert* [Berlin, 1990], 120–121 and cat. 148, 221) identifies the marble as "Portasanta."

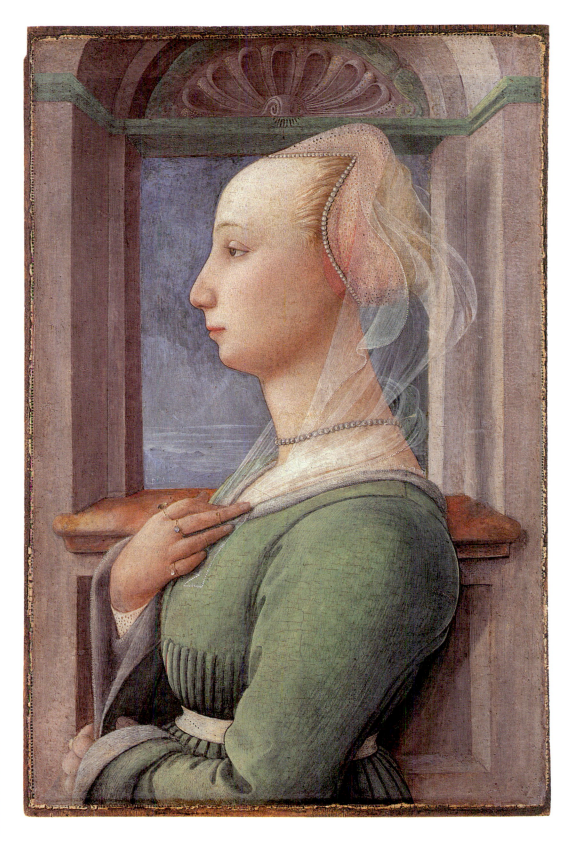

Reverse

III

Attributed to Paolo Uccello | c. 1460 / 1465, tempera on panel 44.1 × 31.5 (17 3/8 × 12 3/8) | Isabella Stewart Gardner Museum, Boston

5 *A Young Lady of Fashion*

SELECTED BIBLIOGRAPHY

Craven, Jennifer E. "A New Historical View of the Independent Female Portrait in Fifteenth-Century Florentine Paintings," cat. 7, 235–237. Ph.D. diss., University of Pittsburgh, 1997.

Hendy, Philip. *European and American Paintings in the Isabella Stewart Gardner Museum*, 267–269. Boston, 1974.

Kanter, Laurence B. "The 'cose piccole' of Paolo Uccello." *Apollo* 152 (August 2000), 17–19.

Pope-Hennessy, John. *The Portrait in the Renaissance*, 40–41. Princeton, 1966.

Wohl, Hellmut. *The Paintings of Domenico Veneziano*, cat. 51, 178–179. New York, 1980.

The aptly named *Young Lady of Fashion* in the Gardner Museum belongs to a group of three female profiles painted in Florence during the 1460s. The other similar works are the *Profile Portrait of a Lady* (fig. 1) in the Metropolitan Museum, New York, and the *Portrait of a Lady* (fig. 2), formerly in the Lehman collection, New York, and recently with the Sarti Gallery in Paris. The three portraits have often been attributed to a single artist, whether Domenico Veneziano, Paolo Uccello (1397–1475), or the so-called Master of the Castello *Nativity*. But what links them is not their individual style but the flat, decorative treatment of figure and setting. The ex-Lehman portrait, whose half-length format with hands seems to echo Filippo Lippi's *Young Woman* (cat. 4) in Berlin, is probably by the Castello Master.[1] The other two works are apparently by a different hand. The author currently favored for the Gardner portrait is Paolo Uccello, who, if both works are by the same artist, would also have painted the one in New York.[2] The two female figures, especially the long neck and pointed face of the Gardner lady, do resemble the diminutive profile of the princess in Uccello's *Saint George and the Dragon* in the National Gallery, London. The question is whether Uccello would have adopted such a profile for an independent portrait or whether the pictures in Boston and New York are not by a follower familiar with his facial types. The attribution problem is complicated by the poor condition of all three paintings. The Gardner picture, nevertheless, retains (on three sides) its original dimensions, and although the darkened blue background and the sitter's costume are damaged and restored, her flesh-tones and elaborate hairdress are fairly well preserved.

Combining a realistic rendering of the sitters' features with a stiffly upright pose, the three profiles follow the conventions for female portraiture established in Florence by Filippo Lippi. But they also transform the Lippi prototype. Except for the ex-Lehman *Lady*, the hands are omitted, resulting in a bust-length format. The sitters' faces, moreover, are flatly modeled with minimal shading, and they are placed on insubstantial busts against uniform blue backgrounds.[3] Instead of Lippi's solidity and space, the portraits in Boston, New York, and Paris all share a highly decorative quality in which costume and ornament play a major role. While not particularly beautiful themselves, the women are portrayed as beautiful objects both in terms of literary notions of female pulchritude, which called for fair skin and blonde hair, and of contemporary fashion. Costly brocaded fabrics and pearls and precious stones serve not only to display the sitters' familial wealth and status but also to enhance their physical appearance—in art, as in life. In addition to a red and gold brocaded sleeve and a *giornea* or sleeveless overdress, the woman portrayed in the Gardner picture wears a *brocchetta di testa* or head brooch, a pearl choker with a jeweled pendant, and a white *cuffia* or cap ornamented with pearls. This fashionable beauty, like her counterparts in New York and Paris, looks impassive, immobile, and immutable, as if she were outside space and time. Her portrait image, in common with the others, has a static, stereotyped character, in which the sitter's individuality is almost entirely suppressed in favor of the social ideals for which she stands. DAB

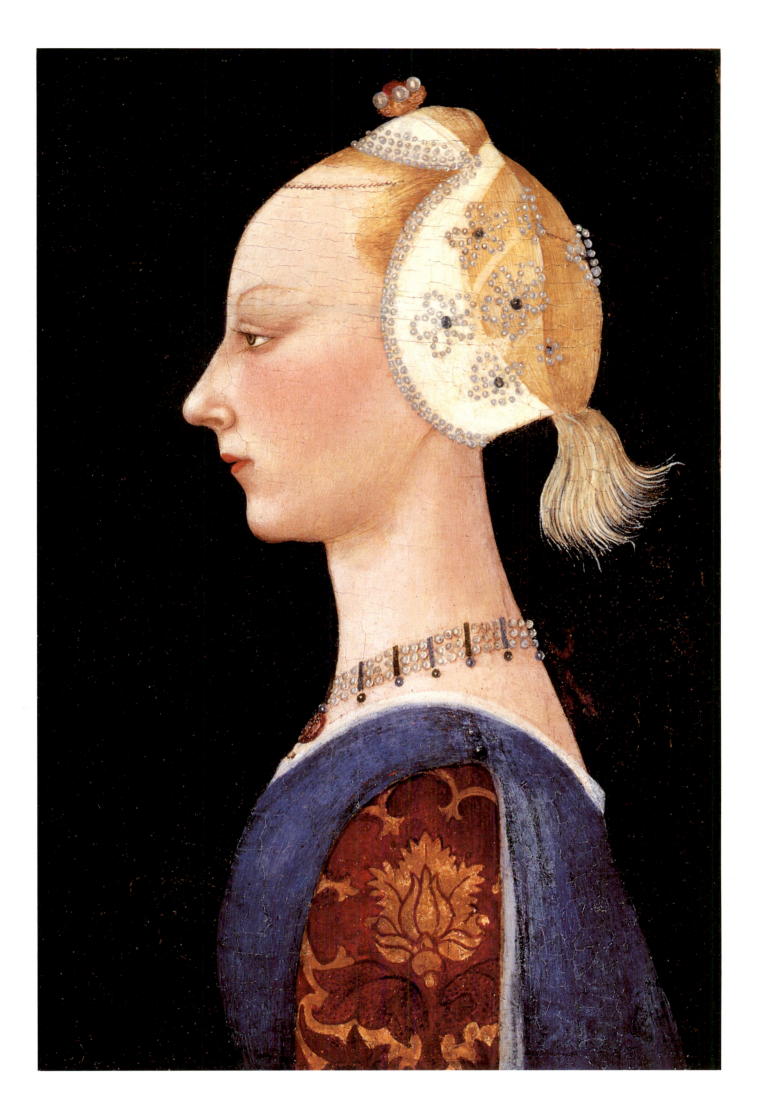

1
Florentine, *Profile Portrait of a Lady,*
The Metropolitan Museum of Art,
New York, The Jules Bache Collection,
1949. All rights reserved

2
Master of the Castello Nativity, *Portrait
of a Lady,* private collection, courtesy of
G. Sarti Gallery, Paris

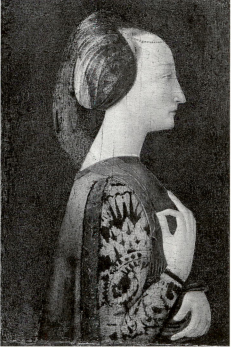

NOTES

1. This profile portrait, in which the sitter faces right, not left as was customary, was sold in Florence in 1883 as a likeness of Battista Sforza by Piero della Francesca. In the Lehman collection it was called Domenico Veneziano (Osvald Siren and Maurice W. Brockwell, *Loan Exhibition of Italian Primitives* [exh. cat., Kleinberger Galleries] [New York, November 1917], cat. 20, 57) or Paolo Uccello (Lionello Venturi, *Italian Paintings in America,* 2 vols. [Milan, 1933], 2: note to pl. 193). The attribution to the follower of Filippo Lippi known as the Master of the Castello *Nativity,* advanced by Jean Lipman ("Three Profile Portraits by the Master of the Castello Nativity," *Art in America* 24 [1936], 110–126), following Richard Offner, is now widely accepted (Chiara Lachi, *Il Maestro della Natività di Castello* [Florence, 1995], cat. 36, 118–119). For the complete attribution history, see G. Sarti, *Trente-trois Primitifs Italiens de 1310 à 1500: du Sacré au Profane* (Paris, 1998), cat. 27, 162–169.

2. For the critical fortune of the *Profile Portrait of a Lady,* acquired after the sale of the Holford collection in England by the dealer Duveen and sold to the American collector Jules Bache, who bequeathed it to the museum, see Federico Zeri and Elizabeth Gardner, *Italian Paintings. A Catalogue of the Metropolitan Museum of Art. Florentine School* (New York, 1971), 114–116; and Wohl 1980, cat. 60, 184. The Boston portrait, acquired by Mrs. Gardner in 1914, has recently been reattributed to Paolo Uccello in a detailed analysis of the picture, together with its cognates, by Laurence Kanter (2000). Earlier, Pope-Hennessy (1966, note 62, 308–309) had claimed that the Boston and New York panels were by a single hand inferior to Domenico Veneziano or Uccello and distinct from that responsible for the ex-Lehman portrait, while Wohl (1980) proposed that they both derive from a lost work by Domenico Veneziano cited in a Medici inventory.

3. The characteristics defining the group are seen exaggerated in a provincial variant, convincingly attributed to Masaccio's brother, called lo Scheggia, in the Johnson collection, Philadelphia (Laura Cavazzini, *Il fratello di Masaccio. Giovanni di Ser Giovanni detto lo Scheggia* [exh. cat., San Giovanni Valdarno] [Florence, 1999], cat. 22, 82–83).

| Antonio del Pollaiuolo | c. 1475, tempera and oil on panel 48.9 × 35.2 (19¼ × 13⅞) | The Metropolitan Museum of Art, New York, Bequest of Edward S. Harkness, 1940 |

6 *Portrait of a Young Woman*

SELECTED BIBLIOGRAPHY

Berenson, Bernard. *Italian Pictures of the Renaissance. Florentine School,* 1: 179. 2 vols. London, 1963.

Craven, Jennifer E. "A New Historical View of the Independent Female Portrait in Fifteenth-Century Florentine Paintings," cat. 12, 245–246. Ph.D. diss., University of Pittsburgh, 1997.

Dempsey, Charles. *The Portrayal of Love: Botticelli's Primavera and Humanist Culture at the Time of Lorenzo the Magnificent,* 132. Princeton, 1992.

Frankfurter, Alfred M. "Great Renaissance Portraits. A Unique Exhibition of Twenty-Five Italian Masterpieces." *The Art News* 38 (March 1940), 7–8.

Pons, Nicoletta. *I Pollaiolo,* cat. 20, 105–106. Florence, 1994.

Pope-Hennessy, John and Keith Christiansen. "Secular Painting in 15th-Century Tuscany: Birth Trays, Cassone Panels, and Portraits." *The Metropolitan Museum of Art Bulletin* 38 (summer 1980), 61–63.

Ragghianti, Carlo L. and Gigetta Dalli Regoli. *Firenze 1470–1480. Disegni dal Modello,* 21 and note 38, 43–44. Pisa, 1975.

Wohl, Hellmut. *The Paintings of Domenico Veneziano,* 180. New York, 1980.

Zeri, Federico and Elizabeth E. Gardner, *A Catalogue of the Collection of the Metropolitan Museum of Art. Italian Paintings. Florentine School,* 125 (with bibliography). New York, 1971.

This painting is one of a group of five profile portraits of women attributed to Antonio (1431/1432–1498) or Piero Pollaiuolo. There is no consensus about the authorship of these works, but a case can be made for distinguishing four of them, including the one exhibited here, from the fifth, which differs in style and quality. The division reflects the differences between the two artists: the elder and more gifted Antonio, after training as a goldsmith, headed the shop in which Piero worked mainly on large-scale painting commissions, either on his own or in collaboration with his brother.[1] As the creative force behind their productions, it was Antonio who established the portrait type represented by the Metropolitan picture. Homogeneous in style and technique, this and the other profiles attributed to Antonio in the Gemäldegalerie, Berlin (fig. 1), the Museo Poldi Pezzoli, Milan (Woods-Marsden essay, fig. 2), and the Uffizi Gallery, Florence (Woods-Marsden essay, fig. 3), diverge significantly from earlier examples. The affinities between the sitters, with their pearl necklaces, brocaded dresses with pomegranate-patterned sleeves, and similar hairstyles, can best be explained, as Jennifer Craven has suggested, by assuming that Antonio created a distinctive type that his clients wanted to emulate in their portraits.[2] Most striking is the resemblance between their features.[3] Gone are the physiognomic peculiarities that differentiated the women painted by Filippo Lippi (cats. 3, 4) and other masters. Instead, Pollaiuolo has approximated the individuality of his sitters to an ideal type, and in so doing has transformed them into enduring symbols of feminine allure. But it is not only through their charm and vivacity that Pollaiuolo's women come to life.[4] His delicate yet incisive treatment of their facial contours lends them a physical presence that is all the more remarkable for the fact that their forms are scarcely modeled in light and shade. The effect of

immediacy is further heightened by the artist's innovative use of the new oil medium to describe and differentiate the textures of skin, brocade, and gemstones: his fine impasto brushstrokes even simulate raised strands of hair. Paradoxically, this tactile quality makes Pollaiuolo's ideal seem more real today than the efforts of his predecessors to capture a likeness.

As a group Antonio's female profiles differ from Piero's *Woman in Green and Crimson* in the Gardner Museum in Boston.[5] Painted in a thin oil layer on bare wood, which shows through as a brownish tone in the shadows, this work lacks the elegant contours and details that make Antonio's portraits so impressive. The sitter, in addition, has an almost caricatural quality shared with the figures in Piero's signed *Coronation of the Virgin* of 1483 in the church of Sant'Agostino in San Gimignano.[6] Despite the sameness of Antonio's profiles, by contrast to that of Piero, the pictures in Berlin, Milan, Florence, and New York differ sufficiently from each other to be arranged in a series showing the evolution of the artist's concept. The earliest in the series is the *Profile Portrait of a Young Woman* in Berlin, in which the sitter is shown against a marble balustrade and a blue sky background borrowed from the brothers' *Three Saints* altarpiece of 1467 in the Uffizi.[7] The woman's head is in strict profile, as in the other examples, but her bust is turned in three-quarter view to display the splendid brocades of her dress and sleeves. Her hair is simply dressed. In the captivating portrait in Milan, architecture is omitted and the sitter's head and bust better integrated.[8] Turned only slightly toward the viewer, the bust is cropped at the shoulder, which is lowered to form a continuously flowing contour around the pale fleshtones. The woman's hairdress is of the elaborate type found in all three of the later profiles; this one is datable to the early 1470s.

1

Antonio del Pollaiuolo, *Profile Portrait
of a Young Woman,* Staatliche Museen
zu Berlin, Preussischer Kulturbesitz,
Gemäldegalerie (photo: Jörg P. Anders)

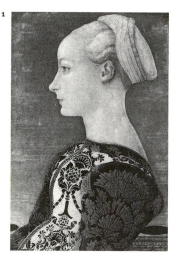

Despite the fact that it is damaged and extensively repainted, Antonio's *Portrait of a Lady* in the Uffizi marks a new stage in the development of the series.[9] The sitter's head and bust are both in pure profile, and her shoulder is raised, giving greater prominence to the pomegranate design of the brocaded sleeve. Contemporaneous with the Uffizi portrait is the one in the Metropolitan Museum, and this work, like that one, is damaged.[10] The paint surface is much abraded and in part destroyed; the blue background, for example, is the underpainting of the missing sky behind the sitter. And yet the quality of Antonio's portraiture is generally preserved. The features are fairly intact, and the pink painted frame surrounding the image along the top and sides of the panel has been reconstructed from the few traces of pigment that survive, as has the patterned dress. The sitter's hairdress is better preserved; indeed, it is the most elaborate of all those painted by the artist. The tresses are fastened in a *frenello* from which they emerge as a swirling tassel in the back.[11] Strings of small pearls wind around the hair and loop down over the fashionably high forehead. Demonstrating Antonio's virtuoso skill as a metalworker, exquisitely crafted blue rosettes studded with pearls dot the hair, culminating in a *fermaglio,* or head brooch, with larger pearls and a ruby in a gold petal-shaped setting. This spectacular headdress alone indicates that the picture, presently labeled "Piero Pollaiuolo" in the museum, should be reattributed to his brother. DAB

NOTES

1. For the distinction between the two artists, see David Alan Brown, *Leonardo da Vinci. Origins of a Genius* (New Haven, 1998), 10–21.

2. See Craven (1997, 245), who is the only scholar in the last half-century to attribute all four of the profiles discussed here to Antonio.

3. Maud Cruttwell (*Antonio Pollaiuolo* [London, 1907], 179) claimed that the sitters in the Berlin and Milan portraits were sisters, while Adolfo Venturi (*Storia dell'Arte Italiana* 7.1 [1911], 576–577) thought they were the same person. Pons (1994, 106) similarly suggested that the Milan portrait sitter was also portrayed in the picture in New York.

4. The consistent charm of Pollaiuolo's portraits of women is the female counterpoint to the almost brutal aggressiveness of the muscular nude males he depicted; both are stereotyped extremes.

5. About the portrait, attributed to Piero by comparison with the *Galeazzo Maria Sforza* in the Uffizi, which he painted on the occasion of the duke's visit to Florence in 1471, see Philip Hendy, *European and American Paintings in the Gardner Museum* (Boston, 1974), 186–188; and Pons 1994, cat. 12, 99. The incongruity between the woman's loosely painted sleeve and her carefully rendered bust reflects the technique of the large paintings jointly produced in the shop.

6. Pons 1994, cat. 19, 104–105.

7. About this portrait, painted in a mixed medium of tempera and oil on a panel measuring 52.5 × 36.5 centimeters, see *Catalogue of Paintings. 13th–18th Century,* trans. Linda B. Parshall, 2d rev. ed. (Berlin, 1978), no. 1614, 331; and Pons 1994, cat. 7, 97. For the attribution history see Hellmut Wohl, *The Paintings of Domenico Veneziano* (New York, 1980), cat. 50, 177–178. About the brothers' altarpiece from San Miniato al Monte, Florence, see Pons 1994, cat. 5, 96–97.

8. About the picture, painted in tempera and oil on a panel measuring 45.5 × 37.7 centimeters and repainted at the edges, see Mauro Natale, *Museo Poldi Pezzoli. Dipinti* (Milan, 1982), cat. 186, 151–152; and Pons 1994, cat. 16, 101, 104. For past attributions, which have wavered between Antonio and Piero, see Wohl 1980, cat. 58, 182–183.

9. For the picture, painted in a mixed medium on a panel measuring 55 × 34 centimeters and still in its original engaged frame, see Pons 1994, cat. 21, 106; for the attribution history, see Wohl 1980, cat. 52, 179–180.

10. Acquired, following the typical pattern for these female profiles, by an American millionaire (through a dealer who had it) from a British collection and bequeathed to the museum in 1940, the painting was attributed, together with those in Berlin, Milan, and Florence, to Piero Pollaiuolo by Berenson (1963) and Zeri (1971). An old exhibition label once on the back of the panel fancifully identified the sitter as Dante's beloved Beatrice (*Italian Renaissance Portraits* [exh. cat., Knoedler and Co.] [New York, 1940], cat. 4, 7).

11. Defined by Jacqueline Herald (*Renaissance Dress in Italy 1400–1500* [London, 1981], 151, 217) as a transparent veil edged by a fine wire and pearls.

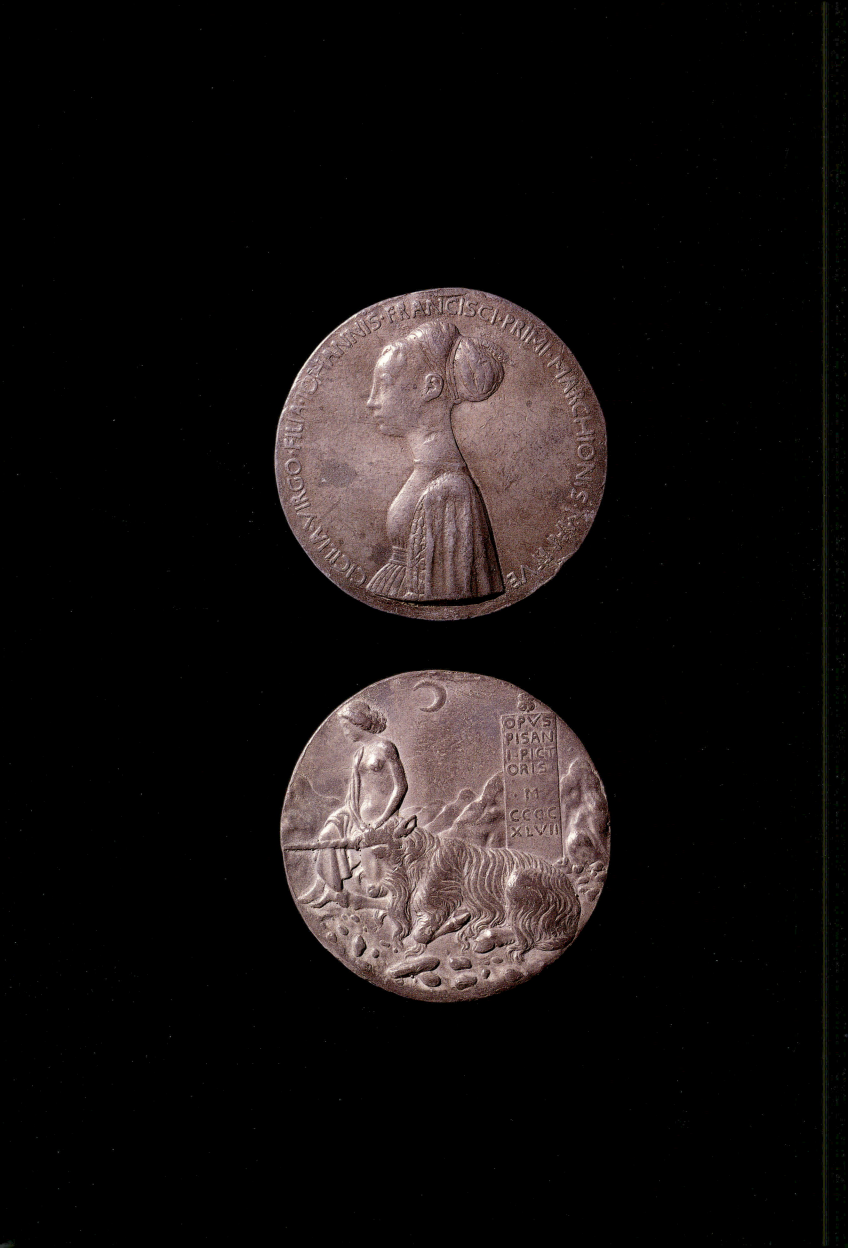

Pisanello

1447, lead alloy
8.6 (3 3/8)

National Gallery of Art, Washington,
Samuel H. Kress Collection,
1957.14.609

7 *Cecilia Gonzaga*

INSCRIPTIONS

Obverse: around the field CICILIA ·
VIRGO · FILIA · IOHANNIS ·
FRANCISCI · PRIMI · MARCHIONIS ·
MANTVE (Cecilia, virgin daughter of
Gianfrancesco, first marquis of Mantua);
Reverse: on the stele, OPVS / PISAN /
I · PICT / ORIS · / · M · / CCCC / XLVII
(the work of Pisano the painter, 1447)

SELECTED BIBLIOGRAPHY

de Turckheim-Pey, Sylvie. In *Pisanello*
[exh. cat., Musée du Louvre] (Paris,
1996), 407, no. 285.

Gasparotto, Davide. In *Pisanello* [exh.
cat., Museo del Castelvecchio, Verona]
(Milan, 1996), 396–397, no. 91.

Hill, George Francis. *A Corpus of Italian
Medals of the Renaissance before Cellini*,
11, no. 37. London, 1930.

Hill, George Francis and J. Graham
Pollard. *Renaissance Medals from
the Samuel H. Kress Collection at the
National Gallery of Art*, 10, no. 17.
London, 1967.

Rossi, Massimo. In *I Gonzaga. Moneta
arte storia* [exh. cat., Palazzo Te, Mantua]
(Milan, 1995), 396–397, no. v.3.

Rugolo, Ruggero. In *Pisanello. Una
poetica dell'inatteso*, 172–173, no. 16.
Cinisello Balsamo, 1996.

Scher, Stephen K. In *The Currency of
Fame* [exh. cat., National Gallery of Art]
(New York, 1994), 52–53, no. 7.

The medal is a quintessentially humanist form of portraiture that emerged from a blending of the revival of interest in ancient numismatics with the values of the chivalric culture of the princely class. Comprising an obverse portrait and a reverse composition, usually of a complex symbolic nature, the medal includes inscriptions that both identify the sitter and provide some commentary on her life and character. About one-tenth of Renaissance medals represent female sitters, the daughters and wives of the ruling elite.[1] Pisanello (Antonio Pisano c. 1395–1455), the most talented artist to produce medals, is credited with "inventing" this art form, probably under the patronage of Leonello d'Este and with the input of humanists like Leon Battista Alberti.

Born in 1426, Cecilia, youngest daughter of Marquis Gianfrancesco Gonzaga of Mantua and Paola Malatesta, was educated in the classics alongside her brothers in Vittorino da Feltre's famed Scuola 'Zoiosa.[2] Something of a prodigy, she was noted for her academic achievement by all her contemporaries, including Ambrogio Traversari who commented on her proficiency in Greek.[3] Despite her intellectual abilities, her father intended for her to marry the son and heir of the count of Urbino, Oddantonio da Montefeltro. Cecilia however, challenged paternal authority and sought to devote herself to the religious life. Eventually Gianfrancesco relented and in his will granted her permission to become a nun. Following his death, in 1444, Cecilia entered the Clarissan convent of Corpus Domini on 2 February 1445. For the ceremony, according to an eyewitness, she wore a white damask dress with gold decoration around the collar and sleeves, and on her head was a garland of juniper with gold spangles.[4] By the time of her death in 1451, Cecilia was widely regarded for her piety.

Pisanello could not have taken her likeness from life. Besides, her elegant court dress and coiffure do not correspond to that which she was described as having worn for her entry into the convent. Thus, it is likely that Pisanello used an earlier drawing as a model, possibly one representing a different woman. This hypothesis is also suggested by the similarity of Cecilia's portrait with Pisanello's *Portrait of Ginevra d'Este* in the Louvre, not only in details of dress and features, but also in the half-length depiction of the sitter, which is highly unusual in a medal.[5]

The theme of Cecilia's chastity (VIRGO) on the obverse inscription is echoed and expanded upon in the serene and poetic reverse of a seminude classical maiden taming a unicorn under the moon, symbol of the chaste Diana. According to medieval lore, first recounted in the *Physiologus,* only a virgin could tame the wild unicorn.[6] In this case the girl, surely not Cecilia herself, may be an allusion to Diana, thus melding medieval and classical myth in a celebration of chastity. Petrarch's choice of unicorns to lead the way in his Triumph of Chastity firmly codified this association in the Italian Renaissance and the iconography was even used by Leonardo (cat. 18). At the same time, the medieval identification of the unicorn with Christ would have been most appropriate in a medal of a chaste princess who had pledged herself to Christ. The placid unicorn, which anchors the foreground horizontally, is based on a drawing of a goat by Pisanello or his circle in the Louvre.[7] A similar animal, a ram, crouches in the same pose behind the princess of Trebizond in Pisanello's fresco in Sant'-Anastasia, Verona, of c. 1438–1439.[8] The drawing may well be related to the fresco and later reused by the artist as an attribute for another depiction of a

noble and virtuous princess. George Hill (1930) was the first to suggest that the goat used for the body of the unicorn refers to Cecilia's wisdom, though it must be noted that in the *Physiologus* the unicorn is described as a goatlike animal.[9] In what is one of Pisanello's most successful medallic creations, and the only one to represent a woman, the artist places the vertical element of the portrait in the middle of the halolike legend, an opposite compositional construction to the reverse, where the two vertical elements of the virgin and the stele are joined by the horizontal mass of the unicorn but leave an empty space along the vertical axis. In this space only the slim sickle of the moon shines on a rocky and barren landscape, echoing the circular form of the medal. EL

NOTES

1. This ratio is easily determined by a quick count in George Francis Hill, *A Corpus of Medals of the Renaissance before Cellini* (London, 1930), still the definitive source in the field.

2. On the life of Cecilia Gonzaga, see Francesco Tarducci, *Cecilia Gonzaga e Oddantonio da Montefeltro* (Mantua, 1897); Giovanni Scatena, *Oddantonio da Montefeltro* (Rome, 1989), 31–42, 108–112; Rodolfo Signorini, "AENIGMATA *Disegni d'arme e d'amore* ossia imprese e motti su medaglie e monete di principi Gonzaga e di tre personaggi coevi," in *Monete e medaglie di Mantova e dei Gonzaga dal XII al XIX secolo,* 4 vols. (Milan, 1996), 2: 67–71.

3. Traversari records Cecilia's accomplishment with wonder in his *Hodoeporicon* (Florence, 1678), 34. He also noted it in a letter of c. 1435: "Era ivi ancora una fanciulla figliuola del principe di circa dieci anni, che scrive sì bene in greco, ch'io mi vergognai riflettendo che di quanti io ne ho istruiti, appena vi ha chi scriva leggiadramente" (as transcribed in *Mantova. Le lettere,* ed. Emilio Faccioli, 3 vols. [Mantua, 1962], 2: 25). A mark of Cecilia's unusual achievement is the fact that fully one-third of Vespasiano da Bisticci's life of Vittorino da Feltre is devoted to her (Vespasiano da Bisticci, *The Vespasiano Memoirs: Lives of Illustrious Men of the XVth Century,* trans. William George and Emily Waters [Toronto, 1997], 411–412). A fellow woman of learning, Costanza Varano, expressed her admiration for Cecilia's "noble erudition and unique eloquence" in a letter of c. 1444 (translated in *Her Immaculate Hand. Selected Works by and about the Women Humanists of Quattrocento Italy,* ed. Margaret King and Albert Rabil [Binghamton, N.Y., 1992],

53–54). A fellow pupil of Vittorino's, Gregorio Correr wrote in 1443 an impassioned Latin oration in support of Cecilia's resolution to embrace the religious life, which gives a fascinating glimpse into the Mantuan court and attests to Cecilia's remarkable learning and virtue (*Her Immaculate Hand* 1992, 93–105). For a description of Cecilia's appearance we turn to Francesco Prendilacqua, also a pupil of Vittorino da Feltre: "Regolarmente maestosa per grandezza di corpo e forme di volto, per coltura di lettere e per costumi prestantissima e degna veramente che fosse sposata a qualche grand'uomo" (*Intorno alla vita di Vittorino da Feltre: dialogo,* trans. from Latin, Giuseppe Brambilla [Como, 1871], 76).

4. The account of the contemporary Mantuan merchant Gianfrancesco Maloselli is transcribed by Signorini (1996, 2: 70–71).

5. On the Louvre panel, see Dominique Cordellier, *Pisanello. La princesse au brin de genévrier* (Paris, 1996). Most often identified as Leonello d'Este's sister Ginevra, the sitter in the painting may have been Leonello's first wife, and Cecilia's deceased older sister, Margherita Gonzaga.

6. For the relevant text of the *Physiologus* and a clear interpretation, see Margaret Freeman, *The Unicorn Tapestries* [exh. cat., The Metropolitan Museum of Art] (New York, 1976), 19, 34–35, 42–54: "Physiologus says that the unicorn has this nature. He is a small animal, like a kid, but exceedingly fierce, with one horn in the middle of his head; and no hunter is able to capture him. Yet he may be taken in this manner: men lead a virgin maiden to the place where he most resorts and they leave her in the forest alone. As soon as the unicorn sees her he springs into her lap and embraces her." The story of the unicorn tamed by a virgin was mostly popular north of the Alps. Cecilia's medal may be one of the first instances of this iconography in Italy. On the unicorn in Renaissance art, see Lise Gotfredsen, *The Unicorn* (New York, 1999), 122–130.

7. Maria Fossi Todorow, *I disegni di Pisanello e della sua cerchia* (Florence, 1966), 24, 64, no. 14; Dominique Cordellier in *Pisanello* (Paris, 1996), 341–342, no. 222.

8. Monica Molteni in *Pisanello. Una poetica dell'inatteso,* ed. Lionello Puppi (Cinisello Balsamo, 1996), 76–89.

9. Freeman 1976, 19, 34.

| Mantuan artist, possibly Giancristoforo Romano | c. 1485, bronze 6.1 (2 7/16) | National Gallery of Art, Washington, Samuel H. Kress Collection, 1957.14.668 |

8 *Giulia Astallia*

INSCRIPTIONS

Obverse: around the field DIVA · IVLIA ASTALLIA (the divine Giulia Astallia); Reverse: around the field EXEMPLVM VNICVM · FOR · ET · PVD · (unique example of beauty and chastity)

SELECTED BIBLIOGRAPHY

Friedländer, Julius. *Die Italienischen Schaumünzen des fünfzehnten Jahrhunderts*, 129. Berlin, 1880.

Hill, George Francis. *A Corpus of Italian Medals of the Renaissance before Cellini*, 53–54, no. 218. London, 1930.

Hill, George Francis and J. Graham Pollard. *Renaissance Medals from the Samuel H. Kress Collection at the National Gallery of Art*, 19, no. 75. London, 1967.

Luchs, Alison. In *The Currency of Fame* [exh. cat., National Gallery of Art] (New York, 1994), 84–85, no. 19.

One of the most graceful and engaging medals of the Renaissance, this work is unusual in that both the author and the sitter have not been securely identified. The type of portrait, however, is clearly indebted to Florentine sources.[1] Originally connected by Julius Friedländer (1880) to the Mantuan medalist Bartolo Talpa, the work was eventually attributed by George Hill (1930) to the manner of Antico on the basis of a similarity in the pose and downcast look of the lady to those of Maddalena Mantuana in her medal.[2] While granting certain affinities between the two medals, the rounded, relatively high-relief forms of the Giulia Astallia portrait are at variance with the delicate low-relief of Maddalena Mantuana. Furthermore, the confident modeling, rendering of the hair, epigraphy and positioning of the inscriptions, and absence of a border recall the medal of Isabella d'Este, not that of Maddalena, by Giancristoforo Romano (c. 1465–1512).[3] The rounded truncation of the bust, as well as the same style of lettering, are also present on Giancristoforo's medal of Isabella of Aragon. A certain clarity and naturalism of the forms in the medal of Giulia Astallia is also a constant feature of this artist's work; it may well reflect the influence of Roman art of the Augustan period with which he was so familiar.[4]

On the obverse Giulia is shown waist length in profile to the left, with her torso in three-quarter view. As in the medal of Cecilia Gonzaga, this unusual vantage point may result from the use of a painted likeness as a model. Giulia's plain laced-up dress with a decorated border along the neckline finds parallels in portraits of Florentine women of the 1480s (see cats. 29, 31B). More distinctive is her elaborate hairstyle, which, together with her elongated neck and elegant stance, recalls Botticelli's women, especially his *Young Woman in Mythological Guise* of c. 1480/1485 (cat. 28). In addition, Giulia's gaze and melancholy air are typical of Botticelli, especially his Madonnas, adding to the overall Florentine appearance of the portrait.

Friedländer (1880) suggested that the sitter might be the protagonist of one of Bandello's stories: a servant girl from Gazzuolo named Giulia, in the service of Bishop Lodovico Gonzaga, who, having been raped, drowns herself rather than live unchaste. Alison Luchs (1994), however, points out that there is no evidence that Giulia of Gazzuolo's last name was Astallia, nor was this name known in that region. The only Astalli family of note is from Rome, Giancristoforo Romano's city of origin and one that he visited frequently throughout his life.[5] Documented to have executed a medal of Pope Julius II by 1507, the artist likely could have created works for other Roman patrons earlier in his career.[6] The Florentine look of the portrait could then be explained if the painted portrait of a Roman sitter on which the medal is modeled was by a Florentine artist, possibly one of the group that traveled to Rome in 1481–1482 to decorate the Sistine chapel.

The sitter's downcast gaze, together with the resurrection iconography associated with the phoenix on the reverse, may indicate that this is a posthumous medal.[7] The bird, with its distinctive peacocklike crown, was said to regenerate itself from its own aromatic funeral pyre every five hundred to one thousand years.[8] It is depicted here at the moment of death: while looking at the sun it spreads its wings as flames envelop its body. The inscription on the reverse seems to be a comment on the sitter, though, as PVD (icitia), chastity, must surely refer to Giulia. It follows, then, that FOR must stand for *forma* (beauty), and not *fortitudo* (fortitude), because it appears commonly in inscriptions about female sitters of the late fifteenth century, most notably Leonardo's *Ginevra de' Benci* (cat. 16).[9] But the legend also cleverly ties together the two sides with a description of the virtues of the lady as unique—also one of the defining characteristics of the phoenix.[10] In a typically complex blending of classical and Christian iconography the medal then proclaims that Giulia Astallia's redemption is assured by those virtues, which are as unique as the phoenix. EL

NOTES

1. Evidence of the popularity and beauty of Giulia's medal is the fact that Bastianini copied the portrait in a rectangular marble relief; see John Pope-Hennessy, *The Study and Criticism of Italian Sculpture* (New York, 1980), 259–261, fig. 61.

2. Hill 1930, no. 215.

3. On Isabella d'Este's medal of 1498, see Hill 1930, 55–56, no. 221; Andrea Norris, "Gian Cristoforo Romano: The Courtier as Medalist," *Studies in the History of Art* 21 (1987), 133–136; Luke Syson, "Reading Faces. Gian Cristoforo Romano's Medal of Isabella d'Este," in *La corte di Mantova nell'età di Andrea Mantegna: 1450–1550,* ed. Cesare Mozzarelli, Robert Oresko, and Leandro Ventura (Rome, 1997), 281–294. Though Giulia's medal must date to some ten years before Isabella's memorial, it does not seem inappropriate to compare the two since Giancristoforo's style remained constant. For example, his medal of Isabella of Aragon of c. 1507 (Hill 1930, 56–57, no. 223) is quite close to that of Isabella d'Este.

4. Giancristoforo Romano's knowledge of Roman antiquities is well attested to not only by his contemporaries, but also by his frequent and erudite quotation of classical subjects in his medals and in the tomb of Gian Galeazzo Visconti in the Certosa of Pavia. On the artist, see Adolfo Venturi, "Gian Cristoforo Romano," *Archivio storico dell'arte* 1 (1888), 49–59, 107–118, 148–158; Norris 1987; Andrea Norris, "Gian Cristoforo Romano," in *The Dictionary of Art* 12 (1996), 582–583.

5. On the Astalli family, see Teodoro Amayden, *La storia delle famiglie romane,* ed. Carlo Augusto Bertini, 2 vols. (Rome, 1914; reprint ed., Bologna, 1979), 1: 85–88; Luchs 1994, 379, note 10.

6. For the medal of Julius, see Hill 1930, 56, no. 222; Norris 1987, 136–137.

7. The downcast look in Botticelli's portrait of *Giuliano de' Medici* (cat. 27) is one reason the painting is believed to be posthumous (Fern Rusk Shapley, *Catalogue of the Italian Paintings,* 2 vols. [Washington, 1979], 1: 83–84; 2: pl. 55). The appellative DIVA on the obverse inscription probably derives from its use on Roman imperial coins to indicate that the empress is deceased. It is unclear whether fifteenth-century humanists were aware of this usage, as DIVA occurs frequently on medals of women who were certainly living. On this point, see Eleonora Luciano, "Diva Isotta and the Medals of Matteo de' Pasti," *The Medal* 29 (1996), 12, 17, note 62.

8. Ancient authors and medieval bestiaries give slightly varying accounts of the story of the phoenix; for a thorough summary, see Mary Edwards, "Petrarch and the Phoenix in the Chapel of San Felice in the Basilica of Sant'Antonio in Padua," *Il santo* 31 (1991), 382–389.

9. Closest to Giulia's medal legend is that on the reverse of the medal of Lucrezia Borgia attributed to the school of Giancristoforo Romano: VIRTVTI · AC · FORMAE · PVDICITIA · PRAE-CIOSISSIMVM · (Hill 1930, no. 233). *Forma* is celebrated also in several other medals of Renaissance women: Matteo de' Pasti's *Isotta degli Atti* reads ISOTE · ARIMINENSI · FORMA · ET · VIRTVTE · ITALIE · DECORI · (Hill 1930, nos. 167, 170); Jacoba Correggia's medal of the Mantuan school reads IACOBA · COR-RIGIA · FORME · AC · MORVM · DOMINA (Hill 1930, no. 234); and *Maddalena Rossi* on the obverse reads MAGDALENA · RVBEA · MORIB · ET · FORMA · INCOMPARABIL · (Hill 1930, no. 235).

10. As noted by Edwards (1991), most sources describe the bird's sex as male, but Lactantius in his poem "De ave phoenice" gave it as female also using the adjective "unica" (*Minor Latin Poets,* trans. J. Wight Duff and Arnold Duff [London and Cambridge, 1935], 652, lines 31–32). In two of his poems Petrarch associated the phoenix with the rarity of his feelings for his beloved, thus providing a precedent for connecting this bird with young maidens (*Petrarch's Lyric Poems* [Cambridge and London, 1976], no. 135, lines 9–15; no. 323, lines 49–60).

**Attributed to
Niccolò Fiorentino**

c. 1475, bronze
9 (3 9/16)

National Gallery of Art, Washington,
Samuel H. Kress Collection,
1957.14.866

9 *Maria de' Mucini*

INSCRIPTIONS

Obverse: around the field · MARIA · DE
MVCINY · (Maria de' Mucini); Reverse:
on a scroll in upper field · EXPE CTO ·
(I am waiting); on a scroll in lower left ·
ASSIDVVS (faithful); on a scroll in lower
right MITIS · ESTO · (be humble)

SELECTED BIBLIOGRAPHY

Börner, Lore. *Die italienischen Medaillen
der Renaissance und des Barock,* 98–99,
no. 375. Berlin, 1997.

Hill, George Francis. *A Corpus of Italian
Medals of the Renaissance before Cellini,*
260, no. 991. London, 1930.

Hill, George Francis and J. Graham
Pollard. *Renaissance Medals from
the Samuel H. Kress Collection at the
National Gallery of Art,* 52, no. 272.
London, 1967.

From the mid-fifteenth century portrait medals flourished in the north Italian courts. The art form reached republican Florence only in the 1470s and may have paralleled the newfound interest in contemporary biography evidenced by works like Vespasiano da Bisticci's *Vite di uomini illustri.* The principal medalist was Niccolò di Forzore Spinelli, known as Niccolò Fiorentino (1430–1514), whose bold and incisive style of portraiture, coupled with generally coarse and repetitive reverses, dominates the production.[1] Of the 150 or so medals attributed by Hill to Niccolò and his school, it is noteworthy that 28 depict female sitters—a ratio twice as great as that of all Italian Renaissance medals. Of this large corpus only five are signed,[2] and none of those represent women, but many, like the medals of Maria de' Mucini and Giovanna degli Albizzi, are of such fine quality that they are most probably by the master himself.

Maria de' Mucini's likeness, with her full cheeks and prominent nose and eyes, is one of the most expressive on any medal of a woman. The construction of the shoulder and collarbone with the very elongated neck as well as the simplicity of the image are similar to Botticelli's sober *Portrait of a Woman* in the Galleria Palatina, Florence.[3] The best clue for dating Maria's medal is offered by her hairstyle and dress. The laced-up bodice over a bordered chemise is common in Florentine portraits of women of the last quarter of the quattrocento, from *Ginevra de' Benci* to *Giovanna degli Albizzi Tornabuoni* (cats. 16, 30). The hair, modestly pulled back and secured by thin bands, is more rare; a parallel is the young donor on the right in Ghirlandaio's fresco of the *Madonna della Misericordia* of 1472–1473 (Vespucci Chapel, Ognissanti, Florence).[4] Both the hairstyle and dress suggest a date around 1475. Unfortunately, the young Maria has not been identified as almost nothing is known of the Mucini family except that they were Florentine and a coat of arms is recorded for them.[5]

Two of the main elements of the reverse, with their accompanying *mottos,* are Strozzi emblems.[6] Perhaps the medal functioned as a celebration of a betrothal to a member of that family, though probably not a marriage as the sitter is not identified as "uxor" (wife) in the inscription, as on that of Giovanna degli Albizzi, for example. The first element, a molting falcon, occurs not only on the reverse of Filippo Strozzi's medal but also on other Florentine medals and may proclaim the allegiance of the sitters.[7] As the old Italian word for falconer is "strozziere," the bird is a particularly apt impresa for that family. The falcon's shedding of plumage signifies renewal, and the word "expecto" may refer to the expectation of rewards for the virtues embodied in the hound and the lamb depicted below the falcon.[8] The lamb, at right, with its Christian connotation, is the second main emblem used by Filippo Strozzi. It does not appear on his medal, but figures prominently in the lavish miniatures for a manuscript of Pliny's *Natural History* decorated for him by Gherardo (or Monte) di Giovanni (Bodleian Library, Oxford).[9] The playful dog, at left, is a common symbol of fidelity, as is noted on the scroll, and would have been especially appropriate for the medal of a bride-to-be. According to Giovio the flaming structure below the falcon was an emblem invented by Poliziano for Lorenzo de' Medici to symbolize the ardor of his love.[10] The device occurs on two other Florentine medals and would also have been well suited for a betrothal celebration.[11] EL

NOTES

1. Hill 1930, 243, 246; Graham Pollard in *The Currency of Fame* [exh. cat., National Gallery of Art] (New York, 1994), 132; Stephen K. Scher, "Niccolò di Forzore Spinelli," *The Dictionary of Art* 29 (1996), 408–409.

2. Hill 1930, 246–247, nos. 922–926.

3. Jennifer Craven, "A New Historical View of the Independent Female Portrait in Fifteenth-Century Florentine Painting," Ph.D. diss., University of Pittsburgh, 1997, 283–285, no. 26.

4. Ronald Kecks, *Domenico Ghirlandaio* (Florence, 1998), 47–49.

5. Howel Wills, *Florentine Heraldry* (London, 1901), 157: "Per fess or and azure, a lion rampant counterchanged."

6. On the Strozzi emblems of the falcon and the lamb, see J. Russell Sale, *Filippino Lippi's Strozzi Chapel in Santa Maria Novella* (New York, 1979), 85–88.

7. Other medals with the molting falcon device are Hill 1930, nos. 978 (Giovanni Antonio de' Conti Guidi), 982 (Pietro Machiavelli), 1046 (Giovanni Gozzadini). The molting falcon is also on the carved top of a *sgabello* from the Strozzi palace in the Metropolitan Museum of Art, New York (Wolfram Koeppe, "French and Italian Renaissance Furniture at the Metropolitan Museum of Art," *Apollo* 138 [1994], 28–29). Similarly it is woven on a lavish silk brocade panel (Bargello, Florence) with the motto SIC ET VIRTVS EXPECTO on a scroll and with the Strozzi emblem of the half-moons (*Tessuti italiani del Rinascimento. Collezioni Franchetti Carrand,* ed. Rosalia Bonito Fanelli and Paolo Perri [Florence, 1981], 80, cat. 28). The falcon was also used by the Medici as an emblem (see cat. 10, note 8).

8. Sale 1979, 88.

9. Lilian Armstrong in *The Painted Page. Italian Renaissance Book Illumination,* ed. Jonathan Alexander [exh. cat., Royal Academy of Arts, London] (Munich, 1994), 174–176, no. 85.

10. Paolo Giovio, *Dialogo dell'Imprese* (Lyon, 1574; reprint ed., New York, 1979), 49.

11. Hill 1930, nos. 976, 1052.

Attributed to Niccolò Fiorentino

1485/1486, bronze
7.5 (2¹⁵/₁₆)

National Gallery of Art, Washington, Samuel H. Kress Collection, 1957.14.891

IO *Lodovica Tornabuoni*

INSCRIPTIONS

Obverse: around the field · LVCDOVICA · DE TOR NABONIS · IO · FI · (Lodovica Tornabuoni, daughter of Giovanni)

SELECTED BIBLIOGRAPHY

Börner, Lore. *Die italienischen Medaillen der Renaissance und des Barock*, 103–104, no. 403. Berlin, 1997.

Hill, George Francis. *A Corpus of Italian Medals of the Renaissance before Cellini*, 275–276, no. 1069. London, 1930.

Hill, George Francis and J. Graham Pollard. *Renaissance Medals from the Samuel H. Kress Collection at the National Gallery of Art*, 131, no. 297. London, 1967.

This medal, attributed to Niccolò Fiorentino (1430–1514), memorializes Lodovica Tornabuoni as a nine-year-old girl. With her baby cheeks and upturned nose, she looks like a dressed-up child. She was probably born in 1476, as her father Giovanni declared that in 1480 she was four years old.[1] We know her age at the time of the portrait because a cast of this medal in the Münzkabinett, Berlin, bears the inscription · AN · VIIII (nine years old).[2] Medals of children are rare in the Renaissance. Occasionally the eldest son of a prince, like Alfonso I d'Este, was honored with such a portrait in celebration of dynastic continuity,[3] but it is much less clear why a young girl would be celebrated.

Lodovica's medal is roughly the same size as that made for her brother Lorenzo and, as suggested by George Hill, may have been commissioned as a companion piece on the occasion of his wedding in June 1486. At that time, depending on her exact date of birth, Lodovica would have been nine or ten years of age.[4] The medal would then have served as part of a program of family celebration that also included the likeness of Giovanna degli Albizzi, Lodovica's sister-in-law. Lodovica herself married Alessandro di Francesco Nasi in 1491.[5]

On the obverse the girl is shown in profile to the left. Her hair curls around her cheeks and is loosely gathered in back with a small triangular coif. A large jeweled pendant adorns her tightly fitting bodice. Enrico Ridolfi was the first to identify another portrait of Lodovica in Ghirlandaio's fresco of the *Birth of the Virgin* in the Tornabuoni chapel of Santa Maria Novella on the basis of its similarity to the medal (fig. 1).[6] The identification has been widely accepted and is supported by striking similarities in the unusual hairstyle as well as the likeness. Patricia Simons has gone so far as to identify the jewel worn by Lodovica in the fresco as a "crocettina" mentioned in Giovanni Tornabuoni's will.[7] That jewel does look remarkably similar to the one on the medal, though in the frescoed version large pearls have been added to the perimeter, a common practice for Renaissance jewelers.

In the fresco, painted around 1489/1490, Lodovica is depicted as an attendant to the *Birth of the Virgin* and appears older than in the medal—a girl of thirteen or fourteen. She is resplendently clad in gold brocade woven with an intricate pattern consisting of the Tornabuoni device of triangles, a targetlike motif with sun rays and an undulating scroll, and a displayed bird on a sawed-off branch. The latter is probably the Medici device of a falcon on a branch, clearly proclaiming the close Tornabuoni ties to the ruling family.[8] The cloth, combining a show of family wealth with heraldic pride, must have been woven especially for the Tornabuoni. Its significance is underscored by the fact that in the same fresco cycle Giovanna degli Albizzi wears an overdress of that fabric (cat 30, fig. 1). What is of particular interest in connection with Lodovica's medal is the Medici bird woven into the pattern, which may also appear on the medal reverse perched on a verdant branch in front of the crouching unicorn. Hill (1930) identified the bird as a dove, notable for its purity and amiability, but it may just as plausibly be a falcon, a phoenix, or a peahen. As in the medal of Cecilia Gonzaga (cat. 7), the unicorn celebrates Lodovica's chastity, but in this case it may be understood in the context of her virtue and desirability as a bride.[9] Whatever its type, the bird's symbolism must be one that complements the unicorn, which looks up in an unspoken exchange. On a mid-fifteenth-century Florentine *cassone* depicting the Judgment of Solomon, a unicorn with a scroll ornaments the lavish mantle worn by the bride-to-be while a falcon appears on the cape worn by the bridegroom.[10] The *cassone* suggests a particular association of the two animals in a betrothal or marriage context that may also be appropriate for the medal of Lodovica Tornabuoni.[11] EL

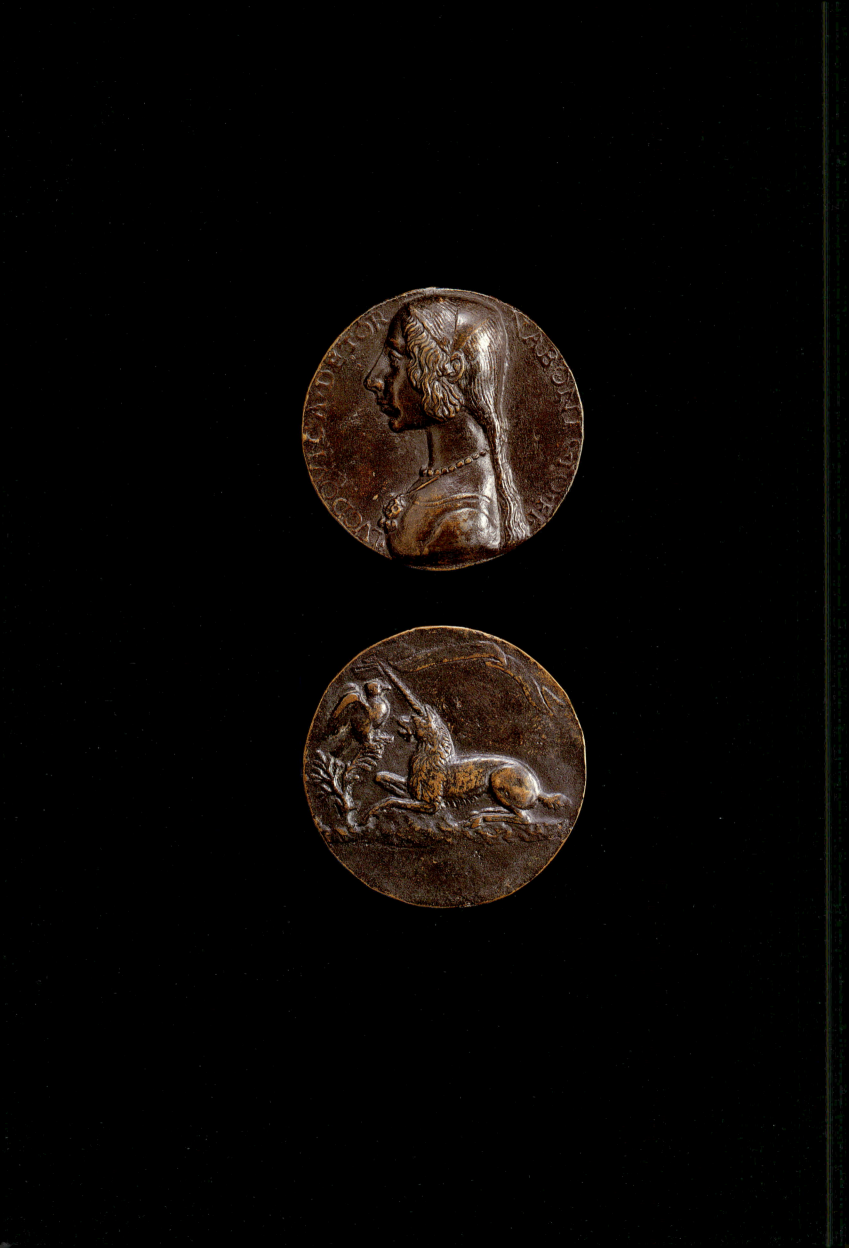

1

Domenico Ghirlandaio, *Birth of the Virgin* (detail), Tornabuoni Chapel, Santa Maria Novella, Florence (photo: Scala/Art Resource, N.Y.)

1

NOTES

1. Enrico Ridolfi, "Giovanna Tornabuoni e Ginevra de' Benci nel coro di S. Maria Novella in Firenze," *Archivio storico italiano* 6 (1890), 451–452, note 2. Patricia Simons, "Portraiture and Patronage in Quattrocento Florence with Special Reference to the Tornaquinci and Their Chapel in S. Maria Novella," Ph.D. diss., University of Melbourne, 1985, 130, 299.

2. Börner 1997. Another medal, that of Peretta Usodimare, granddaughter of Pope Innocent VIII, attributed to Niccolò, also represents a young girl (Hill 1930, no. 944).

3. Hill 1930, 31, no. 118.

4. On the basis of a rather rigid interpretation of the reverse iconography of Lorenzo Tornabuoni's medal, Hill (1930, 275, no. 1068) believed that though the portraits were modeled around 1486, the medals themselves were created only after the return to power of the Medici in 1512.

5. Ridolfi 1890. For her wedding Lodovica was furnished with an impressive dowry and lavish jewels (Simons 1985, 139).

6. Ridolfi 1890, 451. A Botticelli fresco (now destroyed) in the Villa Lemmi is believed to have included a portrait of the young Lodovica with her father Giovanni: Ronald Lightbown, *Botticelli* (Paris, 1989), 172, 374, no. B45a.

7. Simons 1985, 139; Patricia Simons, "Women in Frames: The Gaze, the Eye, the Profile in Renaissance Portraiture," in *The Expanding Discourse. Feminism and Art History*, ed. Norma Broude and Mary Garrard (New York, 1992), 42.

8. The Medici falcon may be connected to the Strozzi falcon (depicted on the medal of Maria de' Mucini, cat. 9), though it is not molting. According to Giovio it was originally adopted by Piero de' Medici il Gottoso (Paolo Giovio, *Dialogo dell'Imprese* [Lyon, 1574; reprint ed., New York, 1979], 48). Giovanni Tornabuoni was not only Lorenzo's uncle, but also head of the Medici bank since 1465 (Donatella Pegazzano, "Giovanni Tornabuoni," in *The Dictionary of Art* 31 [1996], 173).

9. On the unicorn, see cat. 7, note 6.

10. The *cassone* frontal, in the collection of Mary Pavan De Carlo, Florence, is published by Jerzy Miziołek, "The Queen of Sheba and Solomon on Some Early-Renaissance *Cassone* Panels *a pastiglia dorata*," *Antichità viva* 36 (1997), 9–11, 13–14, 22–23, notes 56, 60, 61, figs. 11, 15–16.

11. The possibility of a standard iconographic connection between the falcon and the unicorn is strengthened by the presence of the two animals next to each other on a sheet in the Gabinetto Disegni e Stampe of the Uffizi, Florence. Attributed to an anonymous Florentine quattrocento artist, it was first noticed in this context by Miziołek (1997, 13–14, fig. 22). See also Luisa Tongiorgi Tomasi in *Il disegno fiorentino del tempo di Lorenzo il Magnifico*, ed. Annamaria Petrioli Tofani [exh. cat., Uffizi, Gabinetto Disegni e Stampe] (Florence, 1992), 183, no. 9.4.

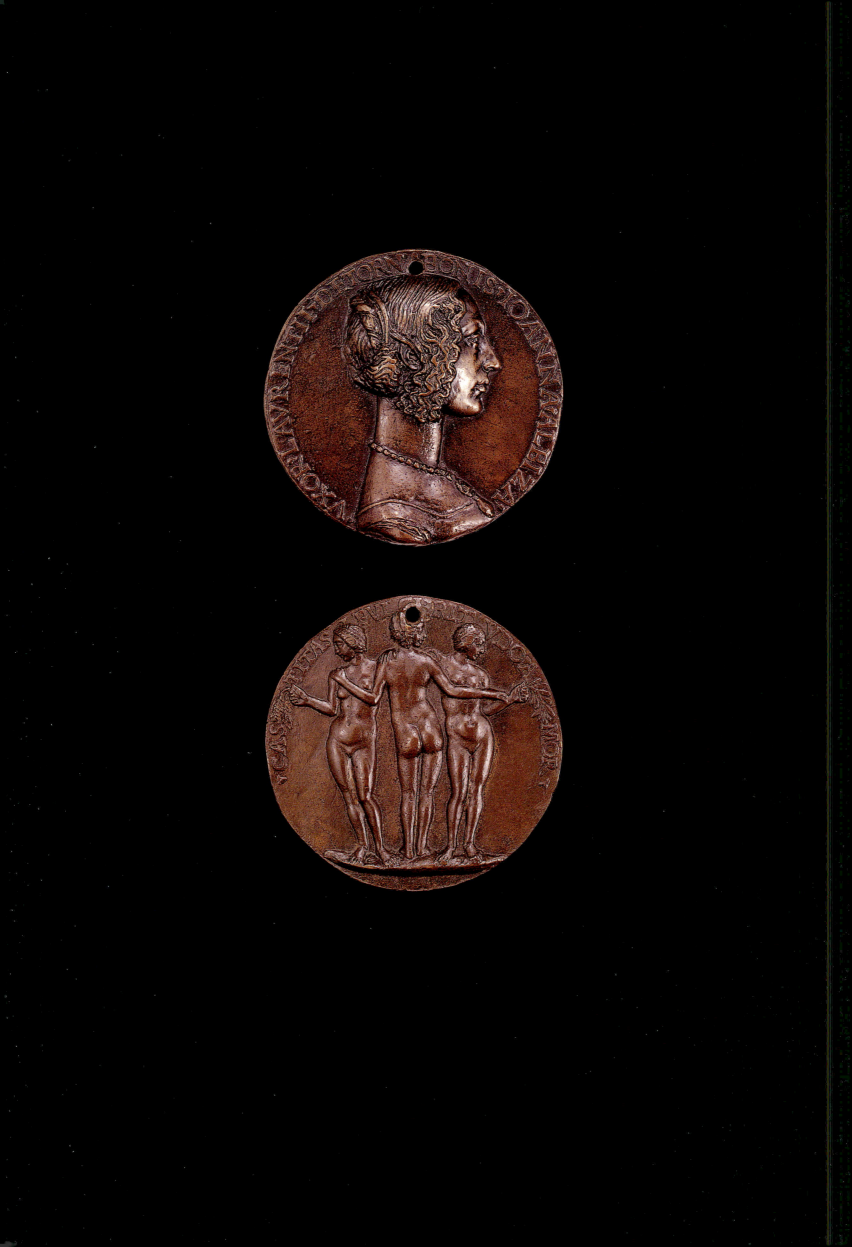

Attributed to Niccolò Fiorentino

c. 1486, bronze
7.8 (3 1/16)

National Gallery of Art, Washington,
Samuel H. Kress Collection,
1957.14.882

II *Giovanna degli Albizzi Tornabuoni*

INSCRIPTIONS

Obverse: around the field · VXOR ·
LAVRENTII · DE TORNABONIS ·
IOANNA · ALBIZA · (the wife of Lorenzo
Tornabuoni, Giovanna Albizzi);
Reverse: around the field · CAS TITAS ·
PVLCHRIT VDO · A MOR · (chastity,
beauty, love)

SELECTED BIBLIOGRAPHY

Hill, George Francis. *A Corpus of Italian
Medals of the Renaissance before Cellini,*
267, no. 1021. London, 1930.

Hill, George Francis and J. Graham
Pollard. *Renaissance Medals from
the Samuel H. Kress Collection at the
National Gallery of Art,* 54, no. 288.
London, 1967.

Pollard, Graham. In *The Currency of
Fame* [exh. cat., National Gallery of Art]
(New York, 1994), 135–136, no. 45.

Giovanna, daughter of Maso degli Albizzi and his second wife Caterina Soderini, was born in 1468. None other than Lorenzo de' Medici brokered her marriage to Lorenzo Tornabuoni, son of the enormously wealthy Giovanni, on 15 June 1486.[1] The sumptuous ceremony in Florence's Santa Maria Novella marked an important alliance between the dynastically distinguished Albizzi and the influential Tornabuoni, who owed their recent success to their Medicean alliance. In her nuptial procession Giovanna is said to have been attended by one hundred maidens and fifteen young men in livery.[2] She fulfilled her conjugal duties by giving birth to a son, Giovanni, in October of 1487. Such good fortune, however, was short-lived: she died in childbirth in October of 1488 and was buried in Santa Maria Novella, presumably within sight of Ghirlandaio's frescoes.[3] Poliziano, her husband Lorenzo's tutor, wrote an epigram for her tomb summarizing the felicity of her short life.[4]

Giovanna's medal, one of the most graceful of the entire Florentine production, is characterized by the same incisive portraiture that is present on the signed medals of Niccolò Fiorentino (1430–1514) and must be the work of the master himself.[5] Clearly a consort portrait, that role is stressed in the obverse inscription, which starts with the word VXOR (wife). The medal was probably commissioned on the occasion of her marriage in 1486, as part of a program of celebration that may have included the medals of Lorenzo and Lodovica Tornabuoni (cat. 10) as well as the still extant Albizzi-Tornabuoni *spalliera* panels.[6] On the obverse Giovanna is depicted in profile to the right, with her hair flowing in curls down her cheek and gathered tightly at the back of her head. She wears a large pearl necklace with a sizable pendant. Her plain dress, with a square-cut neckline marked by a thin border, is similar to that worn by *Ginevra de' Benci* (cat. 16). Giovanna's elegant and dignified medal is the basis for the identification of her portraits by Ghirlandaio—the panel in Madrid (cat. 30) and the frescoes in Santa Maria Novella.[7] Though Giovanna faces left instead of right in Ghirlandaio's likenesses and is wearing a different style of dress, her features are clearly recognizable, as is the hairstyle, which is identical in all her portraits.

The charming group of the Three Graces on the reverse is copied from one of the many antique representations of this composition, but the exact source is not known. Shown nude, two from the front and one from the back, the goddesses, with arms interlaced, appear in ancient art on coins, mirror backs, terra-cotta lamps, as well as in frescoes and sculptural reliefs, and as freestanding figures.[8] George Hill (1930) believed that the features of the central figure on the medal reverse were intended as a portrait of Giovanna, but this theory seems improbable both on visual grounds and for reasons of propriety. As in the ancient models, the Grace on the left holds two stalks of wheat while her companion on the right proffers a branch with long thin leaves, perhaps from an olive tree.

The presence of the Three Graces here has Neoplatonic connotations, as the inscription is a variant on a text by the humanist Marsilio Ficino and the same composition, with Ficino's original text, occurs on the reverse of the medal of Giovanni Pico della Mirandola.[9] As interpreted by Edgar Wind, these mythological figures represent a complex understanding of love, both earthly and divine, as tripartite involving the acts of giving, accepting, and returning.[10] The inscription on Pico's medal, PVLCHRITUDO AMOR VOLVPTAS, a direct quotation from Ficino, suggests that "Love is passion aroused by beauty." In Giovanna's medal CASTITAS has been substituted for VOLVPTAS and the meaning has been transposed to indicate that "Beauty is love combined with chastity."[11] Like Bernardo Bembo's device on the reverse of *Ginevra de' Benci*'s panel, the Three Graces on the reverse of Giovanna degli Albizzi's medal may be evidence of a Platonic liaison between the newlywed lady and Pico, a nobleman as well as a humanist.[12] The relationship was meant as a compliment to the lady and was formally acknowledged by her with the acceptance of the suitor's chosen emblem.

This portrait medal is exceptional in that it was also cast with a reverse of an armed Venus and with an inscription from Virgil's *Aeneid*.[13] The subject of this reverse makes it likely that it, too, was commissioned on the occasion of Giovanna's wedding. Fully expressing the complexities of the humanist interpretation of love, the marriage medals of Giovanna degli Albizzi celebrate its subject by stressing not only the essential wifely virtues of virginity and chastity, but also her beauty, as evidence of platonic virtue. EL

NOTES

1. On the life of Giovanna degli Albizzi, see Enrico Ridolfi, "Giovanna Tornabuoni e Ginevra de' Benci nel coro di Santa Maria Novella in Firenze," *Archivio storico italiano* 6 (1890), 426–456; Georges Dumon, *Les Albizzi* (Cassis, 1977), 184–188; Patricia Simons, "Portraiture and Patronage in Quattrocento Florence with Special Reference to the Tornaquinci and Their Chapel in S. Maria Novella," Ph.D. diss., University of Melbourne, 1985, 142–144, 118–119, notes 195–197, 199; Maria DePrano, "*uxor incomparabilis*: The Marriage, Childbirth, and Death Portraits of Giovanna degli Albizzi," M.A. thesis, University of California, Los Angeles, 1997, 12.

2. The sumptuous wedding was described in the seventeenth century by Scipione Ammirato, *Delle famiglie nobili fiorentine* (Florence, 1615), 42.

3. For the record of Giovanna's burial see Alison Luchs, *Cestello. A Cistercian Church of the Florentine Renaissance* (New York, 1977), 45, note 16.

4. Simons 1985, 143–144.

5. On the five signed medals of Niccolò Fiorentino, see Hill 1930, 246–247, nos. 922–926.

6. On the medals, see Hill 1930, 275–276, nos. 1068, 1069; for the beautiful *spalliera* decorations see Everett Fahy, "The Tornabuoni-Albizzi Panels," in *Scritti di storia dell'arte in onore di Federico Zeri*, ed. Mauro Natale, 2 vols. (Milan, 1984), 1: 233–247.

7. Simons 1985 (305–306, 311) identified Giovanna degli Albizzi's portrait not only in the fresco of the *Visitation*, but also as the richly dressed lady in three-quarter view in the foreground of the *Birth of Saint John the Baptist*. On the frescoes see also Ronald Kecks, *Domenico Ghirlandaio* (Florence, 1998), 144, 170–174.

8. For a survey of the antique iconography of the Three Graces and its extant examples, see Hellmut Sichtermann, "Gratiae," in *Lexicon iconographicum mythologiae classicae*, 8 vols. (Zurich, 1986), 3.1: 203–210; 3.2: 157–167. John Spencer proposes a Roman terra-cotta lamp or mirror back as the source for the medal composition: "Speculations on the Origins of the Italian Renaissance Medal," *Studies in the History of Art* 21 (1987), 202–203, figs. 11, 12.

9. Edgar Wind, "The Medal of Pico della Mirandola," in *Pagan Mysteries in the Renaissance* (New York, 1968), 43. Ficino's text from the *De Amore* (11, ii) reads: "Amor igitur in voluptatem a pulchritudine desinit" (Love starts from beauty and ends in pleasure).

10. Wind, "Medal," 1968, 37–41.

11. Edgar Wind, "Orpheus in Praise of Blind Love," in *Pagan Mysteries in the Renaissance* (New York, 1968), 73.

12. Wind, "Orpheus," 1968, 73.

13. Hill 1930, 267–268, no. 1022. The inscription from Virgil, *Aeneid*, I, 315 reads VIRGINIS OS HABITVM QVE GERENS ET VIRGINIS ARMA (With a virgin's dress and mien and a virgin's arms).

Bertoldo di Giovanni | 1478, bronze | National Gallery of Art, Washington,
6.6 (2⅝) | Andrew W. Mellon Fund, 1988.30.2

12 *Lorenzo de' Medici, Giuliano de' Medici, and the Pazzi Conspiracy*

INSCRIPTIONS

Obverse: around the field LAVRENTIVS
MEDICES (Lorenzo de' Medici); across
the center SALVS / PVBLICA (public
safety); Reverse: around the field
IVLIANVS MEDICES (Giuliano de'
Medici); across the center LVCTVS /
PVBLICVS (public mourning)

SELECTED BIBLIOGRAPHY

Bode, Wilhelm von. "Bertoldo di
Giovanni und seine Bronzebildwerke."
*Jahrbuch der Königlich preussischen
Kunstsammlungen* 16 (1895), 153–155.

Draper, James. *Bertoldo di Giovanni
Sculptor of the Medici Household*, 86–95,
271. Columbia, 1992.

Draper, James. In *The Currency of
Fame* [exh. cat., National Gallery of Art]
(New York, 1994), 129–131, no. 41.

Hill, George Francis. *A Corpus of Italian
Medals of the Renaissance before Cellini*,
240–241, no. 915. London, 1930.

Wright, Alison. In *Renaissance Florence.
The Art of the 1470s* [exh. cat., National
Gallery] (London, 1999), 128, no. 2.

On 26 April 1478, a group of conspirators headed by Francesco de' Pazzi and supported by the anti-Medicean Pope Sixtus IV attempted to murder Lorenzo and Giuliano de' Medici during High Mass in Santa Maria del Fiore. The twenty-five-year-old Giuliano was stabbed nineteen times and died in front of the cathedral choir. The elder Lorenzo, though lightly wounded in the neck, was able to escape behind the bronze doors of the sacristy. Popular support for the Medici and Lorenzo's leadership ensured the failure of the plot, and in the immediate aftermath the conspirators were brutally executed. Many eyewitnesses reported the events, including Angelo Poliziano, who wrote an elegant and impassioned account in Latin.[1] This medal is the only visual record of the attempted coup—an extraordinary function for any Renaissance work of art. Its journalistic character must have been dictated by the exceptional events that it commemorates.

A letter of 11 September 1478 from the medalist Andrea Guacialotti to Lorenzo accompanied four casts of the medal and indicates that it was commissioned by Lorenzo himself and cast by Guacialotti from a model by Bertoldo di Giovanni (c. 1430/1440 –1491).[2] A pupil of Donatello and one of Michelangelo's teachers, Bertoldo spent his entire career in the service of the Medici; he died in Lorenzo's villa at Poggio a Caiano. Primarily active as a bronze sculptor, the artist is credited with six medals characterized by rather pictorial portraits and complex low-relief reverses with numerous figures.[3]

In this medal the unusual obverse and reverse compositions are mirror images, with the profile head of each man placed above the octagonal wooden choir of the cathedral.[4] Though small, the portraits are lively, recognizable likenesses without any of the exaggerated emphasis that often plagues depictions of Lorenzo.[5] They are probably based on images by Botticelli, especially Giuliano's effigy, which, though in reverse, is close to the portrait in the National Gallery of Art (cat. 27).[6]

On both sides of the medal the attacks are depicted as continuous narratives on either side of the choir, with the celebration of Mass occurring in the east end. Below his profile to the right, on the south side of the choir, the cloaked Lorenzo is seen first fending off the attackers then retreating to the wooden structure, and finally crouching just above its banister as he makes his escape into the sacristy. Contemporary accounts confirm that Lorenzo saved himself in just this way by crossing through the choir. Lest there be any doubt about his survival the inscription below his head proclaims the public's safety, clearly equating it with that of Lorenzo. On the other side of the medal, usually considered the reverse, Giuliano is also shown in a cloak, first being stabbed in the chest and then lying on the ground as the conspirators, with raised swords, continue to attack. In the inscription in the center, his death is declared public mourning.

In both narratives the dramatically active attackers are shown nude, a reference to classical art and possibly as a sign of disrespect for the traitors. The figures recall Antonio Pollaiuolo's fierce warriors in the engraving *Battle of the Nudes* (usually dated to c. 1470–1475),[7] and it is easy to see why Vasari, who knew the medal, thought that it was by his hand.[8] On closer examination, however, the influence of Donatello is equally present in the shallow relief, reminiscent of *rilievo schiacciato*, and dynamic composition. But conceptually the artist is beholden to no one in abandoning the traditional formula of the medal, in which one side is subordinated to the explication of the other. In this case, Bertoldo exploits the intrinsic duality of the art form with parallel compositions commemorating opposite outcomes of the same event: death and survival. Each side, in turn, conflates the canonical medallic form by presenting the portrait together with its historical commentary.

Beyond its unique significance as a visual record of the Pazzi conspiracy, Bertoldo's medal offers evidence of the skill and sophistication with which Lorenzo the Magnificent used art to further Medicean hegemony in Florence. Lorenzo's success in consolidating his power after the Pazzi conspiracy was such that his de facto rule was never challenged again. EL

NOTES

1. Lorenzo commissioned the *Coniurationis Commentarium* from Poliziano immediately after the conspiracy. For this and a summary of other accounts, see Alessandro Perosa, *Della congiura dei Pazzi* (Padua, 1958); *The Earthly Republic. Italian Humanists on Government and Society,* ed. Benjamin Kohl, Ronald Witt, and Elizabeth Welles (Philadelphia, 1978), 293–322.

2. Bode (1895) was the first to establish a connection between the medal and the letter. Relevant portions of the letter, transcribed by Draper (1992, 271, no. 4), read: "Mandove per el presente aportatore, ch'è ser Bartholomeo mio cappellano, quatro medaglie, le quali ò trayetate con li mei mano, che Bertoldo à facta la prima impronta."

3. On the life and work of Bertoldo, see Draper 1992.

4. Designed by Brunelleschi.

5. On the sculptural portraits of Lorenzo, see Alison Luchs, "Lorenzo from Life? Renaissance Portrait Busts of Lorenzo de' Medici," *The Sculpture Journal* 4 (2000), 6–23.

6. Hill (1930) was the first to suggest Botticelli as a source for the portraits.

7. On the print and its dating, see Laurie Fusco in *Early Italian Engravings from the National Gallery of Art* [exh. cat., National Gallery of Art] (Washington, 1973), 66–80, no. 13; Laurie Fusco, "Pollaiuolo's *Battle of the Nudes*: A Suggestion for an Ancient Source and a New Dating," in *Scritti di storia dell'arte in onore di Federico Zeri,* ed. Mauro Natale, 2 vols. (Milan, 1984), 1: 196–199.

8. Giorgio Vasari, *Le Vite de' più eccellenti pittori scultori ed architettori,* ed. Gaetano Milanesi, 9 vols. (Florence, 1906), 3: 297.

Rogier van der Weyden	c. 1460, oil on panel	National Gallery of Art, Washington,
	37 × 27 (14 1/8 × 10 5/8)	Andrew W. Mellon Collection,
		1937.1.44

13 *Portrait of a Lady*

SELECTED BIBLIOGRAPHY

Campbell, Lorne. *Van der Weyden,* 9–10. New York, 1980.

Campbell, Lorne. *Renaissance Portraits. European Portrait-Painting in the 14th, 15th, and 16th Centuries,* 96–97. New Haven, 1990.

Davies, Martin. *Van der Weyden,* 222, 241. London, 1972.

De Vos, Dirk. *Rogier van der Weyden. The Complete Works,* 116–118 and cat. 34, 328. Trans. Ted Alkins. Antwerp, 1999.

Hand, John Oliver and Martha Wolff. *Early Netherlandish Paintings,* no. 1937.1.44 (44), 241–246. National Gallery of Art. Washington, 1986.

Kemperdick, Stephan. *Rogier van der Weyden 1399/1400–1464,* 98–100, 102. Trans. Anthea Bell. Cologne, 1999.

Schneider, Norbert. *The Art of the Portrait. Masterpieces of European Portrait-Painting 1420–1670,* 40. Cologne, 1994.

During the half-century since the Franco-Flemish *Lady* (cat. 1) was painted, the concept of aristocratic portraiture in northern Europe changed dramatically. In his smaller-scaled *Portrait of a Lady,* Rogier van der Weyden (c. 1400–1464) abandoned the traditional profile to depict the sitter turned in three-quarter view to the left. The formula he adopted had been explored earlier by Robert Campin, his teacher, and by Jan van Eyck, his predecessor as Burgundian court painter. As Van der Weyden used it, the three-quarter view, showing more of the face, revealed the sitter's personality in a more intimate and directly personal way. Once believed to be Marie de Valengin, illegitimate daughter of Duke Philip the Good of Burgundy, the subject has not been identified, though, to judge from her costume and bearing, she was highly placed at court. In the manner of Van der Weyden's other late portraits, her figure is set against a dark background in a boldly abstract design that appeals to modern taste. The half-length format also permitted the painter to include the sitter's hands, which are held, not in prayer, as in a devotional portrait (cat. 14), but as if resting on an unseen ledge. This motif of clasped hands, right over left, proved to be very influential, though in Van der Weyden's case, what we see is the woman's fingers pressed together.[1] The small hands and narrow waist are disproportionate to her large head, which is emphasized by the costume. It is not just a matter of the woman's coif, with the hair pulled back from her high forehead and held in place by the black band of her bonnet; the interlocking triangles of the headdress and neckline also focus attention on the face. Rejecting the rich color previously associated with aristocratic portraiture, Van der Weyden adopts a somber scheme of dark brown, blue, and white, broken only by the bright red accent of the woman's waistband. Similarly, gold is restricted to the two rings and the delicately filigreed belt buckle. The sitter's sober dress obviously reflects changing fashion, but it also underscores her introspective mood.

In Van der Weyden's portrait the sitter's spreading headdress frames the face, which seems to emerge from the diaphanous wimple and kerchief. Modern writers on the painting have stressed the tension between the woman's outwardly dignified pose and downcast eyes, indicative of modesty, and a kind of smoldering inner life suggested by her sensual lips and tightly compressed hands.[2] This sort of psychological interpretation is risky, even when, as in Van der Weyden's case, it seems to be called for, but there can be no doubt that the woman's thoughtful, self-absorbed expression links her figure to many others painted by the artist. In Italy, it was precisely this quality of emotional intensity that was most admired in Van der Weyden's works. The artist probably made a trip to Rome in the Jubilee year of 1450, as the humanist Bartolomeo Fazio reported in his *De Viris Illustribus,* written in 1456. Citing Van der Weyden, along with Van Eyck, as the most famous and highly regarded Northern master of the day, Fazio noted that Italian connoisseurs and patrons particularly prized the "variety of feelings and passions" in his paintings.[3] Not just at the Este court in Ferrara, where he seems to have sojourned, but also in Florence, Van der Weyden's works were eagerly sought by collectors such as the Medici.[4] DAB

NOTES

1. Lorne Campbell (1990, 72–74 and fig. 82) aptly compares the Rogierian formula for hands with later Italian portraits of women, like the so-called *Muta,* attributed to Raphael, in the Galleria Nazionale delle Marche, Urbino. Though the position of the hands is much altered, Leonardo's *Mona Lisa* offers another example. In Memling's equally influential portraits, the sitter's left hand is usually shown resting on the right (Campbell 1990, fig. 83).

2. No less an authority than Erwin Panofsky spoke of the lady's "excitability" (*Early Netherlandish Painting. Its Origins and Character* [Cambridge, Mass., 1953], 292).

3. Michael Baxandall, "Bartholomaeus Facius on Painting. A Fifteenth-Century Manuscript of the *De Viris Illustribus,*" *Journal of the Warburg and Courtauld Institutes* 27 (1964), 104–106.

4. Paola Nuttall, "The Medici and Netherlandish Painting," in *The Early Medici and Their Artists,* ed. Francis Ames-Lewis (London, 1995), 135–152.

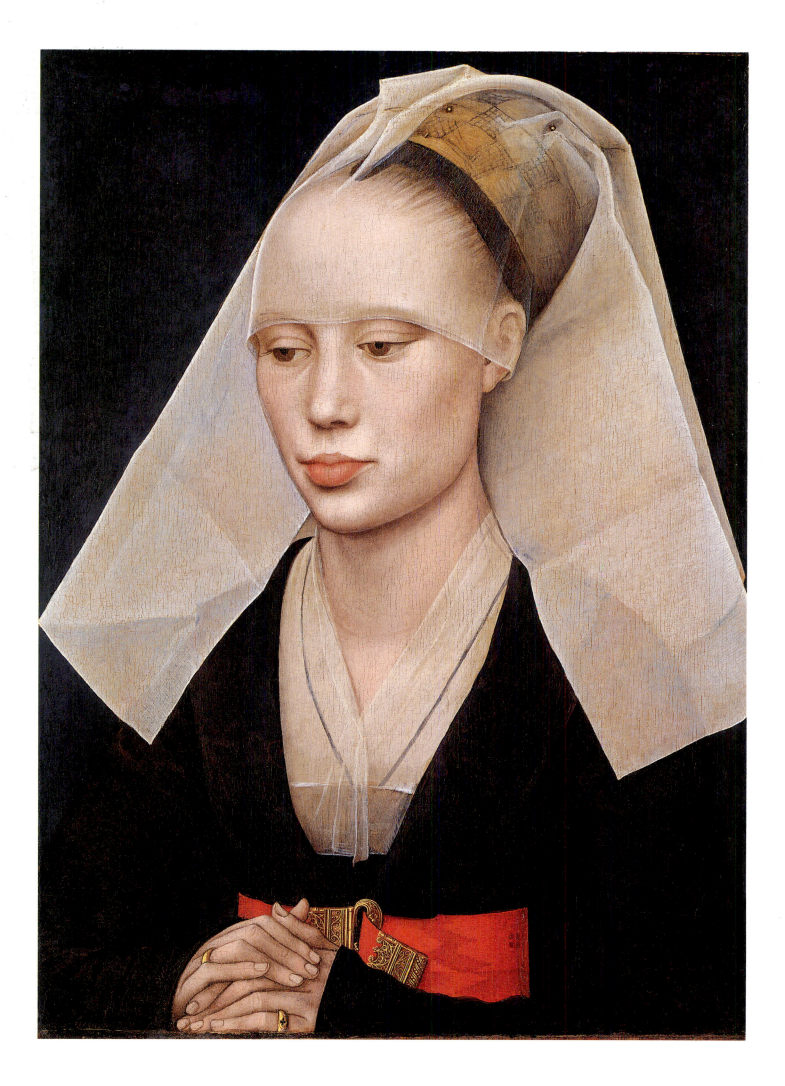

137

Petrus Christus

A c. 1455, oil on panel
42 × 21.2 (16½ × 8⅜)
National Gallery of Art, Washington,
Samuel H. Kress Collection,
1961.9.10

B c. 1455, oil on panel
41.8 × 21.6 (16½ × 8½)
National Gallery of Art, Washington,
Samuel H. Kress Collection,
1961.9.11

14 *Portrait of a Male Donor* (A) *Portrait of a Female Donor* (B)

SELECTED BIBLIOGRAPHY

Ainsworth, Maryan. *Petrus Christus
Renaissance Master of Bruges* [exh. cat.,
The Metropolitan Museum of Art]
(New York, 1994), cat. 12, 131–135.

Eisler, Colin. *Paintings from the Samuel
H. Kress Collection. European Schools
Excluding Italian*, nos. K488A / B, 51–54.
Oxford, 1977.

Hand, John Oliver and Martha Wolff.
Early Netherlandish Paintings, nos.
1961.9.10 (1367) and 1961.9.11 (1368),
49–55. National Gallery of Art.
Washington, 1986.

Lane, Barbara G. "Petrus Christus: A
Reconstructed Triptych with an Italian
Motif." *Art Bulletin* 52 (December
1970), 390–393.

Schabacker, Peter H. *Petrus Christus*, 51,
and cat. 18, 113–114. Utrecht, 1974.

Upton, Joel M. *Petrus Christus. His
Place in Fifteenth-Century Painting*, 85–
87. University Park, Pa., 1990.

This pair of devotional panels by Petrus Christus (active c. 1444–1472) demonstrates the growing international character of fifteenth-century portraiture in Italy and the North. The commission of the works was itself an act of piety, and that is the role in which the sitters appear. The donor and his wife are portrayed kneeling in three-quarter view, rather than in profile, in a spacious interior with views of a distant landscape. The man has removed his clogs and his red *chaperon,* while the woman is at a prie-dieu with an open prayer book. The object of their devotion was presumably represented in a central panel, which is either missing, as some scholars believe, or identifiable with the artist's *Madonna and Child Enthroned with Saints Jerome and Francis* of 1457, in Frankfurt.[1] Whatever the case, the composition and relatively small scale of the Gallery's panels indicate that they originally formed the wings of a triptych meant for private devotion in a domestic setting similar to the one shown in the paintings. There the donors would have addressed their prayers to the sacred personages venerated by their portrait images in the altarpiece. Reinforcing this "mirror of devotion" effect, Christus exploited the oil medium to capture the sitters' likenesses, the precise textures of their garments, and the luminous landscape.

In the *Madonna Enthroned,* the saints are shown together with the Virgin and child in the manner of an Italian *sacra conversazione.*[2] But the borrowing of the Italian compositional type, together with the use of single-point perspective, does not necessarily mean that Christus painted the picture in Italy. Even if he was in Italy—and there is no documentary evidence recording his presence there[3]—he probably completed the donor portraits in his native Bruges. Admittedly, the sitters are Italian: the coat of arms affixed to the wall behind the man has been tentatively identified as that of the Lomellini, while the arms suspended behind the woman are those of the Vivaldi.[4] Both families belonged to the mercantile elite of Genoa, but they were also active throughout the fifteenth century as merchants and bankers in Bruges, and the subjects of the Washington panels are, accordingly, portrayed wearing Northern dress. Italian patrons of Netherlandish painters, like the Lomellini, brought their works back to Italy when they repatriated, and it is not surprising, therefore,

that the Gallery's donor portraits are said to have come from Genoa.[5] But the large number of Christus' pictures with an Italian provenance includes some that were apparently commissioned in Italy. In Florence, for example, the Medici owned two works by the artist cited in the 1492 inventory of Lorenzo de' Medici's collection—a *Saint Jerome,* sometimes connected with the miniature-sized panel plausibly attributed to Christus in Detroit, and a female portrait that has been tentatively identified with his *Portrait of a Lady* in Berlin.[6] The latter, or a work like it, was surely known to Leonardo when he painted *Ginevra de' Benci* (cat. 16).[7] DAB

NOTES

1. Opinion about the reconstruction, bringing together the *Madonna Enthroned* in the Städelsches Kunstinstitut and Städtische Galerie in Frankfurt with the Washington donor portraits, as proposed by Lane (1970), is about evenly divided with Eisler (1977) and Upton (1990) in favor, and Schabacker (1974), Wolff in Hand and Wolff (1986), and Ainsworth (1994) opposed. Further about the Frankfurt picture see Ainsworth 1994, cat. 13, 136–141, and Jochen Sander, *Niederländische Gemälde im Städel 1400–1550* (Mainz, 1993), 154–174.

2. As noted by Lane 1970.

3. The mention of a "Piero de' Burges" and an "Antonello da Sicilia" at the Sforza court in Milan in 1456, supposedly alluding to Petrus Christus and Antonello da Messina, has been shown to refer instead to the provisioning of soldiers (Ainsworth 1994, 60–62). Even so, the problem of whether Christus visited Italy (or whether Antonello went to Flanders) remains open, because of the close stylistic resemblance between their works.

4. For the heraldry see Wolff in Hand and Wolff 1986. The colored woodcut representing Saint Elizabeth of Hungary, attached to the wall behind the female sitter, helps to identify her as an Elisabetta Vivaldi, married to a Lomellini resident in Bruges in the mid-fifteenth century.

5. Another example of this kind of conduit for Netherlandish art in Italy is offered by Memling's pendant portraits of the Florentine Tommaso Portinari and his wife Maria, dated c. 1470, shortly after the sitters' marriage, in the Metropolitan Museum, New York. The half-length portraits of the praying donors are clearly the wings of a small devotional triptych, the central panel of which is lost. During his stint in Bruges, Portinari also commissioned Hugo van der Goes' altarpiece, now in the Uffizi.

6. About these two works see Ainsworth 1994, cat. 1, 68–71, and cat. 19, 166–169.

7. For the comparison, see David Alan Brown, *Leonardo da Vinci. Origins of a Genius* (New Haven, 1998), 110–111.

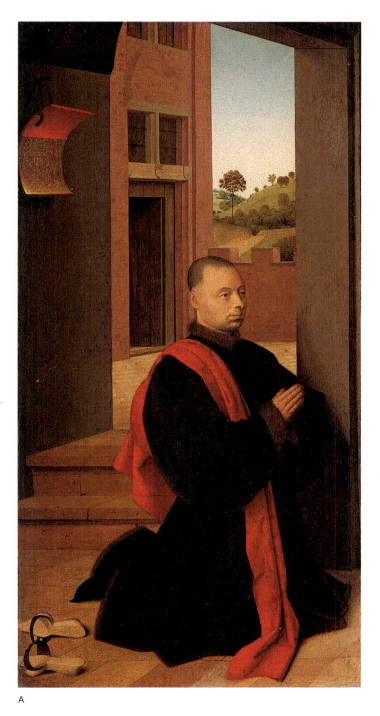

A

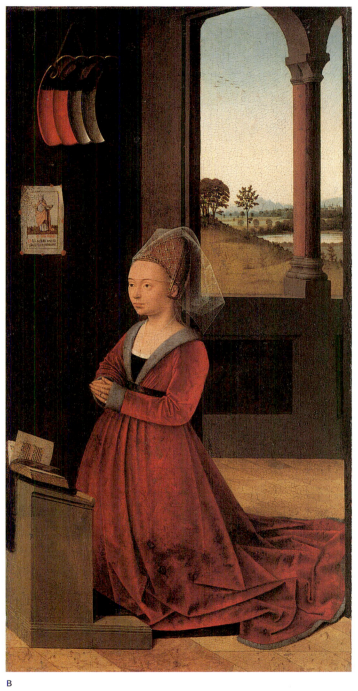

B

Hans Memling

A c. 1485 / 1490, oil on panel
43.2 × 18.7 (17 × 7 3/8)
The Metropolitan Museum of Art,
New York, The Jules Bache
Collection, 1949

B c. 1485 / 1490, oil on panel
43.5 × 18 (17 1/8 × 7 1/8)
Museum Boijmans Van Beuningen,
Rotterdam

15 *Young Woman with a Carnation* (A) *Two Horses and a Monkey in a Landscape* (B)

SELECTED BIBLIOGRAPHY

Campbell, Lorne. Review of De Vos, *Memling,* 1994. *The Burlington Magazine* 137 (April 1995), 253–254.

De Vos, Dirk. *Hans Memling. The Complete Works,* cat. 73, 264–266. Trans. Ted Alkins. Ghent, 1994.

De Vos, Dirk. *Hans Memling. Catalogue,* cat. 1, 124–127. Trans. Ted Alkins and Marcus Cumberledge. Bruges, 1994.

Dülberg, Angelica. *Privatporträts. Geschichte und Ikonologie einer Gattung im 15. und 16. Jahrhundert,* cat. 176, 233. Berlin, 1990.

Giltaij, Jeroen. In *Van Eyck to Bruegel 1400–1550. Dutch and Flemish Painting in the Museum Boymans-van Beuningen,* cat. 31, 150–153. Rotterdam, 1994.

McFarlane, K. B. *Hans Memling,* 41–42, note 51. Oxford, 1971.

Panofsky, Erwin. *Early Netherlandish Painting. Its Origins and Character,* 506–507, note 7. Cambridge, Mass., 1953.

Sprinson de Jesus, Mary. In *From Van Eyck to Bruegel. Early Netherlandish Painting in the Metropolitan Museum of Art.* Ed. Maryan W. Ainsworth and Keith Christiansen [exh. cat., Metropolitan Museum of Art] (New York, 1998), cat. 32, 174–176.

Long considered to be a portrait, *Young Woman with a Carnation* by Memling (active c. 1465–1494) has sometimes been doubted as his work because it failed to meet the standard the artist set for realistic portraiture in such splendid likenesses as those of Tommaso Portinari and his wife Maria Baroncelli, also in the Metropolitan Museum of Art.[1] The most recent and vocal detractor of the painting, Lorne Campbell (1995), objected to the woman's spindly arms and misunderstood costume and to the schematic landscape background. But as Dirk De Vos (1994) has demonstrated, the painting is, in fact, an allegorical representation rare in Northern art of this period and practically unique in Memling's oeuvre.[2] The weaknesses pointed out by Campbell and others would, for De Vos, be stylizations proper to an allegory. Helping to clarify the status of the New York panel is a companion piece of identical dimensions, representing two horses and a monkey in a landscape, in the Boijmans Museum, Rotterdam. The two narrow vertical panels are undoubtedly pendants: the landscape and the architectural setting are consistent in each work, and so are the lighting and perspective. Though the wood supports for the two images have recently been shown to come from the same tree, they did not form the front and back of a single panel, as scholars once believed. Instead, the *Woman* and the *Horses* were meant to be seen side by side, either in the form of a fixed or folding diptych or as the exterior wings of a triptych, viewed in this manner when closed.[3]

Erwin Panofsky (1953) and, following him, De Vos (1994) have convincingly explicated the imagery depicted on the two panels, which the latter calls the *Allegory of True Love.* According to their interpretation, the woman proffers a red carnation, traditionally symbolizing love, betrothal, or marriage, to the pair of horses on the right. Signifying lust, like the monkey on its back, the white horse bends over to quench its thirst, while the brown horse gazes faithfully at the woman in the adjacent panel. Together the animals would stand for the noble and ignoble sides of a man's amorous passion. Significantly, Memling's moralizing allegory of love and virtue has more than a little in common with contemporary Italian

works like Botticelli's so-called *Simonetta Vespucci* (cat. 28) or Leonardo's double-sided portrait of *Ginevra de' Benci* (cat. 16). As with Simonetta, the face of the woman depicted by Memling corresponds to his ideal female type, and her old-fashioned dress strikes a chivalric note, according to De Vos (1994), just as Botticelli's is classicizing. And like *Ginevra de' Benci,* as reconstructed with the sitter's missing hands, Memling's woman holds a symbolic flower before a landscape.[4] These and other resemblances with Italian art suggest that the paintings in New York and Rotterdam might possibly have been completed for an Italian patron.[5] Memling frequently worked for Italians who resided north and south of the Alps (see notes 1 and 3), and the New York panel at least has an Italian provenance, having been acquired by Wilhelm von Bode in Florence in the early 1870s. DAB

NOTES

1. About these two portraits and the realistic full-figure likenesses of the Portinari couple in Memling's *Scenes from the Passion of Christ* in the Galleria Sabauda, Turin, see, respectively, De Vos, *Complete Works,* 1994, cat. 9, 100–103, and cat. 11, 105–109.

2. Another example is Memling's enigmatic *Allegory* in the Musée Jacquemart-André, Paris (De Vos, *Complete Works,* 1994, cat. 34, 164–165).

3. As noted by Sprinson de Jesus (1998), the ensemble, with the central panel and interior wings now missing, might have resembled the so-called Pagagnotti triptych, as reconstructed by Michael Rohlmann ("Memling's 'Pagagnotti triptych,'" *The Burlington Magazine* 137 [July 1995], 438–445), with an unusual representation of a flock of cranes on the exterior wings.

4. For the reconstruction, see David Alan Brown, *Leonardo da Vinci. Origins of a Genius* (New Haven, 1998), 106–109 and fig. 94.

5. De Vos (*Complete Works,* 1994) aptly compares Memling's diptych to Piero di Cosimo's *Allegory,* with a horse symbolizing lust and a female figure standing for virtue, in the National Gallery of Art, Washington (Anna Forlani Tempesti and Elena Capretti, *Piero di Cosimo* [Florence, 1996], cat. 9, 101).

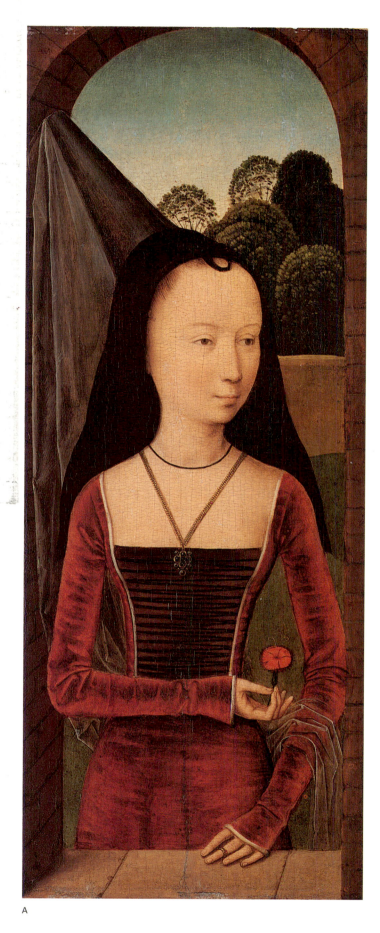

A

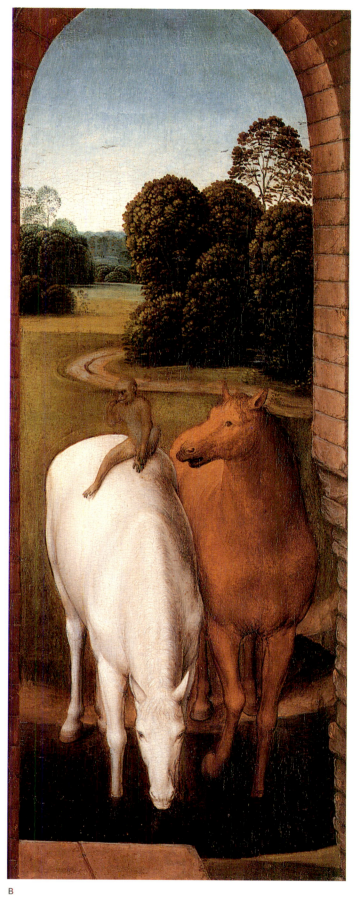

B

Leonardo da Vinci

c. 1474–1478, oil on panel
38.1 × 37 (15 × 14 9/16)

National Gallery of Art, Washington,
Ailsa Mellon Bruce Fund, 1967.6.1

16 *Ginevra de' Benci*

REVERSE

Wreath of laurel, palm, and juniper
with a scroll inscribed VIRTUTEM
FORMA DECORAT

SELECTED BIBLIOGRAPHY

Brown, David Alan. *Leonardo da
Vinci. Origins of a Genius*, 101–122.
New Haven, 1998.

Cropper, Elizabeth. "The Beauty of
Woman: Problems in the Rhetoric of
Renaissance Portraiture." In *Rewriting
the Renaissance: The Discourses of Sex-
ual Difference in Early Modern Europe*,
183, 187–190. Ed. Margaret W. Fergu-
son, Maureen Quilligan, and Nancy J.
Vickers. Chicago, 1985.

Fletcher, Jennifer. "Bernardo Bembo
and Leonardo's Portrait of Ginevra de'
Benci." *The Burlington Magazine* 131
(1989), 811–816.

Garrard, Mary D. "Leonardo da Vinci:
Female Portraits, Female Nature." In
*The Expanding Discourse: Feminism and
Art History*, 59–86. Ed. Norma Broude
and Mary D. Garrard. New York, 1992.

Marani, Pietro. *Leonardo. Una carriera
di pittore*, 38–48. Milan, 1999.

Möller, Emil. "Leonardos Bildnis der
Ginevra dei Benci." *Münchner Jahrbuch
der bildenden Kunst* 12 (1937–1938),
185–209.

Walker, John. "*Ginevra de' Benci* by
Leonardo da Vinci." *Report and Studies
in the History of Art*, 1–38. National
Gallery of Art. Washington, 1967.

Since the time it was acquired by the Gallery from the Liechtenstein collection in 1967, millions of view-ers have admired *Ginevra de' Benci* by Leonardo (1452–1519). But fewer of them may be aware of the picture's painted reverse, which complements the portrayal of the sitter's appearance by alluding to her character. The complete portrait, in other words, includes the back, as well as the front, of the panel. The front side portrays the soberly dressed young woman in a landscape, while the back depicts a wreath of laurel and palm encircling a sprig of juni-per. Entwined around the plants is a scroll with a Latin inscription meaning "Beauty Adorns Virtue." The fact that the wreath is truncated at the bottom indicates that the panel, now measuring about fifteen inches square, was cut down in the past. The identi-fication of the sitter as Ginevra de' Benci is based on the mention of such a portrait by Leonardo in Vasari and the other early sources.[1] The juniper (*gine-pro* in Italian), depicted as a landscape element on one side of the panel and emblematically on the other, puns on the sitter's name. Ginevra was born into a wealthy Florentine banking family in August or September 1457.[2] On 15 January 1474, at the age of sixteen, she married Luigi Niccolini, who reported six years later that his wife had long been sick. Soon after Ginevra's marriage an event occurred which, apart from Leonardo's portrait, is her chief claim to fame. On one of his two missions to Florence, in 1475–1476 and in 1478–1480, the Venetian ambas-sador and humanist Bernardo Bembo adopted the local chivalric fashion and chose Ginevra as the object of his platonic love.[3] Their mutual devotion found expression in a series of Petrarchan poems by writers in the Medici circle, celebrating her beauty and virtue.[4]

One or the other or both of the central events in Ginevra's life (she was childless) may have provided the motive for commissioning her portrait. If Leonardo portrayed Ginevra as Bembo's beloved, the painting would have to have been created in the late 1470s, when most scholars, have, in fact, dated it. Jennifer Fletcher's discovery (1989) that the wreath of laurel and palm on the reverse was Bem-bo's emblem lends support to the hypothesis that he ordered the picture. And yet if we consider *Ginevra* simply as a painting, apart from the sitter's biography, it demonstrably belongs with the Uffizi *Annunciation* and the other works Leonardo completed as a pupil in Verrocchio's shop. In the compiler's monograph of 1998 the solution offered to the problem of whether Ginevra is portrayed as a bride in 1474 or as Bembo's *innamorata* in 1475–1476 or 1478–1480 was that the front side celebrated her marriage and the reverse, Bembo's devotion. Having already been delivered, the painting would have been retrieved and updated after the circumstances of her life changed, not an uncommon practice in the Renaissance. It is, how-ever, just possible that the front side of the panel was completed, together with the reverse, early in 1475.[5] In January of that year, the newly arrived Bembo par-ticipated in a tournament organized by the Medici, and he might at the same time have honored his beloved in the form of a portrait commission.

Ginevra's portrait, the lower part of which was cut down after suffering some damage, may originally have included her hands. A drawing of hands (cat. 17) by Leonardo at Windsor Castle, assuming it is a preparatory study, aids in reconstructing the original format (fig. 1) of the picture.[6] As reconstructed, Leonardo's portrait may be seen to have broken with the long-standing Florentine tradition of portraying women in bust-length profile. In seeking an alterna-tive to the static profile, Leonardo, like Botticelli (cat. 25), seems to have turned to Verrocchio's *Lady with a Bunch of Flowers* (cat. 22) in the Bargello, Florence. Because of the sitter's beautiful hands, which mark an advance over the earlier head-and-shoulders type of sculpted bust, the marble has even been attributed to Leonardo. But the highly inno-vative conception of the half-length portrait bust is surely Verrocchio's achievement. What young Leo-nardo did was to translate this sculptural prototype into a pictorial context, placing his sitter in a watery landscape shrouded in bluish haze. Memling is often cited as a source for the idea of showing Ginevra in three-quarter view in a landscape, but his portraits typically set the sitters' heads against the sky. Ex-

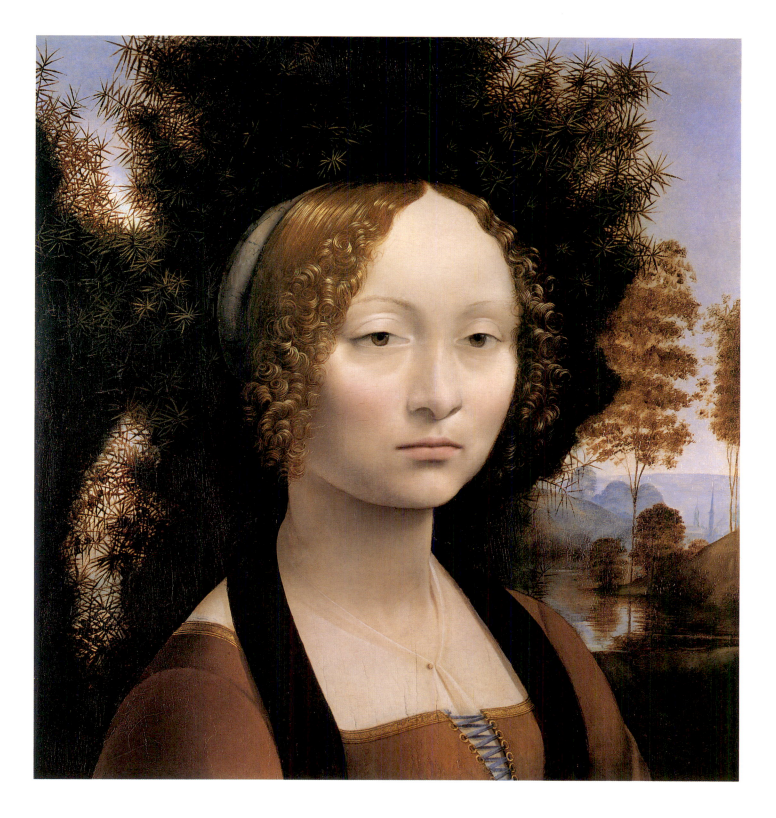

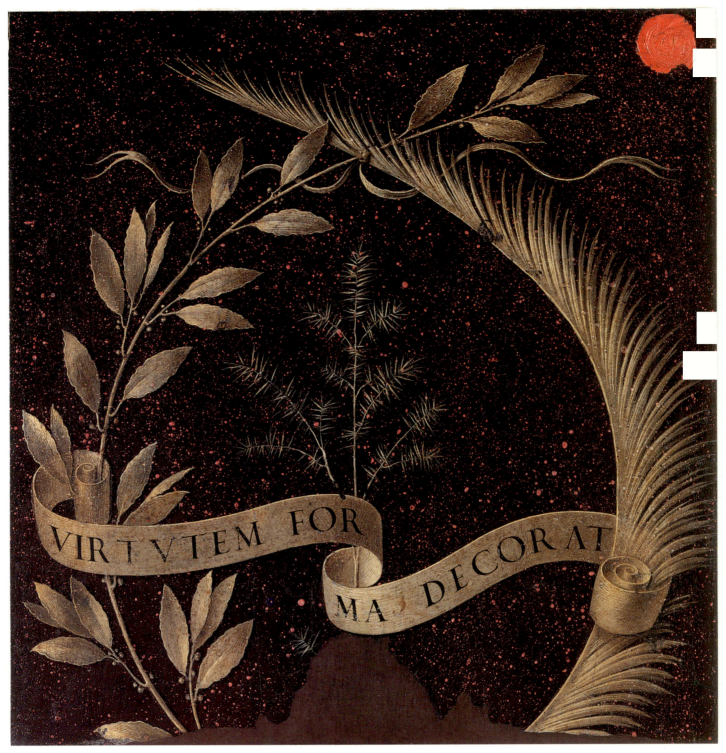

Reverse

144

1 and 2
Computer reconstructions of *Ginevra de' Benci*, front and back, department of imaging and visual services, National Gallery of Art, Washington

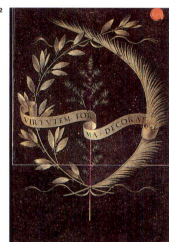

ploiting the fluidity of the new oil medium by using his fingers as well as the brush, Leonardo depicts Ginevra before a juniper bush, which not only plays on her name, but symbolizes her chastity. Far surpassing contemporary botanical depictions, the juniper is observed and painted with the same interest and intensity as the sitter, as an intricate network of needle-like leaves surrounded by light and atmosphere. The plant metaphor is juxtaposed in the painting with Ginevra's pale luminous skin and her golden curls, which anticipate Leonardo's studies of swirling water.

The stone-colored plants and scroll on the back of the panel (fig. 2), shown against a simulated red porphyry background, present an emblematic portrait of Ginevra: the laurel and palm commonly symbolized moral and intellectual virtue, while the Latin word for beauty artfully twines around the juniper. Bembo's emblem of crossed laurel and palm was originally combined with his own motto; then, transposing the juniper from the front, he devised one more suitable for his beloved.[7] Bembo may have encountered prototypes for the back of Ginevra's portrait in Northern art while serving as ambassador to the Burgundian court in 1472.[8] Leonardo's reverse

also resembles those combining an inscription with simulated marble in Jacometto Veneziano's double-sided portraits (cats. 19A, B; 20; 21). Significantly, Jacometto is recorded as having painted a portrait of Bembo's son Carlo, datable to c. 1472.[9] While this work is lost, it is possible that Bembo brought it to Florence and indicated the reverse as a model for Leonardo. The patron may be the link that explains the otherwise puzzling similarity between the painted reverses of Leonardo's and Jacometto's portraits.

If Bembo commissioned the reverse and conceived its design, as seems most likely, he did so in the spirit of the poems his humanist friends dedicated to him. In their verses Ginevra's beauty and virtue, far from being in conflict, are conjoined, as they appear on the front and back of her portrait. In addition to the poems, a letter entitled "A picture of a beautiful body and a beautiful mind," which the dean of Florentine humanists, Marsilio Ficino, sent to Bembo, might almost serve as a subtext for Leonardo's painting.[10] The precise visual form that Leonardo gave to Bembo's conception was determined by the artist's own experience, of course, in this case of Verrocchio's Medici tomb in San Lorenzo of 1472, with its red porphyry sarcophagus and banderoles winding around foliate wreaths. Compared with its Jacometto analogues, the reverse of Leonardo's portrait stands out for its elaborately naturalistic character. Only he—and not Jacometto or some other artist—could be responsible for the organic quality of the monochromatic plants and for the way the scroll coils around them.[11] Leonardo portrayed Ginevra in a highly individual way: his painting is not only a portrait but also a picture of nature which represents the sitter in light of his own preoccupations as an artist. DAB

NOTES

1. Brown 1998, 101 and 201, note 5.

2. For the sitter's biography, see Möller 1937–1938 and Walker 1967.

3. Bembo's biography is Nella Giannetto, *Bernardo Bembo Umanista e Politico Veneziano* (Florence, 1985).

4. For transcriptions and translations of these sonnets, together with two by Lorenzo de' Medici, see Walker 1967, as cited in Brown 1998, 201, notes 14 and 15.

5. If the front side of Leonardo's picture is dated a year after her marriage, the chronology proposed by the compiler in his monograph of 1998 would have to be revised: though their sequence would remain the same, his other early works would each need to be dated a year or so later as well.

6. For the reconstruction, see Brown 1998, note 37, 202–203.

7. Brown 1998, 119.

8. Ample precedents for Leonardo's emblematic reverse exist in Florence, not only in the form of portrait medals but also in painted *deschi,* or birth trays, with figural scenes on the front and personal or heraldic devices decorating the back. Nevertheless, the closest parallels to the *Ginevra* reverse are found in Netherlandish and Netherlandish-inspired paintings, like Memling's *Portrait of Benedetto Portinari,* compared with *Ginevra* by Dirk De Vos (*Hans Memling. The Complete Works* [Ghent, 1994], 49–50, 399, and cat. 79, 284–286). Leonardo knew Portinari, and the triptych containing his portrait was cited as a source for *Mona Lisa* by Susanne Kress ("Memlings Triptychon des Benedetto Portinari und Leonardos Mona Lisa," in *Porträt, Landschaft, Interieur,* ed. Christiane Kruse and Felix Thürle-mann [Tübingen, 1999], 219–234). See also the Rogierian *Portrait of a Man (Guillaume Fillastre?)* in the Courtauld Gallery, London, and numerous other examples discussed by Angelica Dülberg, *Privatporträts. Geschichte und Ikonologie einer Gattung im 15. und 16. Jahrhundert* (Berlin, 1990). On the backs of two Netherlandish portraits of the Medici in Zurich are the family arms framed by garlands in a field of fictive porphyry (Hellmut Wohl, *The Paintings of Domenico Veneziano* [New York, 1980], cat. 81, 195). Exceedingly hard to carve, porphyry in a female portrait context symbolizes the everlasting nature of the patron's love or the sitter's virtue or memory. See Dülberg 1990, 116–133; E. James Mundy, "Porphyry and the 'Posthumous' Fifteenth Century Portrait," *Pantheon* 46 (1988), 37–43; and Suzanne B. Butters, *The Triumph of Vulcan. Sculptors' Tools, Porphyry, and the Prince in Ducal Florence,* 2 vols. (Florence, 1996), 1: 108–110.

9. *Der Anonimo Morelliano,* ed. Theodor Frimmel (Vienna, 1896), 22.

10. In the letter, datable 1477/1478, Ficino explores the relationship between virtue and its "lovely form" (*The Letters of Marsilio Ficino* [London, 1975–], 4 [1988]: no. 51, 66–67).

11. The lettering of Leonardo's inscription, placed on the scroll in a manner that is both legible and illusionistic, differs from that found on the Jacometto portrait reverses in London and Philadelphia, according to Christine Sperling (written communication, 4 December 2000).

Leonardo da Vinci

c. 1474, metalpoint over black chalk with white heightening on buff-colored paper

21.5 × 15 (8 7/16 × 5 7/8)

Lent by Her Majesty Queen Elizabeth II

17 *Study of Hands*

SELECTED BIBLIOGRAPHY

Brown, David Alan. *Leonardo da Vinci. Origins of a Genius,* 106–107. New Haven, 1998.

Clark, Kenneth. *The Drawings of Leonardo da Vinci in the Collection of Her Majesty the Queen at Windsor Castle,* 1: no. 12558, 104–105. 2d rev. ed. with the assistance of Carlo Pedretti. 3 vols. London, 1968.

Clayton, Martin. *Leonardo da Vinci. A Singular Vision* [exh. cat., Queen's Gallery, Buckingham Palace] (New York, 1996), cat. 1, 14–15.

Roberts, Jane. In Martin Kemp and Jane Roberts. *Leonardo da Vinci* [exh. cat., Hayward Gallery] (London, 1989), cat. 4, 51.

Rubin, Patricia Lee. In Patricia Lee Rubin, Alison Wright, and Nicholas Penny. *Renaissance Florence. The Art of the 1470s* [exh. cat., National Gallery] (London, 1999), cat. 30, 189.

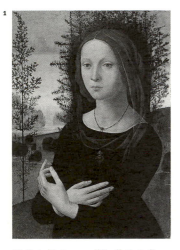

1

Attributed to Lorenzo di Credi, *Portrait of a Lady,* The Metropolitan Museum of Art, New York, Bequest of Richard De Wolfe Brixey, 1943. All rights reserved

The portrait by Leonardo (1452–1519) of *Ginevra de' Benci* (cat. 16), the lower part of which was cut down after suffering some damage in the past, may originally have included the sitter's hands. Scholars have plausibly reconstructed the original format of the painting partly on the basis of a variant (fig. 1), attributed to Lorenzo di Credi, in the Metropolitan Museum, New York.[1] This portrait, which also associates the female sitter with a juniper, is inscribed on the reverse "Ginevera de Am…Benci." Though not the same woman, the sitter in the New York panel holds a ring, which led Wilhelm von Bode to surmise that the missing portion of Leonardo's portrait also included Ginevra's hands.[2] These were represented, he argued, by this beautifully expressive *Study of Hands.* While allowing that the portrait may once have had hands similar to those shown on this sheet, scholars have tended to place the drawing somewhat later in Leonardo's career. And yet in its meticulously finished style and technique, the drawing would seem to date from the earlier part of Leonardo's first Florentine period. The hands closely resemble those of the angel in Leonardo's Uffizi *Annunciation,* for example. If that is the case, then the drawing could have served as a preparatory study for Ginevra's portrait. The hands in the drawing are not posed one above the other, as has often been claimed; rather they are shown resting together at waist level. This arrangement is repeated twice on the sheet, and in each case one hand is fully modeled while the other is merely sketched in. To reconstruct Ginevra's original attitude, therefore, the two finished hands must be joined, thereby functioning as a base for her head and shoulders. In the half-length image that results (see cat. 16, fig. 1), both hands and head are lit from the upper right and both are in three-quarter view. Between the thumb and index finger of the more finished right hand are represented stems and leaves, suggesting that the sitter once held a sprig of a plant. Beyond its obvious suitability for a betrothal or marriage painting, the motif of holding flowers must have had a personal meaning for Leonardo, who returned to it again and again in his early works. DAB

NOTES

1. About this picture, see Federico Zeri and Elizabeth Gardner, *Italian Paintings. A Catalogue of the Collection of the Metropolitan Museum of Art. Florentine School* (New York, 1971), 154–157.

2. Paul Müller-Walde (*Leonardo da Vinci: Lebensskizze und Forschungen über sein Verhältniss zur Florentiner Kunst und zu Rafael* [Munich, 1889], 52) first suggested that the Windsor drawing might have served for the painting now in Washington, and Bode endorsed his proposal (*Studien über Leonardo da Vinci* [Berlin, 1921], 40), dating both the painting and the presumed preparatory study to the later 1470s. A. E. Popham (*The Drawings of Leonardo da Vinci* [New York, 1945], 17–18) and Ludwig H. Heydenreich (*Leonardo da Vinci,* 2 vols. [New York, 1954], 1: 31; 2: IV) concurred, and so did Kenneth Clark, who, after first tentatively dating the drawing, together with the portrait, c. 1474 (*Leonardo da Vinci: An Account of His Development as an Artist* [Cambridge, 1939; rev. eds. 1952, 1959, 1967, and 1988], 17), later placed both works c. 1478–1480 (*Drawings,* 1968, 1: 104–105). Clark's reservations about an early date for such an accomplished drawing were shared by Berenson (*The Drawings of the Florentine Painters,* 2d rev. ed., 3 vols. [Chicago, 1938], 2: no. 1173) and many later scholars, including Jack Wasserman (review of Clark, *Drawings,* 1968, *The Burlington Magazine* 116 [1974], 113), who preferred to connect the hands with a (quite differently modeled) study of a female profile also at Windsor (no. 12505). This hypothesis was further explored by Herman T. Colenbrander ("Hands in Leonardo Portraiture," *Achademia Leonardi Vinci* 5 [1992], 37–43). The grotesque profile in the upper left of the sheet is of the kind that Leonardo drew throughout his career.

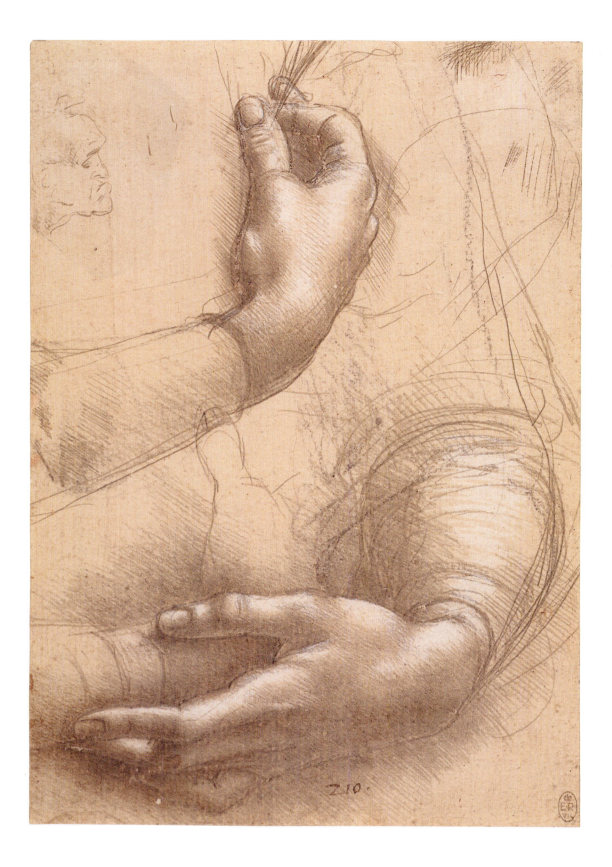

| Leonardo da Vinci | c. 1474, pen and brown ink over stylus indentations on paper 9.4 × 8.1 (3¾ × 3¼) | Visitors of the Ashmolean Museum, Oxford, P II 15 |

18 *Lady with a Unicorn*

Mounted on the same sheet, the separate and somewhat later study of a unicorn by Leonardo

SELECTED BIBLIOGRAPHY

Brown, David Alan. *Leonardo da Vinci. Origins of a Genius,* 106–107. New Haven, 1998.

Parker, K.T. *Catalogue of the Collection of Drawings in the Ashmolean Museum. II. Italian Schools,* cat. 15, 10. Oxford, 1956.

White, Christopher, Catherine Whistler, and Colin Harrison. *Old Master Drawings from the Ashmolean Museum,* no. 3, 24. Oxford, 1992.

The present emblematic reverse of *Ginevra de' Benci* (cat. 16) may not have been the artist's original idea for the back of the panel. Rather, Leonardo (1452–1519) may have envisaged a figural design connoting female virtue (Brown 1998). The evidence for an earlier version of the portrait reverse lies in this sheet depicting a lady with a unicorn. According to legend, the unicorn—an equine creature with a shaggy, goat-like coat and a single horn projecting from its forehead—could be captured only by a chaste maiden. The legendary beast thus became a symbol of virginity or chastity.[1] Leonardo's drawing shows a maiden pointing to a docile unicorn tethered to a tree. John Walker noted the resemblance between Ginevra and the female figure in the drawing, but his suggestion that the sketch possibly served for her portrait on the front side of the panel is unacceptable; it could be a preparatory drawing for the reverse, however.[2] The design is enclosed within framing lines, indicating that Leonardo meant to make a picture of it, and the proportions agree with those of the portrait in its original state. The severe demeanor of the maiden, seated in three-quarter view in a landscape, is comparable with Ginevra's, and so are her costume and coiffure. And the tree (a juniper?) in the drawing sets off the maiden's head just as the juniper enhances Ginevra's pale countenance in the painting.

Had Leonardo completed his scheme for an allegorical reverse, his painting would have resembled several contemporary portraits that associate a female sitter with a unicorn symbolizing her chastity.[3] The most famous of these is Piero della Francesca's Montefeltro diptych (Woods-Marsden essay, fig. 10) in the Uffizi, in which the duke's wife is shown in half-length profile on the front side of the portrait and as a tiny full-length figure riding on a cart pulled by unicorns on the reverse.[4] Piero's pair of double-sided portraits recall such medals as the one (cat. 7) in which

Pisanello paid tribute to Cecilia Gonzaga's chastity (she chose to enter a convent) in the form of a unicorn on the reverse. Less well known but closer in some ways to Leonardo's conception is the *Lady of the Gozzadini Family* in the Lehman collection, Metropolitan Museum, New York, in which the sitter appears twice, bust-length in profile and as a smaller figure accompanied by a unicorn in the landscape background.[5] If he projected an allegorical reverse for Ginevra's portrait, Leonardo never carried it out. When he again took up the idea of a painted reverse, he appears to have briefly considered his earlier scheme of the *Lady with the Unicorn,* as may be seen in two further sketches of a unicorn of slightly later date, one mounted on the same sheet as the sketch in Oxford and the other in the British Museum.[6] But he abandoned that solution in favor of an emblem with a motto. DAB

NOTES

1. On the unicorn, see Odell Shepard, *The Lore of the Unicorn* (New York, 1967); and Rüdiger Robert Beer, *Unicorn. Myth and Reality,* trans. Charles M. Stern (New York, 1977).

2. Raymond Stites pointed out the resemblance to Walker ("*Ginevra de' Benci* by Leonardo da Vinci," in *Report and Studies in the History of Art,* National Gallery of Art [Washington, 1967], 19–20) and elaborated on it in his *The Sublimations of Leonardo da Vinci* (Washington, 1970), 66, 68.

3. A Florentine engraving of a *Lady with a Unicorn,* approximately contemporary with Leonardo's drawing, involves the animal in a marriage context, as indicated by the shields left bare for the coats of arms of the wife and her husband (Alison Wright in Patricia Lee Rubin, Alison Wright, and Nicholas Penny, *Renaissance Florence. The Art of the 1470s* [exh. cat., National Gallery] [London, 1999], cat. 92, 342).

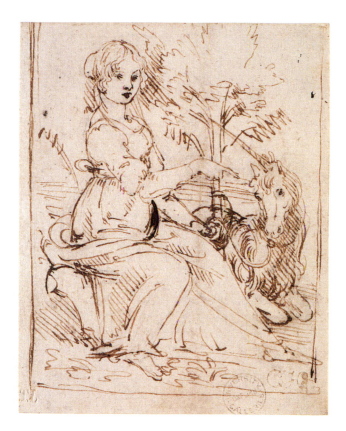

4. In his double-sided diptych of c. 1473 Piero depicts the recently deceased Battista Sforza before a panoramic landscape representing the territory over which she and her husband ruled (Norbert Schneider, *The Art of the Portrait: Masterpieces of European Portrait-Painting 1420–1670* [Cologne, 1994], 48–51).

5. John Pope-Hennessy (*The Robert Lehman Collection, 1: Italian Paintings* [New York, 1987], cats. 89–90, 214–219) ascribes the diptych, representing a member of the Gozzadini family and his wife, to the fifteenth-century Emilian school. That the lady is portrayed again at a smaller scale in the background is made clear by her hairdress and costume, which are the same as those of the bust-length effigy.

6. These drawings by Leonardo depicting the unicorn theme— the one in the British Museum with two sketches of a lady with the beast within frame lines (A. E. Popham and Philip Pouncey, *Italian Drawings in the Department of Prints and Drawings in the British Museum: The Fourteenth and Fifteenth Centuries,* 2 vols. [London, 1950], 1: cat. 98 verso, 59; 2: pl. xci); and the other at Oxford showing the unicorn alone (White, Whistler, and Harrison 1992, cat. 4, 26, and Parker 1956, cat. 16, 10–11 and pl. vi) —have often been associated with the *Lady with the Unicorn* exhibited here and dated, together with that work, to the end of the artist's first Florentine period (Parker 1956, 10; and Martin Kemp in Martin Kemp and Jane Roberts, *Leonardo da Vinci* [exh. cat., Hayward Gallery] (London, 1989), cats. 80 and 81, 154). Popham believed that the Oxford *Lady with the Unicorn* was the final version of the design (*The Drawings of Leonardo da Vinci* [New York, 1945], 18). But those authors connecting the three drawings have admitted that they are not wholly consistent in style, and Adolfo Venturi would seem to be right in differentiating between them (*I Dsegni di Leonardo da Vinci,* 7 vols. [Rome, 1928–1952], 1: 16–17, 20–21, and cats. v and xxxii). In the Oxford *Lady,* which seems to be a portrait, the unicorn is merely an attribute, while in the other two drawings the focus shifts to the animal, integrated with the (generic) maiden in the British Museum sheet and shown alone without her in the second drawing at Oxford. Venturi's juxtaposed illustrations of the two versions of the lady with the unicorn (*Leonardo e la sua scuola* [Novara, 1941], x and pls. 14 and 15) make clear that the British Museum drawing (and the Oxford study of the unicorn alone) must be later, having been made about the same time as the studies for a Virgin with a cat on the obverse of the sheet (Popham 1945, cat. 11, 103; and Popham and Pouncey 1950, 1: cat. 98 recto, 58–59; and 2: pl. xc), which date from the late 1470s.

Jacometto Veneziano

A c. 1485–1495, oil on panel
11.8 × 8.4 (4⅝ × 3 5/16)
The Metropolitan Museum of
Art, New York, Robert Lehman
Collection, 1975

B c. 1485–1495, oil on panel
10.2 × 7.1 (4 × 2 13/16)
The Metropolitan Museum of
Art, New York, Robert Lehman
Collection, 1975

19 *Alvise Contarini* (A) *Portrait of a Lady* (B)

REVERSE

chained deer (A)
female figure in a landscape (B)

SELECTED BIBLIOGRAPHY

Dülberg, Angelica. *Privatporträts.
Geschichte und Ikonologie einer Gattung
im 15. und 16. Jahrhundert,* 36, 124–126
and cats. 183, 184, 236–237. Berlin, 1990.

Heinemann, Fritz. *Giovanni Bellini e
i Belliniani,* 1: no. V.1.42, 239. 2 vols.
Venice, 1962.

Humfrey, Peter. "Jacometto Veneziano."
In *Encyclopedia of Italian Renaissance
and Mannerist Art,* 1: 821–822. Ed. Jane
Turner. London, 2000.

Pope-Hennessy, John. *The Portrait in
the Renaissance,* 211–213. Princeton,
1966.

Pope-Hennessy, John. *The Robert
Lehman Collection. 1. Italian Paintings,*
cats. 96, 97, 240–243. Princeton, 1987.

Servolini, Luigi. *Jacopo de' Barbari,*
28–30. Padua, 1944.

Like *Ginevra de' Benci* (cat. 16), this pair of panel portraits by the Venetian painter and miniaturist Jacometto Veneziano (active c. 1472–1497) have painted reverses. The male portrait reverse, bearing an inscription and an emblem on a ground of fictive porphyry, is similar to Leonardo's formulation. Jacometto's sitters are shown, half-length and in three-quarter view, facing each other against a landscape background. Though they have been attributed to Antonello da Messina and Giovanni Bellini, the portraits are now generally believed to be Jacometto's work.[1] The basis for the attribution is a passage in the diary of the Venetian connoisseur Marcantonio Michiel describing in the house of Michele Contarini in 1543 a "little portrait of Messer Alvise Contarini…who died some years ago; and on the same panel there is a portrait of a nun of San Secondo. On the cover of these portraits there is a small deer (?) in a landscape; and their leather case is decorated with foliage stamped with gold. This most perfect work is by the hand of Jacometto."[2] Apart from a few discrepancies, the portrait of *Alvise Contarini* and its companion piece and their painted covers, as described by Michiel, correspond to the miniature portraits in the Lehman collection with their extraordinary delicacy of execution. Michiel's reference to the animal depicted on the back of the male portrait is unclear, but a later inventory, citing what is obviously the same picture in the Vendramin collection, Venice, specifies that it is a "cerva" or "deer" (Pope-Hennessy 1987). Likewise, Michiel's identification of the female sitter as a "nun of San Secondo" seems odd in view of her costume, which has a low neckline that bares her shoulders. The explanation is not that the order was worldly, but that Michiel, writing half a century after the picture was painted, mistook the woman's coif for a Benedictine habit. In fact, similar headdresses are found in two other female portraits by or attributed to Jacometto in Cleveland (fig. 1) and in Philadelphia (cat. 21). These similarly dressed sitters are surely not all nuns, and no nun, no matter how frivolous, would have chosen to be portrayed in such décolleté. Paired portraits of men and women facing each other invariably represent spouses (cats. 2A, B; 14A, B; 31A, B), and so the lady depicted by Jacometto must be Alvise Contarini's wife.

Now framed separately, the small thin panels in the Lehman collection were originally joined, but Michiel's account of the ensemble is imprecise. Aside from the leather case, he describes an "incontro" or "joining" of the portraits but mentions only one reverse, that of Alvise Contarini. The two panels did not form a conventional diptych as their dimensions do not exactly agree: though usually reproduced at the same scale, the male portrait is significantly larger in height and width than its female counterpart. Nor can the woman's portrait have served as a cover for that of her companion; as Angelica Dülberg (1990) has objected, such sliding covers have armorial or emblematic images and were larger, not smaller, than the portraits underneath. It may be, then, that the female portrait was nestled in the frame of the male one. When closed, the reverse would have been exposed (accounting, perhaps, for the fact that it is damaged), and when opened, the lady's portrait would have been displayed next to that of the man, with the landscape fairly continuous from one panel to another, as they were intended to be seen.

A

Reverse

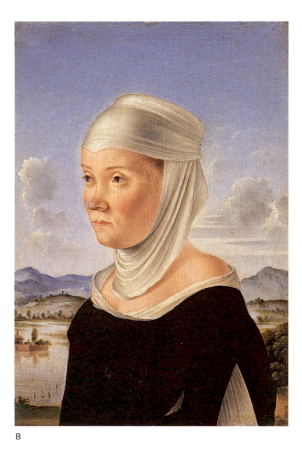

B

Reverse

1
Jacometto Veneziano, *Portrait of
a Lady*, Cleveland Museum of Art

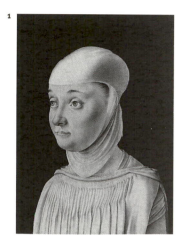

1

As in Florence, Venetian portraiture developed from
the traditional profile to the three-quarter view, again
under Flemish influence. In Venice, however, the
shift was more abrupt because of the brief but inten-
sive activity of Antonello da Messina in 1475–1476.
A number of surviving portraits painted by Anto-
nello, all showing the (male) sitters bust length and
in three-quarter view, had a profound impact, begin-
ning with Giovanni Bellini. Jacometto's extant por-
traits, adopting the three-quarter view, must postdate
Antonello's sojourn, and, among them, the Lehman
pair is the most developed and so presumably the
latest. The obverses show the sitters half-length be-
fore a panoramic landscape, and the reverses also go
beyond the purely emblematic designs previously
depicted by the artist (cats. 20, 21). Like the portrait
images, the reverses are pictorial, featuring a deer
and what appears to be a female figure, both seated
on a rocky ledge. The bronze-colored female reverse
is nearly illegible, but that of Alvise Contarini depicts
a deer chained to a golden roundel with the Greek
inscription "ΑΙΕΙ," meaning "forever." Like the uni-
corn in the drawing associated with Leonardo's
portrait (cat. 18) and (one of) the horses in Memling's
diptych (cat. 15 B), the tethered deer evidently sym-
bolizes sexual continence. Jacometto's naturalistic
plant and animal depiction is set against a background
of fictive porphyry resembling the one in the Cleve-
land panel.[3] The reverse imitating this hard-to-
carve and expensive red-flecked stone, together with
the inscription and the chained deer, stands for
Contarini's everlasting fidelity to his wife.[4] DAB

NOTES

1. For the attribution history, see Pope-Hennessy 1987.

2. Theodor von Frimmel, *Der Anonimo Morelliano* (Vienna,
1896), 112. The English translation is from Humfrey 2000.

3. The portrait, which is painted in oil on a panel measuring
9¹³⁄₁₆ × 7⅛ inches and which formerly belonged to Kenneth
Clark, is clearly by the same hand as that responsible for the
Lehman panels. In its present state, the reverse, with two paper
labels and a wax seal affixed to it, lacks an emblem or inscrip-
tion referring to the sitter.

4. For an iconographic reading of the portrait reverse which
is at odds with Dülberg's (1990, 124–125), see E. James Mundy,
"Porphyry and the 'Posthumous' Fifteenth Century Portrait,"
Pantheon 46 (1988), 37–43, stressing the funerary meaning of
the stone.

| Jacometto Veneziano | c. 1480 / 1485, oil on panel
26 × 19.1 (10¼ × 7½) | The National Gallery, London |

20 *Portrait of a Man*

REVERSE

Inscription and sprays of laurel

SELECTED BIBLIOGRAPHY

Davies, Martin. *Paintings and Drawings on the Backs of National Gallery Pictures,* note to pl. 35, xi–xii. London, 1946.

Davies, Martin. *National Gallery Catalogues. The Earlier Italian Schools,* no. 3121, 259–260. 2d rev. ed. London, 1961.

Dülberg, Angelica. *Privatporträts. Geschichte und Ikonologie einer Gattung im 15. und 16. Jahrhundert,* 38–39, 88, 111, 131, and cat. 168, 228. Berlin, 1990.

Dunkerton, Jill, Susan Foister, Dillian Gordon, and Nicholas Penny. *Giotto to Dürer. Early Renaissance Painting in the National Gallery,* 100, 102. New Haven, 1991.

Little is known about the life and work of Jacometto Veneziano (active c. 1472–1497), yet this Venetian painter and miniaturist enjoyed a high reputation among contemporary collectors and connoisseurs.[1] The information that we have about Jacometto comes mostly from Marcantonio Michiel's diary, which cites several portraits and other small-scale works by the artist in Venetian and Paduan collections. Of these only the pair of miniature panels in the Lehman collection (cat. 19A, B) can be identified today. These portraits, with their painted reverses, form the basis for attributing additional works to Jacometto. Four other small portraits are now generally accepted as his work, including the *Portrait of a Lady* in the Cleveland Museum of Art (see cat. 19A, B, fig. 1); the *Portrait of a Young Man* in the Metropolitan Museum, New York; and the *Portrait of a Boy* in the National Gallery, London.[2] The two male portraits are close in composition and style to those painted by Antonello da Messina, and they presumably date to the years following his Venetian sojourn in 1475–1476.

The fourth of the additional works now widely recognized as Jacometto's is the *Portrait of a Man* in the National Gallery. Formerly attributed to Antonello, this picture is not so close to that artist as is Jacometto's *Portrait of a Boy* in the same gallery. The forms are softer and, with more of the sitter's bust and the background showing, there is less emphasis on the expressive features of the head. In both of these respects the picture is more akin to Giovanni Bellini, who, after Antonello's departure, became the dominant force in Venetian painting. Also differing from the male portraits cited in note 2, this one, like the pair in the Lehman collection, has an emblematic reverse. Featuring a Latin inscription above a device of crossed laurel branches tied with a knot, Jacometto's design, more than that of any other double-sided portrait, resembles the reverse of Leonardo's *Ginevra de' Benci* (cat. 16). The inscription FELICES TER ET AMPLIVS / QUOS / IRRVPTA TENET COPVLA, meaning "Thrice Happy and More Are Those Bound Together," is borrowed from Horace's *Odes* (Book 1, Ode 13, lines 17–18). It is painted in gold on a black ground, like the laurel, which here symbolizes eternity rather than chastity.[3] When this panel, like Leonardo's, was turned over, it would have conveyed an amorous message about the sitter (and his wife) to his family and friends. DAB

NOTES

1. Peter Humfrey, "Jacometto Veneziano," in *Encyclopedia of Italian Renaissance and Mannerist Art,* ed. Jane Turner (London, 2000), 1: 821–822.

2. See Federico Zeri and Elizabeth Gardner, *Italian Paintings. A Catalogue of the Collection of the Metropolitan Museum of Art* (New York, 1973), no. 49.7.3, 34–36; and Davies 1961, no. 2509, 258–259.

3. Mirella Levi d'Ancona, *The Garden of the Renaissance. Botanical Symbolism in Italian Painting* (Florence, 1977), 201–204.

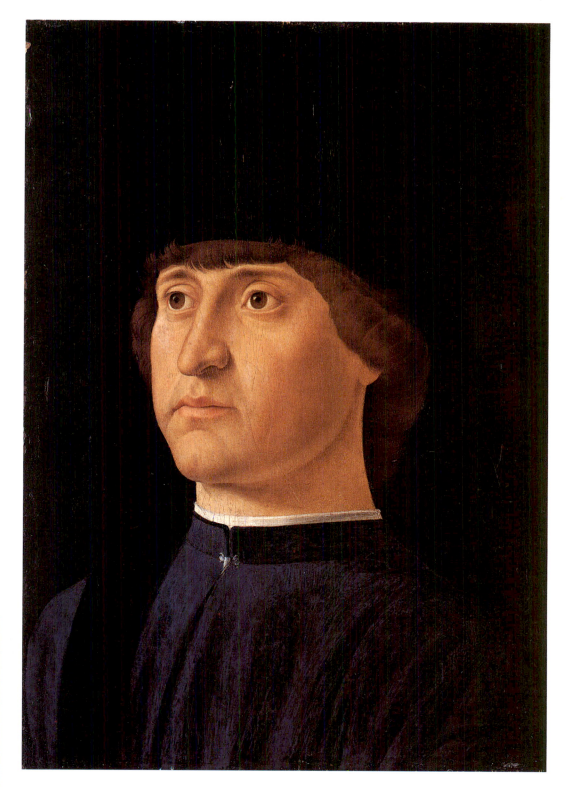

Reverse

Attributed to	c. 1480/1490, oil on panel	Philadelphia Museum of Art,
Jacometto Veneziano	34 × 27.5 (13 3/8 × 10 13/16)	Philadelphia, John G. Johnson
		Collection

21 *Portrait of a Lady*

REVERSE

Inscription and sprig of plant

SELECTED BIBLIOGRAPHY

Aikema, Bernard and Beverly Louise
Brown. *Renaissance Venice and the
North: Crosscurrents in the Time of
Bellini, Dürer and Titian,* cat. 66,
326–327. Milan, 1999.

Berenson, Bernard. *Catalogue of a Col-
lection of Paintings and Some Art Objects.
Italian Paintings,* I: cat. 243, 154–155.
Philadelphia, 1913.

Dülberg, Angelica. *Privatporträts.
Geschichte und Ikonologie einer Gattung
im 15. und 16. Jahrhundert,* 57–58, 131–
132, 153, and cat. 167, 228. Berlin, 1990.

Manca, Joseph. *The Art of Ercole
de' Roberti,* 34–35, cat. R36, 186–187.
Cambridge, 1992.

Sweeny, Barbara. *John G. Johnson
Collection. Italian Paintings,* no. 243,
39–40. Philadelphia, 1966.

This panel, still in its original engaged frame, is
double-sided, as are the other portraits by or attrib-
uted to Jacometto Veneziano (active c. 1472–1497)
in the exhibition (cats. 19A, B; 20). The peculiar coif
worn by the sitter, covering the forehead and ex-
tending in a loop over the bust, is similar to those
found in the artist's female portraits in the Lehman
collection and in the Cleveland Museum of Art.
The woman depicted here, however, is no longer
young, and the artist has not shrunk from showing
her double chin and long nose. His unflattering por-
trayal differs from the idealized type of portraiture
prevalent at the north Italian courts (cat. 2A, B).
Bernard Berenson's tentative attribution (1913) of the
Johnson picture to the Ferrarese court artist Ercole
de' Roberti, though widely accepted, is untenable,
therefore, and was rightly rejected by Joseph Manca
(1992). The portrait is Venetian, not Ferrarese, and
the attribution, accordingly, is now divided between
Jacometto Veneziano (Sweeny 1966) and Jacopo de'
Barbari (Aikema and Brown 1999). Comparison of
this painting with de' Barbari's *Old Man Embracing
a Young Woman,* also in the Johnson collection, demon-
strates that both could not be by the same hand, and
the attribution to Jacometto seems more plausible.
Admittedly, the portrait lacks the minutely rendered
details and subtle modeling of the miniatures in the
Lehman collection, but it was overcleaned in the
past. Now skillfully restored, the painting provides
more clues about its original appearance. The woman's
cheeks, for example, are not ruddy but blushed.
Above all, a remarkable, finely hatched underdrawing
(fig. 1), discovered using infrared reflectography dur-
ing the recent treatment of the picture, reveals not
only significant *pentimenti* in the sitter's features and
bodice but also the same attention to detail found
in the Lehman portraits.

The reverse of the panel has an inscription in gold
letters, together with the sprig of an unidentified
plant also painted in gold, on a dark red marbleized
ground. Though not an exact match in certain cases,
the letters are close enough, according to Christine
Sperling, to those on the back of Jacometto's *Portrait
of a Man* (cat. 20) in London to make it reasonable
to suppose that the same artist painted both works.[1]
The inscription reads:

V LLLL F / DELITIIS ANIMUM / EXPLE /
POST MORTEM / NULLA VOLUP / TAS

The first line is puzzling. Evidently an abbreviation
with four L's referring to the sitter, it is not part
of the motto, which means: "Satisfy the Soul with
Delights for after Death There is No Pleasure." The
second part of the motto is a well-known classical
epigram preceded, in the original, by the equally
familiar "Eat, Drink, and Be Merry." Significantly,
the epigram was modified to suit the sitter's appar-
ent age and character. Not a typical *vanitas,* it does
not exhort the woman to "gather ye rosebuds while
ye may," but to experience the refined pleasures of
the spirit. DAB

NOTES

1. Written communication of 4 December 2000.

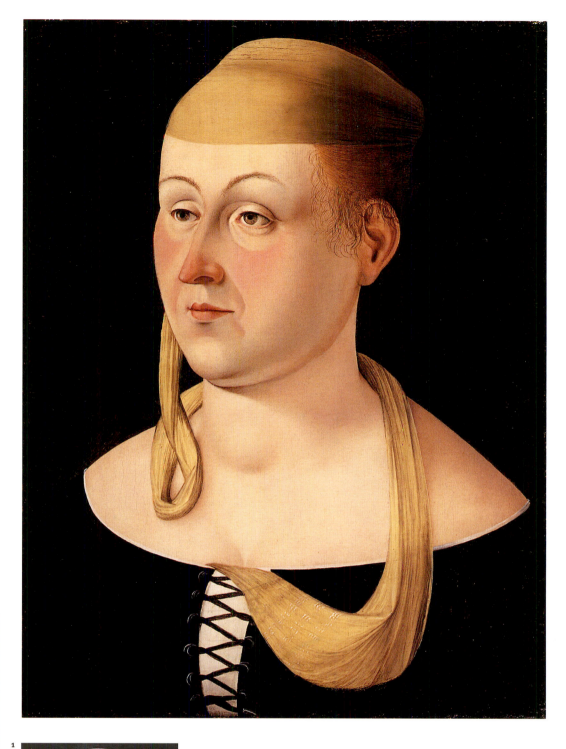

Reverse

1

Infrared reflectogram showing under-
drawing of cat. 21, Philadelphia Museum
of Art (photo: courtesy Mark Tucker and
Joe Mikuliak, conservation department,
Philadelphia Museum of Art)

Andrea del Verrocchio | c. 1475, marble | Museo Nazionale del Bargello,
| 60 × 48 × 25 (23 5/8 × 18 7/8 × 9 13/16) | Florence

22 *Lady with a Bunch of Flowers*

SELECTED BIBLIOGRAPHY

Brown, David Alan. *Leonardo da Vinci.
Origins of a Genius,* 109–110. New
Haven, 1998.

Butterfield, Andrew. *The Sculptures of
Andrea del Verrocchio,* 90–128, 217–218.
New Haven, 1997.

Caglioti, Francesco. In *Eredità del
Magnifico* [exh. cat., Museo nazionale
del Bargello] (Florence, 1992), 50–54.

Passavant, Günter. *Verrocchio,* 33–34,
180–181. Trans. Katherine Watson.
London, 1969.

Pope-Hennessy, John. *Italian Renaissance
Sculpture,* 194, 385. London, 1996.

Rossi, Filippo. *Il museo del Bargello
a Firenze,* opposite pl. 34. Milan, 1932.

A masterpiece by Verrocchio (c. 1435–1488), this bust
is the only quattrocento sculptural portrait in which
the sitter is shown half-length with her arms and
hands. The tenderness with which the lady holds the
flowers to her breast contrasts with the distant seren-
ity of her expression; the contrast underscores both
the technical and emotional complexity of the por-
trait. Wilhelm von Bode, noting a similarity with the
head of Faith in the Forteguerri monument in Pis-
toia, first assigned the sculpture to Verrocchio.[1] Most
subsequent writers have agreed with this view, but
starting with Hans Mackowsky, Leonardo was also
proposed as the author of the work.[2] This attribution
was suggested by the Leonardesque character of the
hands (cat. 17)[3] and the lady's affinity with the por-
trait of *Ginevra de' Benci* (cat. 16). No sculpture by
Leonardo is extant to serve as a comparison, however,
and the *Lady with a Bunch of Flowers* is fully compa-
tible with Verrocchio's style.[4]

Scholars agree in dating the work to Verrocchio's
maturity, c. 1475. The lady's hairstyle is identical to
the one worn by Ginevra de' Benci, as is the veil-like
coverciere fastened with a small button just below her
throat. The sitter's dress, a *guarnello,* is notable for
its simplicity; it appears to be the same type of infor-
mal garment that is worn by the sitter in Botticelli's
portrait of Smeralda Brandini (cat. 25).[5] But the
way its folds are made to cling to the sitter in the
bust recalls hellenistic sculpture, which was probably
known to the artist.[6] As noted by Andrew Butter-
field, ancient funerary reliefs, in which the deceased's
hands are included, may have inspired Verrocchio
to show the sitter in half-length. The Bargello lady,
however, moves beyond all ancient prototypes in being
fully developed in the round with multiple viewpoints
(fig. 1).

Two women have been proposed as the possible sub-
ject of this sculpture: Ginevra de' Benci and Lucrezia
Donati, Lorenzo de' Medici's platonic lover. The first
identification was suggested to early writers by the
similarity in expression and mood with Leonardo's
portrait (cat. 16), now securely identified as Ginevra.
Jane Schuyler adduces as further evidence a poem in
which Alessandro Braccesi describes Ginevra holding
violets, but the verses hardly seem conclusive, as the
sculpted flowers do not appear to be violets.[7] They
were at one time called primroses, but experts have
concluded that—though not precisely identifi-
able—the flowers most resemble dog-roses.[8] Jennifer
Fletcher's observation in connection with Ginevra
and the bust that roses are the main element of
Bernardo Bembo's coat of arms seems more relevant
given that he was Ginevra's platonic lover.[9] But it
is also not sufficient for a positive identification.
Though a similarity in mood and facial type is unde-
niable, there are many differences in the features
between Leonardo's sitter and the Bargello lady.
Brown and Butterfield concur that the bust and the
painting do not represent the same person. The
presence in the exhibition of the two works side by
side offers an unprecedented opportunity to further
evaluate the relationship between them.

The identification with Lucrezia Donati was based
primarily on a mistaken and long-held belief that the
bust had a Medici provenance. In fact, the Uffizi
acquired the sculpture in 1825 from a local dealer who
was said to have purchased it from a Florentine fam-
ily.[10] Lorenzo de' Medici is documented as having
commissioned portraits of his beloved Lucrezia in
both painting and sculpture, a painting or relief being
by Verrocchio himself.[11] She was also celebrated in
contemporary literature for her beautiful hands and,
like Ginevra, was described holding flowers.[12] But,

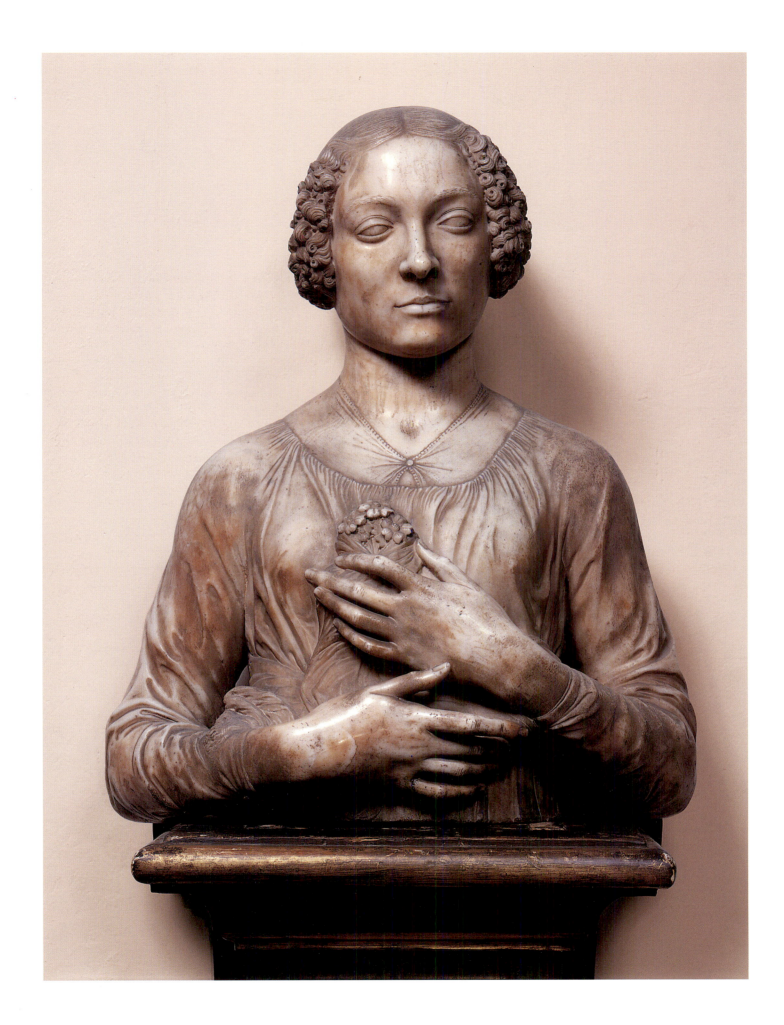

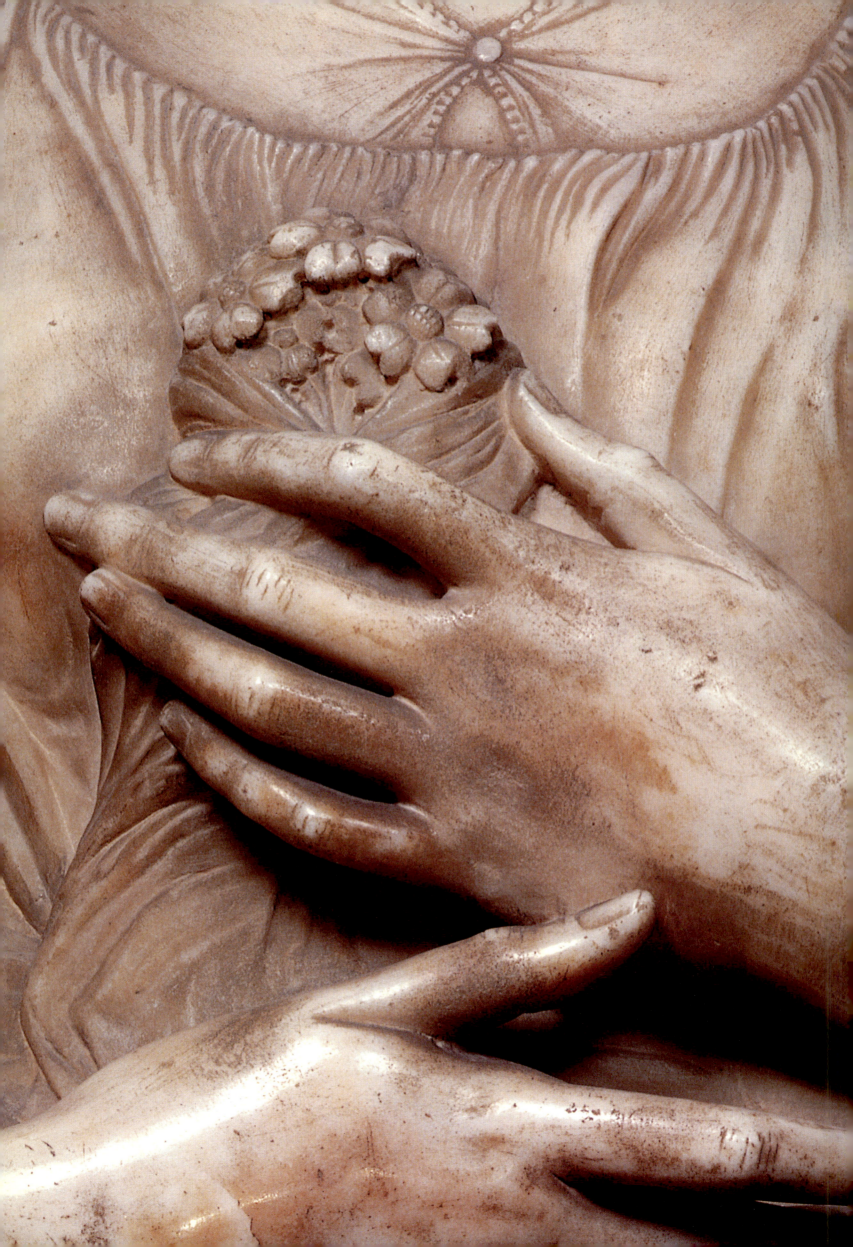

1

Profile view of cat. 22
(photo: Alinari/Art Resource, N.Y.)

1

in the absence of a concrete Medici connection and an authentic likeness it cannot be determined whether the sculpture represents Lucrezia Donati. What seems probable, as suggested by Butterfield, is that the Bargello bust represents the patron's beloved. Her hands and flowers have numerous counterparts in the courtly literature that celebrates platonic mistresses like Ginevra de' Benci and Lucrezia Donati.

In the *Lady with a Bunch of Flowers* Verrocchio makes the subject startlingly tangible by means of the accurate rendering of subtle asymmetries. She holds the flowers with her left hand so that her left shoulder is slightly higher than her right, which droops gently as she tilts her head ever so slightly toward that side. The resulting sense of arrested motion is so well developed that it is even evident from the fully finished back in which the lady's left arm, the one holding the flowers, is pressed more closely to her side, while the right falls farther away. The bust is also innovative in connecting the natural world so intimately with a sitter, as was beginning to happen in painting. The delicate blossoms that the lady cradles against her chest are wrapped as if in swaddling cloths in her belt: perhaps the cloth also serves to protect against the thorns of the dog-roses. EL

NOTES

1. Wilhelm von Bode, "Die italienischen Skulpturen der Renaissance in den königlichen Museen," *Jahrbuch der Königlich preussischen Kunstsammlungen* 3 (1882), 103, 260.

2. For the attribution history of the work see Butterfield 1997. Hans Mackowsky, *Verrocchio* (Bielefeld, 1901), 45–46. The Leonardesque qualities of the work had already been noted by Eugène Müntz, *Histoire de l'art pendant la Renaissance,* 3 vols. (Paris, 1889–1895), 2: 503, but only a few scholars have embraced Mackowsky's view (for a list see Butterfield 1997, 217). In later publications Bode accepted a connection to Leonardo, going so far as to state that Leonardo may have carved the bust in Verrocchio's shop (Wilhelm von Bode, "Italian Portrait Paintings and Busts of the Quattrocento," *Art in America* 12 [December 1923], 5).

3. Noting the similarity of the drawing with the sculpture, Kenneth Clark rejected the notion that the two works are by the same artist: Kenneth Clark, *The Drawings of Leonardo da Vinci in the Collection of Her Majesty the Queen at Windsor Castle,* 2 vols. (London, 1968), 1: 104. See also Kathleen Weil-Garris Brandt, "Leonardo e la scultura," *Lettura vinciana* 38 (1998), 15.

4. Brown 1998.

5. On the *guarnello,* a type of garment meant to be worn indoors, see Jacqueline Herald, *Renaissance Dress in Italy 1400– 1500* (London, 1981), 220, who cites Botticelli's portrait (cat. 25) as an example of the garment. Butterfield (1997, 90) calls the lady's dress a *cotta,* which is, however, a rather formal garment.

6. See especially Roman reliefs of maenads, which Dobrick has shown to have influenced Verrocchio and other Florentine quattrocento artists: J. Albert Dobrick, "Botticelli's Sources: A Florentine Quattrocento Tradition and Ancient Sculpture," *Apollo* 110 (August 1979), 120, 127, fig. 19. According to Vasari, Verrocchio decided to become a sculptor after having seen ancient sculpture in Rome. According to the same, he had also restored some of the ancient sculptures belonging to the Medici (Giorgio Vasari, *Le Vite de' più eccellenti pittori scultori ed architettori,* ed. Gaetano Milanesi, 9 vols. [Florence, 1906], 3: 359, 366–367).

7. Jane Schuyler, *Florentine Busts: Sculpted Portraiture in the Fifteenth Century* (New York, 1976), 183–193.

8. Mackowsky (1901) and Maud Cruttwell (*Verrocchio* [London, 1904], 109) called the flowers primroses. Botanists were consulted by Passavant (1969, 180) and Butterfield (1997, 218); all came to similar conclusions.

9. Jennifer Fletcher, "Bernardo Bembo and Leonardo's Portrait of Ginevra de' Benci," *The Burlington Magazine* 121 (December 1989), 813.

10. This identification is argued most extensively by Emil Möller (*La gentildonna dalle belle mani di Leonardo da Vinci* [Bologna, 1954]), who paradoxically is also the first to outline the non-Medici provenance of the bust. A letter documenting the provenance is published by Möller (1954, 6, note 2), and more extensively by Paola Barocchi, "La storia della Galleria degli Uffizi e la storiografia artistica," *Annali della scuola normale di Pisa* 12 (1982), 1503, note 431.

11. Butterfield 1997, 217–218.

12. Möller 1954.

| Andrea del Verrocchio | 1480s, marble
47.9 × 48.7 × 23.8
(18⅞ × 19³⁄₁₆ × 9³⁄₈) | The Frick Collection, New York,
Bequest of John D. Rockefeller, Jr. |

23 *Bust of a Lady*

SELECTED BIBLIOGRAPHY

Butterfield, Andrew. *The Sculptures of Andrea del Verrocchio*, 16–18, 203, no. 4, fig. 20. New Haven, 1997.

Cruttwell, Maud. *Verrocchio*, 110–111, pl. 24. London, 1904.

Pope-Hennessy, John. "Deux Madones en marbre de Verrocchio." *Revue de l'art* 80 (1988), 22–23, fig. 12.

The first recorded Florentine portrait bust of a woman, representing Lucrezia Tornabuoni, does not survive. Vasari mentions it as a companion piece to that of her husband, Piero de' Medici, whose bust was carved by Mino da Fiesole in 1453 (Bargello, Florence).[1] Alessandro Bacci wrote an epigram on another marble bust, that of Albiera degli Albizzi, as a memorial after her death in 1473. Bacci's verses suggest that, in addition to their function as consort portraits, busts of women were commissioned as individual tributes.[2] None of the extant Florentine sculpture of women has an inscription identifying the sitter or the artist. This is in contrast to busts of men, which, for the most part, proudly proclaim at least the name of the subject; identity, perhaps, was not of primary concern in female portraiture. What was paramount was the representation of beauty, considered a sign of virtue. In other respects Florentine busts of women conformed to the canons used for men: subjects are portrayed bust length, truncated just above the elbow, and without an integral base or border.

This bust of a young woman was originally assigned to Verrocchio (c. 1435–1488) by Wilhelm von Bode and accepted as his work by most writers, except Leo Planiscig and Günter Passavant who do not consider it at all.[3] Recently Andrew Butterfield has reaffirmed the attribution on grounds of stylistic affinities with Verrocchio's *Lady with a Bunch of Flowers* (cat. 22). The overall treatment of the subject as well as the execution of the bust and the weighty, detailed torso is comparable, though clearly more developed in the Bargello sculpture. Nicholas Penny, however, has doubted the attribution because of "an interest in evanescent effects" in the features and the extensive use of drilling in the hair.[4] While the Frick lady is more softly modeled, especially in the face, and endowed with a greater gentility of expression than the Bargello sitter, her affinity to the latter is evident in the overall proportions of the head and torso. Perhaps some shop intervention may account for the less innovative character of the sculpture and the more extensive drilling in the hair.

Butterfield proposes a date in the 1460s because the bust is less volumetric than the Bargello lady. However, both the sitter's hairstyle and dress are not comparable to ones in works dated to before 1470. The hairstyle, with elegant curls framing the face, is similar to that of Ginevra de' Benci (cat. 16) as well as to the Bargello lady (cat. 22), and is of the same type as that worn by a young donor in Ghirlandaio's *Madonna della Misericordia* fresco of c. 1472–1473 in the Vespucci chapel in the Ognissanti, Florence.[5] As noted by John Pope-Hennessy, the rosettes, which decorate the back of her hair, are also seen in the *Portrait of a Girl* attributed to the workshop of Ghirlandaio in the National Gallery, London.[6] The tight-fitting brocade or velvet dress is of the same type as that worn by Giovanna degli Albizzi in Ghirlandaio's portrait of c. 1488/1490 (cat. 30). This evidence would support Pope-Hennessy's dating for the bust to c. 1480.

Ulrich Middeldorf, following early writers, believed that the sitter could be identified as Medea Colleoni, daughter of the famed *condottiere* Bartolomeo, because the pattern on her sleeves was assumed to be a family device (fig. 1).[7] But Maud Cruttwell already pointed out that our sitter bears no resemblance to Medea's tomb effigy in Bergamo. Moreover, as noted by Butterfield, the seven pear-shaped objects that appear within a large thistle design on the sleeves are unlike the three testicles of the Colleoni, as well as greater in number. A brief look at Renaissance textiles reveals that this stylized thistle design, with its distinctly shaped seeds, was common for textiles, mostly cut velvets, in the second half of the fifteenth century.[8] While devices were often present on sleeves in Italian Renaissance portraits of women, this practice was by no means universal. Pollaiuolo's beautiful likenesses of women (cat. 6) are notable for the intricate designs on the velvet sleeves, which are clearly not family devices, but rather lavish displays of conspicuous consumption and virtuoso painting. EL

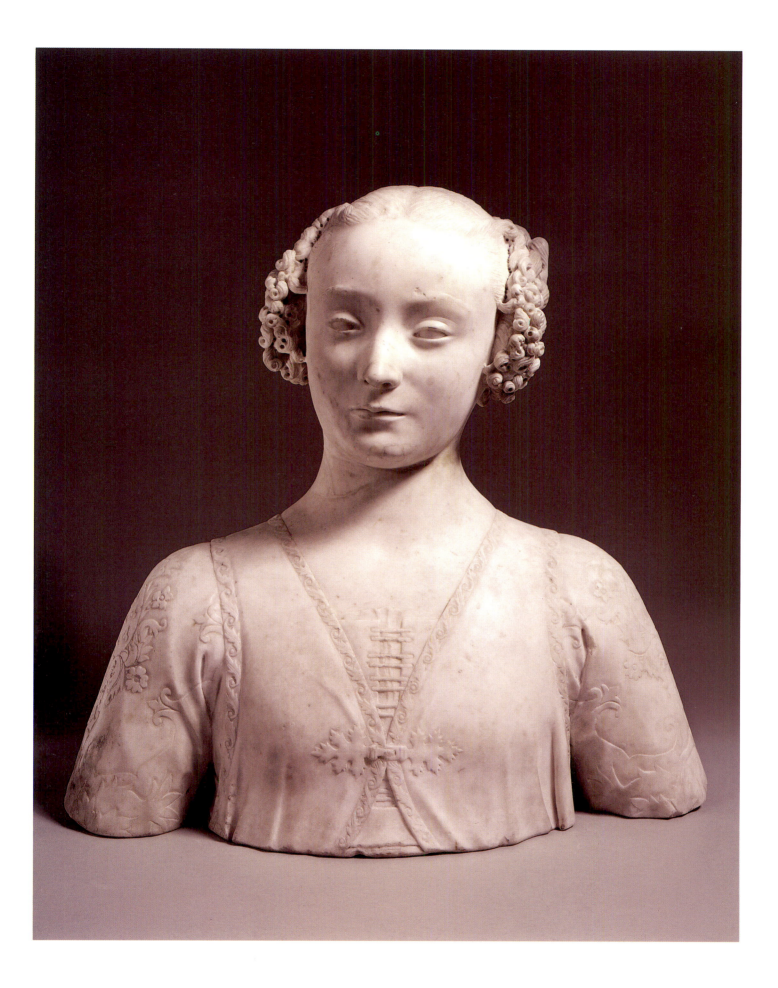

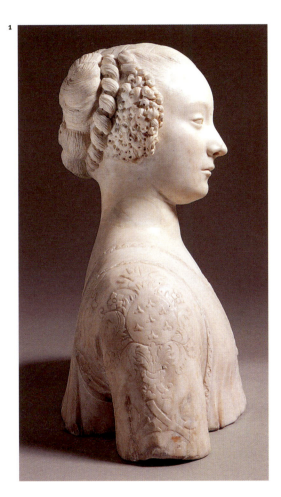

1

NOTES

1. Giorgio Vasari, *Le Vite de' più eccelenti pittori scultori et architettori,* ed. Gaetano Milanesi, 9 vols. (Florence, 1906), 3: 123; Shelley Zuraw ("The Medici Portraits of Mino da Fiesole," *Piero de' Medici il Gottoso (1416–1469),* ed. Andreas Beyer and Bruce Boucher [Berlin, 1993], 317–339) believes that a bust in Pisa may be identified with Mino's Lucrezia.

2. Albiera was Giovanna degli Albizzi's eldest half-sister (cats. 11, 30). She died unexpectedly in 1473 at the age of fifteen. She was mourned by her betrothed and her family, who commissioned a series of tributes in verse. Among these was Bacci's epigram "Ad bustum marmoreum." See Federico Patetta, "Una raccolta manoscritta di versi e prose in morte d'Albiera degli Albizzi," *Atti della R. accademia delle scienze di Torino* 52 (1916–1917), 123; Irving Lavin, "On the Sources and Meaning of the Renaissance Portrait Bust," in *Looking at Italian Renaissance Sculpture,* ed. Sarah Blake McHam (Cambridge, 1998), 70–71, 78, notes 46–47.

3. Wilhelm von Bode, "Die italienischen Skulpturen der Renaissance in der königlichen Museen 11: Bildwerke des Andrea del Verrocchio," *Jahrbuch der Königlich preussischen Kunstsammlungen* 3 (1882), 103–104. For the attribution history of the bust, see Butterfield 1997, 203.

4. Nicholas Penny, "Cast from the Life," review of Butterfield 1997, *Times Literary Supplement,* 3 April 1998, 4.

5. Ronald Kecks, *Domenico Ghirlandaio* (Florence, 1998), 48–49. As noted by Valentiner, the hairstyle of the Frick lady, as seen in profile, is repeated almost exactly in a profile portrait of a *Young Woman* in the Detroit Institute of Arts: Wilhelm Valentiner, "Verrocchio or Leonardo," *Bulletin of the Detroit Institute of Arts* 16 (1937), 56.

6. Martin Davies, *National Gallery Catalogues. The Earlier Italian Schools* (London, 1961), 220, no. 1230.

7. Ulrich Middeldorf, "Statuen und Stoffe," *Pantheon* 35 (1977), 10–14.

8. In addition to the velvet panel published by Middeldorf, at least four other examples of such textiles with "seeded" thistles are recorded. The number of "seeds" varies from four to ten. See Christa Mayer, *Masterpieces of Western Textiles from the Art Institute of Chicago* (Chicago, 1969), pl. 97 (pile-on-pile voided silk velvet, 37.771); Rosalia Bonito Fanelli, *Five Centuries of Italian Textiles: 1300–1800* [exh. cat., Museo del Tessuto] (Prato, 1981), 72, fig. c (satin damask, Museo Nazionale del Bargello, Florence, Carrand coll. 2374); Alessandra Mottola Molfino in *Museo Poldi Pezzoli. Tessuti-sculture metalli islamici* (Milan, 1987), 19–20, cat. 2–3 (pile-on-pile voided silk velvet, inv. 3203); Silvia Casini in *"Drappi, velluti, ta età et altre cose." Antichi tessuti a Siena e nel suo territorio,* ed. Marco Ciatti (Siena, 1994), 112–113, no. 15 (silk voided velvet, church of Sant'Andrea, Siena).

**Circle of Andrea
del Verrocchio**

c. 1470, marble
53 × 48.8 × 19.9
(20⅞ × 19⅛ × 7¾)

National Gallery of Art, Washington,
Samuel H. Kress Collection,
1939.1.326

24 *A Lady*

SELECTED BIBLIOGRAPHY

Cardellini, Ida. *Desiderio da Settignano*,
202. Milan, 1962.

Luchs, Alison. In *Italian Renaissance
Sculpture in the Time of Donatello*
[exh. cat., Detroit Institute of Arts]
(Detroit, 1985), 207–208.

Middeldorf, Ulrich. *Sculptures from
the Samuel H. Kress Collection: European
Schools, XIV–XIX Century*, 20–21.
London, 1976.

Wright, Alison. *Renaissance Florence.
The Art of the 1470s* [exh. cat., National
Gallery] (London, 1999), 324–325.

Originally attributed to Desiderio da Settignano by Wilhelm von Bode,[1] the bust was first tentatively assigned to Verrocchio (c. 1435–1488) by Charles Seymour.[2] Seymour was responding to William Suida's overzealous attempt to give the work to the young Leonardo.[3] John Pope-Hennessy thought that it recalled Benedetto da Maiano's bust of Pietro Mellini in the Bargello, Florence, in the treatment of the "unfinished pattern of the dress."[4] When it was exhibited in Detroit (Luchs 1985) and London (Wright 1999), doubts were raised about its authenticity by Bruce Boucher and Carl Strehlke, respectively. The first noted a blending of stylistic elements from Desiderio da Settignano, Verrocchio, and Benedetto da Maiano as cause for skepticism.[5] Strehlke found the "hard geometry" of the lady's face at odds with Verrocchio's style, suggesting that this is not a work by the artist's hand.[6] However, the fact that the bust is not by Verrocchio does not mean that it is not a quattrocento production, especially since the resulting strong-featured aloofness of the lady is far from nineteenth-century canons of beauty, but true to those of the Renaissance. And the fact, commented upon by Strehlke, that the bust offers more than one main view (fig. 1) and is successfully completed in the round, as is the case with busts by Mino da Fiesole, Desiderio, and Verrocchio, is no argument against its authenticity.

Numerous aspects of the lady's dress and hair arrangement are consistent with a date of c. 1470. As noted by Alison Wright, the sitter's cut velvet *cotta* is of a style common in the 1460s and early 1470s. Materials with different pomegranate designs were used for the sleeves and the bodice—a common feature of Florentine dress of this decade, seen in Pollaiuolo's *Portrait of a Lady* in Berlin, for example.[7] Most striking is the similarity in dress and features with the *Portrait of a Lady in Red* (fig. 2) in the National Gallery, London.[8] In the latter not only does the sitter wear the same type of garment with a relatively low neckline in the back and a small edge of the chemise showing in front, she also has the same hairstyle with shaved forehead and the hair and ears snugly covered by a stiff coif, which appears to be open in the back. In the sculpture the coif is fastened at the bottom by

means of two laces and the hair is secured in the back with a Y-shaped cord.[9] The lady's strong features are also alike in the two works, leading Strehlke to further question the sculpture. But the relationship of the two portraits is akin to that which exists between Leonardo's *Ginevra de' Benci* and Verrocchio's Bargello bust (cats. 16, 22). The similarity is probably the result of portraying certain features, or even the same sitter, in two different media.

William Suida had identified the sitter as Simonetta Vespucci on the basis of a likeness with the portrait of a member of the Vespucci family in Ghirlandaio's fresco of the *Madonna della Misericordia* in the Ognissanti church, Florence.[10] Since the identification of the fresco figure with Simonetta is highly tentative, and because the similarity in the features is of a general kind, as with the London painting, it seems highly improbable that the marble bust represents Giuliano de' Medici's beloved.[11]

The powerful beauty of this portrait, commanding yet attractive, was much remarked upon by early writers. In it the artist has abstracted the sitter's strongly individual features into smooth geometric volumes. A fundamental convention of Renaissance portraiture of women, the rendering of unapologetically correct physiognomy in an idealized idiom is evidence for the Florentine fifteenth-century origin of this sculpture. Alison Luchs notes a similar abstracting of the features and treatment of the eyes in Verrocchio's terra-cotta bust of *Giuliano de' Medici*, also in the National Gallery, Washington. And she points out related treatment of the marble with the edge of the dress pressing into the flesh of the shoulders in figures on the Forteguerri monument in Pistoia by Verrocchio and his workshop. A positive reassessment of the *Bust of a Lady* by Luchs is forthcoming and will address the stylistic complexities of the work.[12] EL

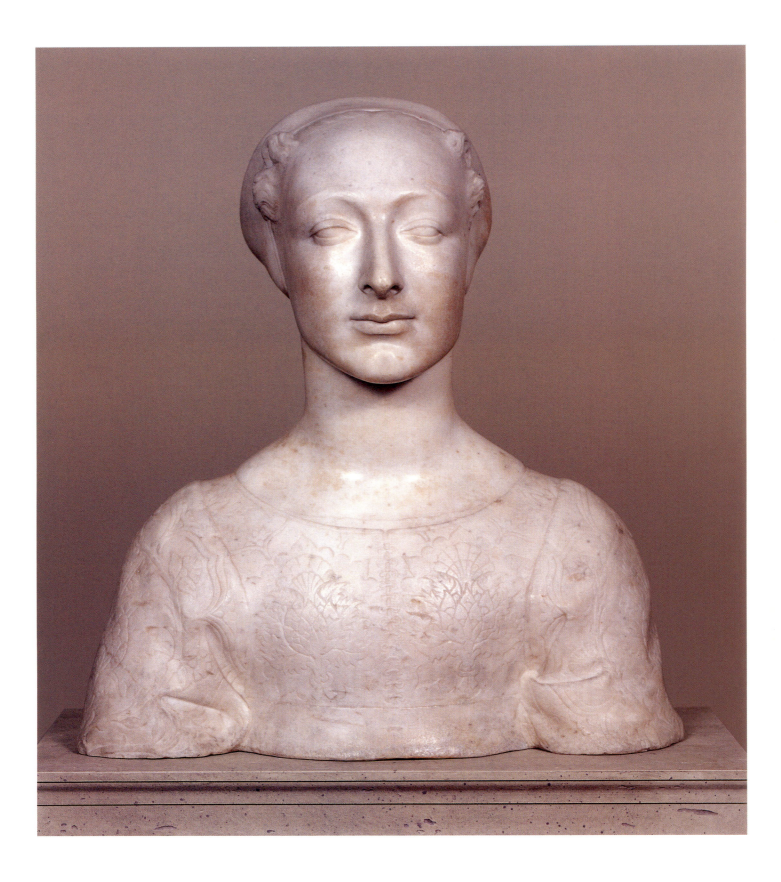

1
Profile view of cat. 24

2
Florentine, *Portrait of a Lady in Red*,
National Gallery, London

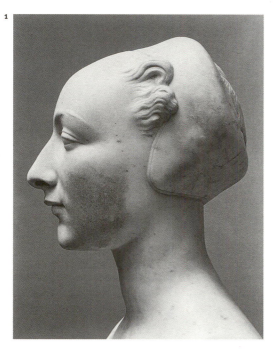

1

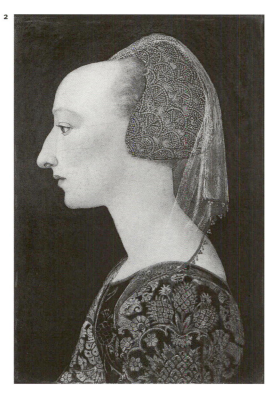

2

NOTES

1. Wilhelm von Bode, *Florentiner Bildhauer der Renaissance* (Berlin, 1921), 195.

2. Charles Seymour, *Masterpieces of Sculpture from the National Gallery of Art* (Washington, 1949), 176; Charles Seymour, *The Sculpture of Verrocchio* (Greenwich, 1971), 169.

3. William Suida, "La Bella Simonetta," *Art Quarterly* 11 (1948), 3–8.

4. First published in John Pope-Hennessy, *Italian Renaissance Sculpture* (London, 1958), 304, and reaffirmed in the 4th ed., London 1996, 377.

5. Bruce Boucher, "Detroit and Fort Worth, Sculpture in the Time of Donatello," review of Luchs 1985, *The Burlington Magazine* 128 (January 1986), 68.

6. Carl Strehlke, "London, Florence in the 1470s," review of Wright 1999, *The Burlington Magazine* 142 (January 2000), 46–47.

7. Nicoletta Pons, *I Pollaiolo* (Florence, 1994), 49, 97.

8. First noted by Middeldorf (1976) and mentioned by Strehlke as suspicious. Recent technical examination and analysis of the London painting confirms that it is a fifteenth-century work (communication to Alison Luchs from Susanna Avery-Quash). On the costume in the painting, see Jacqueline Herald, *Renaissance Dress in Italy 1400–1500* (London, 1981), 81, pl. 6.

9. Cords are used in a similar way in a *Bust of a Lady* by Desiderio da Settignano in the Bargello (Cardellini 1962, 198–201). They are also evident in different arrangements in the Frick bust (cat. 23) and in the medal of Maria de' Mucini (cat. 9).

10. Suida 1948.

11. Like many other portraits of this period, in the early twentieth century the bust was identified as Isotta degli Atti, the notorious mistress of Sigismondo Malatesta, but there is no evidence to support this view.

12. I am grateful to Alison Luchs for her generous help with this entry. I am also indebted to Leanne Montgomery, who gathered extensive material on the bust during a summer internship in 2000.

Sandro Botticelli

c. 1470 / 1475, tempera on panel
65.7 × 41 (25⅞ × 16⅛)

Victoria and Albert Museum,
London

25 *Woman at a Window (Smeralda Brandini?)*

INSCRIBED

Smeralda di…Bandinelli moglie di
Vi[viano] Bandinelli

SELECTED BIBLIOGRAPHY

Caneva, Caterina. *Botticelli. Catalogo completo dei dipinti,* cat. 20, 43. Florence, 1990.

Craven, Jennifer E. "A New Historical View of the Independent Female Portrait in Fifteenth-Century Florentine Paintings," cat. 16, 253–256. Ph.D. diss., University of Pittsburgh, 1997.

Kauffmann, C.M. *Catalogue of Foreign Paintings. I. Before 1800,* cat. 37, 37–39. Victoria and Albert Museum. London, 1973.

Lightbown, Ronald. *Sandro Botticelli,* I: 38–39; 2: cat. B15, 28–29. 2 vols. London, 1978.

Rubin, Patricia Lee. In Patricia Lee Rubin, Alison Wright, and Nicholas Penny. *Renaissance Florence. The Art of the 1470s* [exh. cat., National Gallery] (London, 1999), cat. 83, 326–327.

Though doubted in the past, this picture is now universally accepted as a work by Botticelli (1444/1445–1510), painted during the early to mid-1470s, when the artist, having studied with Filippo Lippi and still influenced by Verrocchio, was not yet in possession of the style for which he would later become famous.[1] The portrait obviously represents an individual, and yet the woman's facial type and arresting outward glance resemble those of Saint Catherine in Botticelli's *Madonna and Child Enthroned with Saints* in the Uffizi.[2] On the basis of the later inscription on the windowsill, the sitter has been tentatively identified as Smeralda Brandini, grandmother of the sculptor Baccio Bandinelli.[3] Whoever she may be, the woman is simply dressed: over her white *camicia* or chemise and her red *gamurra* or gown, she wears a loose-fitting, washable cotton garment called a *guarnello,* the transparency of which is a tour de force of the artist's tempera technique.[4] In a bold departure from the profile pose hitherto adopted for Florentine portraits of women, Botticelli depicts the sitter in three-quarter view to the left.[5] Literally recalling Alberti's concept of the picture as a window, the woman has opened the shutter, visible on the right, and stands before a fictive window looking out at the viewer, with her right hand resting casually on the frame. In this manner the sitter and the viewer exchange glances.

There does not seem to have been any change in the status of women during this period that would warrant Botticelli's choice of the three-quarter view over the traditional profile. Rather, he may have wished to overcome the limitations of the static profile in an attempt to convey the physical and psychological presence of his sitter—"lifelikeness" rather than "likeness." The young artist's formulation cannot be entirely original, however, and, in fact, the portrait has sources in the work of both Lippi and Verrocchio. The latter's marble *Lady with a Bunch of Flowers* (cat. 22), particularly when viewed from the same angle, bears a striking resemblance to Botticelli's portrait, not only in the informal dress and hairstyle of the sitter but also in the extended format featuring her hands.[6] Verrocchio's near life-size, sculptural prototype was no less important in the evolution of Leonardo's contemporary *Portrait of Ginevra de' Benci* (cat. 16). At the same time Botticelli seems to have looked back to Lippi's *Woman with a Man at a Window* (cat. 3). Both works depict the half-length sitter framed by windows in an interior setting, though in Botticelli's case the interior serves more as an undefined space in which the subject performs an action.[7] DAB

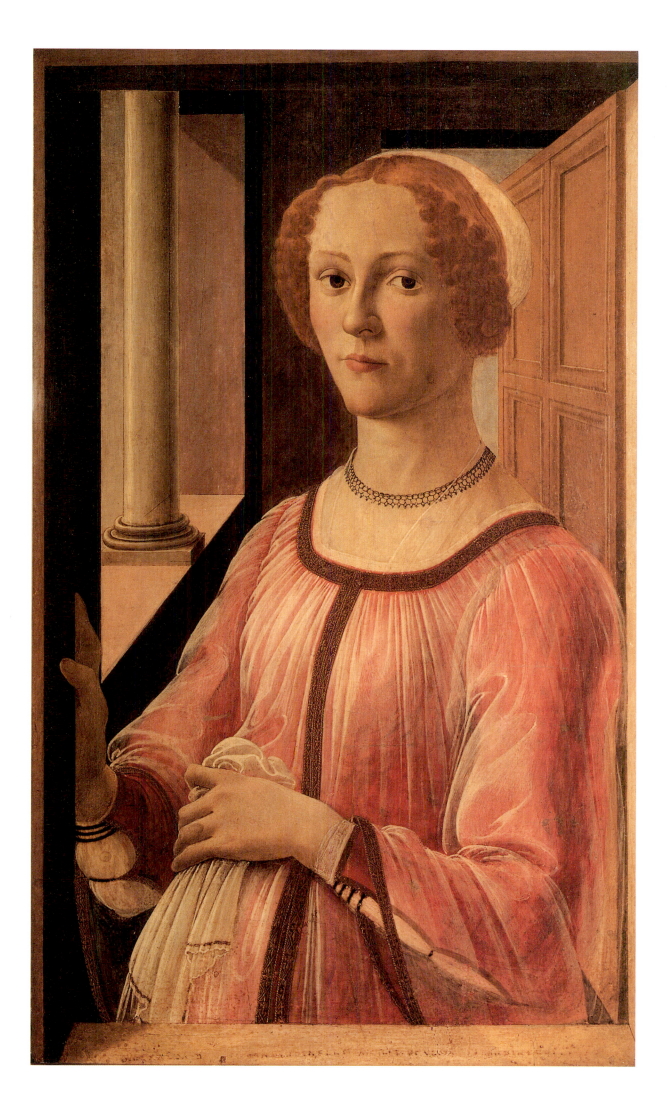

NOTES

1. For the attribution history, see Lightbown 1978.

2. Lightbown 1978, 1: fig. 17; 2: cat. B13, 26–27.

3. If correct, the partly effaced inscription would identify the sitter as Smeralda Donati, wife of Viviano Brandini, grandfather of Baccio Bandinelli. Even assuming that the sculptor (or his descendant Baccio Bandinelli the Younger) owned the picture, we still do not know whether they inherited it and are reporting family history or whether Baccio merely purchased the panel and claimed the (unknown) sitter as the sculptor's grandmother. The name "Smeralda Bandinelli," in any case, is anachronistic, as the socially ambitious sculptor only adopted that surname in the 1520s. About the problem see most recently Rubin 1999, with new information from Louis Waldman.

4. The *guarnello* was possibly worn by pregnant women, according to Jacqueline Herald (*Renaissance Dress in Italy 1400–1500* [London, 1981], 220), and Frank Zöllner has, accordingly, associated the portrait with childbirth (*Leonardo da Vinci. Mona Lisa* [Frankfurt, 1994], 46).

5. The difference between the profile and three-quarter views can be gauged in Botticelli's portrait of his patron Gasparre del Lama, looking out at the viewer amid a group of profiles, in the *Adoration of the Magi,* of c. 1475, in the Uffizi (Lightbown 1978, 1: fig. 19).

6. The Verrocchiesque character of Botticelli's portrait has often been noted (Raimond Van Marle, *The Development of the Italian Schools of Painting* [The Hague, 1931], 12: 40–43). For the relation between the two artists, see David Alan Brown, *Leonardo da Vinci. Origins of a Genius* (New Haven, 1998), 36–37; and about the Bargello bust and its cognates, including the London picture, Andrew Butterfield, *The Sculptures of Andrea del Verrocchio* (New Haven, 1997), 90, 94–103, and cat. 15, 217–218. A key missing work here is the lost portrait of Lucrezia Donati, which Verrocchio is said to have painted for Lorenzo de' Medici.

7. If the *Profile Portrait of a Woman* attributed to Botticelli, in the Lindenau Museum in Altenburg, is actually by the artist, it would be a link between Lippi's double portrait in New York and the *Woman at a Window* in London. For the Altenburg portrait, see Robert Oertel, *Frühe Italienische Malerei in Altenburg* (Berlin, 1961), cat. 100, 151–154, and Lightbown 1978, 2: cat. C31, 160, as shopwork. Like Lippi's double portrait in New York, Botticelli's in London has often been thought to have Flemish sources. Dirk Bouts' *Portrait of a Man,* of 1462, in the National Gallery, London, also has a window on the left, but is unconnected with Florence. Memling's similar *Portrait of a Young Man* in the Lehman collection, Metropolitan Museum, New York, was, however, almost certainly in Florence by the mid-1470s, as it is echoed in Ghirlandaio's early *Madonna and Child* now in the Louvre (see cats. 31A, B). As Mark Evans of the Victoria and Albert has noted, the window device emphasizes the domestic character of Botticelli's portrait.

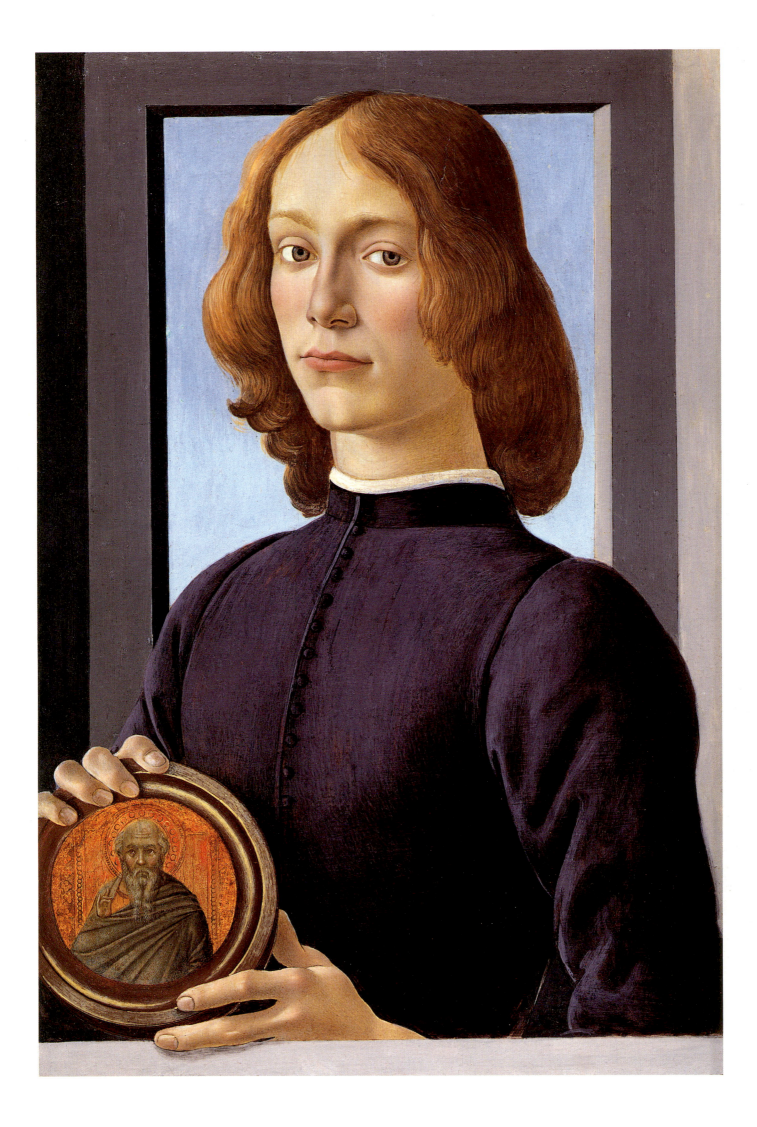

| Sandro Botticelli | c. 1485, tempera on panel
58.4 × 39.4 (23 × 15 ½) | Sheldon H. Solow and The Solow
Art and Architecture Foundation |

26 *Young Man Holding a Medallion*

SELECTED BIBLIOGRAPHY

Christiansen, Keith. "Botticelli's Portrait of a Young Man with a Trecento Medallion." *The Burlington Magazine* 129 (November 1987), 744.

Important Old Master Pictures. Christie's, London, 10 December 1982, lot no. 92, 180–181.

Italian Art and Britain [exh. cat., Royal Academy] (London, 1960), cat. 345, 127–128.

Kathke, Petra. *Porträt und Accessoire. Eine Bildnisform im 16. Jahrhundert,* 185–187 and note to pl. 131, 278. Berlin, 1997.

Scharf, Alfred. *A Catalogue of Pictures and Drawings from the Collection of Sir Thomas Merton,* cat. III, 14. London, 1950.

Stapleford, Richard. "Botticelli's Portrait of a Young Man Holding a Trecento Medallion." *The Burlington Magazine* 129 (July 1987), 428–436.

Botticelli, *Young Man Holding a Medal of Cosimo de' Medici,* Galleria degli Uffizi, Florence (photo: Scala/Art Resource, N.Y.)

In his *Woman at a Window* (cat. 25), Botticelli (1444/1445–1510) depicted the sitter looking directly at the spectator. The artist employed a similar communicative device in his *Young Man Holding a Medallion,* on loan from a private collection to the National Gallery of Art. Given the superb quality and inventiveness of the portrait, it is surprising how often scholars have questioned its attribution to the master.[1] Nevertheless, the picture was auctioned as Botticelli's work in 1982, and Richard Stapleford (1987) subsequently established his authorship beyond a reasonable doubt. Ascribing the portrait to Botticelli, Alfred Scharf (1950) tried to identify the sitter as Giovanni di Pierfrancesco de' Medici, second cousin of Lorenzo the Magnificent. Botticelli did work for this branch of the Medici family, but in the absence of a definite contemporary portrait of Giovanni, Karla Langedijk called Scharf's identification "uncertain."[2] Also considering the identification plausible but unproved, Stapleford compared Botticelli's sitter to the young king in Filippino Lippi's *Adoration of the Magi,* of 1496, in the Uffizi, who served for Vasari's much later likeness of Giovanni di Pierfrancesco in the Palazzo Vecchio, but the two figures do not, in fact, resemble each other.[3]

Portrayed half-length in three-quarter view to the left, Botticelli's handsome young sitter gazes intently at the beholder. His figure occupies a narrow space between a window open to blue sky and a parapet running along the lower edge of the picture. With both hands projecting out into the viewer's space, the youth holds what is the most striking feature of the painting today—a medallion depicting an old bearded saint in the act of blessing on a gold ground.[4] Obviously not by Botticelli, the medallion, surrounded by a painted frame, is a separate fragment of a fourteenth-century altarpiece. Scholars agree that the figure style and decorative punchmarks point to the Sienese Bartolomeo Bulgarini as its author. The fragment, shaped like a roundel measuring 10.6 centimeters in diameter, has been carefully inserted into a cavity hollowed out of the panel. Stapleford (1987) maintained that the medallion originally belonged to the composition, inset by Botticelli to contrast the vital young man with the hoary image

of the saint. Rejecting Stapleford's claim, Keith Christiansen (1987) argued that the trecento medallion is a modern addition. Though the technical evidence is unclear, as the edges of the roundel and the frame painted around it are damaged and restored, Christiansen preferred Longhi's forty-year-old hypothesis that the roundel replaces a damaged stucco relief.[5] Longhi had implicitly compared the portrait to Botticelli's *Young Man Holding a Medal of Cosimo de' Medici* (fig. 1) in the Uffizi, and, in fact, this portrait, dating to the mid-1470s, provides the key to understanding the function and meaning of the later one.

In depicting the sitter in three-quarter view to the left before an open landscape, the Uffizi portrait is extraordinarily innovative: it appears to predate comparable examples by Memling and other Netherlandish masters.[6] Botticelli's sitter has not been identified, but he must be a Medici partisan, to judge from the gilt gesso cast of a medal of Cosimo Pater Patriae, which he holds up for the viewer's inspection.[7] The medal featuring Cosimo's profile is not painted but an actual medallion attached to the panel by the artist, who was trained as a goldsmith. The portrait exhibited here may once have had a similar construction, as Longhi first suggested, but instead of a medal, it can be argued, the addition might have been a circular mirror. The incorporation of a mirror in Botticelli's portrait would be unusual, but small glass or metal mirrors were highly prized household objects and were commonly used by artists in making self-portraits. Whether held in the hand or framed on the wall, they were easily scratched or shattered. Furthermore, with their elaborately carved or gessoed frames, mirrors could themselves become works of art.[8] And they were combined with portraiture. A mirror frame from the workshop of Neroccio de' Landi in the Victoria and Albert Museum, London, for example, includes a female bust above the now missing *sfera* or convex glass.[9] In a beautiful polychromed and gilt marble relief (fig. 2) by Mino da Fiesole in the Bibliothèque Nationale, Paris, a similar female bust takes precedence over the mirror, which again is missing.[10] The latter work may be understood as the idealized portrait of a woman accompanied by a mirror presumably meant to reflect the image of her lover. If Bot-

2
Mino da Fiesole, *Portrait of a Lady,*
Bibliothèque Nationale, Paris

3
Giovanni Cariani, *Man Holding a Female
Portrait,* private collection (photo:
Sotheby's, London, sold April 9, 1986,
lot 84)

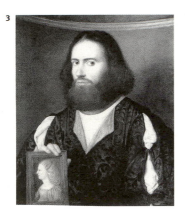

ticelli adopted a similar construction—and this is only conjecture—the shallow cavity surrounded by a frame in Mino's relief provides some idea of what the panel looked like before the circular mirror was set into it.

The examples just cited for comparison represent women, but there is another portrait of a male sitter that helps to visualize Botticelli's original conception —Giovanni Cariani's *Man Holding a Female Portrait* (fig. 3).[11] Recently on the art market, Cariani's portrait depicts the subject looking out at the viewer and holding in his right hand a painted likeness of his (deceased?) wife, which rests on the frame. A mirror does not figure in Cariani's picture, however, and his sitter is older, too. Botticelli's subject is not yet middle-aged, when Renaissance men typically married. Instead, he appears as a youthful lover whose image may have been combined with the mirrored reflection of his beloved. The artist's conceit, in which the intended viewer, looking at her lover's portrait, sees not only his image but also her own reflected in the mirror he holds, resembles the idea behind contemporary mirror-medals, with a male portrait on the obverse and a polished reverse for use as a mirror to reflect the beloved's countenance.[12] Botticelli's portrait, as he may originally have conceived it with its connotations of love and female beauty, thus belongs to the aristocratic rituals of courtly love that dominated Florentine culture and spectacle in this period. DAB

NOTES

1. Everett Fahy ("Some Early Italian Pictures in the Gambier-Parry Collection," *The Burlington Magazine* 109 [March 1967], 137) followed Roberto Longhi ("Uno sguardo alle fotografie della Mostra 'Italian Art and Britain' alla Royal Academy di Londra," *Paragone* 11 [May 1960], 61) in ascribing the picture to Botticelli. Ronald Lightbown (*Sandro Botticelli,* 2 vols. [London, 1978], 2: cat. 33, 160) includes it with "workshop and school pictures," as do Nicoletta Pons (*Botticelli. Catalogo Completo* [Milan, 1989], under cat. 33) and Caterina Caneva (*Botticelli. Catalogo Completo dei dipinti* [Florence, 1990], cat. 26A, 148–149).

2. Karla Langedijk, *The Portraits of the Medici. 15th–18th Centuries,* 3 vols. (Florence, 1981–1987), 2: cat. 57.10, 1045.

3. Stapleford 1987, 435 and figs. 11 and 12.

4. About the projecting hands, see Gigetta Dalli Regoli, *Il Gesto e la Mano. Convenzione ed invenzione nel linguaggio figurativo fra Medioevo e Rinascimento* (Florence, 2000), 46.

5. Longhi 1960, 61, called the insertion of the roundel an "antistorico 'nonsense.'"

6. Lightbown 1978, 2: cat. B22, 33–35.

7. About this new type of "transitive" work implying the presence of the beholder to complete the picture, see John Shearman, *Only Connect: Art and the Spectator in the Italian Renaissance* (Princeton, 1992).

8. For convex glass mirrors in particular, see Heinrich Schwarz, "The Mirror in Art," *Art Quarterly* 15 (summer 1952), 96–118; and Roberta J. Olson, *The Florentine Tondo* (Oxford, 2000), 95–101. A Tuscan mirror of c. 1480 in the Lehman collection still has its original glass (Laurence Kanter, *Italian Renaissance Frames* [New York, 1990], cat. 53, 78–79).

9. For this work and related examples, see John Pope-Hennessy, "A Cartapesta Mirror Frame," *The Burlington Magazine* 92 (October 1950), 288–291.

10. Shelley Zuraw ("The Sculpture of Mino da Fiesole [1429–1484]," Ph.D. diss., New York University, 1993, 2: cat. 48, 813–816) dates the relief c. 1465.

11. About the portrait, which was auctioned at Sotheby's, London, on 9 April 1986, as lot no. 84, see Rodolfo Pallucchini and Francesco Rossi, *Giovanni Cariani* (Milan, 1983), cat. 60, 133.

12. Stephen K. Scher, *The Currency of Fame* [exh. cat., National Gallery of Art] (New York, 1994), cat. 36, 120–121.

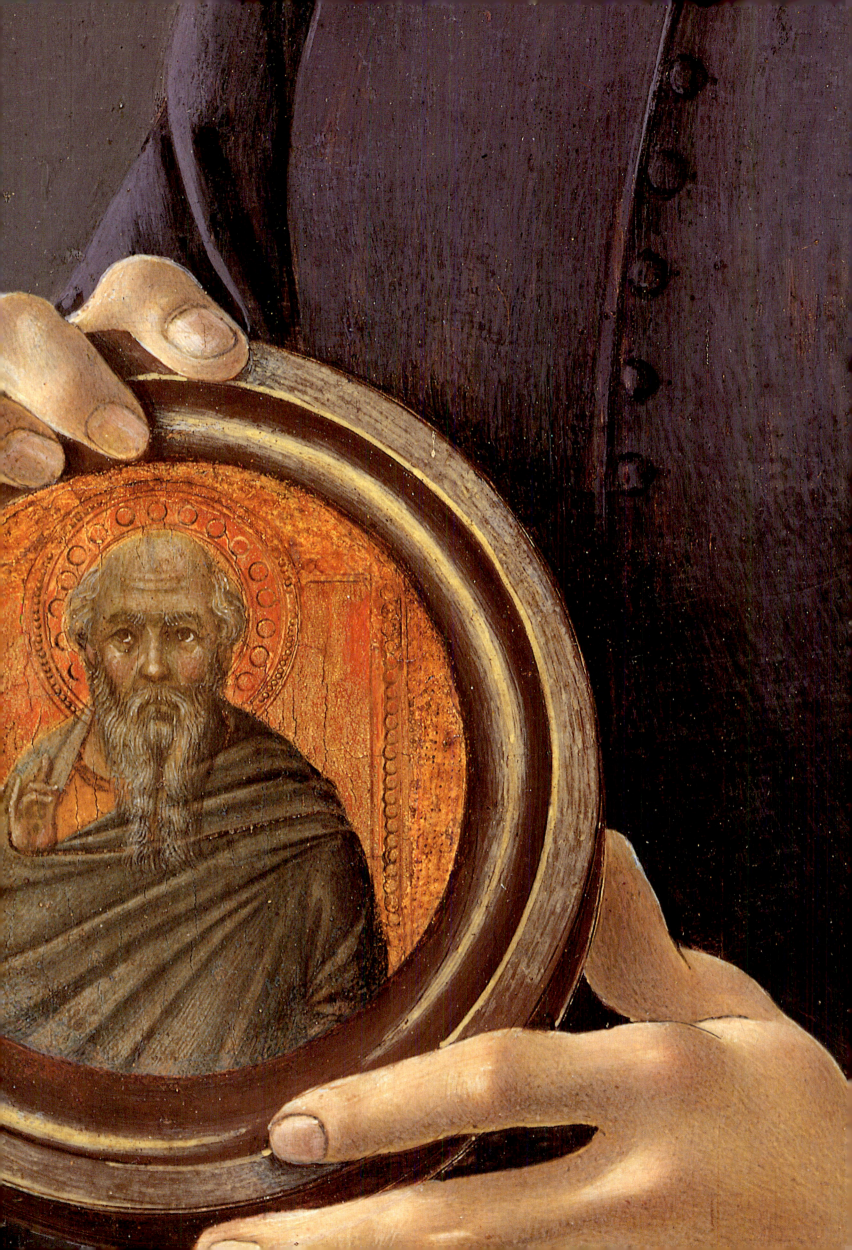

Sandro Botticelli | c. 1478/1480, tempera on panel 75.6 × 52.6 (29¾ × 20⅝) | National Gallery of Art, Washington, Samuel H. Kress Collection, 1952.5.56

27 _Giuliano de' Medici_

SELECTED BIBLIOGRAPHY

Campbell, Lorne. _Renaissance Portraits. European Portrait-Painting in the 14th, 15th, and 16th Centuries,_ note to fig. 136. New Haven, 1990.

Langedijk, Karla. _The Portraits of the Medici. 15th–18th Centuries,_ 1: 32–34; 2: cat. 8, 1068. 3 vols. Florence, 1981–1987.

Lightbown, Ronald. _Sandro Botticelli,_ 1: 40, 44; 2: cat. B20, 30–32. 2 vols. London, 1978.

Rubin, Patricia Lee. In Patricia Lee Rubin, Alison Wright, and Nicholas Penny, _Renaissance Florence. The Art of the 1470s_ [exh. cat., National Gallery] (London, 1999), cat. 1, 126–127.

Shapley, Fern Rusk. _Catalogue of the Italian Paintings,_ 1: no. 1135, 83–84. 2 vols. National Gallery of Art. Washington, 1979.

Though it adopts the same spatial arrangement, with the sitter depicted in a domestic interior, the _Giuliano de' Medici_ in the National Gallery of Art is larger and more monumental than other portraits by Botticelli (1444/1445–1510). In particular, it is the largest and most elaborate of three panel portraits of Giuliano by the artist and his workshop. The other examples, both limited to the sitter's head and shoulders and measuring 54 × 36 centimeters, are in the Gemäldegalerie, Berlin, and the Accademia Carrara, Bergamo.[1] In all three works the costume is the same, and the window in the Washington version is repeated (without the shutters) in the one in Bergamo. Scholars are divided over which of the three paintings is or are autograph. The Gallery's picture is in good condition, apart from fairly extensive retouching in the hair and bust, and the other examples are also well-enough preserved to be reliably assessed. The Berlin and Bergamo pictures appear to offer slight variations on Botticelli's own style, the first being somewhat softer, and the second, a bit more schematic. The presumption is, therefore, that the larger and iconographically more complex version in Washington is the prototype on which the other two are based.[2]

The Gallery's portrait, depicting Giuliano in near profile to the right and nearly to the waist, is probably posthumous to judge from the degree of idealization of the sitter. This and the melancholy air of the portrait contrast with the vitality of Verrocchio's terra-cotta bust of Giuliano, also in the National Gallery of Art, made around the time of the _giostra_ or tournament he organized in January 1475.[3] The charismatic younger brother of Lorenzo the Magnificent, Giuliano was just coming into his own when on Easter Sunday, 26 April 1478, conspirators led by members of the Pazzi family set upon the two Medici brothers while at Mass in Florence Cathedral. Lorenzo escaped, but Giuliano, aged only twenty-five, was assassinated. A medal was struck to commemorate the event (cat. 12), and Botticelli himself painted defamatory frescoes of the conspirators, who were captured and hanged.[4]

Botticelli's posthumous portrait of the murdered Giuliano is not only tinged with sadness; it features two motifs that seem to refer specifically to the sitter's death. The turtledove perched on a dead branch in the lower left corner traditionally signifies mourning, just as the partly opened window is a classical funerary symbol adapted from Roman sarcophagi. That Botticelli's portrait commemorates Giuliano as a martyr seems more likely than another theory, according to which he is shown as living and lamenting the death of his beloved Simonetta Cattaneo Vespucci, who died in April 1476.[5] The sitter's lowered eyelids suggest, to the contrary, that the portrait was made from a death mask or drawing of the deceased, and there is, in addition, no indication of Simonetta's presence in the painting. She does figure, however, in a number of idealized images by Botticelli and his shop, one of which is included in the exhibition (cat. 28). DAB

NOTES

1. For the Berlin and Bergamo portraits, see Lightbown 1978, 2: cats. B18–B19, 30, respectively. A third version, now in an American private collection, appears to be a forgery (Luisa Vertova, "Botticelli tra falsificazioni e reinvenzioni," _Antichità Viva_ 30 [1991], 24–29).

2. Though Langedijk (1981) found the Gallery's picture the weakest of the surviving examples, Lightbown (1978) is surely closer to the mark in declaring it the original from which the others derive. His assessment of the picture's condition is unduly pessimistic, however, and contrary to his statement, it does not seem to be a life portrait of the lively young Giuliano.

3. Andrew Butterfield, _The Sculptures of Andrea del Verrocchio_ (New Haven, 1997), cat. 29, 239–240; and Alison Wright in Patricia Lee Rubin, Alison Wright, and Nicholas Penny, _Renaissance Florence: The Art of the 1470s_ [exh. cat., National Gallery] (London, 1999), cat. 17, 160–161.

4. The series was destroyed when the Medici were expelled from Florence in 1494 (Samuel Y. Edgerton, _Pictures and Punishment_ [Ithaca, 1985], 104–109).

5. See note 2 above. In this case the turtledove would symbolize fidelity to a lost mate (Herbert Friedmann, "Two Paintings by Botticelli in the Kress Collection," in _Studies in the History of Art Dedicated to W.E. Suida_ [London, 1959], 116–119).

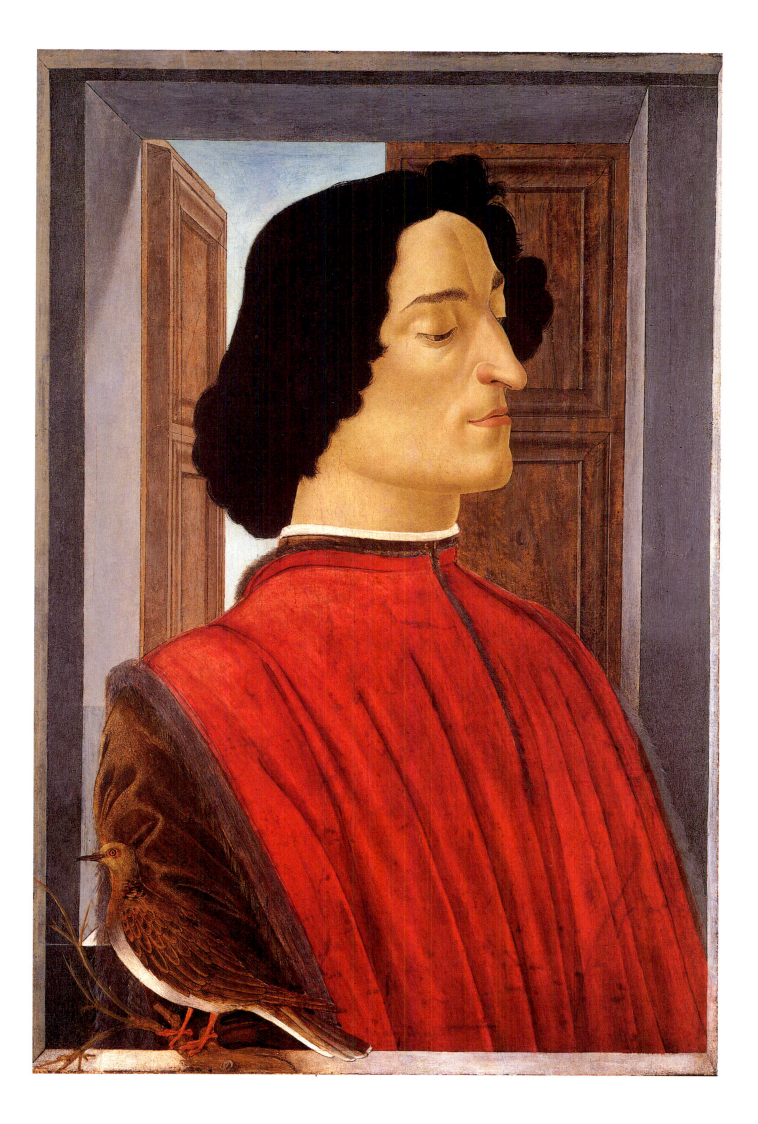

Sandro Botticelli | c. 1480 / 1485, tempera on panel 81.5 × 54.2 (32 1/16 × 21 5/16) | Städelsches Kunstinstitut, Frankfurt am Main

28 *Young Woman (Simonetta Vespucci?) in Mythological Guise*

SELECTED BIBLIOGRAPHY

Buske, Stefan. *Sandro Botticelli. Weibliches Brustbildnis (Idealbildnis Simonetta Vespucci?).* Frankfurt am Main, n.d. [1988].

Cieri Via, Claudia. "L'immagine dietro al ritratto." In *Il Ritratto e la Memoria. Materiali 3,* 13–14. Ed. Augusto Gentili, Philippe Morel, and Claudia Cieri Via. Rome, 1993.

Lightbown, Ronald. *Sandro Botticelli,* 2: cat. C3, 116–117. London, 1978.

Sander, Jochen and Bodo Brinkmann. *Italian, French, and Spanish Painting before 1800 at the Städel,* 22. Frankfurt am Main, 1997.

Schmitter, Monika A. "Botticelli's Images of Simonetta Vespucci: Between Portrait and Ideal." *Rutgers Art Review* 15 (1995), 33–57.

Simons, Patricia. "Portraiture, Portrayal, and Idealization: Ambiguous Individualism in Representations of Renaissance Women." In *Language and Images of Renaissance Italy,* 309. Ed. Alison Brown. Oxford, 1995.

Tinagli, Paola. *Women in Italian Renaissance Art. Gender, Representation, Identity,* 73–75. Manchester, 1997.

This painting belongs to a group of depictions of the same female type attributed to Botticelli (1444/1445–1510) or his workshop. Recent cleaning of the picture reveals that, although the edges are damaged, the figure is well preserved apart from some discrete losses and a vertical crack through the face. The treatment suggests, moreover, that doubts about Botticelli's authorship (Lightbown 1978) may be unfounded, as the painting appears to be comparable in style and quality to the artist's *Mars and Venus* in the National Gallery, London, and it may be dated to the same time, the early 1480s. As with the posthumous portrait of Giuliano de' Medici (cat. 27), the Frankfurt picture is the largest and iconographically most complex of the group. The fact that it is much larger than contemporary portrayals and that the woman unconventionally faces right suggests that the painting is not an ordinary portrait. Above all, it is not concerned with likeness. The features and elaborately coiled and flowing hair have no basis in physical reality, but correspond, rather, to Botticelli's ideal type of female beauty. The same type recurs in *Mars and Venus,* as well as in other mythologies by the artist, such as the *Birth of Venus* and the *Pallas and the Centaur,* both in the Uffizi. Though it is associated with him, Botticelli was not the inventor of this type, which goes back to Verrocchio, who adopted it for a standard he (and his pupil Leonardo) created for the *giostra* or tournament held by Giuliano de' Medici in January 1475.[1] The type also echoes well-established literary conventions for describing female beauty. Even more than the straightforward portraits of women, however idealized, Botticelli's lady displays the attributes of Petrarch's beloved Laura: long golden tresses, partly loose and partly braided; high forehead; arched eyebrows; and pearly skin.[2]

More than a century ago Aby Warburg argued that Botticelli's poetic conception was an idealized portrait of Giuliano de' Medici's ladylove Simonetta Vespucci.[3] Of Genoese origin, Simonetta Cattaneo married Marco Vespucci in 1468. As Giuliano's beloved, "la bella Simonetta" was celebrated both in the tournament he won in 1475 and, after her death

at the age of twenty-three in 1476, in the verses of Lorenzo de' Medici and the poets in his circle.[4] A veritable cult of Simonetta grew up after her death culminating in Poliziano's famous *Stanze per la Giostra,* in which she is the central figure.[5] With no authentic portrait of Simonetta for comparison, Warburg based his argument in part on Vasari's mention in his *Vita* of Botticelli of the profile of a woman in the Medici *guardaroba,* which was said to represent Giuliano's "innamorata."[6] This "beloved" is unnamed, but she is unlikely to have been an ordinary mistress, who would not have been idealized as a golden-haired nymph of the sort described in Poliziano's poem.

Warburg also cited a key element in the painting to support his identification of the subject as Simonetta. The woman's head is in profile, but her bust is turned in three-quarter view to feature a cameo medallion worn around her neck (fig. 1). The medallion is a copy in reverse of a famous antique carnelian, representing Apollo and Marsyas, which belonged to Lorenzo de' Medici. Listed in the inventory of his possessions in 1492, the gemstone is now in the Museo Archeologico Nazionale, Naples.[7] Numerous bronze plaquettes were also made of the gem, and, like the cameo in the painting, they are reversed (fig. 2).[8] It is not necesary to suppose, therefore, that the picture was commissioned by Lorenzo or that it represents his beloved Lucrezia Donati, as the actual gem is not depicted.[9] Rather, the cameo serves to associate the subject of the picture with the Medici. If the woman's pendant refers to the Medici, her elaborate coiffure may offer another clue to her identity. Knotted at the back, in plaits and with loose curls, her golden hair is braided with pearls. The pearl net woven through her hair was called a "vespaio" because of its similarity to a wasp's nest.[10] The "vespe" or wasps represented in Botticelli's *Mars and Venus* have been taken to refer to the patron, since Botticelli is known to have worked for the Vespucci family.[11] It is equally possible that the "vespaio" worn by the woman in the Frankfurt picture is a punning allusion to Marco Vespucci's wife.[12]

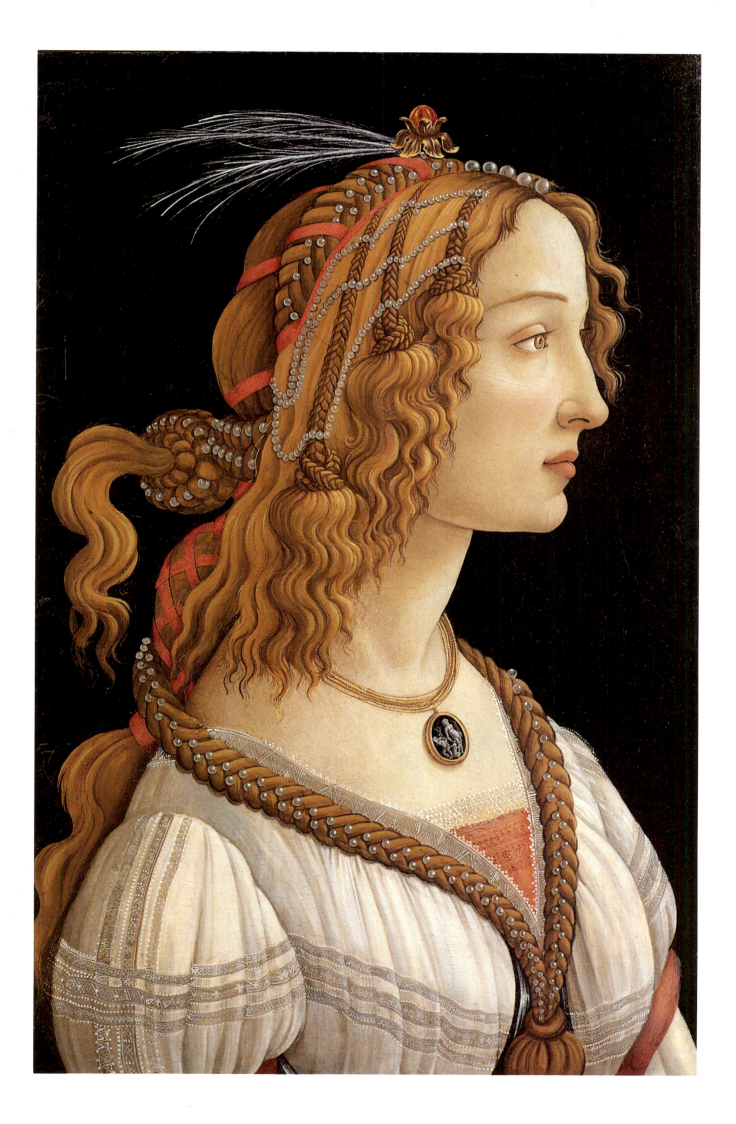

1
Detail showing cameo medallion

2
Florentine, *Apollo, Marsyas and Olympus*, National Gallery of Art, Washington, Widener Collection

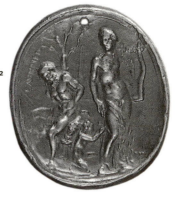

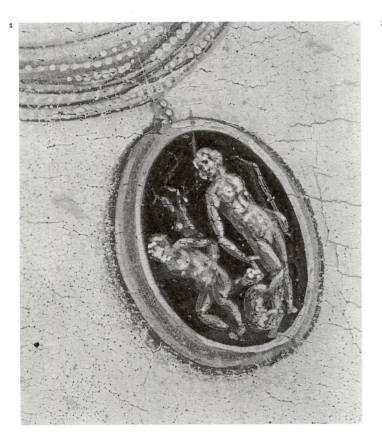

External evidence likewise indicates that the Frankfurt picture might in some sense be a portrait of Simonetta. Both the large scale of the image, suggesting that it may have been part of some decoration, and the way in which the woman is idealized are comparable to Botticelli's portrayal of Simonetta in the guise of Pallas Athena on the standard that Giuliano carried in the *giostra* of 1475. The tournament standard, recorded in the 1492 inventory of Lorenzo's possessions, is lost, but literary descriptions and a tapestry deriving from it allow us to envisage its appearance. Simonetta-Pallas was shown in a white dress with the warlike attributes of the goddess—a lance and the shield with Medusa's head; in the tapestry she holds a helmet and an olive branch.[13] The woman in the painting is not so identified, but her facial type and flowing hair are the same, and it is worth noting, too, that a shiny metal corselet can just be observed circling her breasts.

Aside from its similarity to Botticelli's lost portrayal of Simonetta Vespucci as Pallas, the Frankfurt picture is closely related to several other representations of the same female type. Closest to the painting is the example now belonging to the Marubeni Corporation in Tokyo, in which the subject is represented before an open window, as in Botticelli's posthumous portrait of Giuliano de' Medici.[14] Also facing right, the female image in another of these depictions, in the National Gallery, London, is completed by a painted emblematic reverse whose significance has not been explained.[15] The fourth example in the Gemäldegalerie, Berlin, of higher quality than the one in London, differs from the other versions in that the subject faces left.[16] None of these works is a portrait in the ordinary sense. Headed by the Frankfurt picture, the group represents the same ideally beautiful young woman mythologized as a nymph or goddess. The mode of creation in these pictures differs radically from the process of idealization at work in contemporary portraits, in which the sitter's appearance was approximated to a norm of beauty, all the while maintaining the necessary element of likeness. These "portraits," by contrast, are purely imaginary. They describe a poetic ideal, not an individual, in the manner of Lorenzo de' Medici, who wrote, upon seeing Simonetta's corpse, that her beauty "appeared perhaps greater even than ever it had in life."[17] DAB

NOTES

1. For Verrocchio's large-scale study of a nymph's head in the British Museum, see Patricia Lee Rubin in Patricia Lee Rubin, Alison Wright, and Nicholas Penny, *Renaissance Florence. The Art of the 1470s* [exh. cat., National Gallery] (London, 1999), cat. 29, 184–187.

2. Compare the sonnet beginning "Breeze that surrounds those blond and curling locks, that makes them move and which is moved by them in softness, and that scatters the sweet gold, then gathers it in lovely knots recurling, you linger in the eyes whence wasps [*vespe,* in Italian] of love sting me …." (Petrarch, *The Canzoniere,* trans. Mark Musa [Bloomington, 1996], poem no. 227, 326–327).

3. Aby Warburg, "Sandro Botticelli's *Birth of Venus* and *Spring.* An Examination of Concepts of Antiquity in the Early Renaissance," in his *The Renewal of Pagan Antiquity,* trans. David Britt (orig. ed., Hamburg, 1893; Los Angeles, 1999), 88–156. Warburg also identified the figure of Flora in Botticelli's *Primavera* as an idealized representation of Simonetta.

4. On Simonetta's historical and poetic identity, see Charles Dempsey, *The Portrayal of Love: Botticelli's Primavera and Humanist Culture at the Time of Lorenzo the Magnificent* (Princeton, 1992), 114–139; and by the same author, "Portraits and Masks in the Art of Lorenzo de' Medici, Botticelli, and Politian's *Stanze per la Giostra,*" *Renaissance Quarterly* 52 (spring 1999), 18–21, 24–39; and Schmitter 1995, 40–50.

5. A modern translation of the poem, first published in 1494, is David Quint, *The Stanze of Angelo Poliziano* (Amherst, Mass., 1979).

6. Giorgio Vasari, *Le Vite de' più eccellenti pittori scultori ed architettori,* 9 vols. (Florence, 1878–1886), 3: 322: "Nella guardaroba del signor Duca Cosimo sono di sua mano due teste di femmina in profilo, bellissime: una delle quali si dice che fu l'innamorata di Giuliano de' Medici, fratello di Lorenzo…."

7. Phyllis Pray Bober and Ruth Rubinstein, *Renaissance Artists and Antique Sculpture. A Handbook of Sources* (London, 1986), cat. 31, 74–75.

8. One example, from the more than seventy plaquette casts that survive, in the Widener Collection in the National Gallery of Art (no. 1942.9.201), bears the inscription "LAU. R. MED" referring to Lorenzo de' Medici, who probably acquired the celebrated gem on a visit to Rome in 1471.

9. Dempsey 1992, 132–133.

10. Jacqueline Herald, *Renaissance Dress in Italy 1400–1500* (London, 1981), 230.

11. Frank Zöllner, *Botticelli. Images of Love and Spring* (Munich, 1998), 26–27.

12. As suggested by Jennifer Craven in "A New Historical View of the Independent Female Portrait in Fifteenth-Century Florentine Painting," Ph.D. diss., University of Pittsburgh, 1997, cat. 20, 271–272.

13. Lightbown 1978, 2: 166–167, and Dempsey 1992, 136.

14. Lightbown 1978, 2: cat. C5, 117–118.

15. Lightbown 1978, 2: cat. C6 and C7, 118–119.

16. Lightbown 1978, 2: cat. C4, 117. There are, in addition, a more divergent version of the painted type now in the Kisters Collection, Kreuzlingen; a drawing of the same right-facing profile, attributed to Botticelli, in the Ashmolean Museum, Oxford; and Piero di Cosimo's much-discussed *Allegorical Portrait,* inscribed with Simonetta Vespucci's name, in the Musée Condé, Chantilly, which, though it sheds light on the Frankfurt picture, is too problematical to discuss here.

17. Quoted in Dempsey 1992, 125.

Domenico Ghirlandaio | c. 1480 / 1490, tempera on panel | Sterling and Francine Clark
56 × 37.6 (22 1/16 × 14 13/16) | Art Institute, Williamstown,
Massachusetts

29 *Portrait of a Lady*

SELECTED BIBLIOGRAPHY

Brooks, John H. *Highlights,* cat. 3,
14–15. Sterling and Francine Clark Art
Institute. Williamstown, Mass., 1985.

Brooks, John H. In *Selections from the
Sterling and Francine Clark Art Institute,*
22. New York, 1996.

Francovich, Géza de. "David Ghirlan-
daio. 11." *Dedalo* 11 (August 1930), 134.

Fredericksen, Burton B. and Federico
Zeri. *Census of Pre-Nineteenth-Century
Italian Paintings in North American
Public Collections,* 83. Cambridge, Mass.,
1972.

Italian Paintings and Drawings, cat.
412. Sterling and Francine Clark Art
Institute. Williamstown, Mass., 1961.

Smith, Webster. "Observations on the
Mona Lisa Landscape." *The Art Bul-
letin* 67 (June 1985), 194–195.

Van Marle, Raimond. *The Development
of the Italian Schools of Painting,* 13: 156,
159. The Hague, 1931.

This picture, in which the green underpaint now shows through the fleshtones, belongs to a group of similar portraits attributed to Domenico Ghirlandaio (1449–1494).[1] They date from the last quarter of the fifteenth century, when the profile pose hitherto used to portray Florentine women was being superseded by the three-quarter view. The newer type, adopted for portraits of both sexes, was of Netherlandish origin, as seen in Rogier van der Weyden's *Lady* (cat. 13) exhibited here. It was introduced into Florence by Leonardo and Botticelli, whose *Ginevra de' Benci* (cat. 16) and so-called *Smeralda Brandini* (cat. 25), respectively, echo the Flemish type. Like Leonardo and Botticelli, Ghirlandaio and his shop were firmly committed to the three-quarter view. It is true that Ghirlandaio's great *Giovanna Tornabuoni* (cat. 30) in the Thyssen Collection, Madrid, renders the sitter in profile, but special circumstances (the portrait is posthumous) explain the artist's choice. Though Ghirlandaio's other masterpiece of the genre, the *Old Man and His Grandson* in the Louvre, adopts the three-quarter view for the principal sitter, there is no fully accepted independent portrait by the artist showing a female sitter in the Flemish manner.

Acquired by Stephen Clark as a work of Domenico Ghirlandaio in 1913 (for the provenance, see Introduction), this picture, like the others in the group, is not equal in quality to the *Giovanna Tornabuoni.* Nor is it entirely consistent with the other female portraits, which differ slightly from each other in style and treatment. The sitter in the *Portrait of a Girl* in the National Gallery, London, is shown bust-length in three-quarter view to the right against a dark background.[2] The execution of another work of the same size and format, the *Portrait of a Young Woman* in the Gulbenkian Museum, Lisbon, is more refined, though the sitter, facing left, wears a bright red dress, as in the previous example.[3] Closest to the Clark picture in its larger size and half-length format is the *Young Lady of the Sassetti Family* in the Metropolitan Museum, New York.[4] Both paintings are also executed somewhat more broadly, in the manner of Ghirlandaio's frescoes, and in both the sitter turns toward the left but looks sideways at the viewer. Like another of these Ghirlandaiesque portraits,

the *Lady* by Sebastiano Mainardi in the Lindenau Museum, Altenburg, the Clark picture has a landscape background, and it may be this aspect of the painting that provides a clue to its authorship.[5] Domenico ran a family shop that employed his younger brothers Benedetto and Davide, his brother-in-law Sebastiano Mainardi, and his son Ridolfo, as well as a number of anonymous assistants. The Clark portrait has, in fact, been attributed to Davide Ghirlandaio by Géza de Francovich (1930), Raimond Van Marle (1931), and Everett Fahy (written communication, 2000). The motif of the walled cityscape on the left in the portrait reappears in the same position in a *Madonna and Child* (fig. 1), which Fahy also gives to Davide, in the Musée Condé at Chantilly.[6] Though this landscape motif recurs in other works produced in the shop, the Clark and Chantilly pictures might well be by the same hand.[7]

The Clark portrait, in which the unidentified sitter is shown half-length and in three-quarter view before a landscape background, belongs to a late quattrocento type established, as far as female portraiture is concerned, by Leonardo's *Ginevra de' Benci* (cat. 16). In its reconstructed format, Leonardo's sitter was portrayed holding a flower, and this motif is common in other depictions as well. In the case of the Clark portrait, the sitter, resting her right hand on a ledge covered by a typical Florentine textile, holds an orange blossom, symbolizing the chief virtue a woman brought to marriage, her chastity.[8] The sitter identified as Costanza de' Medici in another portrait associated with the Ghirlandaio workshop also holds a posy in her right hand resting on a parapet (Woods-Marsden essay, fig. 8).[9] In two further examples the female sitter picks a flower from a bowl on the ledge separating her from the spectator—the former in the Pinacoteca, Forlì, by Lorenzo di Credi, and the latter, formerly in the Payson collection, New York, ascribed to Mainardi and Davide Ghirlandaio, among others.[10] Having abandoned the traditional profile in favor of the three-quarter view, which lacked any connotation of virtue, the authors of these portraits had to find another way to express the moral character of their subjects. The solution was a type of betrothal or marriage portrait, in which a young woman offers a flower to her husband, who is the implied viewer of the painting. DAB

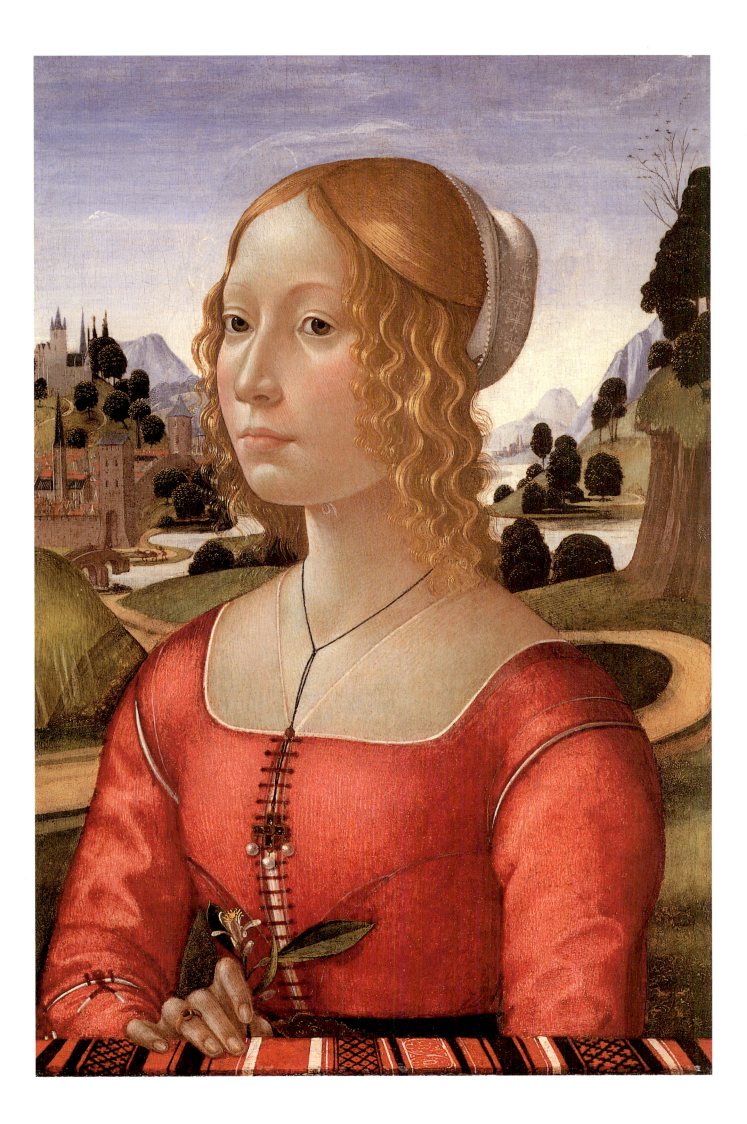

1

Attributed to Davide Ghirlandaio,
Madonna and Child, Musée Condé,
Chantilly (photo: Alinari/Art
Resource, N.Y.)

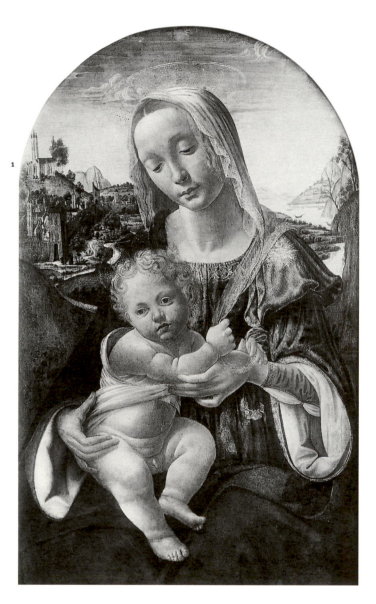

1

4. Federico Zeri and Elizabeth Gardner, *Italian Paintings: A Catalogue of the Collection of the Metropolitan Museum of Art. Florentine School* (New York, 1971), 137 (no. 32.100.71).

5. Jutta Penndorf in *Frühe Italienische Malerei im Lindenau-Museum Altenburg,* ed. Jutta Penndorf (Leipzig, 1998), 52.

6. Elisabeth de Boissard in *Chantilly, musée Condé. Peintures de l'École italienne* (Paris, 1988), cat. 36, 86. The detailed Gothic architecture in the background of the *Madonna* presumably preceded the simplified version of the motif in the Clark portrait. Susanne Kress ("Memlings Triptychon des Benedetto Portinari und Leonardos Mona Lisa. Zur Entwicklung des weiblichen Dreiviertelporträts im Florentiner Quattrocento," in *Porträt–Landschaft–Interieur. Jan van Eycks Rolin-Madonna in ästhetischer Kontext* [Tübingen, 1999], 222), claims that the landscape in the portrait derives from that in Memling's triptych for Benedetto Portinari, but this work (Dirk De Vos, *Hans Memling. The Complete Works,* trans. Ted Alkins [Ghent, 1994], cat. 79, 284–286) is dated 1487, and it lacks the key motif of the city. Furthermore, the type and individual forms of the Clark landscape, with a river meandering through a valley toward a mountainous horizon, are typically Florentine.

7. Carl Strehlke, in a letter of 26 May 1981, on file at the Clark Art Institute, cites another instance of the motif in a Ghirlandaiesque *Adoration of the Child* (no. 32.841) in the Brooklyn Museum.

8. For the orange blossom as a symbol of matrimony, see Mirella Levi d'Ancona, *The Garden of the Renaissance. Botanical Symbolism in Italian Painting* (Florence, 1977), 272–276.

9. Formerly called Ghirlandaio (Martin Davies, *National Gallery Catalogues. The Earlier Italian Schools,* 2d rev. ed. [London, 1961], no. 2490, 223–224) or Lorenzo di Credi (Gigetta Dalli Regoli, *Lorenzo di Credi* [Pisa, 1966], cat. 43, 122–123), the painting has been correctly attributed to the young Fra Bartolomeo by Everett Fahy ("The Earliest Works of Fra Bartolommeo," *The Art Bulletin* 51 [March 1969], 150).

10. For the Forli portrait, see Gigetta Dalli Regoli, *Lorenzo di Credi* (Pisa, 1966), cat. 59, 130–131; and for the ex-Payson one, Tancred Borenius, "A Portrait by Bastiano Mainardi," *Apollo* 5 (January 1927), 16–18; and Francovich 1930, 144.

NOTES

1. The *Portrait of Lucrezia Tornabuoni,* in the Kress collection at the National Gallery of Art, also abraded but important because of the sitter, is considered in Dale Kent's essay "Women in Renaissance Florence" in the present catalogue.

2. Martin Davies, *National Gallery Catalogues. The Earlier Italian Schools,* 2d rev. ed. (London, 1961), no. 1230, 220.

3. Luísa Sampaio in *"Only the Best": Masterpieces of the Calouste Gulbenkian Museum, Lisbon,* ed. Katharine Baetjer and James David Draper [exh. cat., Metropolitan Museum of Art] (New York, 1999), cat. 19, 46.

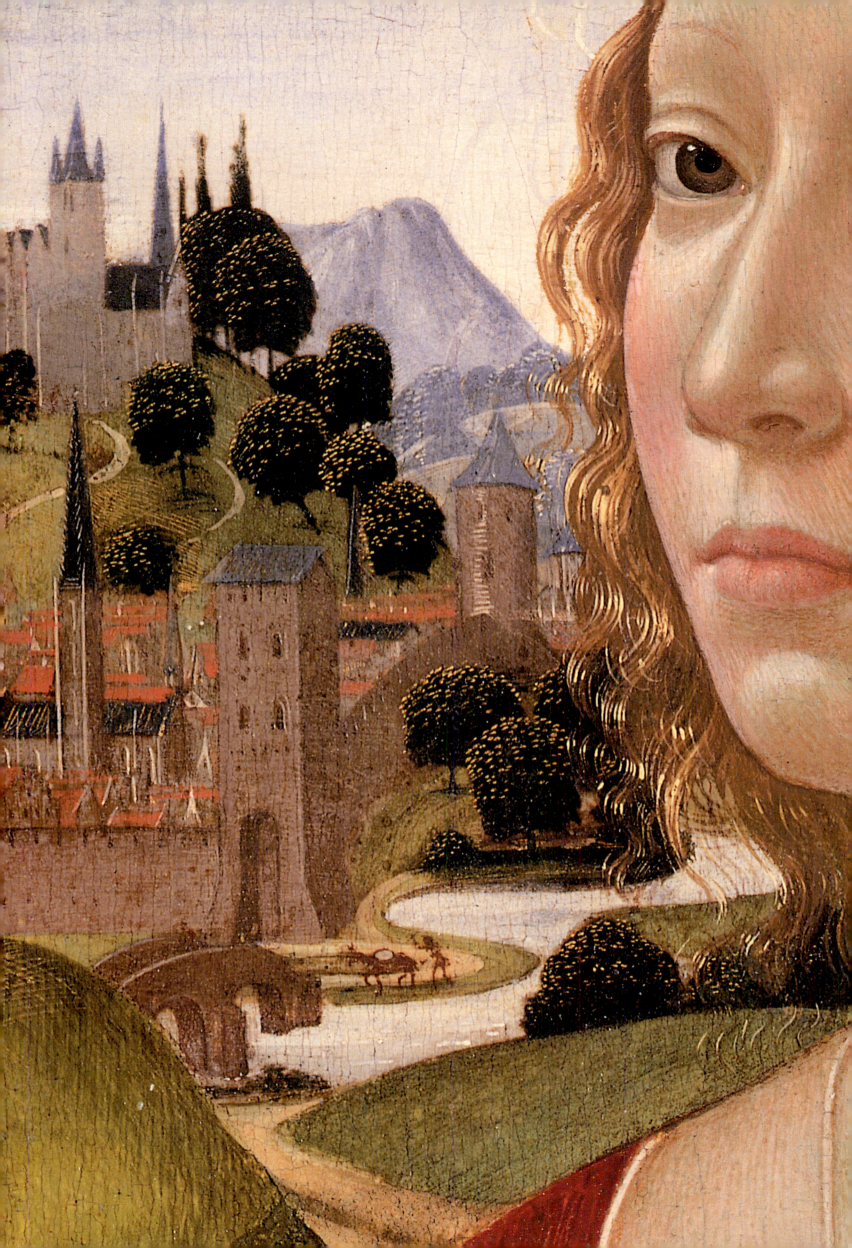

| **Domenico Ghirlandaio** | c. 1488 / 1490, tempera on panel | Museo Thyssen-Bornemisza, |
| | 77 × 49 (30 5/16 × 19 5/16) | Madrid |

30 *Giovanna degli Albizzi Tornabuoni*

SELECTED BIBLIOGRAPHY

Kathke, Petra. *Porträt und Accessoire. Eine Bildnisform im 16. Jahrhundert,* 69–70, 294. Berlin, 1997.

Kecks, Ronald. *Domenico Ghirlandaio und die Malerei der Florentiner Renaissance,* cat. 22, 347–348. Munich, 2000.

Pita Andrade, José Manuel and Maria del Mar Barobia Guerrero. *Old Masters. Thyssen-Bornemisza Museum,* 98–99, 678. Barcelona, 1992.

Pope-Hennessy, John. *The Portrait in the Renaissance,* 24–28. Princeton, 1966.

Quermann, Andreas. *Domenico di Tommaso di Currado Bigordi. Ghirlandaio 1449–1494,* 132–133. Cologne, 1998.

Rosenberg, Charles M. "Virtue, Piety, and Affection: Some Portraits by Domenico Ghirlandaio," in *Il Ritratto e la Memoria. Materiali 2,* 173–195. Ed. Augusto Gentili, Philippe Morel, Claudia Cieri Via. Rome, 1993.

Shearman, John. *Only Connect: Art and the Spectator in the Italian Renaissance,* 108–113. Princeton, 1992.

Simons, Patricia. "Women in Frames. The Gaze, the Eye, the Profile in Renaissance Portraiture." In *The Expanding Discourse. Feminism and Art History,* 44–45. Ed. Norma Broude and Mary D. Garrard. New York, 1992.

Tinagli, Paola. *Women in Italian Renaissance Art. Gender, Representation, Identity,* 77–79. Manchester, 1997.

Once the prize of J. P. Morgan's prestigious collection in New York (see Introduction), this painting by Ghirlandaio (1449–1494) is perhaps the most admired and discussed of all the Florentine profiles of women. During the last decade or so two issues have been of special concern to scholars writing about the picture: one involves its relation to a nearly identical frescoed image of the same subject by the same artist; and the other, the meaning of the inscription behind the sitter and how it pertains to portraiture of the period. The sitter has long been identified as Giovanna degli Albizzi by comparison with two medals inscribed with her name. The medals, portraying what is obviously the same woman in profile facing right, have different reverses; the one exhibited here (cat. 11) shows the Three Graces and the inscription CASTITAS PULCHRITUDO AMOR (Chastity, Beauty, Love).

Little is known about Giovanna, who was born into an old and distinguished Florentine family in 1468 and who married Lorenzo Tornabuoni in 1486. Her marriage, probably the occasion for the medals, was short: having produced a son, Giovanna died in her second childbirth on 7 October 1488, not yet twenty years old. In Ghirlandaio's panel she is represented half-length in profile to the left, as if seen through a window onto a small room with a niche in the back wall. Like the supposed Angiola Scolari in Filippo Lippi's portrait in the Metropolitan Museum (cat. 3), Giovanna faces a doorway, which provides the light source for the picture. Her stiffly erect posture, with arms bent at right angles and hands demurely folded, is also in the tradition established by Lippi. Half a century separates the two portraits, however, and in the meantime fashion had changed. Giovanna's hair is knotted at the back and long curls fall at the sides of her face. She wears an orange *giornea,* decorated with emblems marking her as a Tornabuoni, over a red *gamurra* with the sleeves slit to reveal the white *camicia,* or chemise, underneath. A latticelike pattern of flowering plants is woven into the brocade of the sleeves, while hanging from a delicate cord around her neck is a gold pendant set with a ruby and three large pearls.[1]

Though dressed in the finery associated with marriage, Giovanna's is not a marriage or betrothal portrait, as it is dated to the year of her death, 1488, on the *cartellino* attached to the wall behind the sitter. A nearly identical portrait of her appears, full length, in Ghirlandaio's fresco of the *Visitation,* part of the cycle commissioned by her father-in-law Giovanni Tornabuoni in 1485 to decorate the family chapel in the church of Santa Maria Novella in Florence. This stately figure (fig. 1), misidentified by Vasari as Ginevra Benci, may also be a posthumous likeness of Giovanna, as the frescoes were completed over a four-year period, from 1486 to 1490.[2] The striking resemblance between the two portraits has naturally raised the question of which came first, the panel or the fresco? Most likely the frescoed image was the source for the panel. As Ghirlandaio and his shop were otherwise committed to the more advanced three-quarter view for independent portraiture (cat. 29), only a special circumstance, such as the sitter's death, could account for the use of the profile here. He evidently took her image in the fresco as a model for the panel portrait, which is considerably larger than other female profiles of the time. Both portraits, in any case, were probably made using a cartoon, or full-scale preparatory drawing, that was based, in turn, on a life study in the manner of the cartoon (cat. 33) for another female portrait in Ghirlandaio's decoration. The *Visitation,* to judge from its low position on the wall, was completed toward or in 1490, so the date inscribed on the panel, while referring to the sitter's death, does not necessarily record the year the picture was painted.

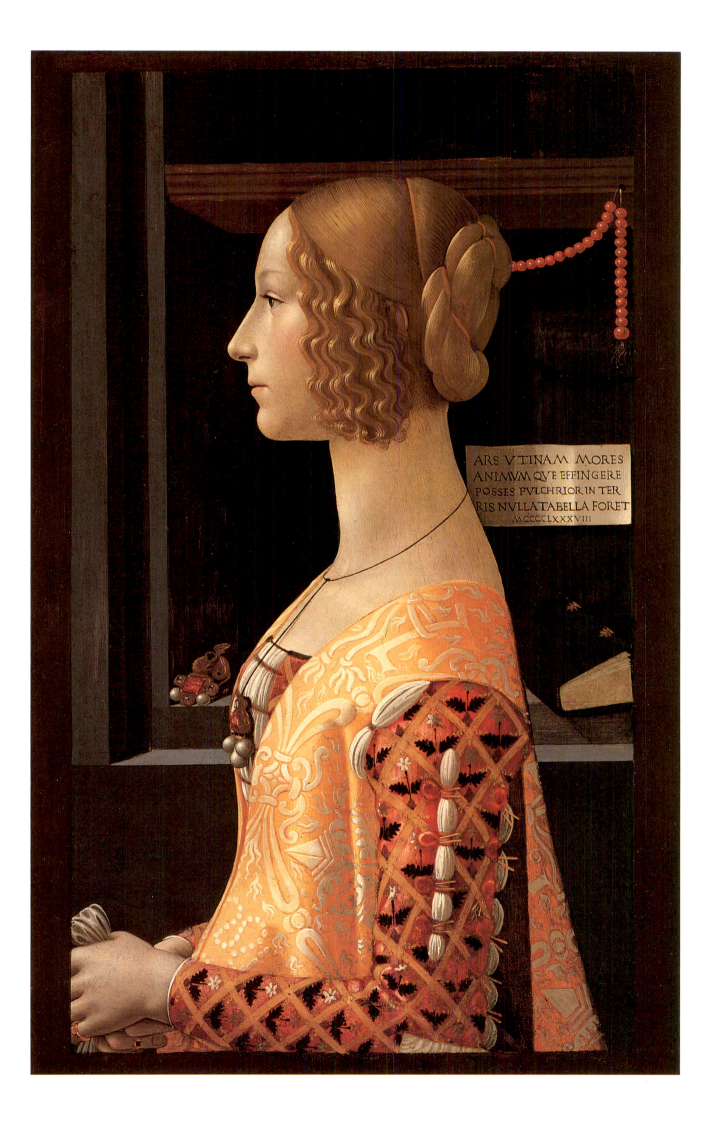

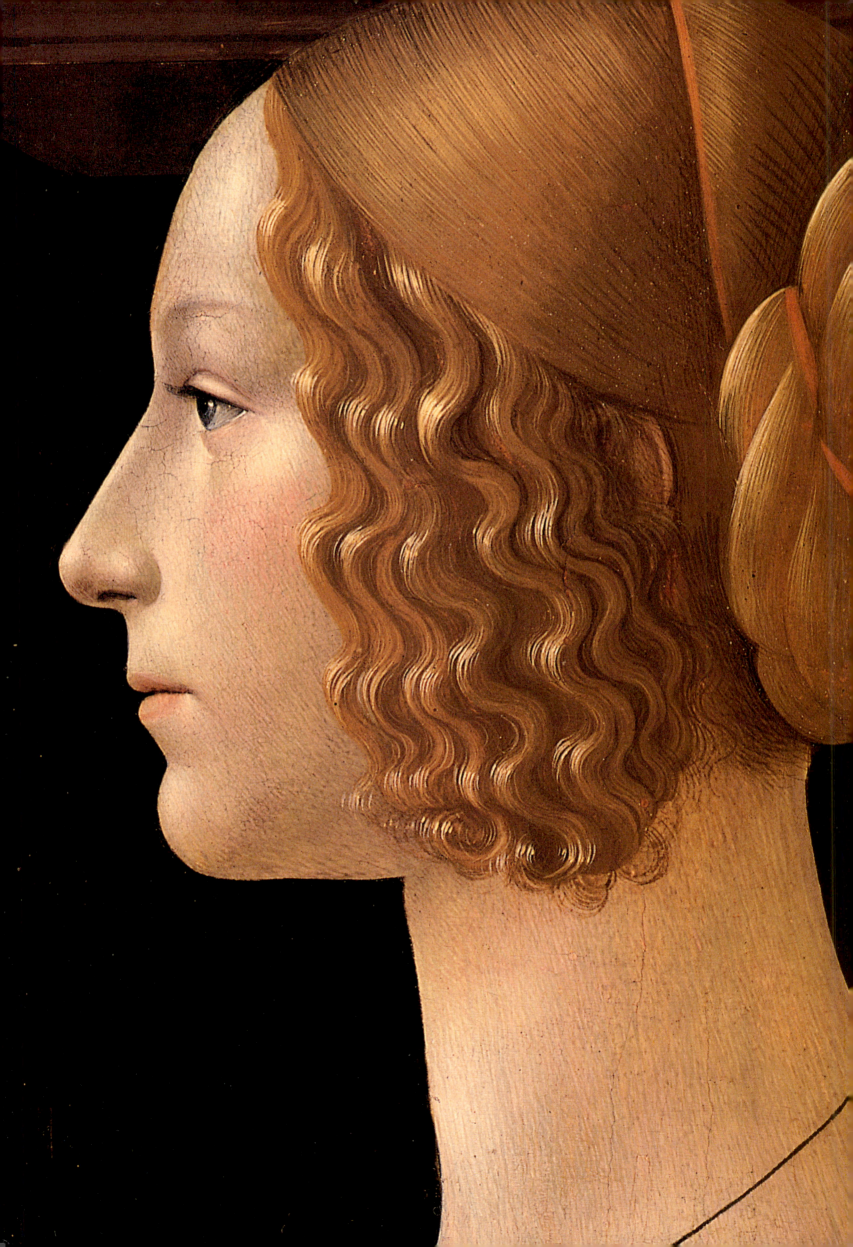

1

Domenico Ghirlandaio, *Visitation* (detail),
Tornabuoni Chapel, Santa Maria Novella,
Florence (photo: Scala/Art Resource, N.Y.)

1

When Ghirlandaio transferred Giovanna's image
from fresco to panel, he changed the background.
In the *Visitation* the scene is set outdoors, whereas in
the panel the sitter appears before a niche contain-
ing a variety of objects. One of these, the *cartellino*
affixed to the wall on the right, bears the following
Latin inscription:

ARS UTINAM MORES / ANIMUMQUE EFFINGERE /
POSSES PULCHRIOR IN TER- / RIS NULLA
TABELLA FORET / MCCCCLXXXVIII

The inscription, which has been studied by John
Shearman (1992), reads in his translation: "Art, would
that you could represent character and mind. There
would be no more beautiful painting on earth."
Adapted from an epigram by the Roman poet Mar-
tial, the inscription records a topos in the writing
on portraiture, found in Petrarch and Lorenzo de'
Medici, for example.[3] Shearman noted that by a
grammatical shift Ghirlandaio has the inscription
address art itself. The inability of the painter to rep-
resent the character or conduct of his subject is a
commentary on both portraiture in general and this
portrait. Did Ghirlandaio manage to convey only
Giovanna's physical appearance and not her mind
or soul? Rather than acknowledging a shortcoming
in his picture, it would seem that the artist was
demonstrating his superior skill and issuing a chal-
lenge to other painters.[4] Ghirlandaio's painting is,
in fact, exceptionally beautiful. And he succeeded
in depicting the sitter's moral character if not her
personality by showing her in the traditional profile
pose emblematic of virtue.[5] In addition, two of the
objects in the niche framing Giovanna's figure may
also allude to her inner qualities. Unlike the jeweled
brooch on the left, the string of coral beads (a
rosary?) and the book, presumably a prayer book,
would have been the sitter's personal property.
The way the beads and the book are juxtaposed with
the inscription underlines their role in the picture
as symbolic references to Giovanna's piety and devo-
tion. No mere likeness, then, Ghirlandaio's portrait

resolves the painter's dilemma by making the sitter's
virtue visible. Contrasting the luminous image
of the beautiful and proud woman who died young
with the dark chamber in which she appears, as in
a tomb, the painter conveys, as well as any poet
could, the survival of her spirit through his art. DAB

NOTES

1. About the sitter's jewels, see Dora Liscia in *L'Oreficeria
nella Firenze del Quattrocento,* ed. Maria Grazia Ciardi Duprè
(Florence, 1977), cat. 189, 296–297.

2. The correct identification was again based on the medals
(Enrico Ridolfi, "Giovanna Tornabuoni e Ginevra de' Benci
nel coro di S. Maria Novella in Firenze," *Archivio Storico Ital-
iano* 5 [1890], 426–456). For the most complete discussion
of the familial element in the chapel decoration, see Patricia
Simons, "Patronage in the Tornabuoni Chapel, Santa Maria
Novella, Florence," in *Patronage, Art and Society in Renais-
sance Italy,* ed. F. W. Kent and Patricia Simons (Canberra, 1987),
221–250.

3. See Tinagli 1997, 83 note 24; and Elizabeth Cropper,
"The Beauty of Woman: Problems in the Rhetoric of Renais-
sance Portraiture," in *Rewriting the Renaissance. The Discourses
of Sexual Difference in Early Modern Europe,* ed. Margaret N.
Ferguson, Maureen Quilligan, and Nancy J. Vickers (Chicago,
1986), 182.

4. Frank Zöllner ("Leonardo's Portrait of Mona Lisa del
Giocondo," *Gazette des Beaux-Arts,* series 6, 121 [March 1993],
128–129) maintains that Leonardo's *Mona Lisa* is in part an
answer to the challenge posed by Ghirlandaio's portrait.

5. On the expressive qualities of Giovanna's profile, see Simons
1992, 45; Luke Syson, "Consorts, Mistresses and Exemplary
Women: The Female Medallic Portrait in Fifteenth-Century
Italy," in *The Sculpted Object, 1400–1700,* ed. Stuart Currie
and Peta Motture (Aldershot, 1997), 52–53; and Alison Wright,
"The Memory of Faces: Representational Choices in Fifteenth-
Century Portraiture," in *Art, Memory, and Family in Renais-
sance Florence* (Cambridge, 2000), 88–89.

Attributed to Domenico Ghirlandaio

A c. 1490, tempera on panel
51.8 × 39.7 (20 3/8 × 15 5/8)
The Arabella Huntington Memorial
Collection, The Huntington Library,
Art Collections and Botanical
Gardens, San Marino

B c. 1490, tempera on panel
51.8 × 39.7 (20 3/8 × 15 5/8)
The Arabella Huntington Memorial
Collection, The Huntington Library,
Art Collections and Botanical
Gardens, San Marino

31 *Portrait of a Young Man* (A) *Portrait of a Young Woman* (B)

SELECTED BIBLIOGRAPHY

Berenson, Bernard. *Italian Pictures of the Renaissance. Florentine School,* 1: 128. 2 vols. London, 1963.

Craven, Jennifer E. "A New Historical View of the Independent Female Portrait in Fifteenth-Century Florentine Paintings," cat. 31, 298–300. Ph.D. diss., University of Pittsburgh, 1997.

Richter, Jean Paul. *Catalogue of Pictures at Locko Park,* cats. 60 and 67, 23 and 27. London, 1901.

Valentiner, W. R. *A Catalogue of Early Italian Paintings Exhibited at the Duveen Galleries* (1924), cats. 18, 19. New York, 1926.

Van Marle, Raimond. *The Development of the Italian Schools of Painting,* 13: 211–213. The Hague, 1931.

Venturi, Lionello. *Italian Paintings in America,* 2: notes to plates 274, 275. 3 vols. New York, 1933.

This portrait diptych presumably depicts a newlywed couple, with the husband on the left and the wife on the right, as was traditional (compare cats. 2 A, B). Though the paintings are clearly pendants (the landscape is continuous), the male sitter is shown in three-quarter view to the right, while the female faces him in profile. The discrepancy in their poses, one being more advanced and the other old-fashioned, is only the beginning of the mystery surrounding the two paintings. However unusual, the panels are not unique but form one of three such pairs of nearly identical portraits all of the same size. The second pair of conjugal portraits is in the Gemäldegalerie, Berlin (figs. 1, 2), while the third is in the Musée Fabre, Montpellier.[1] The latter pair, formerly in the Arconati Visconti Collection, Paris, are lower in quality than the other two and can safely be dismissed as copies or variants.[2] The attribution of the portrait pairs in San Marino and Berlin wavers between Domenico Ghirlandaio (1449–1494) and his two principal assistants, his brother Davide and his brother-in-law Sebastiano Mainardi. The relationship between the two pairs is also much debated with some scholars regarding the one in Berlin as the original and the other in San Marino as a replica and other writers arguing the opposite. In the case of the Huntington panels, the nineteenth-century attribution to Domenico Ghirlandaio (Richter 1901) was later abandoned in favor of Mainardi by W. R. Valentiner (1926), Raimond Van Marle (1931), Lionello Venturi (1933), and Bernard Berenson (1963), among others. Recently, however, Everett Fahy (written communication, 2000) has again proposed Domenico as their author. The tangled attribution problem raised by the two sets of related portraits, involving the inner workings of the Ghirlandaio shop, is beyond the scope of this entry. What can be said about the paintings is that, while the compositions are virtually the same in each case, they differ somewhat in style and execution. Essentially, the Berlin portraits are more detailed, as seen in the Gothic cityscape and the pair of lovers behind the male sitter and the puckers in his sleeve, as well as in the legible script in the book on the shelf behind his spouse. And the paint handling is correspondingly tighter. Aside from these artistic differences, the male sitters, to judge from their features and hair color, do not appear to be the same person. Did the woman, who is identical in both paintings, have two husbands? Or does one figure represent her husband and the other a relative or even her lover?

The odd juxtaposition of the three-quarter view for the man and the profile for the woman has been interpreted as having a social or psychological significance. In this gender-based interpretation, the male, shown before an open landscape with buildings, ships, and tiny figures, would represent the active partner, while the female portrayed in a loggia overlooking the landscape—one author calls her "housebound"—is subordinated to her spouse, as women were, in fact, in the Renaissance.[3] But there may be a simpler explanation for the artist's choice of disparate poses—namely, his reliance on different visual prototypes. As has often been noted, the female profile derives from Domenico Ghirlandaio's *Giovanna Tornabuoni* (cat. 30) in the Thyssen Collection, Madrid. In this work, dated 1488, the sitter is portrayed posthumously in profile, echoing her appearance in the artist's *Visitation* fresco in Santa Maria Novella. The Madrid picture further provided the still-life of the alcove with coral beads, a book, and a jeweled pendant behind the sitter. The author of the Huntington painting was also familiar with the source for the setting in the Tornabuoni portrait—Memling's *Portrait of a Young Man* in the Lehman collection in the Metropolitan Museum, New York. This Netherlandish portrait was already known in Florence in the 1470s, as can be deduced from an early *Madonna* by Ghirlandaio in the Louvre, employing the architectural motif of the loggia with two columns, much as in the portrait in San Marino.[4] At the same time, the male half of the diptych conforms to the type of bust-length three-quarter-view portraits of men against a landscape background current in the Ghirlandaio shop.[5] DAB

1

Attributed to Sebastiano Mainardi, *Portrait of a Man*, Staatliche Museen zu Berlin, Preussischer Kulturbesitz, Gemäldegalerie (photo: Jörg P. Anders)

2

Attributed to Sebastiano Mainardi, *Portrait of a Woman*, Staatliche Museen zu Berlin, Preussischer Kulturbesitz, Gemäldegalerie (photo: Jörg P. Anders)

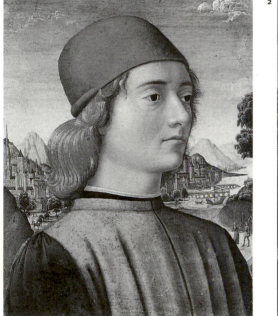

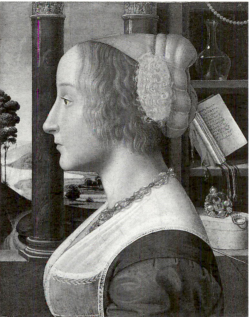

NOTES

1. For the Berlin pair, see *Catalogue of Paintings. 13th–18th Century,* Gemäldegalerie, Berlin, trans. Linda B. Parshall, 2d rev. ed. (Berlin, 1978), cats. 83, 86, 251–252.

2. For illustrations of these damaged and restored works belonging to the Louvre, see Jaynie Anderson, "Giovanni Morelli et la Collection Arconati-Visconti," *Revue du Louvre* 40 (1990), 208–209 and figs. 4b, 5b.

3. See Patricia Simons, "Women in Frames: The Gaze, the Eye, the Profile in Renaissance Portraiture," in *The Expanding Discourse. Feminism and Art History,* ed. Norma Broude and Mary D. Garrard (New York, 1992), 52; and Frank Zöllner, *Leonardo da Vinci. Mona Lisa* (Frankfurt, 1994), 58–61.

4. About Memling's portrait, see Dirk De Vos, *Hans Memling. The Complete Works,* trans. Ted Alkins (Ghent, 1994), cat. 48, 200–201; and Mary Sprinson de Jesus in *From Van Eyck to Bruegel. Early Netherlandish Painting in the Metropolitan Museum of Art,* ed. Maryan W. Ainsworth and Keith Christiansen [exh. cat., Metropolitan Museum of Art] (New York, 1998), cat. 28, 166–167. Lorne Campbell ("Memling and the Followers of Verrocchio," *The Burlington Magazine* 125 [November 1983], 675–676) first posited the Memling portrait

as a source for the Louvre *Madonna,* which also contains the still-life-on-a-shelf motif found in the portraits in Madrid and San Marino. In the Huntington portrait the coral beads, crystal vase, prayerbook, ring, and needle patently refer to the woman's wifely virtues.

5. Compare the examples in Oxford (Christopher Lloyd, *A Catalogue of the Earlier Italian Paintings in the Ashmolean Museum* [Oxford, 1977], no. A83, 73–74) and in London (Martin Davies, *National Gallery Catalogues. The Earlier Italian Schools,* 2d rev. ed. [London, 1961], no. 2489, 221–222).

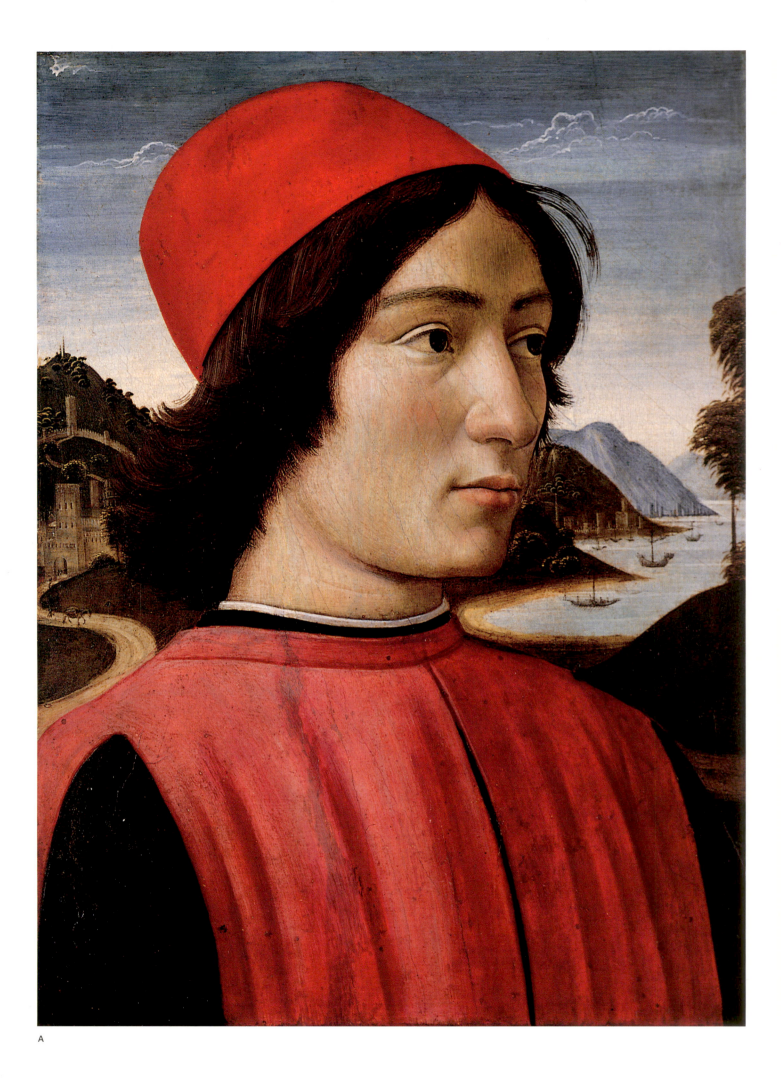

A

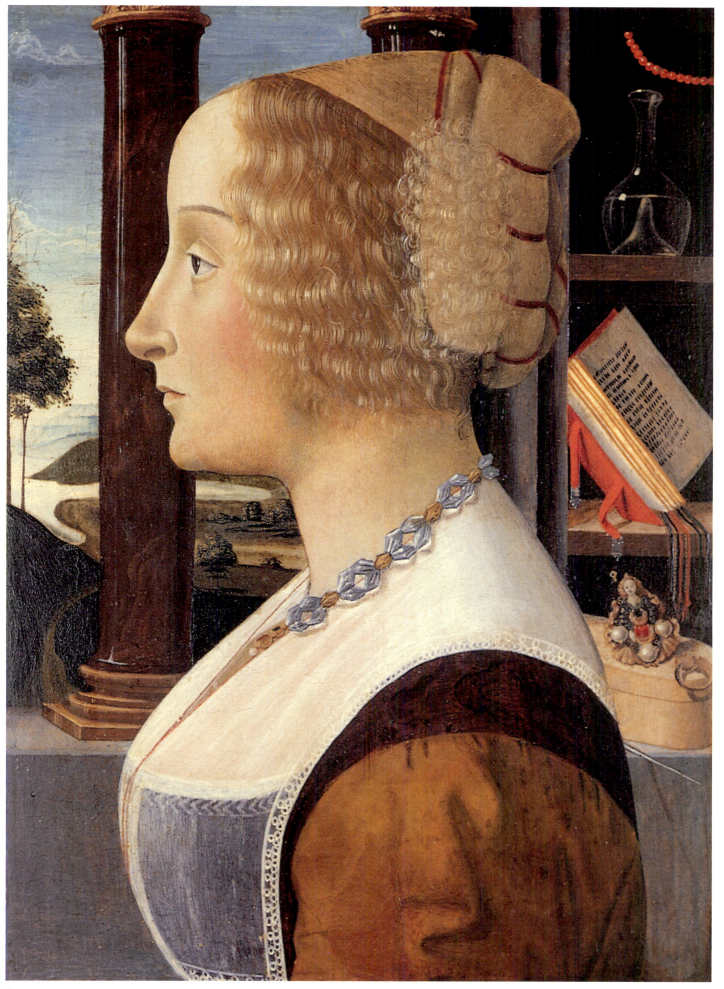

B

| Pietro Perugino | c. 1480 / 1490, metalpoint on gray prepared paper 37.7 × 24.3 (14 ¹³/₁₆ × 9 ⁹/₁₆) | The British Museum, London, Pp 1–26 |

32 *Bust of a Young Woman*

SELECTED BIBLIOGRAPHY

Berenson, Bernard. *The Drawings of the Florentine Painters,* 2: cat. 880, 92. 2d rev. ed. 3 vols. Chicago, 1938.

Davies, G. S. *Ghirlandaio,* 143. London, 1908.

De Tolnay, Charles. *History and Technique of Old Master Drawings,* cat. 38, 110. New York, 1943.

Fischel, Oskar. *Die Zeichnungen der Umbrer,* cat. 46, 112. Berlin, 1917.

Popham, A. E. and Pouncey, Philip. *Italian Drawings in the Department of Prints and Drawings in the British Museum,* 1: cat. 191, 117. 2 vols. London, 1950.

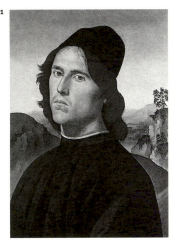

1

Perugino, *Portrait of a Man,* National Gallery of Art, Washington, Widener Collection

Though often criticized as sentimental, the figures in paintings and drawings by Perugino (c. 1450–1523) can also be more forceful. The artist's early work, in particular, reveals a firm sense of realism derived from the Florentine Andrea del Verrocchio, whom he assisted in the 1470s. Later, in the 1480s and early 1490s, Perugino continued to frequent Florence; indeed, he kept a shop there, and his works, though unmistakably Umbrian in style and mood, have many Florentine elements. Not surprisingly, therefore, this near life-size drawing of a woman's head was formerly attributed to Domenico Ghirlandaio as a study for a figure in his fresco of the *Birth of the Baptist* in the church of Santa Maria Novella, Florence, or for the artist's *Portrait of a Lady of the Sassetti Family* in the Metropolitan Museum, New York.[1] Oskar Fischel (1917), nevertheless, gave the drawing to Perugino, and Bernard Berenson (1938), Charles De Tolnay (1943), and A. E. Popham and Philip Pouncey (1950) fully endorsed his attribution. Fischel aptly compared the study to Perugino's *Portrait of a Youth* in the Uffizi, a work which, like the artist's other portraits in the same gallery—the *Francesco delle Opere* of 1494 and the two profile heads of monks—is full of character. An even closer comparison is offered by Perugino's *Portrait of a Man* (fig. 1), otherwise called a self-portrait of Lorenzo di Credi, in the National Gallery of Art.[2] Both works share the distinctive backward tilt of the sitter's head and the rather melancholy outward gaze, and both probably date from the 1480s: Perugino is recorded in Florence late in 1482 and again in 1488–1489.

The woman's hairstyle in the drawing, with curls falling along the sides of the face, and the dress, with slashed sleeves and a laced bodice, are typically Florentine, while the three-quarter pose, in common with painted portraits of the period, derives from Flemish art. Similar portrait drawings of women by or attributed to Rogier van der Weyden or Petrus Christus, dating from the mid-fifteenth century, are known, but Italian examples are rare.[3] The aim of such drawings was to record the subject's physical appearance, particularly his or her features, as the basis for the painted portrait, which was probably not carried out in the presence of the sitter. More than the finished portrait, then, the preparatory drawing made from the living model was an unmediated likeness. Perugino's study typically focuses on the head, keenly observed in contrast to the less carefully rendered bust. The artist's technique, with the delicate metalpoint strokes crosshatched for the shadowed areas around the features, served him well in characterizing his subject. DAB

NOTES

1. Raimond Van Marle ("I Ritratti di Domenico Ghirlandaio," in *Bollettino d'Arte* 25 [July 1931], 13–14 and fig. 4; and *The Development of the Italian Schools of Painting* [The Hague, 1931], 13: 95–99 and fig. 61), in connecting the drawing with the painting in New York, also attributed a *Portrait of a Lady,* formerly in the collection of Baron Lazzaroni, Paris, to Ghirlandaio, but this work is obviously a forgery.

2. Filippo Todini, *La pittura umbra dal duecento al primo cinquecento,* 2 vols. (Milan, 1989), 1: 283. The picture (Widener Collection, no. 1942.9.38 [634]), in accordance with verbal opinions rendered by Richard Offner, Everett Fahy, and Konrad Oberhuber, will be reattributed to Perugino in the forthcoming systematic catalogue of the Gallery's early Italian paintings.

3. Maryan Ainsworth, *Petrus Christus. Renaissance Master of Bruges* [exh. cat., Metropolitan Museum of Art] (New York, 1994), cat. 23, 184–187; cat. 25, 190–192.

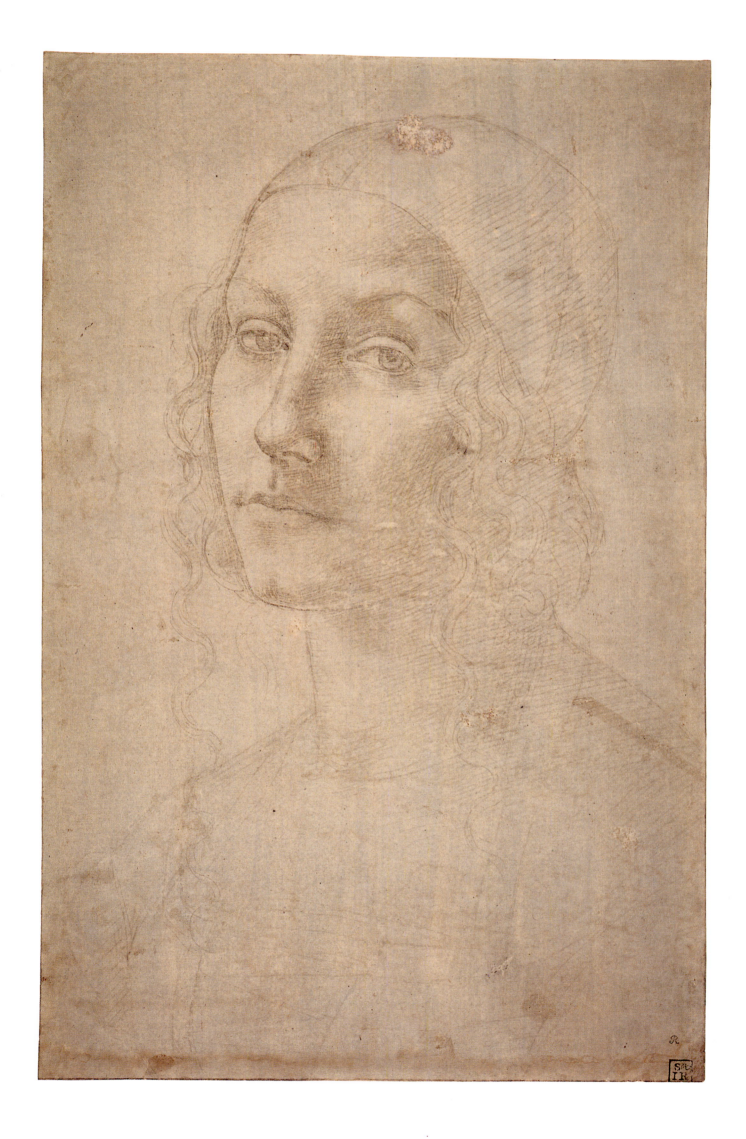

Domenico Ghirlandaio

c. 1486 / 1490, black chalk, pricked
for transfer (drapery study for a
standing female figure on the verso)
36.6 × 22.1 (14⁷⁄₁₆ × 8¹¹⁄₁₆)

The Duke of Devonshire and
The Chatsworth Settlement Trustees,
Bakewell, Derbyshire, 885 A, B

33 *Head of a Woman*

SELECTED BIBLIOGRAPHY

Ames-Lewis, Francis and Joanne Wright.
*Drawing in the Italian Renaissance
Workshop* [exh. cat., Victoria and Albert
Museum] (London, 1983), cat. 71,
306–309.

Bambach Cappel, Carmen. "The Tradi-
tion of Pouncing Drawings in the Italian
Renaissance Workshop: Innovation and
Derivation," 1: cat. 113, 147–149. Ph.D.
diss., Yale University, 1998.

Bambach, Carmen C. *Drawing and
Painting in the Italian Renaissance Work-
shop. Theory and Practice, 1300–1600,*
240–241. Cambridge, 1999.

Cadogan, Jean K. "Domenico
Ghirlandaio in Santa Maria Novella:
Invention and Execution." In *Florentine
Drawing at the Time of Lorenzo the
Magnificent* [Villa Spelman Colloquia 4],
63–72. Ed. Elizabeth Cropper. Bologna,
1994.

Caneva, Caterina. In *Il Disegno Fioren-
tino del Tempo di Lorenzo il Magnifico.*
Ed. Annamaria Petrioli Tofani [exh. cat.,
Gabinetto Disegni e Stampe, Galleria
degli Uffizi] (Florence, 1992), cat. 4.6,
100–101.

Danti, Cristina. "Osservazioni sulla
tecnica degli affreschi della Cappella
Tornabuoni." In *Domenico Ghirlandaio
1449–1494,* 146. Ed. Wolfram Prinz
and Max Seidel. Florence, 1996.

Jaffé, Michael. *Devonshire Collection of
Drawings. Tuscan and Umbrian Schools,*
cat. 29, 62–63. London, 1994.

Rosenauer, Arthur. "Observations and
Questions concerning Ghirlandaio's
Work Process." *Canadian Art Review* 12
(1985), 149–153.

This drawing is a full-scale preparatory study for the head of the older woman (fig. 1) standing by the stair-case on the left in Ghirlandaio's fresco of the *Birth of the Virgin* in the Tornabuoni chapel in the church of Santa Maria Novella, Florence. Commissioned by Giovanni Tornabuoni in September 1485, the cycle to which the fresco belongs was completed by Dom-enico (1449–1494) and his brother Davide between 1486 and 1490. The left wall of the chapel, facing the altar, depicts events from the life of the Virgin, and the right, ones from the life of John the Baptist, the donor's patron saint. Florentine fresco decorations commonly included portraits of the donor, his family, and his friends, but this one is exceptional in having such a strong female presence. The women of the family are portrayed appropriately in scenes concern-ing childbirth—not only the Birth of the Virgin but also the Birth of the Baptist and the Visitation. Depicted in interior settings in the context of daily life, the Tornabuoni women, most of them unidenti-fied, are distinguished from the religious figures by their contemporary dress and features. As witnesses to the sacred events being enacted on the chapel walls, they serve as exemplars of piety for present and future generations. And set as they are within narra-tives of childbirth, the women further exemplify the female virtue of fecundity necessary for the family to flourish.

The woman portrayed in the fresco belongs to a group of five females who display the same dignified demeanor but who are distinguished from each other by costume. The foremost and youngest mem-ber of the group, tentatively identified as the patron's daughter Lodovica, has her hair uncovered and is richly dressed in the manner of a young unmarried or recently married woman. Her companions are older and more soberly garbed. The woman depicted in the drawing wears a high-necked dress, a robe, and a coif over her head, marking her as a matron. While she has an air of kindly wisdom appropriate to her famil-ial role and status, the drawing representing her is not a life study.[1] Rather, to judge from its large scale and perforations, it is a cartoon in which the contours are pricked for transfer to the surface to be painted. Though probably based on a life study, the Chats-worth portrait performed a different function, that

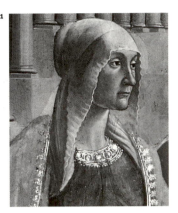

Domenico Ghirlandaio, *Birth of the Virgin*
(detail), Tornabuoni Chapel, Santa
Maria Novella, Florence (photo: Scala/
Art Resource, N.Y.)

of indicating the outlines and modeling of the figure to be painted on the wall. The cartoon is so well preserved that scholars have concluded it must have served to make another cartoon used during the execution. If this were the case, then two steps in the design process separated the artist's original study recording the sitter's features from the finished por-trait. The preparatory work leading up to the fresco, involving repeated transfers of the design, coupled with the possibility that the painted image was exe-cuted by Domenico's collaborator, Davide, or another assistant, indicates how far removed this Renaissance portrait is from the notion of portraiture as a direct likeness completed in the sitter's presence, commonly held today. DAB

NOTES

1. For examples of relatively small-scaled life studies of female sitters made by Ghirlandaio in metalpoint on prepared paper, see Jane Roberts, *Italian Master Drawings from the British Royal Collection. Leonardo to Canaletto* (London, 1987), cat. 1, 22; Roberta Bartoli in *Sandro Botticelli: Pittore della Divina Com-media,* ed. Sebastiano Gentile, 2 vols. [exh. cat., Scuderie Papali al Quirinale, Rome] (Milan, 2000), cat. 5.26; A. E. Popham and Philip Pouncey, *Italian Drawings in the Department of Prints and Drawings in the British Museum. The Fourteenth and Fif-teenth Centuries,* 2 vols. (London, 1950), cat. 73, 48, pl. LXXI; Annamaria Petrioli Tofani, *Inventario. 1. Disegni esposti,* Gabi-netto Disegni e Stampe degli Uffizi (Florence, 1986), nos. 174E and 175E, 77.

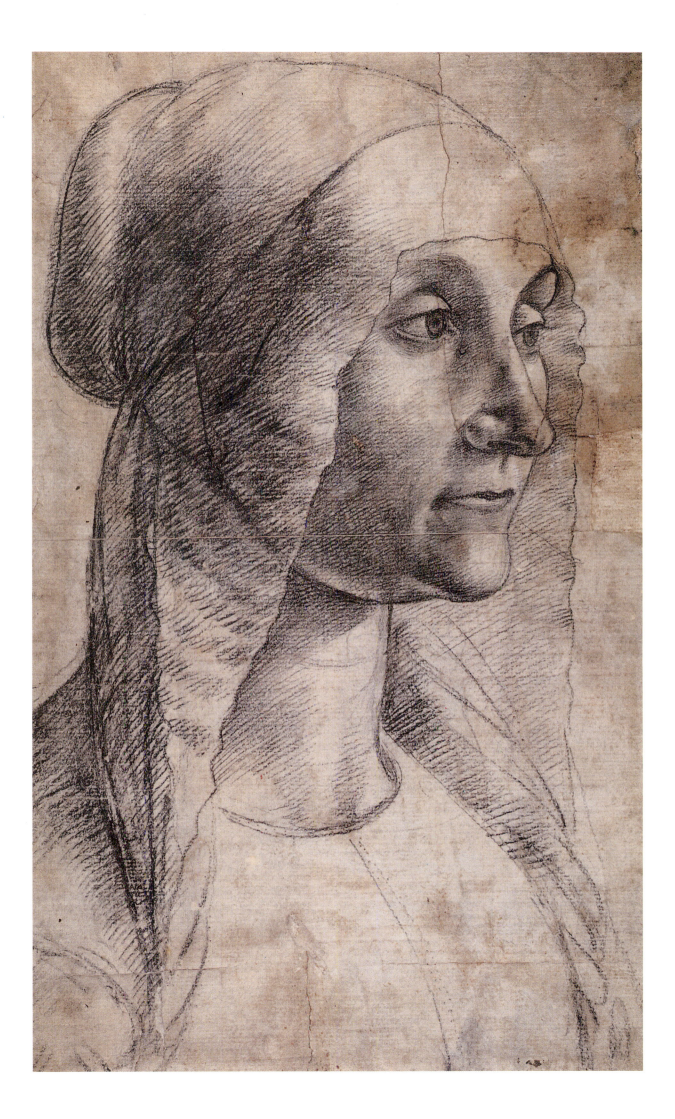

Raphael

c. 1504, black chalk over stylus, partly reinforced in pen and ink, with traces of white heightening (on the verso a tracing in pen and ink of the profile on the recto)
25.5 × 16 (10 1/16 × 6 5/16)

Galleria degli Uffizi, Gabinetto Disegni e Stampe, Florence, no. 57E

34 *Young Woman in Profile*

SELECTED BIBLIOGRAPHY

De Vecchi, Pierluigi. In Annamaria Petrioli Tofani and Pierluigi De Vecchi. *I Disegni di Raffaello nel Gabinetto dei Disegni e delle Stampe degli Uffizi,* cat. 3, 8–9, 87–89. Milan, 1982.

Ferino Pagden, Sylvia. In *Raffaello a Firenze. Dipinti e disegni dalle collezioni fiorentine* [exh. cat., Palazzo Pitti, Florence] (Milan, 1984), cat. 25, 328–329.

Ferino Pagden, Sylvia. *Disegni Umbri del Rinascimento da Perugino a Raffaello* [exh. cat., Galleria degli Uffizi] (Florence, 1982), cat. 55, 88–90.

Fischel, Oskar. *Raphaels Zeichnungen,* 1: cat. 32, 54, 57. 8 vols. Berlin, 1913–1941.

Joannides, Paul. *The Drawings of Raphael,* cat. 80, 152. Berkeley, 1983.

Knab, Eckhart, et al. *Raphael. Die Zeichnungen,* cat. 74. Stuttgart, 1983.

Petrioli Tofani, Annamaria. *Inventario. 1. Disegni esposti,* no. 57E, 27. Gabinetto Disegni e Stampe degli Uffizi. Florence, 1986.

Traditionally given to Mino da Fiesole and later inventoried as "sixteenth-century Florentine," this drawing was first attributed to Raphael (1483–1520) by Oskar Fischel (1913) as a life study for the figure of a woman in profile on the right in the *Presentation in the Temple,* part of the predella to the artist's *Coronation of the Virgin* in the Vatican. Raphael completed the altarpiece for the church of San Francesco in Perugia not long before going to Florence in 1504. If the Uffizi drawing had been made for the *Presentation,* it would precede the change in Raphael's style that occurred after his decisive encounter with Florentine art, but the drawing is too large in scale and too detailed to have served for the diminutive figure in the predella panel. In addition, it exhibits a distinct portrait character, as Pierluigi De Vecchi (1982) and Sylvia Ferino Pagden (1982, 1984) have noted. The half-length figure (the hands were cropped when the sheet was cut down), with long braided hair, is slouched with the torso inclined backward and the head tilted forward. Lending a gentle curve to the upper body, the pose had already been adopted for the corresponding figure in the predella, as well as for the females depicted in another early work by the artist—the *Marriage of the Virgin* in the Brera.

Once in Florence Raphael undertook the careful study of Leonardo that would transform his art.[1] In portraiture, this phase is represented by the preparatory study in the Louvre for the *Maddalena Doni* of c. 1506, in the Uffizi: the painting and even more so the drawing are clearly based on *Mona Lisa.*[2] But when he first arrived in Florence, Raphael seems to

have responded to a variety of influences. In the case of the Uffizi drawing, he was apparently reacting to the familiar series of Florentine profile portraits of women. His drawing "corrects" that tradition by eliminating the upright character of the profiles, emblematic of the sitters' virtue, in favor of a mode of portrayal that is both more graceful and more natural. Equally, the style of the drawing, with the forms lightly modeled in black chalk with white heightening, breaks with the linearity of the Florentine profile. By the early sixteenth century, profile portraits, like Ghirlandaio's of Giovanna Tornabuoni (cat. 30), must have seemed unnaturally stiff and sharp to artists like the young Raphael. It seems ironic, therefore, that another draftsman should have betrayed Raphael's intentions, reinforcing the woman's profile in pen and ink on the recto and then, turning the sheet over, tracing the contour onto the verso. DAB

NOTES

1. Jürg Meyer zur Capellen, *Raphael in Florence* (London, 1996).

2. Joannides 1983, commentary to pl. 15, 62–63, and cat. 175, 175.

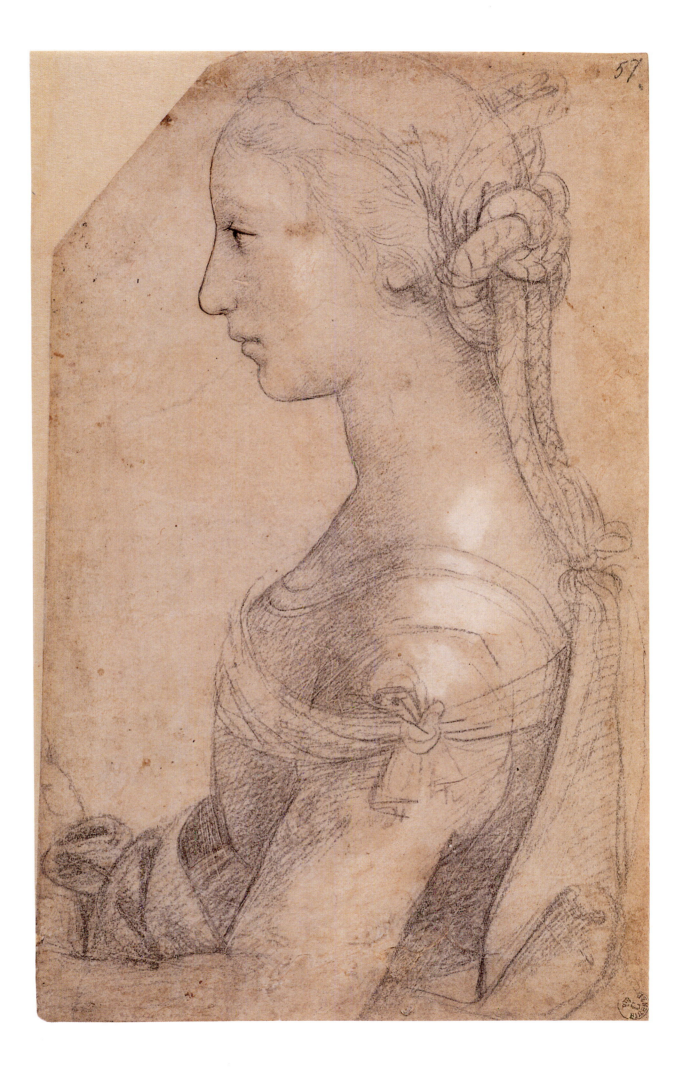

Girolamo di Benvenuto | c. 1508, tempera and oil (?) on panel 60 × 45.4 (23 5/8 × 17 7/8) | National Gallery of Art, Washington, Samuel H. Kress Collection, 1939.1.353

35 *Portrait of a Young Woman*

SELECTED BIBLIOGRAPHY

Angelini, Alessandro. "Girolamo di Benvenuto." In *La pittura in Italia. Il Quattrocento*, 2: 649–650. Ed. Federico Zeri and Giovanni Agosti. 2 vols. Milan, 1986.

Douglas, Robert Langton, *Exhibition of Pictures of the School of Siena* [exh. cat., Burlington Fine Arts Club] (London, 1904), 70–71, no. 52, pl. 36.

Fredericksen, Burton and Darrell Davisson. *Benvenuto di Giovanni. Girolamo di Benvenuto*. Malibu, 1966.

Shapley, Fern Rusk. *Catalogue of the Italian Paintings*, 2: 224–226. 2 vols. Washington, 1979.

Zeri, Federico. "Girolamo di Benvenuto: il completamento della *Madonna della Nevi*." *Antologia di Belle Arti* 3 (1979), 48–54.

This bust-length, life-size portrait of a young woman became famous in the nineteenth century, when it was thought to be a portrait of Petrarch's beloved Laura. The sitter wears an embroidered green dress, its bodice cut wide and laced with fine dark brown cords over the breast to reveal an expanse of her embroidered chemise, which also puffs out above the attached sleeves. Wisps of her golden hair frame her face; otherwise her head is covered by a transparent veil bound by a fine fillet. She wears a pearl necklace from which hangs a ruby in an ornamented gold setting with three pendant pearls. Though the slight turning and tilting of the head and the lines to the sides of the mouth lend a personal quality, the rather hard surface and flattened form link this portrait more closely to the tradition of Sienese fifteenth-century painting than to recent works produced in Florence, such as Raphael's portrait of Maddalena Doni.[1]

In his *Storia della Scultura,* first published in 1813, Leopoldo Cicognara noted this portrait in the collection of Antonio Piccolomini Bellanti in Siena, identifying the sitter as Laura and the artist as Simone Martini (fig. 1).[2] In so doing he was joining a long and heated debate about whether a portrait of Laura by Simone survived. Cicognara possessed a tracing of the image, which was then used as the basis for the engraving he published, together with two others after the head of a woman in a niello in the Museo Malaspina in Pavia, and two details of heads from the frescoes in the Spanish chapel in Santa Maria Novella in Florence, then attributed to Simone Martini. The suggestion that these two figures in the fresco were Petrarch and Laura had been made by Vasari, but Cicognara rightly dismissed the possibility. He may not have seen the portrait in the Piccolomini Bellanti collection, but thought it likely by Simone (though he noted Giulio Mancini's objections to the idea that the elderly artist could have gone to Avignon to paint such a portrait), and quite possibly of Laura, describing the figure as "a young woman nobly and richly dressed in a gentle provençal costume." He invoked various authorities that such a portrait of Laura had existed in Siena, but he would take no position on whether or not the letters *F. P.*

originally appeared on the ruby pendant, adding that people often read such letters where they did not exist, as if seeing figures in clouds. In the engraving in his book the letter *P* is clearly delineated, but in the portrait the carving on the stone is too indistinct to be read as a letter. Subsequently, in 1819, Raphael Morghen's engraving after the Piccolomini Bellanti portrait (fig. 2), which did not depict letters on the pendant, served as a frontispiece for an edition of Petrarch's poetry published in Padua.[3] This engraving identified the owner, correctly, as Cavaliere Antonio Piccolomini Bellanti, and claimed once again that the artist was none other than the great trecento Sienese painter Simone Martini.

The two engravings remove any suspicions that the work is a twentieth-century fake, and the attribution to Girolamo di Benvenuto (1470–1524), first proposed by Langton Douglas in 1904, has received general acceptance.[4] The present appearance of the portrait is adversely affected by the overpainted black background. The gold interlace border painted on top of this may have been intended to suggest the gilded cover of a book of poetry, but it abuts the shoulders and head of the sitter in a clumsy way, compounding the awkwardness of the left arm, which looks equally odd in the engraving in Cicognara's book.

When Cicognara and Morghen associated this lady with both Simone Martini and Laura, they were inspired by the belief that such a portrait had existed. Petrarch's two sonnets in praise of Simone Martini's lost portrait of Laura (who died on Easter Sunday, 1348) provided the greatest incentive and challenge to Renaissance painters, including Leonardo da Vinci, to equal Simone's ability to portray the beloved.[5] In one sonnet Petrarch addresses the image as a work produced in paradise, for it is something unimaginable on earth "where the body is a veil to the soul." In his second sonnet, however, he laments that Simone has not brought Laura alive in the manner of Pygmalion by endowing her with voice and intellect, for when he speaks to the likeness of his beloved she never replies. Petrarch's lyric poems were devoted to keeping Laura alive in his own heart,

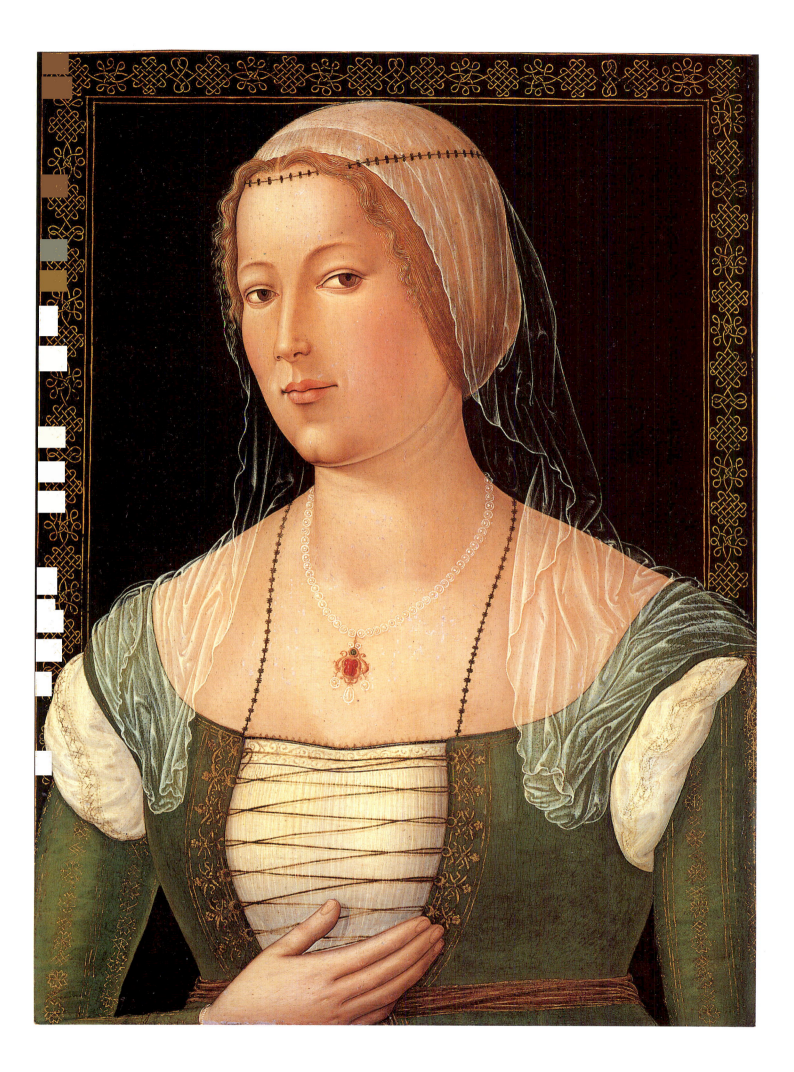

1

Giuseppe Dala, engraving of cat. 35
as Laura, in Leopoldo Cicognara, *Storia
della Scultura dal suo risorgimento
in Italia fino al secolo di Canova*, 2nd ed.
(Venice, 1823), pl. 43

2

Raphael Morghen, engraving of cat. 35
as Laura, from Francesco Petrarca, *Le Rime
del Petrarca*, 2 vols. (Padua, 1819–1820),
frontispiece (photo: Library of Congress)

and as a result the question of the *paragone,* or rivalry, among the arts of poetry, painting, and sculpture, to provide such immortality became a major theme in the criticism of painted and poetic representations of lyric beauty. In this sense almost all the portraits in the exhibition, and especially Leonardo's *Ginevra de' Benci,* reflect the intense importance given to the painted portrait of his beloved by Petrarch.[6]

This young woman prominently displays "una bella ignudo mano," and her light veil, golden locks, and hint of a smile may all be associated with the standard stock of Petrarchan imagery, though no laurel branch points specifically to Laura's name. Very few independent portraits of women were produced in Siena in the Renaissance, however, and the existence of a representation of a blond, veiled woman in a noble collection in Simone Martini's native city was just too tempting for antiquarians to ignore in their search for historical evidence of Laura's beauty.[7] On the other hand, Petrarch's poems on Simone's portrait were so fundamental to the whole discourse on painting, beauty, and fame in the sixteenth century that it is even possible that this rare Sienese portrait was actually produced by Girolamo di Benvenuto as a modern reconstruction of Simone's famous lost image.[8] This would account for the existence of the independent portrait itself, the out-of-date green dress, the odd misalignment of the sloping almond eyes that suggests the style of Simone, and other retardataire features. EC

NOTES

1. It is noteworthy that the black chain passing around the lady's neck, and which is of a slightly different pattern from the metal fillet, or *ferronière* around her head, is exactly like the black border of Maddalena Doni's transparent veil in Raphael's portrait of her.

2. Leopoldo Cicognara, *Storia della Scultura dal suo risorgimento in Italia fino al secolo di Canova* (orig. ed., Venice, 1813; 2d ed., Prato, 1823), 3: 307–329, esp. 325–327, pl. 43.3.

3. Antonio Marsand, ed., *Le rime del Petrarca,* 2 vols. (Padua, 1819–1820). Marsand, however, rejected the attribution to Simone. For the history of the controversy over portraits of Laura, including this one, see Alessandro Bevilacqua, "Simone Martini, Petrarca, i ritratti di Laura e del poeta," *Bollettino del Museo civico di Padova* 68 (1979), 107–150. On the eventual determination that this lady is not Laura, see Donata Levi, "Carlo Lasinio, Curator, Collector, Dealer," *The Burlington Magazine* 135 (1993), 137–138.

4. The existence of an underdrawing for the head and of a pentimento in the drawing of the hand also supports the work's early origin. First to impugn the painting was Bode, who claimed that it was relatively modern, apparently because he hoped to purchase it for the Berlin museum. Van Os' suggestion (1992) that the portrait is by the modern Sienese forger Joni is disproved by the engravings.

5. For these sonnets see Robert M. Durling, trans. and ed., *Petrarch's Lyric Poems* (Cambridge, Mass., 1976), "Rime sparse," 176–179 (nos. 77 and 78).

6. For this *paragone* of the portrait of the beloved and its origins in ancient literature, especially Lucian's essay "On Portraiture," see Elizabeth Cropper, "The Beauty of Woman: Problems in the Rhetoric of Renaissance Portraiture," in *Rewriting the Renaissance: The Discourses of Sexual Difference in Early Modern Europe,* ed. Margaret W. Ferguson, Maureen Quilligan, and Nancy Vickers (Chicago, 1986), 175–190, 355–359.

7. The portrait has often been compared to the image of a female donor in Girolamo di Benvenuto's *Madonna of the Snows* for the Sozzino chapel in San Domenico (signed and dated 1508, and now in the Pinacoteca in Siena), but the similarity is not compelling.

8. Vasari, for example, cites the two poems at the beginning of his life of Simone, adding that they had made the painter more famous than any of his own works. See Giorgio Vasari, *Le Vite de' più eccellenti pittori scultori ed architettori,* 9 vols. (Florence, 1906), 1: 546.

| Giuliano Bugiardini | A c. 1516, oil on panel
65.1 × 47.9 (25 5/8 × 18 7/8)
Galleria degli Uffizi, Florence,
inv. 1890 n. 8380 | Attributed to
Giuliano Bugiardini | B c. 1516, oil on panel
73 × 50.3 (28 3/4 × 19 3/4)
Galleria degli Uffizi, Florence,
inv. 1890 n. 6042 |

36 *Portrait of a Lady ("La Monaca")* (A) *Portrait Cover with Mask and Grotesques* (B)

SELECTED BIBLIOGRAPHY

Natali, Antonio. *La Piscina di Betsaida. Movimenti nell'arte fiorentina del Cinquecento*, 117–137. Florence, 1995.

Natali, Antonio. In *L'Officina della Maniera: Varietà e fierezza nell'arte fiorentina del Cinquecento fra le due repubbliche 1494–1530* [exh. cat., Galleria degli Uffizi] (Venice, 1996), 134.

Pagnotta, Laura. *Bugiardini*, 201–202. Turin, 1987.

1

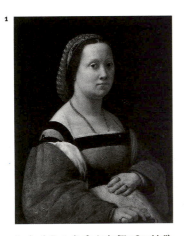

Raphael, *Portrait of a Lady ("La Gravida")*, Galleria Palatina, Palazzo Pitti, Florence (photo: Alinari/Art Resource, N.Y.)

Portrait of a Lady was acquired in 1810 from the Niccolini family by the Florentine grand duke Ferdinando III.[1] It carried an attribution to Leonardo da Vinci together with the suggestive, but equally misleading, title *La Monaca* (the nun). Alternative attributions have not been lacking, and among them the names of Ridolfo Ghirlandaio, Mariotto Albertinelli, and Giuliano Bugiardini (1475–1554) predominate. These three names constitute a sort of Bermuda Triangle for orphaned paintings of the earlier sixteenth century. Even so, Hermann Ulmann's attribution to Bugiardini, seconded by Bernard Berenson, with which we tend to agree, has won all but universal acceptance. However, in recent years estimable scholars like Luciano Bellosi and Antonio Natali have reopened the question, the former suggesting the names of Raphael and Albertinelli, and the latter championing Ridolfo.[2]

The painting is normally dated to the second decade of the sixteenth century on the basis of its close affinities with Leonardo's new invention for the half-length female portrait, established in his *Ginevra de' Benci* (cat. 16), and given definitive form in the *Mona Lisa*, and in particular with Raphael's adaptation of these conventions for his *Lady with the Unicorn* in the Galleria Borghese (who is posed, like *La Monaca*, in an open loggia overlooking a landscape), his *Portrait of Maddalena Doni* in Palazzo Pitti (c. 1506), and, above all, his *Portrait of a Lady*, known as *La Gravida* (or "the pregnant woman," c. 1508), also in Palazzo Pitti (fig. 1). So close is *La Monaca* to this last, which is of virtually identical dimensions, in the line of her neck and shoulder, the rotation of her body, in the positioning of her right hand, and in the details of her costume (a square-necked *gamurra* with attached sleeves, enlivened by a puff of fabric from her *camicia*, or undergarment, at the point of attachment), that we might surmise that Bugiardini made use of a cartoon or tracing of *La Gravida* as a template for establishing the pose of *La Monaca*.[3] A small but significant difference between the two must be noted,

however. The bodice of *La Monaca's gamurra* is slightly lower, revealing more of her swelling breasts than is normal for fashions of the period.

A striking landscape is visible through the arches to the left and right of the sitter. The former shows three nuns in the piazza of Santa Maria Novella before the Ospedale di San Paolo, and the domed church of Santo Spirito, across the Arno to the south. The latter looks toward the Porta al Prato, the church of the Dominican convent of San Jacopo di Ripoli, and a luminous sunset over the mountains to the west. In an important study of the Ospedale di San Paolo, Richard Goldthwaite and Roger Rearick (1977) have shown that a part of the governance of that institution was ceded to the Franciscan sisters by their male counterparts in 1534.[4] They have suggested that the painting commemorates that event, also finding closer stylistic affinities with later works by Bugiardini such as the *Rape of Dinah* in Vienna. Their observations have been challenged by specialists in Florentine art, who have objected that neither the painting's style nor the fashion of the lady's dress seems consistent with a date later than the second decade of the sixteenth century. It is also significant, as Natali has pointed out, that the view of Santo Spirito shows no sign of the bell tower.[5] The foundations for this were begun in 1490, but the construction, on the design of Baccio d'Agnolo, progressed slowly. By 1517 it is likely that the first story was complete, and Vasari's fresco of the *Siege of Florence*, showing the city as it was in 1530, depicts an incomplete, but unmistakable campanile.[6] Given the accuracy of the architectural details of the cityscape behind *La Monaca*, it seems unlikely that the picture could date as late as 1530, for in 1522 expenses were incurred for the repair of the bell known as "Speranza Dei," or "la Piccola."

In 1867 the Florentine galleries acquired a painting from the dealer-collector Baron Ettore de Garriod, who claimed that it was the cover to *La Monaca,* again asserting that the latter was by Leonardo.[7] This cover (called a *tirella,* that is a panel attached by grooves or rods to the frame in such a way that it could be pulled to one side, thereby revealing the portrait beneath), had already been described in detail and quite independently of the sale in the 1851 edition of Vasari's *Lives,* where it was also identified as the cover to Leonardo's *Monaca* from the Niccolini collection.[8] In recent years, following the proposal of Natali, the paintings have been reunited in the same room in the Uffizi, and hang close to each other. The exhibition now provides an opportunity to consider them side by side. The practice of providing portraits with painted covers was fashionable throughout Europe in the first half of the sixteenth century, but covers and portraits were quickly separated when portraits entered the market and very few can now be securely reunited. The provision of covers was closely related to the convention of painting allegorical or heraldic images on the reverse of portraits, a famous example, of course, being Leonardo's *Ginevra de' Benci,* in which the lady's exterior beauty, or *forma,* portrayed in the front is presented as an adornment to her character, or internal *virtus,* emblematically expressed on the back. In the case of the cover for *La Monaca,* however, the emblem is more purposefully enigmatic in its artful dissemblance. For comparison one thinks, for example, of Bronzino's *Pygmalion and Galatea,* painted around 1530–1532 as the cover for Pontormo's *Portrait of Francesco Guardi in the Costume of a Soldier* (as Vasari entitled it), and which carries the quizzical inscription, HEV VI[NCIT] VENUS.[9]

The motto chosen for *La Monaca* derives from an ancient proverb cast in the form of *suum cuique mihi meum,* or "to each his own, and to me mine."[10] It was anthologized in Erasmus' *Adagia,* an immensely popular collection of such Latin and Greek proverbs, where it was cited as an example of *philautia,* or the natural tendency of people to prefer what is their own, whether their own looks, their own country, their own family, or their own lover. Cicero was especially fond of the adage, and Erasmus accordingly quotes from a letter to Atticus, in which Cicero himself quotes a distich by Atilius exemplifying two applications of it: *Suam cuique sponsam, mihi meam: / Suum cuique amorem, mihi meam* ("Each loves his own bride, and I mine; / Each prefers his own love and I mine"). In the case of *La Monaca,* the motto *Sua cuique persona* clearly states that the lady is playing a role of her own choosing, and is wearing her preferred theatrical mask, or *persona* (underscored by the actual mask shown on the cover below the motto). "To each his own persona," the motto reads, its unstated but inevitable conclusion being, "and mine for me." The enigma of this fascinating portrait is to fathom the role the sitter had adopted, for she is not what she appears to be.

Although *La Monaca* is seated in a loggia overlooking the Franciscan nuns going about their work taking care of the sick at the charitable institution of the Ospedale di San Paolo, and though she is dressed in black and holds to her breast a breviary inscribed with the monogram of Christ, she is herself assuredly not a nun. Neither her dress nor her almost completely uncovered shoulder and impressive bosom are consistent with a religious habit. It has been suggested that she may be a widow, but this has met with skepticism for much the same reasons, especially on the grounds of her scarcely concealed physical allure. However, a suggestive parallel exists in Correggio's *Portrait of Ginevra Rangone* in the Hermitage.[11] Ginevra's first husband died in 1517, when, as was customary for newly widowed well-to-do women, she became a Franciscan tertiary. She remarried in 1519. Correggio's portrait dates from the early period

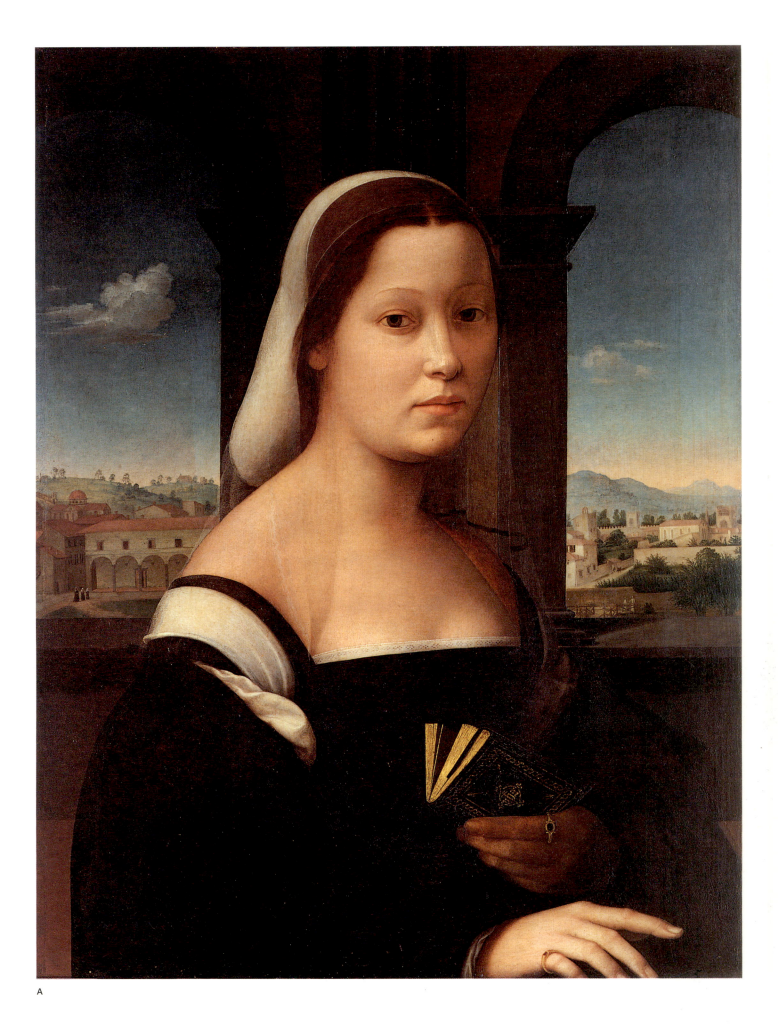

of Ginevra's widowhood, and shows her with the girdle of a Franciscan tertiary visible at her knee, and a scapular suspended from a gold chain at her neck. This has puzzled scholars, who have pointed out that one might expect widows or even tertiaries to be more discreetly veiled, and certainly with covered shoulders and less décolletage. They have also been disturbed by the fact that, while Ginevra's headdress and bodice are consistent with fashion at the moment her portrait was painted, her sleeves accord with an earlier, and somewhat out-of-date style. In this instance, as for *La Monaca,* the paradoxical conjunction of religious piety and womanly allure openly displayed, as well as the presence of anachronistic dissonances, suggests a desire to exhibit the sitter in that fullness of youthful beauty that had won her a husband's love, and at the same time her continuing adherence to the ideals of chasteness and charitable devotion to the Church that had made her worthy of that love. The mask adopted by the sitter is that of her own youthful beauty, which in her maturity is adorned by good works and religion, without in any way foreclosing her future in the world.

Our dating of the portrait of this unknown woman to c. 1516 suggests a connection to a different moment in the history of the good women of San Paolo from that proposed by Goldthwaite and Rearick. The Spedale de' Pinzocheri del Terz'Ordine di San Francesco, popularly known as San Paolo, had begun as a lay charitable organization before it was associated with the Franciscan tertiaries. Though the female members did not take over their share of the government until 1534, women had an important role to play in the work of the hospital from the fourteenth century onward. By the early sixteenth century all the resident charitable workers were women, and they determined to become independent from the Franciscan tertiaries. In 1516 they were given the right to wear the veil and habit of cloistered nuns. Perhaps here, then, is to be found a topical reference. Whereas women living in the hospital (and seen outside the portico to the left), took on the persona of nuns (also adopted by the figures seen outside San Jacopo di Ripoli to the right), our sitter prefers her lay status, paradoxically earning the title of *La Monaca* in later history.

The attribution of the cover to Bugiardini partly follows from the attribution of the portrait, for, as Natali has said, the mask seems almost to have been modeled on the woman's face. The graphic style of the inscription is conventional, but the characters and final flourish are certainly in keeping with those found in other inscriptions by Bugiardini, as in the *Birth of the Baptist* in Stockholm, or the *Madonna and Child* in the Galleria Colonna, Rome. The curvaceous forms of the intertwining tails of the grotesque griffins and dolphins, and the writhing torsion of the forms overall, not to mention the softening effects of chiaroscuro, all suggest a moment in the second decade, rather than evoking the crisper forms of the first. EC

NOTES

1. Pagnotta 1987.

2. Pagnotta 1987. Natali 1995. In his fascinating essay Natali dates the work to c. 1510, with the attribution to Ridolfo.

3. See Pagnotta 1987, 32, on the relationship between Bugiardini and Raphael as portraitists in the first decade of the century.

4. Richard A. Goldthwaite and W. Roger Rearick, "Michelozzo and the Ospedale di San Paolo in Florence," *Mitteilungen des Kunsthistorischen Institutes in Florenz* 21 (1977), 221–306.

5. Natali 1995, 134, and 1996, 134.

6. Emanuela Andreatta, "Il Campanile," in *La Chiesa e il Convento di Santo Spirito a Firenze,* ed. Cristina Acidini Luchinat (Florence, 1996), 135–137.

7. Natali 1995, 130–131. Natali 1995, 135, suggests the identity of this woman might be established from the location of her house, mentioning, for example, that the Pitti lived in this neighborhood.

8. Natali 1995, 132–133.

9. Elizabeth Cropper, *Portrait of a Halberdier* (Los Angeles, 1997), 92–98.

10. Charles Dempsey, "SVA CVIQUE MIHI MEA: The Mottos in the Camerino of Gioanna da Piacenza in the Convent of San Paolo," *The Burlington Magazine* 132 (1990), 490–492.

11. Cecil Gould, *The Paintings of Correggio* (Ithaca, 1976), 211; David Ekserdjian, *Correggio* (New Haven, 1997), 74–75.

37 *A Lady with a Nosegay*

SELECTED BIBLIOGRAPHY

Hendy, Philip. *European and American Paintings in the Isabella Stewart Gardner Museum.* Boston, 1974.

McComb, Arthur. "Francesco Ubertini (Bacchiacca)," *The Art Bulletin* 8 (1926), 140–167.

Merritt, Howard. "Francesco Ubertini called Il Bacchiacca, 1494–1557," *The Baltimore Museum of Art News* 24 (1961), 19–34.

Nikolenko, Lada. *Francesco Ubertini called "Il Bacchiacca,"* 49. Locust Valley, N.Y., 1966.

Rosenthal, Gertrude. "Bacchiacca and His Friends: Comments on the Exhibition," and "Catalogue of the Exhibition," *The Baltimore Museum of Art News* 24 (1961), 7–18, 35–72.

Bacchiacca (1494/1495–1557) belongs to the generation of Pontormo, Franciabigio, and Granacci. Vasari reports that he was a pupil of Perugino, and this helps to explain the oddity of his style in relation to his more modern contemporaries.[1] He specialized in decorative projects, and, indeed, Cosimo I de' Medici commissioned from him a little study painted with animals and rare plants. Like Pontormo, Bacchiacca was especially fascinated by the Northern manner of such artists as Lucas van Leyden, and he appropriated motifs from prints by Lucas and others in his compositions.

Bacchiacca's female heads also reflect this tendency to appropriate models from other artists. The head of the Madonna in the *Madonna and Child* in the Baltimore Museum of Art, for example, is derived from the drawing of an ideal head by Michelangelo (Uffizi 599E). A similar ideal head, or *testa divina,* seen in profile, and with richly ornamented headdress and braids, appears in the *Lady with a Vase of Flowers* (Museum of Fine Arts, Springfield, Massachusetts).[2] In that work the juxtaposition of the woman and the vase establishes the analogy between ideal female beauty and the shape of a vase discussed in connection with Bronzino's *A Young Woman with Her Little Boy* (cat. 41). The pinks and roses in the vase evoke the poetic metaphors of Petrarchan poetry, in which the colors of the cheeks and lips of a beautiful woman are associated with these flowers.

The *Lady with a Nosegay* makes no reference to Michelangelo's drawings of ideal heads, and is more truly a portrait, in which this somewhat graceless lady is associated with the poetic tradition through the format of her portrait and the flowers that she clasps. The overall condition of the work is not very good, and abrasion compromises the appearance of her face and hair especially. In its format the portrait follows the model of Raphael's *La Gravida,* which had already been taken up by Bugiardini in his portrait of *"La Monaca"* (cat. 36A). Bacchiacca followed a different intermediary, however, for the oddly drawn shoulders, one in profile and the other turned forward, suggest a closer connection to Andrea del Sarto's *Portrait of a Young Woman (Lucrezia del Fede),* in the Prado.[3] Bacchiacca turned Sarto's charming

figure into a more awkward one, for the proportions of his figure are unusual, with the head rather too large for the torso, and the brow noticeably wide and high, the chin somewhat square. The long neck, which should signify the lady's ideal beauty, joins the shoulders in an uncertain way—something the string of gold beads only emphasizes. Taken with the disjointed quality of the shoulders, all this produces a highly idiosyncratic image, which the juxtaposition of the purple bows on the lime green headdress with the scarlet damask sleeves and bluish green bodice enhances.

This serious beauty is presented as someone's beloved, for she clasps her flowers in the manner of Verrocchio's *Lady with a Bunch of Flowers* (cat. 22), and Leonardo's *Ginevra de' Benci* (cat. 16), according to David Alan Brown's proposal for its reconstruction. Lorenzo de' Medici's sonnets are full of references to flowers, and in one poem (CIX) he claims that wherever his lady turns her eyes, the goddess Flora makes the flowers spring up.[4] Another sonnet (CXLVIII) is addressed to the violet plucked by his lady and given to him. Lorenzo clasps it to his bare chest, but it seems to want to escape back into his lady's hand. Bacchiacca was known for painting the details of nature. The white jasmine is identifiable, and the other flowers appear to be a species of ranunculus. There may be a rose in bud. The whiteness of these flowers, echoing the whiteness of her *camicia* and sleeves, points up the whiteness of her bosom and complexion. Lorenzo de' Medici also praised the "candido pallore," or gleaming whiteness of his beloved's complexion (CXXVII), which he described as providing a contrast for her other beauties in the way that a green meadow sets off the beauty of the flowers. Like much of Bacchiacca's work, the portrait has an out-of-date quality, which renders the virtuous beauty of this unknown and rather homely woman all the more poignant. EC

NOTES

1. Giorgio Vasari, *Le Vite de' più eccellenti pittori scultori ed architettori,* ed. Gaetano Milanesi, 9 vols. (Florence, 1906), 3: 592.

2. Merritt 1961, 14, 26; Rosenthal 1961, 15; Nikolenko 1966, 61.

3. McComb 1926, 146, 150; Nikolenko 1966, 49; Hendy 1974, 10.

4. Lorenzo de' Medici, *Canzoniere,* ed. Tiziano Zanato, 2 vols. (Florence, 1991), 2.

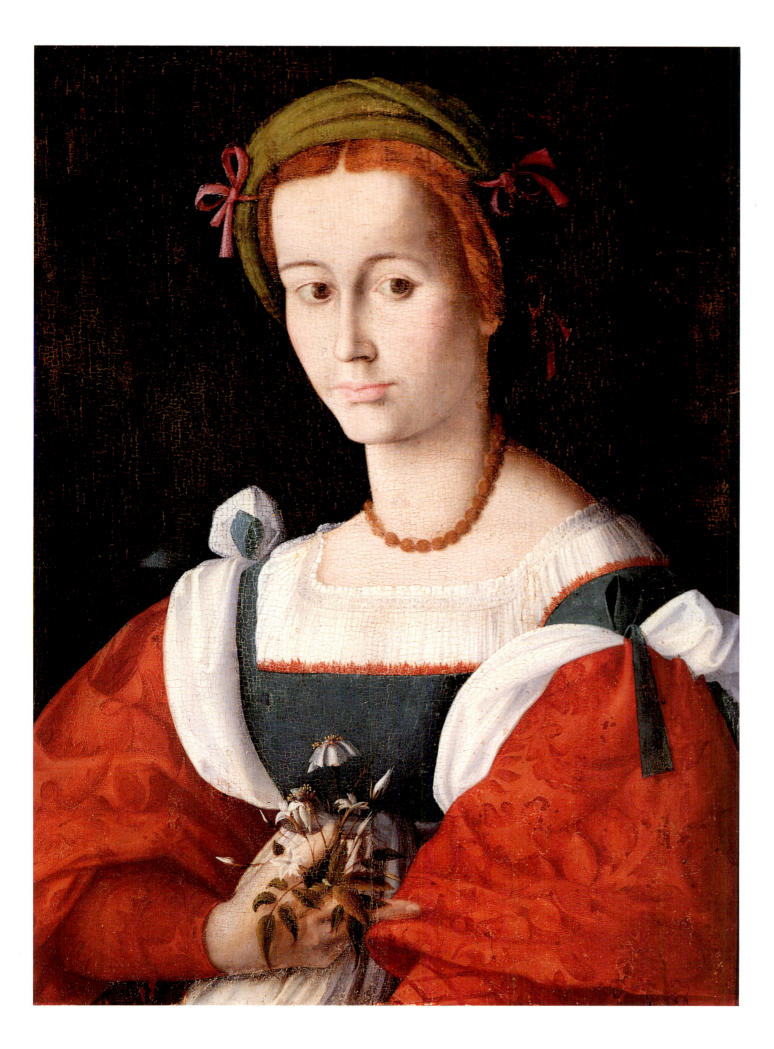

Ridolfo Ghirlandaio

c. 1530–1532, oil on panel
62.9 × 45.7 (24¾ × 18)

National Gallery of Art, Washington,
Widener Collection, 1942.9.23

38 *Lucrezia Sommaria*

SELECTED BIBLIOGRAPHY

Franklin, David. "Ridolfo Ghirlandaio's
Altarpieces for Leonardo Buonafé and
the Hospital of S. Maria Nuova in
Florence," *The Burlington Magazine* 135
(1993), 4–16.

Gamba, Carlo. "Ridolfo e Michele di
Ridolfo Ghirlandaio—1." *Dedalo* 9
(1928–1929), 463–490.

Shapley, Fern Rusk. *Catalogue of the
Italian Paintings,* 1: 90. 2 vols. Washington, 1979.

Ridolfo Ghirlandaio, *Three Angels in
Adoration* (detail), Galleria dell'Accademia,
Florence (photo: Scala/Art Resource, N.Y.)

Since its appearance on the Florentine art market
at the end of the last century and its subsequent
purchase in London by P. A. B. Widener, this work has
remained a mystery. Rightly called "an unassuming
masterpiece" by Shapley, the portrait has long lacked
a secure attribution.[1] The intense aqueous blue-green
of the dress, contrasting with the black border of the
bodice, and the brilliant reflections in the gleaming
white chemise led several scholars, including Shapley,
to suggest the name of Brescianino, who never entirely abandoned his interest in the rich colors of the
north Italian tradition after moving to Siena and
Florence. On the other hand, the names of Franciabigio, Domenico Puligo, Ridolfo Ghirlandaio (1483–
1561), and of his pupil Michele di Ridolfo Tosini have
also been proposed. The difficulty lies in the complexity of the artistic situation in Florence following
the departure of Raphael in 1508, when Fra Bartolomeo and Andrea del Sarto perpetuated and developed a Florentine manner that had its roots in the
religious art of the quattrocento, even as it assimilated the innovations of Leonardo da Vinci. Both Fra
Bartolomeo and Sarto explored the stylistic expression of piety and devotion, something our portrait
also conveys.

Ridolfo Ghirlandaio received a series of commissions
for altarpieces in the 1510s, and these reflect a close
study of Raphael's Florentine works, and of the manner of Fra Bartolomeo, with whom he worked around
1504.[2] He had a long career, however, and his later
work remains largely unstudied. Ridolfo was clearly
a fine portraitist, moving from a style close to that
of his father to a much more individual manner, as
in the portrait of an old man in the National Gallery,
London. An earlier portrait, possibly of this same
man, now in the Sterling and Francine Clark Art
Institute, employs a format similar to that seen in the
portrait of Lucrezia, with the figure set against a plain
background, and including a single hand, though
without the ledge.

Lucrezia does not look out at us, but turns to her
right. Her features are marked by her auburn hair,
wide brow, small mouth, pointed chin, and her
remarkable, almond-shaped, gray eyes. Rather than
resembling any of the recent portraits by Leonardo,
Raphael, or even Sarto, she appears more like a
Madonna, an angel (as in the central figure in the
Three Angels in Adoration in the Galleria dell'Accademia, Florence, fig. 1), or a female saint in one
of Ridolfo's altarpieces (such as the Magdalen in the
Way to Calvary, National Gallery, London). This
type had been made popular in Florence by Fra
Bartolomeo and his colleague Albertinelli, but in
Ridolfo's later picture the liquid quality of the paint
and quiet composure of the figure suggest the new,
cooler elegance of Pontormo and Bronzino.[3] Her
large hand, with its strong fingers and pronounced
joints, is entirely in keeping with Ridolfo's style.
Lucrezia's meditative gaze, quite unusual in a Florentine portrait at this date, is the strongest clue we
have to her personality or status. The inscription
on the ledge on which she rests her arm was reworked
at some point, but nothing suggests that it was
changed (with the possible exception of the abbreviation mark).

The Da Sommaia (or Sommaria), originally from
the place of the same name outside Florence, built
their palace in the sixteenth century at the corner of
via dei' Fossi and via della Spada.[4] Matteoli suggested
that Lucrezia might be the daughter of Gerolamo
di Francesco di Guglielmo da Sommaia, and so sister
of Costanza da Sommaia. Costanza was married
to the writer Giovambattista Doni, and her name is
better known because Vasari records that Bronzino
included her portrait, together with that of Camilla
Tebaldi del Corno, in his *Descent into Limbo,* painted
for the Zanchini chapel in Santa Croce in 1552.[5]
These two women, writes Vasari, were worthy to be
included on account of their "incredible beauty
and honorableness."[6] The registers of the Baptistery
in Florence, however, document only one surviving
Lucrezia born into the Sommaia family, and to

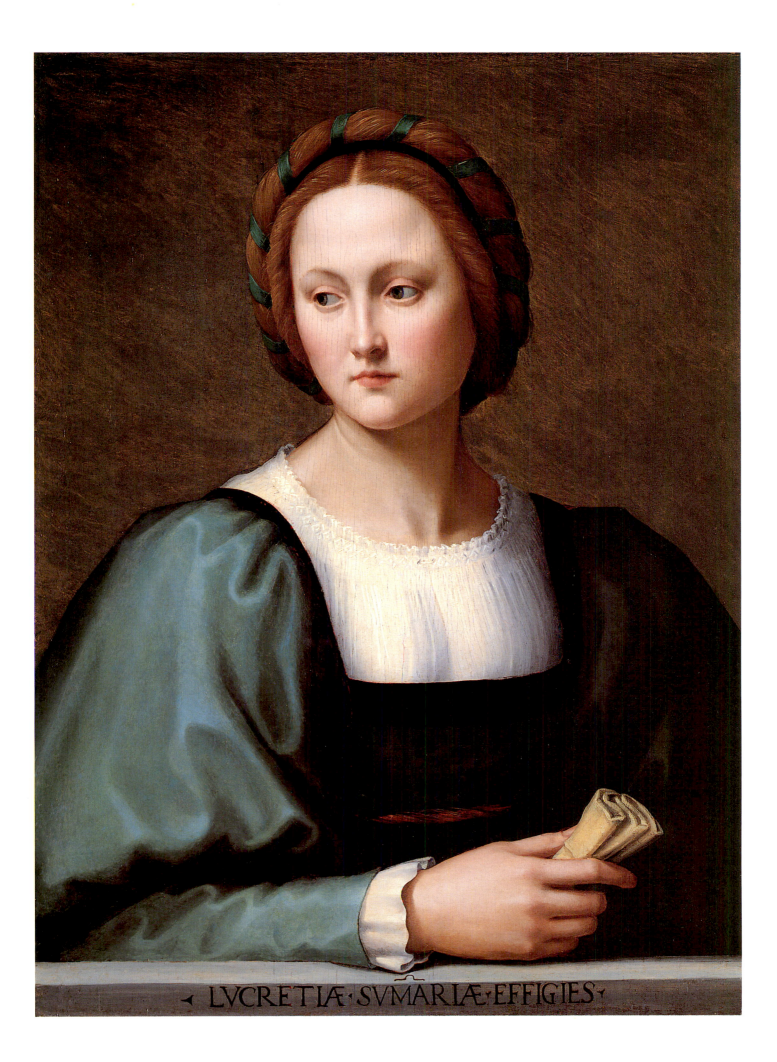

LVCRETIÆ·SVMARIÆ·EFFIGIES

a different father. On 24 January 1513 a baby girl, daughter of Giovanni del Rosso da Sommaia, was baptized Lucrezia Romola. This child must not have survived, for another daughter born to Giovanni was given the same name on 2 April 1514.[7] Lucrezia Sommaria must be sixteen in this portrait, and possibly a year or two older. Though somewhat wan, she is certainly presented as a beauty, and her averted gaze carries the implication of her virtue, perhaps even piety. She wears no jewels, her only ornament being the ring of false hair intertwined with dark blue ribbon (in a style similar to that worn by Bronzino's *Portrait of a Lady,* cat. 39); her exquisitely painted chemise is of the simplest kind, as is the chamois glove in her hand. Giovanni del Rosso da Sommaia gave his daughter an ancient Roman name of great portent. Whatever Lucrezia's fate, her portrait represents her as honest and beautiful as the ancient heroine whose name she bore. EC

NOTES

1. Shapley (1979) attributes the work to Brescianino, while noting the opinions of Venturi, Berenson, and Zeri that it is by Ridolfo.

2. Franklin 1993.

3. The angel, though from an earlier period, has the same high brow, pointed mouth, and oval eyes in softly shaded sockets. See also the Madonna in the *Madonna and Child with Saints* attributed to Ridolfo in the Mint Museum of Art, Charlotte, North Carolina. For examples of earlier works by artists who provided models for Ridolfo, see the *Holy Family* in the Galleria Borghese, Rome (1511), and the *Saint Catherine of Alexandria* in the Pinacoteca Nazionale, Siena (1511), both attributed to Albertinelli, in *L'Età di Savonarola: Fra Bartolomeo e la Scuola di San Marco,* ed. S. Padovani [exh. cat., Palazzo Pitti] (Venice 1996), no. 35, 138–141; no. 40, 145–148.

4. See Roberto Ciabani, *Le famiglie di Firenze,* 4 vols. (Florence, 1992), 3: 669–670.

5. Anna Matteoli, "La Ritrattistica del Bronzino nel 'Limbo,'" *Commentari* 20 (1969), 281–292, esp. 285.

6. Giorgio Vasari, *Le Vite de' più eccellenti pittori scultori ed architettori,* 9 vols. (Florence, 1906), 6: 600. Bronzino also included portraits of the painters Pontormo and Bacchiacca, and of Giovambattista Gelli, writer and fellow member of the Florentine academy, in this altarpiece.

7. I thank Sabine Eiche of the research staff at the Center for Advanced Study in the Visual Arts for sorting out this problem in the Archivio dell'Opera del Duomo, Florence. See Registri di Battesimo, *Femmine,* vol. 1501–1512, c. 189v, for the entry for Lucrezia Romola on 24 January 1512 (1513, modern style). The second Lucrezia Romola appears in vol. 1513–1522, c. 19, where it is recorded that she was baptized on 2 April 1514. No Lucrezia da Sommaia appears in the records for 1489–1501.

| Agnolo Bronzino | c. 1533, oil on panel | Städelsches Kunstinstitut, |
| | 90 × 71 (35 ³/₈ × 28) | Frankfurt am Main, inv. no. 1136 |

39 *Portrait of a Lady*

SELECTED BIBLIOGRAPHY

Cecchi, Alessandro. *Agnolo Bronzino,*
16–17. Florence, 1996.

Costamagna, Philippe. *Pontormo,*
296–297. Milan, 1994.

McCorquodale, Charles. *Bronzino,*
23, 46, 50. London, 1981.

Smyth, Craig Hugh. "Bronzino Studies,"
109–125. Ph.D. diss., Princeton, 1955.

This lady in red communicates an extraordinary combination of composure and sophisticated wit. The wit comes from the alignment of her broad, frank, face, with its penetrating eyes, wide-nostriled nose, and amiable mouth, with the equally attentive head of her little dog, whose large ears only serve to call attention to hers. The grotesque face in gilded bronze on the arm of the chair encourages the viewer to read the portrait this way, for it too is a joke, intended to remind us (as in the case of cat. 36) that faces are masks. Whereas in portraying Ginevra de' Benci Leonardo da Vinci sought to establish that beauty could adorn honor, Bronzino (1503–1572) challenges the viewer to reconsider what a face really signifies and just what beauty might conceal in a courtly world.

The portrait is by no means a caricature, however. It presents a sympathetic figure with real dignity through the skillful manipulation of pose and setting, and this tempers the humor. The austere architectural niche behind the woman establishes a Florentine setting by juxtaposing *pietra serena* pilasters with the white plaster of the curving wall. The stool is placed almost parallel to the picture plane, but in other respects, especially the details of the brilliant golden knobs and the fringes, it calls to mind the elaborate chair upon which the pope sits in Raphael's portrait of *Leo X and the Cardinals,* in the Uffizi, Florence.[1] This was completed in 1518, when it was sent to Florence for the marriage of Lorenzo de' Medici, duke of Urbino, and Maddalena de la Tour d'Auvergne, and it immediately became one of the most renowned works in Florence.[2] Like other Medici possessions it was under serious threat during the years of the last republic, between April 1527 and August 1530, when the Medici were expelled from the city. Raphael's masterpiece would have been especially vulnerable because it portrayed not only the former Medici pope, but also the hated Cardinal Giulio de' Medici, now Pope Clement VII, who enlisted the support of Emperor Charles V to lay siege to the city and defeat

the republic. Ottaviano de' Medici stayed in Florence throughout the siege, and he protected many works of art from Palazzo Medici in his own house. Raphael's portrait was still in his safekeeping in 1537, now as honored as it had been hated.

When Bronzino returned from his two-year stay in Urbino and Pesaro in 1532 he found the Medici returned to power as dukes. Raphael's portrait represented that power, and his rediscovery of this almost completely red painting may help to account for the shocking redness of Bronzino's portrait. Bronzino's interest was as much in Raphael, however, as in political alignments, even as his intense study of Michelangelo's figure of Giuliano de' Medici in the Medici chapel (just beginning to be evident here) was as much about interpreting the work of a Florentine artist as it was about the Medici. In the aftermath of the siege, Bronzino, in particular, explored the idea of expressing a Florentine cultural tradition as a way of putting to rest the horrors of the recent past, an idea that he would share with Cosimo I de' Medici, who became duke in 1537.[3]

All of this denies the old attribution of the portrait to Pontormo. That traditional attribution is a venerable one, for it goes back to the 1612 inventory of the Riccardi collection in Florence, which contained two other known portraits by Pontormo, one of which is included in the exhibition (cat. 40).[4] The name of Bronzino was, however, substituted in the catalogue of the Fesch collection as early as 1841, repeated in Weizsäcker's catalogue of the Gemäldegalerie in 1900, and then firmly proposed by Craig Hugh Smyth in 1955.[5] Distinguishing the hands of Pontormo or Bronzino is especially difficult in this case because until the early 1530s the relationship between the two artists was very close, and Bronzino often used, or reused, drawings by his master. One reason this portrait is so fascinating is that it combines the "republican," more restrained qualities of Pontormo's work of c. 1530 (as in the Getty *Portrait of a Halberdier*) with the new courtliness that Bronzino

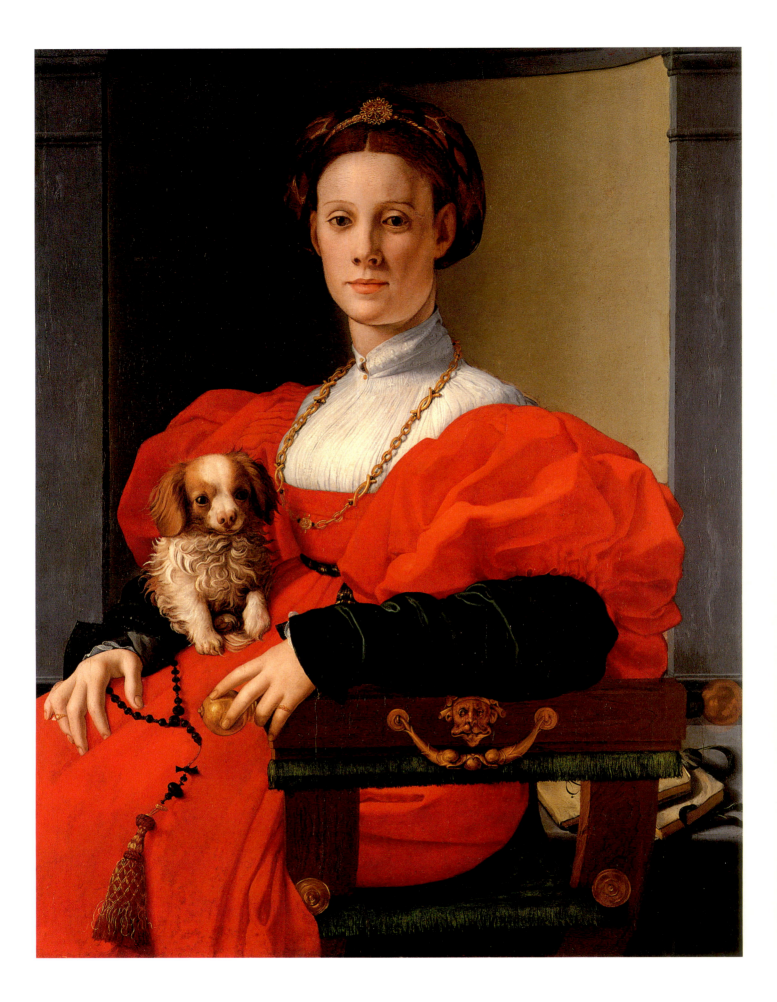

1

Bronzino, *Portrait of a Young Man,*
The Metropolitan Museum of Art, New
York, Bequest of Mrs. H. O. Havemeyer,
1929. The H. O. Havemeyer Collection.
All rights reserved

1

would refine in portraits of the next decade, including *A Young Woman and Her Little Boy* (cat. 41). The Frankfurt portrait has for this reason often been compared to the *Portrait of a Young Man* (fig. 1) in the Metropolitan Museum of Art (for which see also cat. 41). Philippe Costamagna points out that Pontormo never painted the details of finely wrought jewelry seen here, from the golden fillet on the lady's head, with its round centerpiece, to the unique design of her gold chain, and her black rosary, its red silk tassel ornamented with fine gold thread.

Costamagna also suggests that the ring on the woman's right hand points to a connection with the Medici, for whom the diamond was a family emblem, and he concludes that the portrait represents Francesca Salviati, daughter of Lucrezia de' Medici and Jacopo Salviati, who married Ottaviano de' Medici in 1533 after being widowed in her first marriage to Piero Gualterotti.[6] This theory might very

well explain her composure and wit: as a widow she is shown as pious, but she is also the confident descendant of the most powerful family in Florence, and the artistic and architectural associations in her portrait link her to the family tradition. Such a balance of naturalism and wit would not long survive in the 1540s. Whoever this lady is, her portrait, like that of the young man in New York, must date to the 1530s when Bronzino was still following Pontormo's model, and before the austere manners of the court prevailed. EC

NOTES

1. As in the case of Bronzino's *A Young Woman and Her Little Boy* (cat. 41), there seems to be a link to Parmigianino here. The *Portrait of Galeazzo Sanvitale* (1524, Museo e Gallerie Nazionali di Capodimonte, Naples) also shows the sitter looking straight out and seated in a chair with the arm parallel to the foreground plane.

2. See Costamagna 1994, 296–297, no. A57, for the association of the fringe on the chair with Raphael's portrait. On the history and significance of the Raphael, see *Raffaello a Firenze: Dipinti e disegni delle collezioni fiorentine* [exh. cat., Palazzo Pitti, Florence] (Milan, 1984), 189–198, cat. 17.

3. Elizabeth Cropper, "Prologomena to a New Interpretation of Bronzino's Florentine Portraits," in *Renaissance Studies in Honor of Craig Hugh Smyth,* ed. Andrew Morrogh et al., 2 vols. (Florence, 1985), 2: 149–162.

4. These are the *Portrait of a Halberdier* in the J. Paul Getty Museum, Malibu, and the *Portrait of Maria Salviati with Giulia de' Medici* in the Walters Art Museum, Baltimore (cat. 40).

5. Costamagna 1994, 296.

6. Costamagna 1994, 297. The author's arguments concerning color symbolism, and even the diamond, remain speculative, and the claim that the painting must have been in Ottaviano de' Medici's collection because it represents his wife is quite circular.

| Pontormo | c. 1538, oil on panel | The Walters Art Museum, Baltimore, |
| | 88 × 71.3 (34 5/8 × 28 1/16) | inv. no. 37.596 |

40 *Maria Salviati with Giulia de' Medici*

SELECTED BIBLIOGRAPHY

Costamagna, Philippe. *Pontormo*, 236–238. Milan, 1994.

Cox-Rearick, Janet. "Bronzino's *Young Woman with Her Little Boy*," in *Studies in the History of Art* 12 (Washington, 1982), 67–77.

Cropper, Elizabeth. *Pontormo: Portrait of a Halberdier*, 5–7. Los Angeles, 1997.

Keutner, Herbert. "Zu einigen Bildnissen des frühen Florentiner Manierismus," *Mitteilungen des Kunsthistorischen Institutes in Florenz* 7 (1955), 140–154.

King, Edward S. "An Addition to Medici Iconography," *The Journal of the Walters Art Gallery* 3 (1940), 75–84.

Langdon, Gabrielle. "Pontormo and Medici Lineages: Maria Salviati, Alessandro, Giulia and Giulio de' Medici," *RACAR* 19 (1992), 20–40.

In 1612 this portrait was to be seen hanging in one of the lunettes in the courtyard of the elegant casino of the Florentine estate known as Valfonda, which was then owned by Riccardo Riccardi, one of the richest men in the city.[1] Close by, in another lunette, hung the *Portrait of a Lady* now in Frankfurt (cat. 39). In the Riccardi inventory of 1612 the latter was attributed to Pontormo (1494–1556/1557), whereas it is now generally given to Bronzino. The identification in the inventory of the portrait of *Maria Salviati* as by Pontormo, on the other hand, is almost universally accepted. At the end of the nineteenth century, however, the work, then in the Massarenti collection, was briefly attributed to Sebastiano del Piombo. This attribution may have gained support from the fact that the portrait then looked quite different, for the child had been painted out, and the single sitter identified as Vittoria Colonna. The portrait was purchased in this form from Massarenti by Henry Walters in 1902. Only in 1937 was the overpaint removed, revealing the child, and Edward S. King (1940) subsequently published the cleaned work as *Maria Salviati and Her Son Cosimo*.

In a private response to King's argument, jotted on a postcard to Melvin Ross at the Walters on 30 March 1941, Bernard Berenson commented that "the prodigiously learned gentleman who wrote on the Pontormo portrait makes a serious mistake in the sex of the child. This is certainly a girl and therefore not the *boy* destined to become Cosimo I."[2] The child is indeed young enough for there to be some confusion about its sex, and the paint surface is quite damaged toward the lower edge. It was only the discovery of the 1612 inventory of the Riccardi possessions by Herbert Keutner in 1955 that brought support for Berenson's view. In the inventory the picture is described in the following way: "A painting of one and one-half *braccia* of Signora Donna Maria Medici with a little girl *(una puttina),* by the hand of Jacopo da Puntormo."[3] Even so, Keutner himself preferred to continue to read the child as a boy, and the argument that this portrait must represent the widowed Maria Salviati with her son Cosimo has prevailed in the face

of the evidence of the inventory and indeed of the picture itself.[4] The question of the date and the circumstances of the portrait have remained uncertain, however, with some scholars dating the portrait to 1526, soon after the death of Cosimo's father (which would make the child nearly eight), others dating it to 1537, when Cosimo became duke (which would make this a retrospective image of the child), and yet others to the early 1540s, suggesting that this is an entirely retrospective image, painted after the death of Maria Salviati in 1543, and depicting her son as a small boy, as if at the time of his father's death.

In 1992 Gabrielle Langdon cut through this tangled and confusing set of hypotheses, proposing not only that the child is indeed a girl, but also that she is Giulia de' Medici, daughter of Cosimo's cousin, Duke Alessandro de' Medici, whose murder in 1537 led to Cosimo becoming duke.[5] The child, she points out, is surely younger than seven, and is, furthermore, shown as a vulnerable being under the protection of the dignified Maria Salviati, whose widow's dress is unadorned by jewels. There is every reason to believe that Maria, dedicated to the advancement of her son's interests, would never have allowed him to be shown as in need of her protection, especially retrospectively. Other dynastic portraits of young children reveal the importance of having a son resemble his father, both in appearance and in status. This little child's vulnerability, by contrast, is enhanced by the low neckline of the dress, and by the delicacy of the drapery swathed around the shoulders. The visual connection between Maria's bared throat and that of the child is strong, implying shared femininity. The little curls around her brow, and the length of the hair, even if overpainted, provide further clues that this is a young girl, probably not more than three or four years old. Alessandro was widely acknowledged to be the natural son of Pope Clement VII, and his mother Simunetta was very likely a Moorish slave. Giulia was said to resemble her father closely, and comparison with portraits of Alessandro suggest that they share an ancestry that was North African in part.

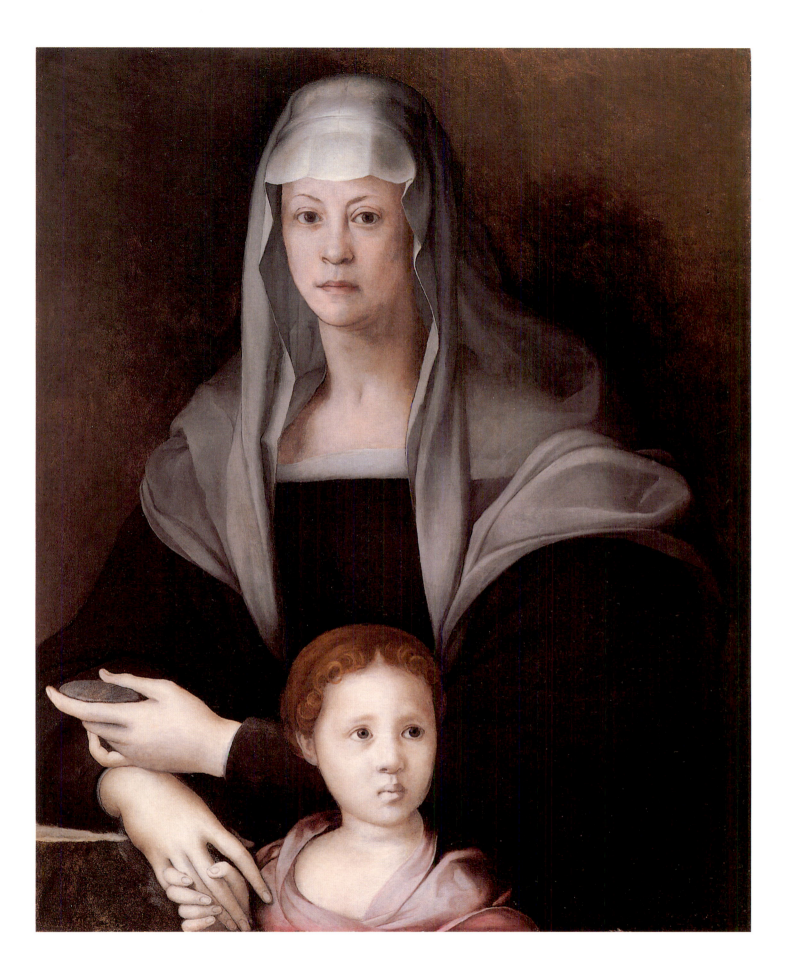

Giulia and Giulio de' Medici, whose very names associate them with their grandfather Cardinal Giulio (elected to the papacy as Clement VII in 1523), were both made wards of Cosimo I after their father was murdered. The powerful Cardinal Cibo was a descendant of Cosimo il Vecchio and had the support of the emperor Charles V. He was also related by marriage to the putative mother of Alessandro's children, and had at first hoped that power might pass to the impossibly young Giulio, then only four years old. He had to settle instead for a promise from Cosimo to avenge his cousin Alessandro's death and to take care of the two orphans. Until Cosimo had heirs of his own, and until his power was assured, it was greatly in his interests to do so, and, despite Cibo's claims to the contrary, there is evidence that he guarded them attentively and with genuine affection. Rather than showing the widowed Maria Salviati protecting her own son, therefore, the portrait documents her protection of Giulia. Quite possibly the medal she holds, the surface of which can no longer be read, once bore an image of Alessandro. Its presence would have reinforced the child's standing, while also underlining the continuity of rule, for Cosimo immediately adapted his murdered cousin's medal to his own image. Until now the child's date of birth has remained uncertain, but her marriage in 1550 supports the view that she could have been born no earlier than 1533 and no later than 1536. The records of the Baptistery in Florence list a "Giulia Romola," father unknown, as having been baptised on 5 November 1535. Giulio is said to have been born in 1533, and a "Giulio Giovanbattista Romolo," appears in the register for 5 December 1533.[6] In any case, the implication, as Langdon has suggested, is that the portrait was made soon after Cosimo became duke in 1537, and when Maria Salviati was about thirty-eight, widowed but still vital. The sobriety of the image and the almost monochromatic values of the portrait associate it with Pontormo's portrait of *Giovanni della Casa* in the National Gallery of Art of about the same date.

If indeed this portrait documents an aspect of the Florentine dynastic crisis after the murder of Alessandro de' Medici, then these special circumstances would help to account for Pontormo's production of a new type of portrait in Florence showing a woman and a child.[7] Cosimo I soon had his own heirs, beginning with Francesco in 1541. In 1545 Bronzino was commissioned by the duke to paint Eleanora with a child, probably their second son Giovanni, then two years old (see cat. 41, fig. 1). Eleanora protects her son, just as her mother-in-law had protected her orphaned ward. The mood is quite different, however, with the jolly child now looking out as confidently as his bejeweled and coolly elegant mother. Thus transformed by Bronzino, the new type of portrait seems to have become so attractive that the portrait of *A Young Woman with Her Little Boy* in the National Gallery of Art (cat. 41) was adapted to match it. EC

NOTES

1. Keutner 1955.

2. From the curatorial files of the Walters Art Museum. Cited by Elizabeth Cropper, *Pontormo: Portrait of a Halberdier* (Los Angeles, 1997), 4.

3. Keutner 1955, 151.

4. For the various views, see Costamagna 1994. Luciano Berti has always maintained that the child is a girl.

5. Gabrielle Langdon, "Pontormo and Medici Lineages: Maria Salviati, Alessandro, Giulia and Giulio de' Medici," *RACAR* 19 (1992), 20–40. Joaneath Spicer, curator of Renaissance and baroque art at the Walters Art Museum, is preparing a short note on the reidentification (accepted by the museum after the appearance of Langdon's argument), and I am grateful to her for discussing it with me. Langdon was not the first to propose the name of Giulia, but the only scholar to provide a convincing argument for her presence.

6. My thanks to Sabine Eiche of The Center for Advanced Study in the Visual Arts for establishing these dates. See Archivio dell'Opera del Duomo, Florence, Registri di Battesimo, *Femmine*, 1533–1542, fol. 46v, and *Maschi*, 1533–1542, fol. 14.

7. Cox-Rearick 1982, 74.

Agnolo Bronzino

c. 1540–1545, oil on panel
99.5 × 76 (39 1/8 × 29 7/8)

National Gallery of Art, Washington,
Widener Collection, 1942.9.6

4I *A Young Woman and Her Little Boy*

SELECTED BIBLIOGRAPHY

Baccheschi, Edi. *L'Opera completa del Bronzino*, 90. Milan, 1973.

Cecchi, Alessandro. *Agnolo Bronzino.* Florence, 1976.

Cox-Rearick, Janet. "Bronzino's *Young Woman with Her Little Boy.*" *Studies in the History of Art* 12 (1982), 67–79.

Emiliani, Andrea. *Il Bronzino*, pls. 58, 59. Busto Arsizio, 1960.

McCorquodale, Charles. *Bronzino*, 93. New York, 1981.

Shapley, Fern Rusk. *Catalogue of the Italian Paintings,* 1: 91–92. 2 vols. Washington, 1979.

In his biography of Bronzino (1503–1572), published in the 1568 edition of the *Lives,* Giorgio Vasari set out to list the names of those Florentines whose portraits the artist had painted in the 1530s, only to tell his reader that he was abandoning the attempt because it would take too long. "It's enough to say," he concludes, "that they were all most natural, made with incredible diligence, and finished in such a way as to leave nothing to be desired."[1] This diligence and ability to imitate natural truth attracted the admiration of Duke Cosimo I de' Medici, and in the years following his marriage to Eleonora of Toledo in 1539 Cosimo had the artist make portraits of the ducal family, together with "many others" (fig. 1).[2] Bronzino's images took on the force of official court portraits, and as a result his representations of members of the Medici family can usually be identified, either by comparison with others or through documents. Vasari's decision not to list all those other Florentines who sat for Bronzino has, by contrast, made it very difficult indeed to identify sitters such as this elegant lady in red standing before a rich green drapery.

In many respects the Washington *Young Woman* closely resembles *Lucrezia Panciatichi* (fig. 2), which, together with the pendant *Bartolomeo Panciatichi* is generally dated to around 1540. Like Lucretia, this young woman wears her hair in a severe style with a center part; her straight nose constitutes one-third of her face, following the rules of Vitruvian proportion; her brow is wide and serene; her lips curving and full, with a little furrow above them. Her long columnar neck sits gracefully on her full, sloping shoulders, like that of a wide-handled vase, and this association is subtly underlined through the lady's earrings, which take the form of little vases with handles. These qualities, especially the association of the figure of a beautiful woman with that of well-proportioned vase, all conform to contemporary codes of female beauty, spelled out in such texts as Agnolo Firenzuola's *Delle bellezze delle donne,* and given their most conspicuous visual expression in Parmigianino's *Madonna of the Long Neck* (1534, Uffizi, Florence).[3] Bronzino's two portraits are linked not only by conventions of beauty, but also those of fashion, for the two women are outfitted in a remarkably similar way. Both wear simple dresses of the type known as a *camora,* with a square neckline modestly, if expensively, filled in with a finely pleated partlet.[4] The puffed and gathered sleeves are of the same fabric as the dress, with the slashed lower sleeves of a different shade, in each case with white ruffles at the wrist. Both women wear two necklaces, one encircling the neck and the other hanging across the breast from the shoulders; and both wear elaborate chains of gold or jewels around the waist. Many of these fashionable accessories are to be found in Bronzino's Medici portraits, especially *Eleonora of Toledo with Her Son Giovanni,* and even in that of Cosimo's little daughter Bia.[5] All of these connections suggest that our portrait represents a woman close to the Medici court around 1540.

The National Gallery portrait once seemed to belong in series between the Panciatichi portrait of a seated woman with no child and the famous portrait of Eleonora of Toledo, richly dressed, with her child. But the cleaning of the painting in 1976 led to the remarkable discovery that the Washington portrait originally depicted a standing woman holding a piece of paper in her right hand, with no child present, and without the gloves in her left.[6] She wore a less ambitious headdress or *balzo,* narrower sleeves (and the changes here where the darker ground shows through the newer paint are visible to the naked eye), and a higher waistline without the belt; the crimson fabric was probably as plain as Lucrezia Panciatichi's. Her face also seems to have been less refined and perfect than the waxen complexion we now see. The reason for all these changes seems clear. Bronzino's *Eleonora of Toledo with Her Son Giovanni,* completed around 1545/1546, made fashionable a new type of portrait of mother and child; furthermore, the rich damask, the soft brown gloves, and the fuller, more imposing costume, are attributable to Eleonora's influence.[7] And, of course, our unknown young woman and her husband must have had a son to include in this sumptuous portrait, emulating the Medici's insistence on Eleonora's fecundity and the continuity of their family. The face of this little boy is even more eerily masklike than that of the young Giovanni de' Medici.

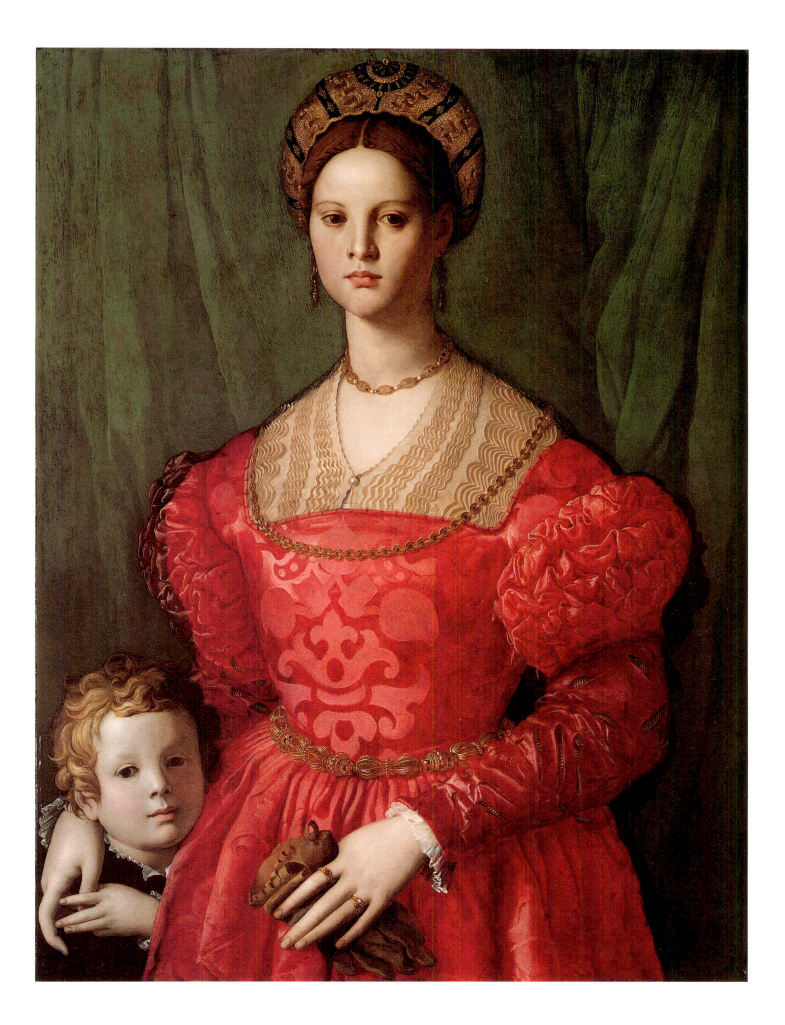

1

Bronzino, *Eleonora of Toledo with Her Son Giovanni,* **Galleria degli Uffizi, Florence (photo: Alinari/Art Resource, N.Y.)**

2

Bronzino, *Lucrezia Panciatichi,* **Galleria degli Uffizi, Florence (photo: Alinari/ Art Resource, N.Y.)**

There is no doubt that the changes in the picture were made by Bronzino himself.[8] How much time elapsed between the two versions is impossible to determine, though it is tempting to read the first portrait as that of a childless younger woman (perhaps holding a letter from a suitor?), with the final image completed some three or four years later when her son could stand beside her. So fashionable is this portrait in every respect, however, even in its first version, that one could also imagine the sitter's family asking Bronzino to include the child once the portrait of Eleonora of Toledo was unveiled, something that might not have occurred to them months before. None of these questions will be resolved until the identity of this imposing young mother is known. The remarkable closeness of her appearance to that of Lucrezia Panciatichi provides an important starting point, for this resemblance goes well beyond the conventions of the mask.[9] EC

NOTES

1. Giorgio Vasari, *Le Vite de' più eccellenti pittori scultori ed architettori,* 9 vols. (Florence, 1906), 7: 595.

2. Vasari 1906, 7: 598.

3. Elizabeth Cropper, "On Beautiful Women, Parmigianino, *Petrarchismo,* and the Vernacular Style," *Art Bulletin* 58 (1976), 374–394. See also Agnolo Firenzuola, *On the Beauty of Women,* trans. and ed. Konrad Eisenbichler and Jacqueline Murray (Philadelphia, 1992), 60–65.

4. For the costume, see Cox-Rearick 1982, 73–77.

5. Connections between the Washington portrait and both Parmigianino's *Portrait of Antea* and Titian's *Portrait of Isabella d'Este* have also been suggested.

6. Shapley 1979, 1: 91–92; and Cox-Rearick 1982.

7. Cox-Rearick 1982, 67–79. Pontormo's *Maria Salviati with Giulia de' Medici,* now in the Walters Art Museum, Baltimore, certainly provided the Florentine model for a standing woman with a child despite its very different mood (cat. 40).

8. The changes he made to render the portrait more imposing and elegant are comparable to those he made in the *Portrait of a Young Man* in the Metropolitan Museum of Art. Bronzino often made substantial changes as he worked, but in these two cases it appears that some time passed between the campaigns.

9. Cox-Rearick 1982, 75, calls attention to the resemblance of the son to children in other works of c. 1545, especially the Christ child in the Panciatichi *Holy Family* in Vienna.

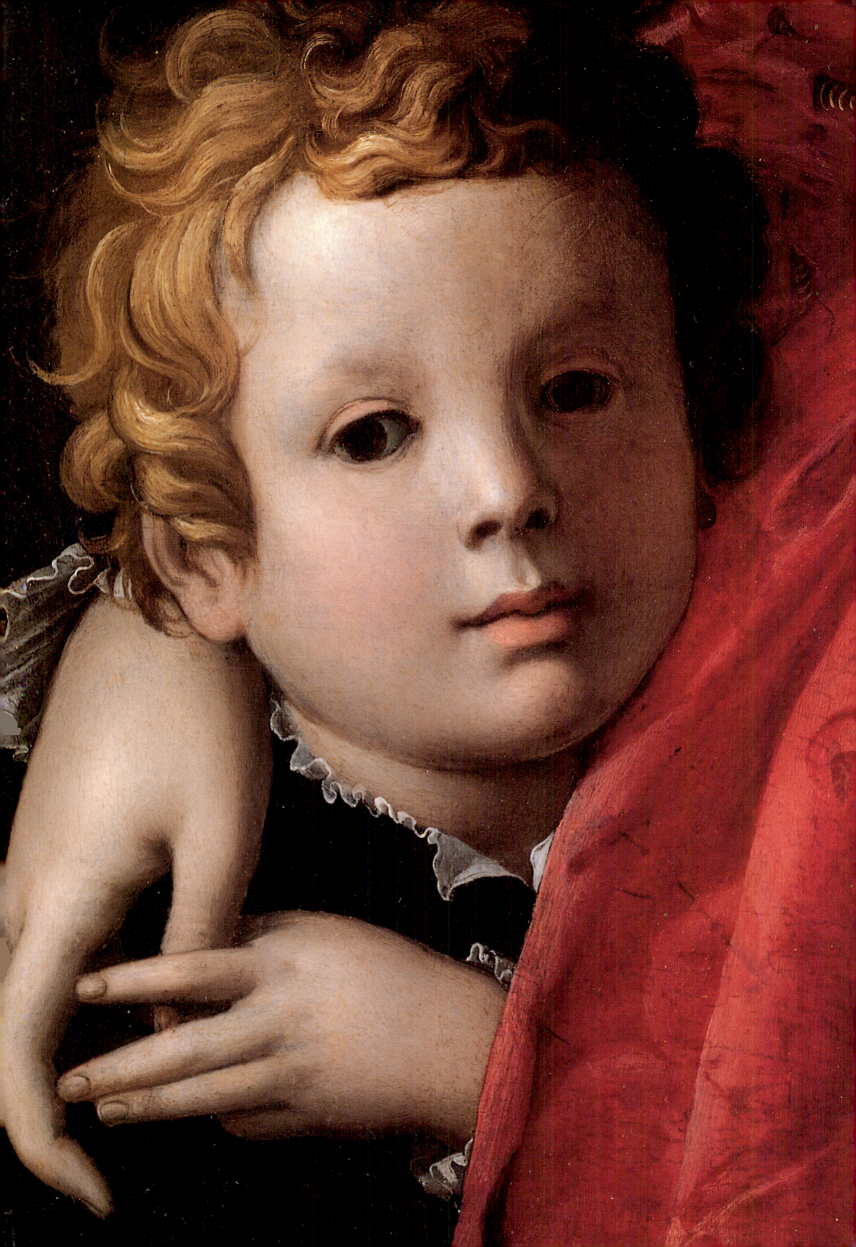

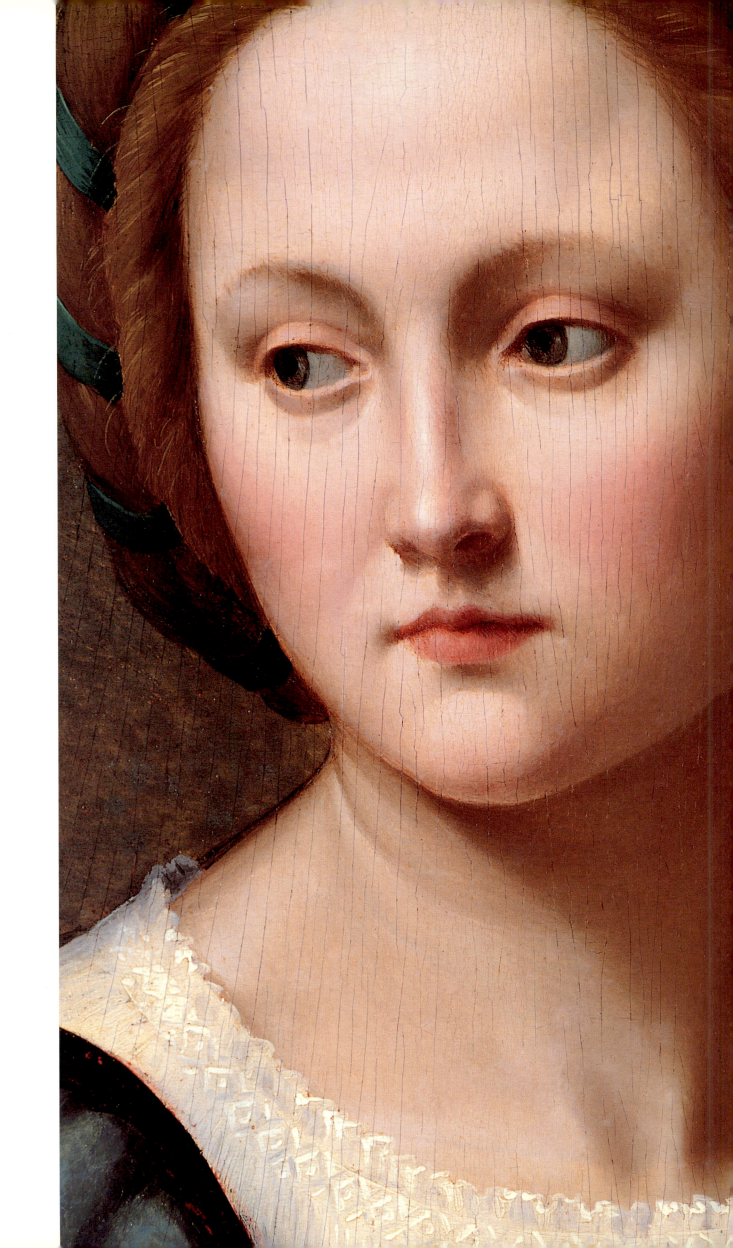

Index

Illustrations

page 2 (left to right):

Sandro Botticelli, *Young Woman (Simonetta Vespucci?) in Mythological Guise* (detail), c. 1480 / 1485, Städelsches Kunstinstitut, Frankfurt am Main (cat. 28)

Franco-Flemish Artitst, *Profile Portrait of a Lady* (detail), c. 1410, National Gallery of Art, Washington, Andrew W. Mellon Collection (cat. 1)

Domenico Ghirlandaio, *Portrait of a Lady* (detail), c. 1480/1490, Sterling and Francine Clark Art Institute, Williamstown, Massachusetts (cat. 29)

Pontormo, *Maria Salviati with Guilia de' Medici* (detail), c. 1538, The Walters Art Museum, Baltimore (cat. 40)

page 3 (left to right):

Agnolo Bronzino, *A Young Woman and Her Little Boy* (detail), c. 1540–1545, National Gallery of Art, Washington, Widener Collection (cat. 41)

Sandro Botticelli, *Young Man Holding a Medallion* (detail), c. 1485, Sheldon H. Solow and The Solow Art and Architecture Foundation (cat. 26)

Domenico Ghirlandaio, *Giovanna degli Albizzi Tornabuoni* (detail), c. 1488/1490, Museo Thyssen-Bornemisza, Madrid (cat. 30)

Ridolfo Ghirlandaio, *Lucrezia Sommaria* (detail), c. 1530–1532, National Gallery of Art, Washington, Widener Collection (cat. 38)

pages 6–7:

Agnolo Bronzino, *A Young Woman and Her Little Boy* (detail), c. 1540–1545, National Gallery of Art, Washington, Widener Collection (cat. 41)

pages 10–11:

Filippo Lippi, *Profile Portrait of a Young Woman* (detail), c. 1450–1455, Staatliche Museen zu Berlin, Gemäldegalerie (cat. 4)

pages 24–25:

Sandro Botticelli, *Woman at a Window (Smeralda Brandini?)* (detail), c. 1470/1475, Victoria and Albert Museum, London (cat. 25)

pages 48–49:

Filippo Lippi, *Woman with a Man at a Window* (detail), c. 1438/1444, The Metropolitan Museum of Art, New York, Marquand Collection, Gift of Henry G. Marquand (cat. 3)

pages 62–63:

Leonardo da Vinci, *Ginevra de' Benci* (detail), c. 1474–1478, National Gallery of Art, Washington, Ailsa Mellon Bruce Fund (cat. 16)

pages 88–89:

Attributed to Paolo Uccello, *A Young Lady of Fashion* (detail), c. 1460/1465, Isabella Stewart Gardner Museum, Boston (cat. 5)

pages 98–99:

Agnolo Bronzino, *Portrait of a Lady* (detail), c. 1533, Städelsches Kunstinstitut, Frankfurt am Main (cat. 39)

pages 230–231:

Ridolfo Ghirlandaio, *Lucrezia Sommaria* (detail), c. 1530–1532, National Gallery of Art, Washington, Widener Collection (cat. 38)

757.4094551 V819

Virtue and beauty :
Leonardo's Ginevra de' Benci
and Renaissance portraits of
women

Central Fine Arts CIRC

ifarw
Houston Public Library